Enlightenment in a Smart City

Enlightenment in a Smart City

Edinburgh's Civic Development,
1660–1750

Murray Pittock

EDINBURGH
University Press

For Alexander Broadie

Edinburgh University Press is one of the leading university presses in the UK. We publish academic books and journals in our selected subject areas across the humanities and social sciences, combining cutting-edge scholarship with high editorial and production values to produce academic works of lasting importance. For more information visit our website: edinburghuniversitypress.com

© Murray Pittock, 2019

Edinburgh University Press Ltd
The Tun – Holyrood Road
12(2f) Jackson's Entry
Edinburgh EH8 8PJ

Typeset in 11/13 Sabon by
Servis Filmsetting Ltd, Stockport, Cheshire,
and printed and bound in Great Britain

A CIP record for this book is available from the British Library

ISBN 978 1 4744 1659 7 (hardback)
ISBN 978 1 4744 1660 3 (paperback)
ISBN 978 1 4744 1661 0 (webready PDF)
ISBN 978 1 4744 1662 7 (epub)

The right of Murray Pittock to be identified as author of this work has been asserted in accordance with the Copyright, Designs and Patents Act 1988 and the Copyright and Related Rights Regulations 2003 (SI No. 2498).

Contents

List of Figures vi
Acknowledgements viii
List of Abbreviations x

1. Remembering and Inventing Enlightenment 1
2. Edinburgh and the Canongate 1660–1750: Communications, Networks, the Routers of Change 41
3. Trades and Professions 86
4. The Arts 131
5. Taverns, Associations and Freemasonry 196
6. Booksellers, Newspapers and Libraries 224

Bibliography 249
Index 280

Figures

1	Vincent's embryo collection	15
2	Edgar's 1742 map of Edinburgh	18
3 and 4	Vertical and horizontal views of a surviving Edinburgh close	26
5	Mylne's Court (1690)	43
6	Tweeddale Court today	63
7	The Jolly Judge: a 'laigh' or basement entry tavern	89
8	A modern reinterpretation off the Canongate of an eighteenth-century Edinburgh garden	91
9	Gladstone's Land (without shop front), still standing today	92
10	*The Duke of Hamilton* by Daniel Mytens	94
11	Holyrood following Bruce's alterations, drawn by Paul Sandby, c. 1750	99
12	*William Carstares* by Richard Cooper	113
13	*Sir Robert Sibbald* by William Home Lizars	117
14	Heriot's Hospital, now George Heriot's School	119
15	Thomas Warrender's depiction of political conflict, party propaganda, ribbons and playing cards	133
16	*The Ruined Castle of Goblin Ha'*	134
17	Notice of Gladstone's Land auction (1697)	136
18	*Self Portrait* by Sir John Baptiste de Medina	139
19	*Self Portrait* by William Aikman	141

20	*Charles Edward Stuart* by Allan Ramsay	152
21	Paul Sandby's view of Edinburgh from the Castlehill (1750)	153
22	Allan Ramsay portrayed by his son in 1729	173
23	Edinburgh pattern (Jacobite) tartan	200

Acknowledgements

Much of the research for this book was carried out with the support of the Royal Society of Edinburgh, who funded the Edinburgh in the First Age of Enlightenment project: (http://www.gla.ac.uk/edinburghenlightenment/) from 2015 to 2017, and with the support of the AHRC, who have funded the £1.05 million Edinburgh Ramsay Project from 2018 to 2023. The interactive map on the above website may be of interest to all readers of this volume, and by the time this book appears it will be in the process of being supplemented by a new AHRC project website. Thanks are due to the web developer on the RSE project and AHRC postdoctoral Fellow, Dr Craig Lamont, and to the research network team of Professor Gerard Carruthers FRSE, Professor Sandro Jung, Professor Daniel Szechi FRSE, Dr Rhona Brown, Dr David McGuinness, Mungo Campbell and Helen Smailes. Thanks too to Aaron MacGregor, Robyn Stapleton, Professor Rab Houston, Dr Esther Mijers and Dr Stana Nenadic for their contributions to the research project. Thanks also to Cliff Siskin, who supported me in a visiting professorship to New York University where I broached this research first at a graduate seminar, and to the College of Arts research team at the University of Glasgow, in particular Sam Gannon, Vicky Hamilton and Ashley Theunissen.

Within the core Project team, Helen Smailes' extraordinary interest in the research and assiduous correction and provision of new and unexpected material has been a tribute both to her own precise and detailed scholarship and to her friendship, for which I am most grateful. I am also grateful to Rosemary Brown, proprietor of the Allan Ramsay Hotel, for initiating

and hosting the Allan Ramsay Festival from 2016, and to Sir Robert and Lady Clerk of Penicuik, John Kennedy of Newhall, Gordon Izatt of Pub is the Hub, Stewarts' Breweries, Cockburns of Leith, Billy Kay, Aaron MacGregor and Robyn Stapleton for their support of the Festival.

My thanks also to Gráinne Rice at the Scottish National Gallery, who gave me opportunity to air these ideas in two public lectures there, and to Lucinda Lax, who lectured at the Ramsay Festival in 2017, with the kind support of Sir Robert and Lady Faye Clerk. Thanks are also due to Hannah Philip of Fairfax House, York, who invited me to give the keynote lecture at the 2016 conference on the Georgian city, and to Clarisse Goddard Desmarest for inviting me to give the opening keynote at the 250th anniversary of the New Town conference at Amiens in 2017. Thanks too to Kenneth Dunn, Ralph McLean and their colleagues at the National Library of Scotland, and to Ashleigh Watson at Edinburgh City Archives, Claire Jackson and others at the National Records of Scotland and the staff of the Edinburgh Room at Edinburgh Central Library, as well as to Dr Jennifer Melville, Head of Collections and Archives at the National Trust for Scotland, and her colleagues Dr David Hopes and Linda Wigley.

The gracious permissions of Sir Robert Clerk (with respect to NRS GD18), Alexander, Lord Leven (with respect to NRS GD26/13), the National Gallery of Scotland, the National Records of Scotland, the WS Society, the Rijksmuseum Amsterdam and the British Library to reproduce material and images in their stewardship have helped make this a better book. It is dedicated to Alexander Broadie, Scot and European, in recollection of our countless conversations on the substance and nature of the Scottish Enlightenment over many years.

Murray Pittock
Glasgow, 21 March 2018

Abbreviations

A number of abbreviations are used in the text that follows, and in bibliographical references. These include:

BOEC: Book of the Old Edinburgh Club
BR: *Extracts from the Records of the Burgh of Edinburgh*
IELM: Index of English Literary Manuscripts
PHSL: *Proceedings of the Huguenot Society of London*
S£: refers to transactions or sums in pounds Scots, which, although technically abolished in 1707, remained a unit of account into the nineteenth century.
Works: *The Works of Allan Ramsay*, Burns Martin, Alexander Kinghorn and Alexander Law (eds), 6 vols, Scottish Text Society (Edinburgh and London: William Blackwood, 1945–74).

1 Remembering and Inventing Enlightenment

The Enlightenment is perhaps too often adduced as a cause of change ... without ever specifying properly what it was or the mechanics by which it supposedly brought about change.
— Bob Harris and Charles McKean, *The Scottish Town in the Age of Enlightenment*

Edinburgh was Scotland's biggest city ... yet its importance for national society and economy awaits full study
— R. A. Houston

The Scottish Enlightenment is both a set of institutions and a set of ideas. As such they represent two differing facets of a complex whole ... It is bad metaphysics to give one some sort of explanatory priority over the other.
— Christopher J. Berry, *The Idea of Commercial Society in the Scottish Enlightenment*

Bourse, brokers, notaries, price-currents, newsletters and publishers ... would not have developed, or would have developed much less vigorously, if the information had been fragmented between several gateways.
— Clé Lesger, *The Rise of the Amsterdam Market and Information Exchange*[1]

This is a book about the Scottish Enlightenment. It is also a book about Edinburgh, the chief city of that Enlightenment. There have been many books about the Scottish Enlightenment, and about the role of Edinburgh in it: but this one is different.

In the chapters that follow, this book will align the importance of Edinburgh for the national economy and national culture at the end of the seventeenth and the first half of the eighteenth centuries with its centrality as a place for the generation of ideas and innovatory practices. In this introductory chapter and those that follow, I will be primarily examining not the ideas of the Enlightenment nor its chief figures, but the mechanics of Enlightenment. Among the questions that will be asked of the evidence are: 'What is the (Scottish) Enlightenment?' 'How did the Enlightenment happen?' 'When did it happen?' and 'Why did it happen in Edinburgh?'

What is the (Scottish) Enlightenment ?

The terms 'Scottish' and 'Enlightenment' have both been frequently challenged over the years by commentators who see them as rhetorical claims rather than real concepts. For some Enlightenment scholars, the 'Scottish Enlightenment' is a core brand to be defended: 'an icon of Scottish self-esteem and identity', as Bruce Lenman puts it.[2] For others, the Enlightenment is a concept which is universal and is demonstrated through the application of reason to knowledge in the context of a challenge to received authority, particularly clerical authority: therefore any claim that it is a 'national' intellectual movement looks chauvinistic and particularist.

This second view is perhaps still the popular intellectual consensus, but it itself is often rooted in the more or less covert application of a single national model or source of ideas as normative and denominational in identifying Enlightenment as a concept internationally. In other words, the 'universality' of Enlightenment, with 'common characteristics ... from Edinburgh to Milan or Paris', turns out to be a national model in disguise. Sometimes this premiss is implicit, sometimes explicit. In the formulation of Peter Gay, the Enlightenment was 'a specific, homogenous movement which had its quintessence in France'.[3] Some definitions seek to give the Englishmen Sir Isaac Newton and John Locke primacy in generating the universal framework of Enlightenment enquiry. Others, most famously Jonathan Israel, point to the Dutch intellectual Baruch Spinoza, a claim substantiated by focusing on the 'radical' or 'democratic' aspects of Enlightenment as more real and important,

because 'moderate Enlightenment' was 'incapable' of delivering 'emancipatory reforms'. In this reading, only Spinoza can serve as 'crystallizing . . . Radical Enlightenment'. Scotland is both small and not a state, so it is usually seen as unlikely to provide the basis for a universal model of Enlightenment based on implicit national grounds, and is definitely not regarded as meeting his appropriate criteria by Israel, who sees the Scottish Enlightenment as not only not radical, but an unnecessary example of the 'resort to national perspectives' in Enlightenment study. The consequence can be that the 'Scottish' Enlightenment is dismissed as a partial account insofar as it converges with the unitary Enlightenment model, and dismissed altogether insofar as it diverges from it, as in Israel's view that it was 'devoted to the consolidation of an inherently corrupt aristocratic and clerically driven establishment'.[4]

Leaving aside disparaging comments of this kind (both 'corruption' and 'inherence' are more easily rhetorically deployed than evidenced), it is nonetheless natural that the idea of a 'Scottish' Enlightenment comes under scrutiny from scholars championing a universal model, sceptical as they are of national Enlightenments while often secretly relying on a model dependent on a national paradigm or an individual seen as representative of that paradigm's best elements to underpin a self-proclaimed internationalism. The 'Scottish' Enlightenment also faces a challenge from scholars who explicitly espouse *other* national Enlightenments. Gertrude Himmelfarb and Roy Porter are among those who have sought to extirpate the nationality of the Scottish Enlightenment while remaining content with a chauvinistic 'broader English Enlightenment' model, which reinforces the importance of the core by cannibalizing the significance of its peripheries. Porter adopted a cautious approach to the idea of the Enlightenment as a single 'thing', noting instead that although 'an anachronistic term . . . it captures . . . the thinking and temper of a movement'. His vision of it was nonetheless highly particularist and chauvinistic. In 1981, Porter argued that 'in England, and in England almost alone, the realization of Enlightenment hopes was not thwarted at every turn', while twenty years later he stated that 'practically all Enlightened thinking was . . . actually coming out of English heads . . . in the first third of the eighteenth century'. Forced to acknowledge that in fact many of these heads were Scottish ones, he sidestepped the fact by noting that 'I have . . . chosen

to splice Scottish thinkers into the British story', which is in fact that of 'many Englands'. That Porter goes on later to decry the Scottish Enlightenment as a concept which 'merely reflects later nationalisms' only underlines the contradictions of his own highly nationalistic argument.[5] That these contradictions have passed almost unnoticed in the response to what was a prizewinning study is a valuable insight into the power of banal nationalism to become normative as a framework for the construction of reality: nationalism as an evil always belongs to other people, but our own is a natural state of affairs. An example of this banality in everyday speech is the description of Berkeley, Hume and Locke as 'British empiricists', thereby neatly conferring an illusory cultural and political unity on their personalities, backgrounds and origins. This itself is often accompanied by the prioritisation of Locke by Anglo-British scholars in eighteenth-century thought, a prioritisation which, following research by Jonathan Clark, Peter de Bolla and others, it is increasingly clear there is not the evidence to support.[6]

Porter's vision of a national Enlightenment effectively made universal claims for English intellectual supremacy, and as well as negating the very concept of a Scottish Enlightenment gave national readings of Enlightenment a bad name by displaying their risk of chauvinism to excess, an approach arguably exacerbated by Porter's celebration of the individual agency of 'great men' in contrast to Gay's collective approach. Jeremy Black's judgement is more moderate than Gay's or Porter's, noting that the Enlightenment 'could be described as a tendency, rather than a movement', which 'varied in different states ... Even in France the views of those generally classed as Enlightened were far from uniform.' Others agree that 'the most widely held view is now probably that there was not a single, contemporaneous Enlightenment'.[7]

Despite the presence of such moderate voices, it is not surprising that the continuing grand claims made on behalf of the Enlightenment in universalist or chauvinist terms should repel many historians, and feed the arguments of a number of scholars who do not like the term 'Enlightenment' itself. These historians see the term as a rhetoricisation of aspiration invented after the events it describes which makes sense of them, whereas those who experienced them, the 'Enlightenment' thinkers themselves, would never have seen their lives and ideas as part of such a 'movement'. In this group are historians who suspect

an intellectual model of the past which is international, unitary, consistent and functions as a premiss for a stadial transition to modernity: 'Enlightenment' is seen by such scholars as a presentist claim born of hindsight rather than an accurate description of a complex past. The term is suggestive of a decisive intellectual and cultural break with the 'continuity' of the past in favour of 'progressive tendencies', as Jeremy Black puts it. Black warns that Enlightenment thinkers were 'not democrats' but 'Hungarian nobles or Virginian gentlemen' who pressed for their liberties, all the while maintaining 'what they saw as a benevolent tutelage over their serfs and slaves'.[8] The writers who identify an 'Enlightenment' are seen in such accounts as having a manifest design on the past, colligating it in a particular manner so as to emplot a consistent narrative of progress at odds with the complexities of the lived life of the eighteenth century's contemporary subjects. This may manifest itself in too great an emphasis on secularism, as Israel identifies in Gay's work, or indeed the presentist model of the Enlightenment as radical and democratic avatar, which is everywhere in Israel's own scholarship. There is also a second group of sceptics, most prominent in the US, who see the 'Enlightenment' as a rhetorical term designed to disguise 'a conspiracy of dead white men ... to provide the intellectual foundation for Western imperialism'.[9]

There are thus three basic models of Enlightenment: international (though often with a preferred national exemplar) and universalist, national and particularist, and accidental and contingent, the third claiming that the category itself is the creation of historians who would wish it to be true, either to justify their own presentist historiography or the historic dominance of the West. The first model is the least contingent, and least historicised: it usually emphasises ideas over context, and identifies either Newton and Locke or the French *philosophes* (or Spinoza) as the key originators of a set of intellectual practices diffused throughout Europe, which emphasised 'Reason' as 'a goal as well as a method' to 'free men from unnecessary fears' and deference towards either clerical or secular authority, or both.[10] The second account emphasises the explicitly national quality of Enlightenments, and the adaptation of their interests to local circumstance, sometimes with consequent influences, as in Lenman's view that 'the Scottish Enlightenment' penetrated 'the intellectual foundations of the new North American Union', or Nicholas Phillipson's judgement that 'Scottish learning began

to penetrate the salons and classrooms of England, France, Germany, Italy and America'.[11] The third approach argues that the whole concept of Enlightenment is an account of diverse and sometimes incompatible intellectual trends gathered under a common heading, which lend an illusory unity of purpose to the diversity of the past. The purpose of 'Enlightenment' in the scenario posited by the sceptics is to serve as a place-marker for the concepts of social and material progress most compatible with modern Western liberalism. In Jonathan Clark's words:

> It can be shown that the reification and popularization of an idea of 'the Enlightenment' happened from the mid-twentieth century as part of a number of attempts to give sanction to certain social crusades ... [12]

Such an Enlightenment is irrevocably, if inconsistently, a genealogy of origin for the various topoi of contemporary democratic and egalitarian obsessions.

The champions of a universalist Enlightenment lend the sceptics room by their own tendency to schematisation and lack of detail. Richard Sher comments that the dual view of Enlightenment as the heir of either Newton or Voltaire is a limited one, while the case for it as a version of 'universal cultural homogenization' – closer to that put forward by Jonathan Israel, who is very critical of *national* Enlightenment as a concept, while being a champion of it internationally – has roused extensive criticism of what has been called the 'modernization' thesis. A 'universalist' Enlightenment approach is more vulnerable to scepticism than those that explore national particularism in detail, because it is less historicised, and its determination to attribute major international intellectual influence to individual writers and texts often rests neither on comprehensive contemporary evidence nor on quantitative analysis. Jonathan Israel's contention is that

> Radical Enlightenment is a set of basic principles that can be summed up concisely as: democracy; racial and sexual equality; individual liberty of lifestyle; full freedom of thought, expression, and the press; eradication of religious thought from the legislative process and education; and full separation of church and state.[13]

This sounds like the weekly shop of liberal modernity with an American tinge. Since it is not easy to identify an Enlightenment

thinker who held all these views (and, as Black suggests, precious few held many of them), this kind of universalism is vulnerable to sceptical readings of the movement as a myth of origin for Western 'white' liberalism. In this reading, Israel's championing of 'the quest for human amelioration' and 'cultural cosmopolitanism' can sound suspiciously like sanitised versions of imperial stadialism and globalisation on the American model. Such scepticism is reinforced by more populist and radical elements in American thought in particular: the continuing domination of Enlightenment thought in the political and cultural self-definition of the United States may well be the reason why that country is home to some of the concept's fiercest opponents. These doubters are not, like the scholarly sceptics, irritated by the lack of evidence to support Peter Gay's universalist thesis of the Enlightenment as 'an international conspiracy of secular-minded and anti-clericals', being instead sympathetic to the complexity of the religiosity of eighteenth-century women and men. Instead, this more radical group sees the universalist Enlightenment and its claims 'as one of the many plots by dead white men to rape the world', thus regarding 'Enlightenment' as public relations for 'Western imperialism', intolerant of local value and custom. Although the two groups of sceptics often originate in very different outlooks, they both home in on the Israel model's alignment of Enlightenment with modern Western aspiration as evidence either of the term's absence or corruption as a descriptive concept for the intellectual world and values of the eighteenth century.[14]

But the sceptics have their own issues too in their denial of the meaningfulness of the Enlightenment as a word which describes a manifest if diverse intellectual movement rather than being a term of historiographical art or a tricky rhetorical turn in the emplotment of cultural memory. One of their most obvious problems is that some of the international phraseology identifying 'Enlightenment' as a collective term is contemporary with the events it describes. Richard Price (1723–91) argued that 'our first concern, as lovers of our country, must be to *enlighten* it', while William Young wrote in 1722 of the 'Light of Knowledge ... now universally breaking in on the world'. For Gilbert Stuart (1742–86) in Scotland, his was 'this enlightened age of philosophy and reflection'. Similar views could be heard across Europe, as Israel points out: *éclairé* and *aufgeklärt* are both terms 'incessantly used at the time'. Kant's

Was ist Aufklärung ('What is Enlightenment ? (1784)) remains a seminal text in its call to dare to know (and to debate it in public). As Margaret Jacob puts it:

> In various European languages ... the fashion arose of praising some people for being 'enlightened': in French, *éclairé*, in German *aufgeklärt*; in Dutch, *verlichte*. As praise, it meant that the person was no timid follower of the clergy or believer in magic. Rather, enlightened people read books and journals and frequented the coffeehouses, salons, Masonic lodges, and reading clubs that sprang up all over Europe ...[15]

Voltaire and Kant's clear belief in 'a great revolution in men's minds' leading to progress, itself an idea possibly first developed by Baron Turgot in 1750 (and later elaborated by Adam Smith), is also relevant here: the idea of progress for which historians of the Enlightenment are castigated was itself the product of that Enlightenment. More speculatively, Jacob goes on to argue that the light metaphor common to many contemporary and subsequent descriptions of Enlightenment ultimately derived from Newton's *Opticks* of 1704, and beyond that from the improved glass manufacture of the late seventeenth century.[16]

Those sceptical of the very idea of an Enlightenment generally oppose this case piecemeal, by pointing out its limitations or the teleological assumptions behind our modern understanding of eighteenth-century language, though sophisticated analytic historians like Jonathan Clark accept a plurality of activities described at the time as enlightened, but not constituting 'the Enlightenment'. Clark notes that the terms used in the eighteenth century which Jacob cites do not exactly mean what we term 'the Enlightenment' today, a term which he notes is not categorised consistently either chronologically or in the features identified by its scholars as pertaining to it. Indeed, Clark suggests somewhat scathingly that Enlightenment history *'est une histoire d'erreurs de traduction entre les principals langues européenes'*, a concept given later plausibility by 'errors of translation that occluded eighteenth-century differences'.[17]

Clark's view that 'modernity' is a nineteenth-century rather than an eighteenth-century concept could be challenged (certainly 'progress' appears to be eighteenth-century),[18] but his assertion of the power of 'growing evangelicalism' is just and cuts across the relentless promotion of the case for early onset

secularism so widely visible in Enlightenment scholarship. Unsurprisingly, Clark likes Rick Sher's thesis, which is based on the power of the Moderate faction in the Kirk of Scotland in defining the Enlightenment there. Porter's view that Clark's long-established position on this issue 'overlooks the zest for change bubbling up in society at large' begs the question: no data was offered by Porter to justify the assumption of widespread progressivism among a population evidently swayed by the Wesley brothers rather more than by Hume's *Treatise of Human Nature*.[19] At the same time, claims such as Peter Gay's that 'there were many philosophers in the eighteenth century, but there was only one Enlightenment' are almost bound to irritate in their intellectual and implicitly moral monism.[20] As long ago as 1960, moderate voices such as Alfred Cobban's were warning against this approach:

> . . . many of those who have written on what, for the sake of brevity, I will call the Enlightenment seem to me to start . . . with a judgement framed on the basis of a contemporary scale of values . . .[21]

This is – then as now – what makes the universalist account vulnerable. The simplicity of its appeal, its elegant ability to rest itself lightly on a few seminal texts and thinkers without the tiresome drudgery of recovering data or reconstructing culture, its assumption of progressive and presentist values, and of course its narcissistic appeal to the idealisation of its own forebears by the modern West, all act in its favour and make it suitable for popular dissemination. These same qualities also earn it many opponents, who variously say the Enlightenment was a more complex thing, a more national thing, a bad thing, or no thing at all.

One might expect in these circumstances that the national account of Enlightenment would be seen as offering the right correctives of specificity, variety and diversity to any overstatement of the unitary integrity of the concept of Enlightenment itself, and would thus represent a middle ground. Such an account can be justified by history, as (to be fair, Israel acknowledges) the psychological shock of the 1648 Westphalian settlement which began to substitute modern states operating in an international order for divinely appointed 'winners' rendered nationality of increasing importance in the Enlightenment era.[22] There are, however, also problems with the national account, not least

in the Scottish case, sandwiched uneasily as it is between the claims of the Enlightenment grand narrative and the debunking detailing of sceptical historians.

When was the Scottish Enlightenment?

Although there are occasional comparative studies which seek a civic or nationally balanced account of particular Enlightenments, such as John Robertson's *The Case for the Enlightenment: Scotland and Naples 1680–1760* (2005), much of the modern evaluation of the Scottish Enlightenment that has utilised a nationally specific model is arguably unduly self-congratulatory, having risen to prominence almost at the same time as the development of modern Scottish nationalism in the late 1960s: Istvan Hont and Michael Ignatieff described 'the Scottish Enlightenment' as having a 'renaissance . . . in the past fifteen years' in 1983. This development, which on the surface bears out Porter's charge of nationalist presentism, sharing as it does a chronological envelope with the early stages of the modern Scottish National Party as an electoral force, has been associated with some rather chauvinist accounts of the Scottish Enlightenment, which by no means always emanate from Scots. A classic example of this is Arthur Hermann's text, *How the Scots Invented the Modern World* (2001), but it can also be found elsewhere: for example, Bruce Lenman declared, 'Scotland in some ways was the first modern nation and culture'. Such an outlook might pass unnoticed in a British context (as Porter's own argument cited above demonstrates) but can be a hostage to fortune in a Scottish one.[23]

This national(ist) account is itself a reaction to the earlier history of the Scottish Enlightenment as a concept denominated by 'the diffusion of philosophical ideas in Scotland' (William Robert Scott in 1900, implying that the ideas originated outwith Scotland) and later refined by Hugh Trevor-Roper. Trevor-Roper followed Henry Buckle (1821–62), who saw Scotland before 1707 as 'a primitive intellectual desert', in seeing the Enlightenment as a dividend of the Union settlement and 'the defeat of the last Jacobite rebellion in 1745'. Without such a development the Scottish Enlightenment would be 'a puzzling phenomenon', as Trevor-Roper put it in 1967.[24] This is the concept of the Scottish Enlightenment which lurks

behind Porter's book: it can be categorised as English because its existence depended on Union with England. The Scottish Enlightenment was thus long seen as neither owned by nor developed in an entity that saw itself as 'Scotland', and the national reaction to this in more recent years has often been correspondingly chauvinistic. Edinburgh was 'the Athens of Great Britain';[25] in many contemporary accounts, Edinburgh's status as an Enlightenment city is rather bound up with its status as the Scottish capital.

Following the long-standing tradition that the settled society of post-Union Scotland ushered in British modernity, wakened Edinburgh 'from the sleep of centuries' and provided an indispensable infrastructure for the achievements of Enlightenment, a new consensus began to emerge which reflected a political shift in Scotland's sense of itself. As David Allan put it in 1993:

> The Scottish Enlightenment has in recent years re-emerged as a major historical issue ... the mainstream of academic debate has allowed Scotland to be seen as a singularly important centre within the celebrated eighteenth-century European revival of learning.[26]

The view Allan is describing is one which has ultimately led to the presentation of the Enlightenment as an intellectual brand, a highpoint of achievement detached from Scotland's preceding history. In this, the advocates of a native Scottish Enlightenment can at times risk being as isolationist as those who once saw it as the beneficial outcome of Union. Allan suggests that the seventeenth century might be more important than we have always acknowledged: but although few scholars since the 1980s have openly disagreed, few have responded with many details to substantiate this, and indeed Allan himself has recently characterised the Scottish Enlightenment as 'a brilliant concentration of cultural and intellectual activity starting in the 1720s and 1730s'. Likewise, Nicholas Phillipson's focus on 'Andrew Fletcher of Saltoun' (1653–1716) as 'the ideological father of the Scottish Enlightenment' is not generally pursued in Phillipson's other work. Alexander Broadie's important research on Scottish seventeenth-century philosophy on the Continent is an exception to this trend, and Broadie also points out that 'we should avoid exaggerating the negative factors at work in Scotland in the late seventeenth century'. Fern Insh likewise notes that while 'the

idea that seventeenth-century Scotland was not a cultural dark age is not new, yet the period still bears the stigma'. Nonetheless, it still usually remains the case that the Scottish Enlightenment is categorised as 'a period of a few decades on either side of 1760'. One of the reasons for this might be the difficulty of acknowledging the importance of Royalist and Episcopalian Scotland to the country's intellectual history: as Clare Jackson points out, the Restoration has long symbolised 'the darkness before the dawn' of Union and Enlightenment. Yet those who came at the tail end of the traditional Enlightenment era, such as Robert Chambers, could be of a different opinion. In the 1820s, Chambers took the view that 'the Union had had a catastrophic effect' on Edinburgh, 'plunging it into ... a Dark Age ... stripped of the metropolitan institutions and the metropolitan élite which had defined its status before the Union'.[27] This was, as we shall see in the chapters that follow, too extreme a verdict: but it is also one which is hardly compatible with the model of the Enlightenment as some kind of Union dividend.

For whatever reasons, both dominant accounts of the Scottish Enlightenment's development continue to start after the Union. In one, 1740 is the effective starting date, conveyed in veiled form in terms of the extension of Newtonian thought into social criticism (the Science of Man), a reference, not always made explicit, to the opening section of David Hume's *A Treatise Concerning Human Nature* (1739–40). This allows even commentators who agree on the seventeenth-century underpinnings of Enlightenment to postpone its 'budding' until the Humean moment, following which 'the plans to build the Edinburgh New Town and the first steps in the realisation of those plans coincided with the beginning of the heyday of the Scottish Enlightenment'. This is effectively true even of some of those scholars who would if pressed backdate the Enlightenment to before Hume's birth in 1711.[28]

The adoption of a single text by Hume (topped up by his 1770 soundbite of 'this is the historical Age and this the historical Nation') as a concealed synecdoche – even a partial one – for a critical intellectual shift, might be argued to be simplistic, and is itself in line with the universalist Enlightenment reliance on 'great men' and 'great texts', be they those of Hume, Newton, Locke or Spinoza. Many scholars have thus advanced a second view of the Scottish Enlightenment based more on the importance of institutions: 'the Church, the law, the lawyers and

the universities', an approach in which 'The Enlightenment in Scotland... was largely an ecclesiastical and academic phenomenon'. This approach, perhaps most eloquently and intensely outlined by Rick Sher with his prosopographic focus on the careers of the leading Moderate literati in the 1750s, has been increasing in prominence in the last thirty years. Sher's argument for the centrality of 'the culture of the literati of eighteenth-century Scotland' and their love of learning and virtue, reason and science, and 'civilized urbanity and polite cosmopolitanism' situated 'within an international framework of values and beliefs, while still allowing for the uniqueness of the Scottish experience' remains central. And indeed all these institutions will be important in the study that follows.[29] Unfortunately, three problems beset institutional accounts. First, they are often not detailed or focused enough (Sher's *Church and University in the Scottish Enlightenment* (1985) and *The Enlightenment and the Book* (2006) are shining exceptions). Secondly, they can be biased towards one institution in particular: for example, something like half the essays in R. H. Campbell and Andrew Skinner's *Origins & Nature of the Scottish Enlightenment* (1982) deal with the universities – not least the University of Edinburgh – but it is far from clear that this is not overstating their importance. Campbell and Skinner are not alone in this: for example, Peter Jones argues that 'The modern republic of letters was not brought to birth easily and if anybody can lay claim to the role of midwife, it must be the Scottish professoriate.' Peter Jones is of course a member of this group.[30]

The University of Edinburgh was not, at least in its earlier stages, always a friend to innovation, as we shall see, though the case for the centrality of higher education to Enlightenment is repeatedly made by higher education professionals, Berry for example noting that 'the theorists of the Scottish Enlightenment were overwhelmingly university professors'. This reads the Moderate era backwards into a time when in fact 'the universities were... dominated by a Whiggish Presbyterianism'. It is also of course no surprise that university professors writing now are often more interested in their predecessors than in the engagement of other professions in the clubs and associations which were the key factors in 'the development of social capital, an informal system of trust-building vital to economic development'. These networks of trust and associationism were far more widespread than those which involved the academy,

for Scotland, and Edinburgh in particular for reasons that will soon be identified, was 'an environment of mutual support and common cause'.[31] In this context, books like Roger Emerson's *An Enlightened Duke* (2013), which focuses on the patronage and influence of Ilay, may be closer to the mark than those which stress the importance of the universities. Institutional accounts of Scotland's Enlightenment often risk partiality and synecdoche in similar senses to those dependent on the influence of particular thinkers.[32]

In the book that follows I will claim that the term 'Scottish Enlightenment' – which of course has many supporters – does indeed have meaning, and that that meaning is best expressed by the definition *'the application of reason to knowledge in a context of material improvement'*: a definition I arrived at in 2003, which is not entirely dissimilar to Israel's stress on the 'quest for human amelioration', but which makes central the relevance of what he rejects, the value of 'sociability and social practices' in Enlightenment 'innovations'. Israel states sweepingly that 'no significant Enlightenment figure had sociability or social practices in mind'. The first part of the above definition ('the application of reason to knowledge') is largely true of thought which we term 'Enlightened' anywhere; the second ('material improvement') was particularly (though not solely) stressed in a Scottish context in response to the generally deteriorating economic conditions of the seventeenth century, accelerated both by sectarian warfare and some phases of poor climate (for example, the famine of 1689–96) and outbreaks of disease (for example, the plague of 1645). The Thames froze over in ten years of the seventeenth century; this was a general northern European problem, but at the latitude of Scotland it was particularly acute. In addition, religious warfare was almost never absent from the country for most of the period between 1638 and 1689. No other country so far north had such a developed and cosmopolitan professional and educational system operating in environmental and political conditions which were so bound to trigger and perpetuate economic decline. Scotland's relatively advanced intellectual infrastructure and cosmopolitan connectivity helped to lay the grounds for a profound social, intellectual and cultural response to economic decay.[33]

The Scottish Enlightenment has a good case, some of which is detailed in the study that follows, for being considered one

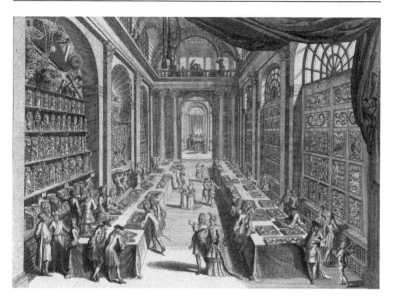

Figure 1 Vincent's embryo collection. By courtesy of the Rijksmuseum.

of the key distinct national Enlightenments, but there are many family resemblances it shares with others. It is perhaps better to describe the Enlightenment as a *genus* (a taxonomic group descriptor), not a single thing. Taxonomies are themselves an Enlightenment development: in collecting, the first cabinets of curiosities became used for research in the first decade of the eighteenth century (for example, Levinus Vincent's embryo collection, see Fig. 1), while subject-based taxonomic organisation was under way by the 1730s (for example, Jean-Baptiste Courtonne's 1739 record of Joseph Bonnier de la Mosson's collection). Hans Sloane's collection of everyday objects were 'grouped . . . together by type rather than chronologically or culturally, in order to compare them and trace "the progress of nations"'.[34] By the middle of the century, when Jean le Rond D'Alembert (1717–83) stated that 'the true system of the world has been recognized' and the *Encyclopédie* 'proclaimed a knowable, demystified universe', the principles of taxonomic order had been extended from the macrocosm of the post-Westphalian state to the microcosm of the farmer and collector. The infrastructural arrangements which sustained the modernising state themselves fed, as we shall see, into the development of its distinctly national

Enlightenment systems, an idea implicitly advanced in Clifford Siskin and Bill Warner's highly original collection, *This is Enlightenment* (2009).[35]

Describing the Enlightenment in taxonomic terms does not mean that it is either a 'universal' or a 'national' concept, though in fact it partakes of both: rather it stresses that the nature of the Enlightenment is a relational one, with mutual connectivity and the ability to reproduce not only the parent ideas of its national or civic origins, but also new offspring of innovation carrying a family resemblance which is newly inflected in fresh directions. The technical definition of *genus* in biology implies common ancestry: relational compactness and distinctiveness depending on evolutionary/ecological environment. These conditions also obtained with respect to the European Enlightenment and the Westphalian system of mutually recognised states which underpinned its political order. Scotland's paradox was that it lost its statehood (although, crucially, not its cultural ecology) during the process of the development of some of its most profound ideas, a situation to which we shall return in this book about the continuing role of its capital as a cultural if not a state actor. Within Scotland, the special case of Edinburgh is itself key to the Scottish Enlightenment.

In this study, Smith and Hume are neither the Scottish members of an intellectual bucket list that begins with Newton and ends with Rousseau, nor the poster boys of Team Scotland in the world cup of modernity. Instead, their ideas are understood as the superstructure of cultural change which was often evidenced through the diffusion of less overtly intellectual innovations through a distinctive ecology of networks which developed to support the diffusion of those ideas themselves. The *imaginaire social* of Edinburgh underpinned the 'vast *imaginarium*' which Nobel prizewinner Edmund Phelps sees as central to the 'experimentation, exploration, daring and unknowability' which are the hallmarks of innovation. This integration of culture created cultural history itself: *Kulturgeschichte*, as well as many individuated yet intersecting cultures: politics, art, music, theatre, consumerism, transport, collecting, libraries, booksellers, markets, education, Freemasonry and taverns. To understand the social imagination of Edinburgh in this era is not to make 'false assumptions about cultural homogeneity', but to acknowledge its diversity. Women, men and their associations, environment and institutions created the dynamic

basis for intellectual change in eighteenth-century Edinburgh, and this book sets out to chart how that happened.[36]

In Scotland, relative economic underdevelopment resulting from adverse climate change and religious conflict in the sixteenth and seventeenth centuries led to an emphasis on material improvement as a consequence of new ideas which was not present to the same extent in other civic and national Enlightenments. The massive shift in Scotland from scientific ideas (including the development of the human sciences) to technological change in the later Enlightenment is evidence of this. This zest for material improvement led to the development of the modern steam engine, coal gas lighting, the hot blast oven, the steam hammer, the passenger steamboat, the telephone, anaesthetic, the hypodermic syringe, tarmac, the bicycle, the pneumatic tyre, the fridge, the flush toilet, the mackintosh and the kaleidoscope, among many other inventions and discoveries. The main argument of the book that follows will build on this initial exploration of the troubled term 'Enlightenment' to identify the ecology and taxonomy of Edinburgh's intellectual and cultural life that made the Scottish Enlightenment possible. It will apply the findings of contemporary research to the Edinburgh of the late seventeenth and early eighteenth centuries. This will demonstrate the answers to what happened, why it happened where it did and how it began, and why what happened can legitimately be narrated as 'Enlightenment'.

How did the Scottish Enlightenment happen, why did it happen and why did it happen in Edinburgh?

The material conditions for the development of the Scottish Enlightenment in Edinburgh were similar to the conditions deemed necessary today for the growth and development of innovative ideas in cities. These include, in the classic formulation of Jane Jacobs, the intermingling of residential and commercial properties (what was once called 'efficient specialization' in segregated neighbourhoods is today seen as presaging economic decline); small and short blocks (the varied closes and wynds of old Edinburgh met this criterion admirably); buildings of different ages, types and size; and high concentrations of people. Edmund Phelps is only one recent commentator who ascribes the rapidly rising growth rates of the modern era to 'population

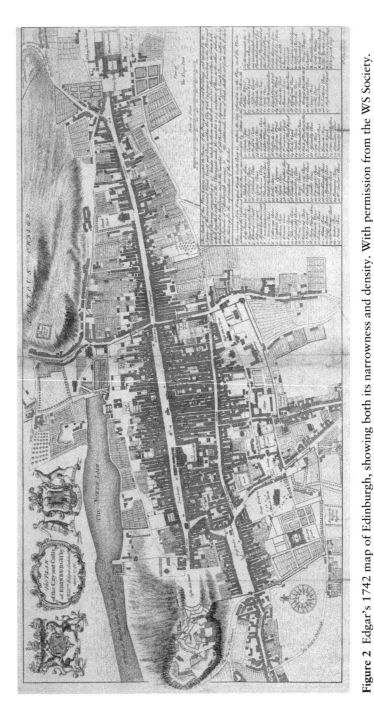

Figure 2 Edgar's 1742 map of Edinburgh, showing both its narrowness and density. With permission from the WS Society.

density'. Few early modern cities were more concentrated than eighteenth-century Edinburgh.[37]

In the contemporary policy realm, it is a commonplace that innovative cities share frequently replicated characteristics: a supportive policy environment, a geographically contiguous employment district, and a diverse workforce. Vancouver and San Francisco are prime examples. It may seem strange to place Edinburgh in 1700 in the same category, but we will see that this is not so. The city and its institutions were geographically concentrated (this results in a 20–30 per cent uplift in patents per capita in modern cities);[38] and its workforce was diverse in point of foreign origin and foreign education. As Phelps puts it, 'people are better able and more apt . . . to innovation when they have been left free to venture from their homes . . . to soak up information on old and new products and new lifestyles', while 'a 2015 study by McKinsey found firms in the top quartile for racial diversity are 35 per cent more likely to make bigger profits than their industry average'.[39] Edinburgh had strong Netherlandish and French communities, as well as many Scots who had been educated or sojourned in these countries. Dutch concepts of open trade (*mare librum* as against the *mare clausum* of powers such as imperial Spain) and – as a haven for many different stripes of Protestant in exile – mutual Protestant toleration were both influential in Edinburgh, if perhaps less so elsewhere in Scotland.

Moreover (at least until 1707), the Scottish government provided a steady diet of often supportive policy interventions directed at the capital. As Edward Glaeser points out, 'the urban ability to create collaborative brilliance isn't new. For centuries, innovations have spread from person to person across crowded city streets.'[40] This was even truer in the cityscape of early modern Edinburgh, where poor lighting and crowded accommodation intensified the normative early modern practice of socialising outdoors: the Hie Gait or High Street and its nearby closes, booths and squares was the open-plan office of national improvement.

Today, effective, connected leadership and engaged citizens are seen as central to 'Smart City' development: both of these factors, as will be seen, were to be found in Edinburgh between 1680 and 1750 in the shape of a nobility engaged with the professions, and a strongly associational culture with multiple overlapping memberships of clubs and societies among those

professions themselves. It should be noted here that one of the categories used in this book, 'nobility', is one which is seen as extending beyond the category of Lords of Parliament (those holding titles equivalent to English barons) into the Scots baronial class, commonly called lairds, chiefs of the name and of major septs, landed baronets and their relations. An estimated 2.45 per cent of the Scottish population was 'noble' in these terms at the Union, a proportion much more in keeping with Continental than English norms. Scotland was more like France than England in the proportion who were noble by rank, title or close relationship. While in England the size of the gentry was estimated at 15,000 in the eighteenth century (0.3 per cent of the population), with the nobility proper numbering only a few hundred, the nobility made up 1–5 per cent of the French population and reached 50 per cent in some pockets of Spain. As late as 1771, 'great landowners' were 'defined as owning more than £2000 Scots' (£167), hardly a challenging level in English terms, even given that prices were only slowly converging with English norms. Edinburgh wages were two-thirds those of Exeter and Manchester and half those of London between 1765 and 1795; in 1700, unskilled workers earned twice as much in England as Scotland, although the exchange rate of just over S£13 to the £1 (standardised as a 12:1 conversion at the Union) understated buying power in Scotland. Despite these statistics, however, the Scottish nobility were poor: one reason why they often entered the professions.[41]

This more inclusive approach to the scale of the noble/gentry class is truer to how Scottish society conceived itself at the time than are many subsequent models which, consciously or not, adopt an Anglocentric paradigm of gentry and nobility, despite the fact that Scotland had no 'squirearchy' of the English kind. Such an approach disregards the resonance of noble names like Boswell, Burnett or Hume to their contemporaries, to say nothing of chiefs of the name like Cameron of Lochiel or Farquharson of Invercauld, who might be lords of tens of thousands of acres and usually did not have title in the British peerage. The chiefs of the name of Campbell, Crawford, Graham, Murray and Scott did have such title; those of Mackintosh or MacLachlan, Cameron or Farquharson did not. To term these men or women as outside the nobility is simply to import English terminology into Scotland. Sir John Clerk of Penicuik, to take only one example of 'gentry', was

frequently addressed in correspondence as 'Baron Clerk', his Scottish title, and Boswell was addressed as 'Baron' on the Continent (a usage which still remains correct). For men like David Hume and Walter Scott, connexion to ancient families of rank was important; for others like Allan Ramsay, who had to be content with a fictional narrative of noble relation to the Dalhousie family, such relations were nonetheless an aspiration to be fulfilled by his son. Ramsay the younger first married the daughter of a minor scion of the Scottish landed classes, Alexander Bayne of Rires, and secondly the daughter of Sir Alexander Lindsay, grand-daughter of Viscount Stormont and niece of Lord Mansfield and the Earl of Dunbar, connexions viewed as most useful by her ambitious Campbell son-in-law. Senior professionals, notably advocates, were also drawn from the ranks of the nobility to an extent unknown in England; and many of those who assumed the title 'Lord' on being elevated to the Court of Session were themselves from the baronial classes: Elliott of Minto, Home of Kames, Alexander Boswell, 5th Baron Auchinleck. The distinctive qualities of Scottish society are important if we are to understand the mechanics of change.[42]

Also important are the arts and culture. As I argue in Chapter 3, the centrality of arts and culture in innovative and heterogenous cities is increasingly understood as a key element in their ability to innovate: it is central, for example, in the 2009 Creative Dublin Alliance and its engagement with a smart economy/knowledge city paradigm in pursuing the resumption of economic growth in the wake of the financial crisis; it has had more recent application still in Glasgow City Government's creative economy strategy and in Innovate UK's focus on digital creativity. As Phelps points out, 'most innovation . . . is remote from science', which makes the linkage of scientific discovery to economic growth a tenuous one in point of evidence.[43] In generating the free time for intellectual play in music or theatre, the arts make a major impact on the environment for the production of fresh ideas: the role of *homo ludens* remains central in generating both the free play of ideas and the playful liturgy of the rituals of sociability, both of which are features of Johan Huizinga's classic study (*Homo Ludens*, 1938) and of Edinburgh in our era. Arts and culture gained their intellectual sinews of innovation in booksellers and libraries, and the changes in domestic life and society which socialised these new practices. In Edinburgh in the first years of the eighteenth

century, the arts unquestionably made, as we shall see, a major impact on a compact city. They were, in the words of *The Mercury* on music in 1717, 'universally accounted' markers of 'civilized quality ... Breeding and Accomplishment', premier outward signs of civility and commerce.[44]

This book is thus an approach to addressing the all too frequent absence of 'the mechanics of change' in understanding the role played in developing the Enlightenment. The Old Town (a term apparently unknown until the 1752 *Proposals* which led to the development of the New) was central to such mechanics: a focus on the New Town has arguably contributed to the relatively inadequate specification of the causes of Enlightenment. In A. J. Youngson's classic work on the New Town, *The Making of Classical Edinburgh*, the older city is characterised as 'a very small town, spilling out from the narrow confines of the old Flodden Wall ... cramped and overcrowded'. This may be technically correct, but Youngson's rhetoric supports his subject by also implying that Edinburgh's success as an intellectual capital depended on the major urban changes that followed the 1752 *Proposals*, and would have been impossible without them. The *Proposals* themselves sought to diminish the Old Town in order to stress the necessity of '*certain Public Works*' to change the city for the better: thus they bring home the point that Edinburgh 'admits but of one good street', and that the New Town would provide the capital's elite with an incentive to live in 'splendour and influence ... at home', rather than have 'an obscure life in LONDON'. Interestingly, however, the New Town did not retain the nobility in Edinburgh in residence. It was the century before it was built which was the sweet spot for the intersection of a native nobility's defence of its declining status and the professional defence of threatened institutions, both taking place in a confined geographical space with a workforce of exceptional diversity for the time, with unusually good transport links by land and sea, which gave, in Edward Glaeser's words, 'a huge edge' to the success of early modern cities. If, as Peter Burke has argued, 'the group identity of the clerisy' was becoming stronger in the early modern period, the political and indeed, to an extent, existential threat posed by the Union to Edinburgh's capital status could only serve to intensify this process: crystallising and developing centres of professional power were faced with the dissolution of the state in which they were located at a critical point in their own rise to prominence. Nor would one

have to be an opponent of Union to participate in the growing solidarity that resulted from these critical circumstances: by no means all supporters of the Union were enthusiasts for its consequences, a fact easily forgotten by posterity and I trust sufficiently evident in the pages that follow.[45]

Despite a literature on Scottish Enlightenment origins dating back many years, emphasis has often still remained on the Enlightenment's own role 'as a cause of change', rather than the genesis of that Enlightenment itself. Moreover, as the historians Bob Harris and the late Charles McKean have recently argued, 'the distinctive language of urban improvement was already very well established by the early eighteenth century' in Edinburgh, as the Restoration capital had begun to display markedly individuated features in urban and civic development, only one reason why it is 'incautious to assume' that an inclination towards improvement was 'derived solely, or even mainly, from copying eighteenth-century London'.[46] London and 'London's recent growth' were topics of anxiety for Edinburgh throughout the eighteenth century: but this did not mean that attempts to rival the metropolis had their sole basis in imitation.[47]

In the book that follows, I will take the view that the historiography of the Enlightenment has itself become rather bogged down in accounts of ideas and their cultural transmission and ownership. The assumptions of an ill-defined process of diffusion, baggy universalism or unevidenced chauvinism present in a good deal of the literature have understandably given rise to scepticism about the consistency, nature or internal workings of the Enlightenment. By contrast, I will seek to provide a mechanics of the Enlightenment, a set of both necessary and sufficient conditions which both enabled and accelerated its development in the Scottish capital. Not all of these applied to other Enlightenment cities, but there were similarities in aspects of process. The following is an indicative (if not exhaustive) list:

- A resident nobility who were closer to the professions in point of sympathy and membership than was the case in many European cities, and who experienced the need to defend a loss of status after 1707 in particular
- Strong and developed professional institutions, with new institutions emerging (for example, the Royal College of Physicians)

- Significant and retained rights of patronage over these institutions in the hands of a broadly patriotic nobility
- Conflict between a Moderate Episcopalian/Presbyterian urban elite and a more conservative Kirk presence in the burgh and university
- Compact living conditions and places of employment, combined with poor light in many buildings, leading to extensive time spent in public places or outdoors, intensifying the velocity of the circulation of ideas
- An associational life which to an extent transcended social divisions
- A high level of innovation in the performing and dramatic arts, and in the creation of libraries
- An increasingly diverse citizenry in terms of national origin, combined with a high proportion of the native elite having received an education in Continental Europe.

In all this, the wide range of personal, urban, national and international networks and groups, as well as key homophile/heterophile and social broker relationships are all relevant (these terms, from network and diffusion theory, will be used frequently in the study that follows). A close examination of Edinburgh in the latter years of the seventeenth century strongly indicates that many of the key areas of infrastructure and distinctive urban and patronage networks associated with the Enlightenment were already coming into being, including the beginnings of a Moderate outlook in the Kirk. The power of Moderate Presbyterians should not be overplayed, but it was a significant cultural current that was one of the things that made the capital different, and helped to provide the environment in which a writer like Allan Ramsay could – despite his many frustrations – flourish, innovate, develop and commercialise new artistic and cultural ventures in a context of densely concentrated multiple weak ties operating in propinquity.

The Scottish capital (although physically indeed a 'very small town' in Youngson's phrase) was Great Britain's second-largest city throughout the 1680–1750 period, with a population of some 47–54,000 in 1691 and (despite the initially economically dampening effects of Union) some 53–57,000 in 1755. Scotland was 'one of the least urbanised' of European countries in the seventeenth century, but its capital was still substantial in Continental terms, if not in the first rank of cities. Like all

Scottish burghs, the heart of Edinburgh was the Hie Gait or High Street, from which 'the principal streets led'. Its 'ports' were also normative, as was the 'secondary space for service activities lying towards the edge of the burgh', for example the Grassmarket. The 'mercat cross' provided the 'key site of authority' here as in other burghs until its removal in 1756, the avatar for a major relocation of urban power across the Nor' Loch. Just as 'spatial intentions are . . . the basis of all architectural decisions', so the nature and power of that space and its use are determining factors in human behaviour and circulation. As Manuel de Landa puts it, 'the urban infrastructure may be said to perform . . . the same function of motion control that our bones do in relation to our fleshy parts', while Phelps argues that 'population density' creates the best environment for being open to 'change, challenge, and lifelong quest for originality, discovery, and making a difference'. This circulation – traceable although not stable, because of the immateriality of the social – produces communication. Edinburgh was densely populated, and, as we shall see, the population was not only closely clustered together, but quite diverse, with many more intersections which were professional or associational (clubs and societies) than those based solely on kin and family. Such associations in their turn eased the friction in daily transactions, whether social or economic, and helped to circulate innovation more rapidly.[48] Early modern Edinburgh was a place of instant communication by virtue of its dense living, rapid building, closely packed tenements (it was not unknown for one to be able to shake hands with a neighbour opposite, and the High Street itself was less than five metres wide at the Luckenbooths) and, above all, narrow space. The city proper measured only 900 by 500 metres from the Castle to the Netherbow, the West Port to the backs above the Nor' Loch. Its 'stacked apartments above merchant's booths . . . rank being defined by storey' was far more European than English, and even in this context 'the houses stand more crouded than in any other town in *Europe*'.

After the 1707 Union, Edinburgh was populated, more than any other British city outwith London, by the professional classes, who drove many of its social networks. The remaining, and relics of the former, institutions of an independent state were overwhelmingly based in its capital: packed into a tight space, highly educated, underemployed and with a need to assert their importance to each other and the world, what

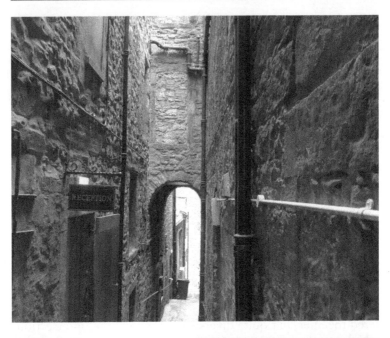

Figures 3 and 4 Vertical and horizontal views of a surviving Edinburgh close. Author's images.

Nicholas Phillipson terms 'a local aristocracy and a dependent literati' trying 'to find a way of asserting their importance in a kingdom becoming a province' were ripe agents and audiences for innovation and new intellectual approaches.[49]

Edinburgh had a distinctive social and institutional pattern among British cities outwith London: as we shall see later, this pattern was itself prominent in the social clashes over ownership and innovation in the Scottish capital. Historian Vic Gatrell's case in *The First Bohemians* (2013) that 'locality and community determined what was known and talked about' in a place where 'stellar talent and workaday street life ... were closely compacted' is at least as true of Edinburgh as of Gatrell's beloved Covent Garden, and the case he makes for 'the absence of serious cultural competition from other British cities' to London needs to be revised in the light of the evidence from the Scottish capital.[50]

Gatrell observes that 'locality and community determined what was known and talked about and provided the patronage, market and service networks upon which creative people depended'.[51] He is right to characterise London in this way, and while Edinburgh was also an exceptional case it was far from a unique one. The drivers of innovation in cities identified by modern research — diversity of workforce, contiguity of environment, high level of higher education and so on — operated to produce 'the Enlightenment' in many more places than Edinburgh. London had significant Huguenot and Jewish communities: the parish of St Anne's in Soho was some 40 per cent French in 1711. Diversity of population and education within a limited space often accompanied this process. In this, although Edinburgh was highly concentrated, it was perhaps less concentrated than Amsterdam, where 'virtually all the information needed to do business on a world scale was concentrated in an area roughly 250 by 500 metres'. As at Edinburgh, 'the concentration of such a vast amount of information in such a small area is the key to understanding the explosion of ... activity and creativity in Amsterdam', where concentration 'made it easier to overcome the obstacles to the reception and application of new information'. The 'infrastructure of the flows of information' was the key to their circulation and triumph.[52]

Edinburgh was similar: as Defoe observed of his visit around the time of the Union, 'in no city in the World [do] so many people live in so little Room as at Edinburgh', also stating that

the High Street was 'perhaps, the largest, longest and finest street for buildings and number of inhabitants, not in Britain only, but in the world' (rather a different view from that taken in the 1752 *Proposals*). More recently, Richard Sher stressed 'the uniqueness of the city's intellectual life in the urban congestion of the Old Town'. Insofar as there were comparators, after the 1707 Union (and arguably before) the Scottish capital was 'a colonial centre like Dublin, Philadelphia, or Boston' rather than a provincial city: distinct but dependent, for even before the Union an independent parliament in the era of a powerful Crown was not the marker of sovereignty it would be today. Edinburgh was also the main locus of routine interchange and exchange between Scotland, England and Ireland, and indeed between Scottish cities.[53]

In arguing for the innovation of early modern Amsterdam, Clé Lesger draws on the insights of J. A. Schumpeter's early approach to the theory of innovation. Like Amsterdam, Edinburgh enjoyed – and this is a relatively neglected element in histories of the city – a cosmopolitan social structure, which will be examined in detail in the next chapter. In such circumstances, the benefits of compactness are enhanced. Not only does 'the geographical concentration of information' make it 'easier to obtain', but when it is 'concentrated in a small space, it . . . became much easier to estimate its value by face-to-face contact with the sources'. The more cosmopolitan their background, the more difficult it is to channel or repel this process, as 'new information becomes easier to absorb and apply when it reaches potential users from various directions and is continually renewed'. Information in short becomes more rapidly socialised in diverse societies, because their heterogenous groupings are more accustomed to circulation and find a commonality in its language and the language of innovation that more homogenous groupings find in family or social ties. Such a flow of information accelerates in a small space, as 'spatial concentration' underpins the 'localization advantages' of information flows, and gives them more strength to resist 'legal prohibitions or active opposition from forces that consider their vested interests under threat from . . . change'. This opposition happened, as we shall see, in Edinburgh, just as it happened in Amsterdam.[54]

The central approach to the extensive surviving data and information from early modern Edinburgh taken in the chapters that follow is one that builds on the classic insights of

later theorists than Schumpeter, principally Everett Rogers in *Diffusions of Innovations* (various editions, 1962–2003). These insights are applied in a very different early modern context, in order to identify the stages of the processes of the introduction and acceptance of change in an early modern city. Whatever criticisms are levelled against Enlightenment as a form of 'modernisation', there can be little doubt that the period gave rise to many new ideas and that the means by which these ideas were diffused was important. In the pages that follow, the nature of some of these innovations is identified, along with their chief communication channels, paying particular attention to homophile groups (groups composed of similar members) and the effectiveness of the multiple weak links of a highly developed associational life. Rogers synthesised over five hundred studies in his classic text and noted the superiority of more loosely constituted networks to strong inward-looking ones (typically kinship networks, though it is noteworthy that relatively weaker kinship networks – for example, cousins – were important in Edinburgh society) in responding to opportunities and making the most of change. This is still true: family businesses are 'less productive than larger companies', and 'family concerns that are managed by outsiders' perform better than those which are not. The importance of changing times and the relatively cosmopolitan nature of Edinburgh was central between 1660 and 1750, along with the nature of opinion leadership and change agency in its advanced and distinctive social system, with strong local leaders of opinion and both relatively strong communications and at the same time intermittent ones with the remote imperial capital of London. Edinburgh had strong immigration, population movement, population clustering, strong relationships and intersections between clubs and societies, as well as gaps between these associations open to exploitation by brokers of social capital. In short – and leaving aside religious, social and cultural ties and similarities – it was quite like Amsterdam, where there were large Huguenot, Fleming, Sephardic Jewish and Westphalian communities.[55]

Rogers argued that there are four main elements in the effective diffusion of innovative ideas, thoughts and practices: the innovation itself; channels of communication within what he calls 'homophilous' (like-minded) groups; time; and the presence within the relevant society/social system of opinion leaders and change agents. Rogers stressed the importance of 'weak ties'

between like-minded people in homophile groups as improving communication, because strong ties of kinship and locality limit openness to new ideas, as has been argued above. The innovations which drive new ideas are not easy to accomplish, requiring a recognition of a problem or need, finding and developing the means to address it, commercialising it and seeing through its diffusion and adoption. Effective diffusion requires a certain degree of 'heterophily': basically, links between people with contrasting backgrounds and experiences. Strong dyadic ties can be of particular importance here: that is, two people of contrasting backgrounds who are close friends: for example, Richard Cooper and Allan Ramsay, discussed below. All these factors are involved: and as this book progresses and the richness of surviving data and detail is revealed, we will see how well Rogers' model, and its later refinements, fits Edinburgh from 1660 to 1750.[56]

Rogers noted 'a tendency for innovators … to travel and read widely and have a cosmopolite orientation', and this was more common than one might expect in the Edinburgh of the period, as we shall see in the next chapter. He points out that conservative social structures can inhibit the 'process of social construction' that ensures the diffusion of an innovation, pointing out how the conservative culture of the navy led to a gap of 194 years between the first clear evidence that citrus fruit prevented scurvy, and its adoption. Edinburgh, by contrast, with its rapidly developing associations, institutions and infrastructure, was already a dynamic cultural space in the reign of Charles II, where heterophile links and groupings promoted the possibility of rapid change, as commitment to such change and interest in it were among the key factors they had in common. This was because 'whereas innovators are cosmopolites, early adopters are localites': a strong sense of rooted Edinburgh culture provided fertile ground for the rapid spread of new influences once the power behind their circulation grew strong enough, for 'homophily and effective communication breed each other'. Similarly, as 'socioeconomic strata and innovativeness appear to go hand in hand', Edinburgh's large professional class, conscious of diminished status after 1707, were themselves especially open to both initiating and adopting change. Rogers concluded that 'the consequences of the diffusion of innovations usually widen the socioeconomic gap': and the history of Edinburgh from the mid-eighteenth century, with the

increasing social stratification evident in the development of the New Town, manifested in stone the success of the diffusion of innovation in the preceding Enlightenment city, as Gibson and Smout's work on Scottish price history bears out.[57] Indeed, as David Allan remarks of the New Town proposals, published in the *Scots Magazine* of August 1752, 'Eyes seem in particular to have been beadily fixed on London's recent growth.'[58] The aim in the *Proposals* for the New Town was consequently to make the Scottish capital 'the centre of trade and commerce, of learning and the arts, of politeness, and of refinement of every kind'.[59]

Strong associations and community life with weak but crosscutting links binding people together are two things which remain strong drivers for social cohesion and material improvement to this day. The 2015 report by the London School of Economics, *Community Capital*, 'argues that investing in building relationships within communities can generate four "social dividends": greater well-being, economic gains, citizen empowerment and improved public service capacity through networked impact.'[60] These circumstances and outcomes were, I will argue, present in Edinburgh in the period 1660–1750, and had similar outcomes. Recent social science research also identifies – both following and demonstrating Rogers – the importance of a strong sense of place, an ethnically diverse population, and the presence of 'disruptive technologies' as drivers of social and economic change. Again, these too were present in the Edinburgh of our era: we shall see in later chapters the ways in which the development of a more hybrid society with widespread circulation and migration led to a climate of greater discussion, while major changes in transport structures and water supply were only two areas of technological change. Diversity fed debate.[61] There is an overlap here with Habermasian notions of the public sphere: certainly in the chapters that follow, it will be clear that libraries, the theatre and other cultural institutions created the 'social space for rational and critical debate' identified by Habermas.[62] On the other hand, as Cliff Siskin and Bill Warner have persuasively argued, the 'public sphere' as a concept downplays 'the mechanics of mediation'. Instead they have stressed the importance of infrastructural development (postage, newspapers, coffee houses and associations) as giving rise not only to the public sphere but also – via circulation, a process they do not stress – to quantitative activity governed by standardising protocols

of address, copyright and so on (one might add orthography and indeed language in general). The Siskin-Warner concept of 'protocol' is an important one, because formalisation implies standardisation.[63] The Siskin-Warner case is also a potent challenge to the sceptical reading of the Enlightenment, in that it draws attention to the quantitative, and the necessity of standardising measures of circulation through social infrastructure in a manner which required quantification. Enlightenment as a process demanded data, from records of postage to financial instruments. Its 'protocols' of modernisation underpinned the development of the analogue processes now being massified afresh on a geometric scale in our digital age, such as the, admittedly long ineffective, standardisation of weights and measures and currency across the British Isles, which began in the late seventeenth century and was formalised in 1707.[64]

With regard to the social environment of Edinburgh in which the circulation of ideas took place, it is also useful to bear actor-network theory in mind, given the growth in forms of consumerism as social differentiators in eighteenth-century Edinburgh, and their function as proxy signs for politeness. Addison noted the importance of global produce in *The Spectator* of 19 May 1710, and since 'by owning their objects, we claim China, Persia, and the Americas as "ours"', the widespread utilisation of international products and trade were to be significant both to Edinburgh's identity as part of the first British Empire and its ability to stand in a position of equality to London. Collecting objects, initially a means 'to comprehend and thereby exploit nature', passed in the eighteenth century from a personal expression of sovereignty ('the world in miniature') to one of taxonomy, from social and emotional power to understanding of the world of things. The marvellous became progressively vulgar in the absence of the modelling of collecting into the 'predictable nature' of systemic order. The development of 'collections as an analytical vehicle' in the Enlightenment was indeed an important one.[65]

As mentioned above, it is important to remember how much time people spent out of doors in a tightly packed city, with the vast majority of the population living in small flats where lighting was both poor and expensive, and where naked flames were often subject to legal prohibition, which – even if ineffective – probably acted at some level as a social constraint. The stroller has been seen as 'the central symbolic

figure of the modern city', and without exploring that line of enquiry further it is noteworthy how much of the life of Edinburgh in the period – as in other cities, but given the above factors, to a greater extent – took place in the open air.[66] From the French Revolutionary era onwards, public space became the location for the development of a whole infrastructure of monuments and festivals, linked to the development of cultural memory through public circulation, which took advantage of the importance of life out of doors for socialisation in an era which continued to suffer from poor artificial lighting even while developing industrial levels of urbanisation. The 'patterning of the public space with heroic statues' in the nineteenth century paid oblique homage to the importance of that space to people's daily lives: many spent their leisure hours outdoors in the town in this era, for extramural society was far more central in ages with poor light and much less access to information media. As Marshall McLuhan pointed out in the 1960s, 'the message of the electric light is total change. It is pure information without any content to restrict its transforming and informing power.' In an earlier era, people's memories were linked more to the historic environment of their city than new monuments of public memory: as when the removal of the mercat cross of Edinburgh caused regret in 1756. But this era and the one that followed shared the centrality of a life outdoors, where the socialisation of innovation was part of the socialisation process itself. It was that life which promoted local memory and local exchanges.[67]

It is a modern truism that innovative cities 'are highly productive, specialized in a range of knowledge intensive innovative sectors, and benefit from a concentration of skilled labour'. The Innovation Cities programme (2006) assessed cities on three criteria: cultural assets, human infrastructure and networked markets.[68] Edinburgh ranked 68th, though this may well change as the city aims for greater connectivity: in the period 1660–1750, it arguably stood much higher. The capital's compactness, cosmopolitanism (of which more below) and intensive cultural and professional concentrations and networks gave it a potential it would amply realise as the period covered by this study progressed. As we shall see in Chapter 2, Edinburgh and Leith were absolutely dominant in Scotland in financial and mercantile terms at the turn of the eighteenth century. Any comparative weakness they suffered on the international stage

was mitigated by the 'innovative and dynamic characteristics of Scottish emigration and how human mobility and migrant networks helped ease the country's lack of economic diversity and mitigate its weak mercantile and fiscal position'. In addition, many Scottish migrants were sojourners who returned to Scotland; and those who did not usually retained their links to the country.[69]

The Union between England and Scotland of 1707 was not unimportant to the development of Edinburgh's Enlightenment, but not in the sense understood by Buckle and Trevor-Roper: it was not an enabler of civility and civilisation, but a risk to the Scottish capital's status to be mitigated by all means possible by those who retained a patriotic interest in their own country. This of course included a very substantial body of those dedicated to ending the Union and restoring the Restoration regime: the Jacobites. One of the fundamental problems in accounts of the Scottish Enlightenment has been the determination to see 'the appeal of Jacobitism' – insofar as it is acknowledged at all – as a 'major problem' for the Enlightenment, and not a key component part of it. This has a great deal to do with the lack of detailed evaluation of the Restoration's intellectual and institutional achievements in Edinburgh, themselves driven by a basic prejudice – not, perhaps, too strong a word – that the Stuart dynasty in power and its later political manifestation out of power as Jacobitism were extreme and retrogressive political options. This is not a well-evidenced view. In the study that follows, I will therefore be examining the involvement of Jacobitism and Jacobite ideas in the generation of the Scottish Enlightenment in some detail.[70]

In the chapters to come, I shall first of all examine the society of Edinburgh in the period and its major areas of innovation and change on a comparative basis with other European cities, before going on in Chapter 3 to look at the professions and in Chapter 4 at art, music and theatre. In Chapter 5, the associational life of Edinburgh is the subject, with a study of the extent to which clubs, taverns and associations (including Freemasonry) played a key role in the changing of the city's mind. Chapter 6 examines newspapers, booksellers and libraries, the conduits of circulation and the sinews of intellectual change. What was the Scottish Enlightenment has been addressed by this first chapter; how and why it happened in Edinburgh continues to underpin the argument made in the rest of this book.

Notes

1. Bob Harris and Charles McKean, *The Scottish Town in the Age of Enlightenment 1740–1820* (Edinburgh: Edinburgh University Press, 2014), 492; R. A. Houston, 'The economy of Edinburgh 1694–1763: the evidence of the Common Good', in S. J. Connolly, R. A. Houston and R. J. Morris (eds), *Conflict, Identity and Economic Development: Ireland and Scotland, 1600–1939* (Preston: Carnegie Publishing, 1995), 45–63 (63); Christopher J. Berry, *The Idea of Commercial Society in the Scottish Enlightenment* (Edinburgh: Edinburgh University Press, 2015 (2013), 1; Clé Lesger, *The Rise of the Amsterdam Market and Information Exchange*, tr. J. C. Grayson (Aldershot: Ashgate, 2006), 248.
2. Bruce Lenman, *Enlightenment and Change: Scotland 1746–1832*, The New History of Scotland, 2nd edn (Edinburgh: Edinburgh University Press, 2009 [1981]), 244.
3. Donald J. Withrington, 'What was Distinctive about the Scottish Enlightenment?', in Jennifer J. Carter and Joan H. Pittock (eds), *Aberdeen and the Enlightenment* (Aberdeen: Aberdeen University Press, 1987), 9–19 (9); Girolamo Imbruglia, 'Enlightenment in Eighteenth-Century Naples', in Imbruglia (ed.), *Naples in the Eighteenth Century: The Birth and Death of a Nation State* (Cambridge: Cambridge University Press, 2000), 70–94 (70); also see Peter Gay, *The Enlightenment: An Interpretation: The Rise of Modern Paganism* (London: Weidenfeld & Nicolson, 1967 [1966]).
4. Jonathan I. Israel, *Democratic Enlightenment: Philosophy, Revolution, and Human Rights 1750–1790* (New York: Oxford University Press, 2011), 6, 10, 14; Nicholas Phillipson, 'Foreword', in Jean-François Dunyach and Ann Thomson (eds), *The Enlightenment in Scotland: national and international perspectives* (Oxford: Voltaire Foundation, 2015), ix–xv.
5. Roy Porter, 'The Enlightenment in England', in Roy Porter and Mikulas Teich (eds), *The Enlightenment in National Context* (Cambridge: Cambridge University Press, 1981), 1–18 (7); Porter, *Enlightenment: Britain and the Creation of the Modern World* (London: Penguin, 2001 [2000]), xvii, xix, 47, 243.
6. Lenman (2009), 244; see the work of Jonathan Clark and Peter de Bolla for evidence of the lack of influence of Locke.
7. Jeremy Black, *Eighteenth-Century Europe*, 2nd edn (Basingstoke: Macmillan, 1999 [1990]), 246; Dunyach and Thomson, 'Introduction', in Dunyach and Thomson (2015), 1–19 (2).
8. Jeremy Black, *Eighteenth-Century Britain 1688–1783*, 2nd edn (Basingstoke: Palgrave Macmillan, 2008 (2001)), 3; Black (1999 [1990]), 252.

9. Eric Hobsbawm, quoted in Porter (2001 [2000]), xx, xxi; Israel (2011), 3.
10. Black (2008 [2001]), 147.
11. Lenman (2009 [1981]), 244; Nicholas Phillipson, 'The Scottish Enlightenment', in Porter and Teich (1981), 19–40 (19).
12. See, for example, Annelien de Dijn, 'The Politics of Enlightenment: From Peter Gay to Jonathan Israel', *Historical Journal* 55:3 (2012), 785–805 (786); Jonathan Clark, '"God" and "the Enlightenment": The Divine Attributes and the Question of Categories in British Discourse', in William J. Bulman and Robert G. Ingram, *God in the Enlightenment* (Oxford: Oxford University Press, 2016), 215–35 (215–16). See also Clark, 'The Enlightenment: Catégories, Traductions, et objects sociaux', *Lumieres* 17–18 (2011), 19–39.
13. Richard B. Sher, *The Enlightenment & the Book* (Chicago: University of Chicago Press, 2006), 12, 13; Jonathan Israel, *A Revolution of the Mind* (Princeton and Oxford: Princeton University Press, 2010), vii–viii.
14. Lenman (2009), 246, 250; Israel (2011), 7, 9.
15. Porter (2001 [2000]), xvii, 5, 45; Israel (2011), 4; Margaret C. Jacob, *The Enlightenment: A Brief History with Documents* (Boston and New York: Bedford/St Martin's Press, 2001), 1.
16. Jacob (2001), 2; Israel (2010), 5–7.
17. Clark (2011), 19–39 (22–3, 39); Clark, email to the author of 15 September 2016.
18. Murray Pittock, 'Historiography', in Alexander Broadie (ed.), *The Cambridge Companion to the Scottish Enlightenment* (Cambridge: Cambridge University Press, 2003), 258–79 (258–9, 263).
19. Jonathan Clark, *From Restoration to Reform: the British Isles 1660–1832* (London: Vintage, 2014), 96, 98, 102; Porter (2001 [2000]), 5.
20. Gay (1967 [1966]), 3.
21. Alfred Cobban, *In Search of Humanity: The Role of the Enlightenment in Modern History* (London: Jonathan Cape, 1960), 29.
22. Israel (2011), 8–9; Henry Kissinger, *World Order: Reflections on the Character of Nations and the Course of History* (London: Penguin, 2014).
23. John Robertson, *The Case for the Enlightenment: Scotland and Naples 1680–1760* (Cambridge: Cambridge University Press, 2007); Istvan Holt and Michael Ignatieff (eds), *Wealth and Virtue: The Shaping of Political Economy in the Scottish Enlightenment* (Cambridge: Cambridge University Press, 1983), vii; Arthur Hermann, *How the Scots Invented the Modern World* (New York: Crown Publications, 2001); Lenman (2009), 244.

24. Richard B. Sher, *Church and University in the Scottish Enlightenment* (Princeton: Princeton University Press, 1985), 4; Lenman (2009), 252; Donald Withrington, 'What was Distinctive about the Scottish Enlightenment?' in Jennifer J. Carter and Joan H. Pittock (eds), *Aberdeen and the Enlightenment* (Aberdeen: Aberdeen University Press, 1987), 9–19 (11); Dunyach and Thomson (2015), 9–11.
25. Sher (1985), 3; Dunyach and Thomson (2015), 5.
26. W. Forbes Gray, 'Edinburgh in Lord Provost Drummond's Time', *BOEC* XXVII (1949), 1–24 (23); David Allan, *Virtue, Learning and the Scottish Enlightenment* (Edinburgh: Edinburgh University Press, 1993), 1.
27. Sher (1985), 4–5; Nicholas Phillipson, 'The Scottish Enlightenment', in Porter and Teich (1981), 19–40 (22); Alexander Broadie, *Agreeable Connexions: Scottish Enlightenment Links with France* (Edinburgh: John Donald, 2012); Broadie, *The Scottish Enlightenment* (Edinburgh: Birlinn, 2001), 1, 7; David Allan, 'The Universities and the Scottish Enlightenment', in Robert Anderson, Mark Freeman and Lindsay Paterson (eds), *The Edinburgh History of Education in Scotland* (Edinburgh: Edinburgh University Press, 2015), 97–113 (101); Fern Insh, 'An Aspirational Era? Examining and Defining Scottish Visual Culture 1620–1707', unpublished PhD (University of Aberdeen, 2014), 1; Clare Jackson, *Restoration Scotland, 1660–1690* (Woodbridge: The Boydell Press, 2003), 2–3; Nicholas Phillipson, 'Lawyers, Landowners, and the Civic Leadership of Post-Union Scotland', *The Juridical Review* (1976), 97–120 (97–8).
28. V. Anand Chitnis, *The Scottish Enlightenment: A Social History* (London: Croom Helm, 1976), 4, 21.
29. Chitnis (1976), 4; Sher (1985), 8, 11, 151.
30. Peter Jones, 'The Scottish professoriate and the polite academy, 1720–46', in Hont and Ignatieff (1983), 89–117 (91).
31. Berry (2015), 13, 17; Jane Rendall, *The Origins of the Scottish Enlightenment* (London and Basingstoke: Macmillan, 1978), 4–6, 37.
32. Roger Emerson, *An Enlightened Duke: The Life of Archibald Campbell (1682–1761) Earl of Ilay 3rd Duke of Argyll* (Kilkerran: humming earth, 2013).
33. Israel (2011), 4, 6.
34. Patrick Mauries, *Cabinets of Curiosities* (London: Thames & Hudson, 2011 [2002]), 105, 185–9. For Sloane, see the British Museum's Enlightenment Gallery.
35. Kissinger (2014), 38–9; Clifford Siskin and William Warner (eds), *This is Enlightenment* (Chicago and London: University of Chicago Press, 2009).

36. Sher (2006), 12, 13, 15, 21, 102 for these different approaches. The gender politics involved is far from tokenistic: for example, little attention has been paid to why Jean Marischal's play *Sir Henry Gaylove*, performed just three years after the opening of the Theatre Royal, received subscriptions from Beattie, Boswell, Ferguson, Hume, Kames, Mackenzie, Gilbert Stuart and Alexander Fraser Tytler, all supporting the work of a woman. See also Edmund Phelps, *Mass Flourishing* (Princeton and Oxford: Princeton University Press, 2013), 27, 78; Peter Burke, *What is Cultural History?* (London: Polity, 2006 [2004]), 4, 6, 25.
37. Jane Jacobs, *The Economy of Cities* (London: Jonathan Cape, 1970 [1969]), 88, 100n; Phelps (2013), 105.
38. American Institute of Architects 2013, *Cities as a Lab: Designing the Innovation Economy*, 6 (http://cityminded.org/cities-lab-designing-innovation-economy-9757#).
39. Phelps (2013), 82; *The Times*, 21 June 2017, 33.
40. Edward Glaeser, *Triumph of the City: How Urban Spaces Make Us Human* (London: Pan, 2012 [2011]), 8.
41. David McCrone and Angela Morris, 'Land & Heritages: The transformation of the Great Lairds of Scotland', in T. M. Devine (ed.), *Scottish Elites* (Edinburgh: John Donald, 1994), 170–86 (171, 172 and 174); see, for example, NRS GD 18/4362. For wage history, see A. J. S. Gibson and T. C. Smout, *Prices, Food and Wages in Scotland* (Cambridge: Cambridge University Press, 1995), 275–7.
42. McCrone and Morris in Devine (1994), 170–86 (171, 172 and 174).
43. John O'Hagan, 'Preface', in Johanna Archbold, *Creativity, the City & the University* (Dublin: Trinity Long Room Hub, 2010), 1–10 (1); Phelps (2013), 11.
44. Johan Huizinga, *Homo Ludens: A Study of the Play Element in Culture* (London: Paladin, 1970 [1949]); *The Mercury*, 8–15 January 1717, 19.
45. *Proposals for carrying on certain Public Works in the City of Edinburgh* (NLS MS 19979), 7; A. J. Youngson, *The Making of Classical Edinburgh* (Edinburgh: Edinburgh University Press, 1988 [1966]), 1, 3, 5, 10; Glaeser (2012), 64; Peter Burke, *A Social History of Knowledge* (Cambridge: Polity, 2008 [2000]), 28.
46. R. H. Campbell and Andrew Skinner (eds), *The Origins & Nature of the Scottish Enlightenment* (Edinburgh: John Donald, 1982); Harris and McKean (2014), 492–3.
47. David Allan, *Scotland in the Eighteenth Century* (Harlow and London: Pearson, 2002), 127, 159.

48. Harris and McKean (2014), 28, 56, 105; I. D. Whyte, 'Scottish and Irish urbanization in the seventeenth and eighteenth centuries: a comparative perspective', in Connolly, Houston and Morris (1995), 14–28 (24); Manuel de Landa, *A Thousand Years of Nonlinear History* (New York: Swerve, 1997), 19, 28; Brian Boydell, *A Dublin Musical Calendar 1700–1760* (Dublin: Irish Academic Press, 1988), 24; Bruno Latour, *Reassembling the Social: An Introduction to Actor-Network-Theory* (Oxford: Oxford University Press, 2005), 1, 30; Lindy Moore, 'Urban Schooling in Seventeenth- and Eighteenth-Century Scotland', in Anderson, Freeman and Paterson (2015), 79–96 (80); Phelps (2013), viii, 105.
49. Roger L. Emerson, *Academic Patronage in the Scottish Enlightenment* (Edinburgh: Edinburgh University Press, 2008), 3.
50. *Proposals*, 7; Harris and McKean (2014), 56; Vic Gatrell, *The First Bohemians* (London: Penguin, 2014 [2013]), xiii, xv, xxiii; Hamish Coghill, *Lost Edinburgh* (Edinburgh: Birlinn, 2014 [2008]), 18.
51. Gatrell (2014 [2013]), xiii.
52. Lesger (2006), 238–45; Lucy Inglis, *Georgian London: Into the Streets* (London: Penguin, 2014 [2013]), 169.
53. Daniel Defoe, *A Tour Through the Whole Island of Great Britain*, ed. Pat Rogers (Harmondsworth: Penguin, 1971 [1724–6]); Sher (2006), 110; Hugo Arnot, *The History of Edinburgh* (Edinburgh: West Port Books, 1998 [1779]), 317–19.
54. Lesger (2006), 139n, 140, 246–8.
55. Everett M. Rogers, *Diffusion of Innovation*, 3rd edn (New York: Free Press, 1983 [1962]), 10–37, 297. See 'Keeping it in the family "is bad news for productivity"', *The Times*, 7 January 2017, 48; see also Bill Jamieson, 'In the Family Way', *Scottish Field* (June 2017), 168–9.
56. Rogers, ibid. and 134–6.
57. Rogers, *Diffusion of Innovations*, 5th edn (New York: Free Press/Simon & Schuster, 2003 [1962]), xvi, xx, 5, 7–8, 283, 289–90, 306, 339–40, 471; A. J. S. Gibson and T. C. Smout, *Prices, food and wages in Scotland 1550–1780* (Cambridge: Cambridge University Press, 1995).
58. David Allan, *Scotland in the Eighteenth Century* (Harlow and London: Pearson, 2002), 159.
59. National Library of Scotland MS 19979 5 ff ('Proposals for carrying on certain Public Works In the City of Edinburgh').
60. 'The Social Dividend', *Royal Society of Arts Journal* 3 (2015), 7.
61. Heather Connon, 'The disruptors', *Trust* (Winter 2015), 10–12 (11); Homi Bhabha, 'Culture's In-Between', in Stuart Hall and Paul du Gay (eds), *Questions of Cultural Identity* (London: Sage,

1996), 53–60 (58). The idea discussed by Connon derives from Joseph Bower and Clayton Christensen at Harvard Business School.
62. Ann Bermingham, 'Introduction', in Bermingham and John Brewer (eds), *The Consumption of Culture 1600–1800: Image, Object, Text* (London: Routledge, 1995), 1–20 (10).
63. Siskin and Warner (2009), 1–33 (11–14, 23).
64. See, for example, the standardisation of weights measure issued at Edinburgh on 16 January 1707: *Ancient Laws and Customs of the Burghs of Scotland Volume II AD 1424–1707* (Edinburgh: Scottish Burgh Records Society, 1910), 171.
65. Ileana Baird, 'Introduction', in Baird and Christina Ionescu (eds), *Eighteenth-Century Thing Theory in a Global Context*, 1–16 (1, 2); Mark Greengrass, *Christendom Destroyed* (London: Penguin, 2015 [2014]), 192; Mauries (2011 [2002]), 68, 193; Archbold (2010), 12.
66. Zygmunt Bauman, 'From Pilgrim to Tourist – or, a Short History of Identity', in Hall and du Gay (1996), 18–36 (26–8); James Donald, 'The Citizen and the Man About Town', Hall and du Gay, 170–90.
67. Mona Ozouf, *Festivals and the French Revolution*, tr. Alan Sheridan (Cambridge, MA: Harvard University Press, 1988), 134; Marshall McLuhan, *Understanding Media: The Extensions of Man* (London: Sphere (1968 [1964]), 62.
68. Lizzie Crowley, *Streets Ahead: what makes a city innovative* (Lancaster: The Work Foundation, 2011), Executive Summary.
69. Andrew McKillop, '"As Hewers of Wood and Drawers of Water": Scotland as an Emigrant Nation, c. 1600 to c. 1800', in Angela McCarthy and John M. Mackenzie (eds), *Colonial Migration: The Scottish Diaspora Since 1600* (Edinburgh: Edinburgh University Press, 2016), 23–45 (30).
70. Rendall (1978), 8 is not untypical here.

2 Edinburgh and the Canongate 1660–1750: Communications, Networks, the Routers of Change

The City and the Capital

In 1660, the 'Guid Toun' and royal burgh of Edinburgh was very compact. Its nine hundred by five hundred metres has been called 'a city without streets', clustered in deep narrow closes round the spine of the Hie Gait/Street, divided from the burgh of regality of the Canongate at St Mary's Wynd; Leith, a separate burgh effectively subordinate to Edinburgh, lay further off. From the heights of the Hie Gait and its buildings, remote views could be seen, but 'the city had no formal vistas'. The capital's cityscape was largely a series of intimate spaces, miniaturised public environments, accessed through close stairs and courts, some closed off for privacy. Each 'land' or high flatted dwelling had a separate address, with tenants or owners usually on different floors, sometimes sharing a floor (though this became more unusual with the passing of time). Property in tofts or strips ran down the closes, while the more public street front faced the main Hie Gait or Canongate. There were some three hundred closes or wynds off what would come to be known as the Royal (Scots) Mile in a configuration of ancient date (the Scots mile is roughly 1,800 metres rather than 1,600). Despite much new building, the infrastructure of the past remained. As Richard Rodger notes, 'Reincarnated, medieval merchants would have been able easily to find their way around eighteenth-century Edinburgh.'[1]

In 1751, there were 6,845 houses in Edinburgh proper (some of huge size and occupied by many families), with a further

2,219 in the Canongate, which was the location for many of the city's 'Bawdy Houses' which threatened the infection of 'Canon-Gate *Breeches*'.[2] This eastern burgh, which ran down to Holyrood Palace, was also traditionally the residence of the nobility and of some of the foreign embassies. Nobility with seats in the provinces might also retain a town house in the Canongate or elsewhere in or near Edinburgh. Following the Union, Canongate declined, and 'growing poverty' was being recorded in the burgh in the 1720s. However, in that decade a number of the lesser nobility began to drift back to the Canongate, which thereafter retained a strong upper- class enclave until at least the end of the 1760s.[3]

In Edinburgh proper, tall flats or 'lands' stretched up far from the ground: the '"great tenement" between Parliament Square and the Cowgate, burnt in 1700' was fourteen storeys high.[4] Although these were socially stratified, with the wealthier residents on the lower or middle floors and poorer folk in attics, ground floors or basements, and although there were certain areas of the capital with town houses or smaller lands which were sought by the well-to-do, it remained the case that the nobility, professionals and poor of the city lived next to each other. With much of daily life carried on out of doors, poor and rich inevitably mixed. The cityscape's manifold different kinds of space helped to promote the intensely networked life for which it was later to be known. In few places was the population so dense or the human institutions and associations which were its infrastructure so specialised and complex as in Edinburgh. But the Scottish capital was also much more of a capital city in its development and facilities than anywhere else in Great Britain outside London: in Edinburgh eyes, if the English city was 'capital City of the Southern Part of *Britain*', then Edinburgh was 'the Chief City in the Northern Part . . . and second Town in this Island'.[5]

Edinburgh was certainly by far the wealthiest city in Scotland, paying in the range of 32 to 40 per cent of the country's taxes in the years between 1649 and 1705, while having only 5 per cent of Scotland's population in its greater urban area. Leith alone was responsible for 63 per cent of French wine imports and Edinburgh wine importers dominated the Scottish market, while 80 per cent 'of the vessels in the Dutch trade sailed to and from the Firth of Forth'. As early as the 1620s, 50 per cent of Scottish imports were from the Netherlands or France, almost a third

Figure 5 Mylne's Court (1690). Author's image.

overall from the Netherlands, where, as we shall see below, Scots mercantile interests were already well established. By 1660, the Edinburgh goldsmiths 'were making loans and dealing in foreign exchange from their booths round St Giles' and were commonly issuing bills of exchange'. These goldsmith-bankers also developed an 'arbitrage and futures business' whereby they gained a margin on exchange rates and interest rates in purchasing assets for delivery from the Highlands; later they acted as brokers for 'lost property offices', including the occasional recovery of slaves. Eventually proscribed in Scotland by the Court of Session, the bitter and inexcusable institution of slavery had a complex existence in Scotland after 1707. Slaves could be freed on baptism, as Scipio Kennedy was early in the century, for example, while from 1756 a series of cases was brought by 'slaves' challenging the right of ownership in Scots Law. The first two (*Montgomery* v. *Sheddan* and *Spens* v. *Dalrymple*) did not come to trial due to the death of the pursuer and the defender respectively; the third (*Knight* v. *Wedderburn*) led to a historic judgement which overturned slavery as a concept in Scots Law, even though Wedderburn had tried to take refuge in the idea that he was only seeking perpetual indentured service from Knight,

and did not own him. Several Enlightenment figures were prominent in the Knight cause.[6]

Schools teaching book-keeping and commerce were set up in Edinburgh from the 1690s, and by 1705 the capital had a 'burghal accountant'. Within Scotland, there were closely aligned rates of exchange between bills from different cities, but London bills might fetch up to a 15 per cent premium in Edinburgh, though such peaks were relatively rare: for example, 2.5 per cent was the premium in the second half of 1681. The Scottish Exchange on London was important to the country's trading prosperity within the British Isles, for 'on the eve of the ... Union ... around one half of the total export trade of Scotland was already directed towards England' (this figure was 64 per cent in 2014, not that much of an increase for three hundred years of Union). The Scottish Exchange (which persisted after the Union) was a sign of Scotland's 'own commercial law and separate economy', giving the country 'some of the elements of a foreign exchange as well as an inland exchange', even after 1707. Scotland's long history of an insufficiency of native bullion leading to multiple currencies circulating within its borders also had a legacy in innovations like the overdraft and the early adoption of paper currency, with Royal Bank and Bank of Scotland £1 notes beginning 'to displace silver and gold in smaller transactions' by the 1740s.[7]

Many of these innovations had their roots in small offices in Edinburgh, such as the 'little wooden shop, high and low [on two storeys], on the South of the old Kirk' let to the goldsmith John Law on 24 June 1681 for 68s 4d per annum. In October 1683, Law moved to the east side of Parliament Close; two years later, a 'piazza or open-air Exchange' was constructed for merchants in Parliament Square. Law's nephew, also John (1671–1732), later Controller General of the Finances of France, was to be a pioneer of paper currency, originator of the scarcity theory of value and controversial founder of French central banking.[8]

Scotland itself had increasingly developed internal markets, with 'Leith Glassworks' having 'a first issue of stock totalling almost £17,000' in 1680, and the 'Glass Manufacture at the head of the Connongate [sic]' producing 'Looking-glasses, Coach-glasses, Chair-glasses, Chimney pieces and Sconces', and no doubt much else. Monopoly positions could be supported by Parliament, as in the case of the Canonmills gunpowder

manufactory, granted a nineteen-year monopoly in 1695, while Leith Glassworks staff were empowered to seize smuggled imports: for example, the 2,600 dozen bottles from Newcastle which were landed at Montrose in February 1700. In the city of Edinburgh itself, there was a lively internal market in tacks on imposts (leases conferring revenue rights) which supported the Common Good fund of the burgh, though in 1685 the owner of the wine tack asked for a reduction, as the freezing of the Nor Loch from October to February had allowed smuggling across the ice to undermine his market. In 1694–5, almost 10 per cent of Edinburgh's households 'had stock valued at 10,000 Scots merks or above': about £155,000 at 2018 prices. Mean wealth was around 4,500 merks in the Old Town, 1,800 merks in the Canongate, and much less in Leith. At the heart of the city, a high proportion of the population belonged to the social elite, with 6 per cent belonging to the gentry/nobility, 12 per cent merchant and 14–15 per cent professional by background at the close of the seventeenth century. Scotland's foreign trade was 'still largely . . . in the hands of Edinburgh merchants'. At the same time, the professional groups that Edinburgh boasted were proportionately significantly more influential than those in London. Although the English capital was ten times the size of its Scottish counterpart (c. 550,000 in 1700), the professional classes, even in inner London, did not exceed 6–7 per cent of the population. Edinburgh's professionals reached this figure across the greater urban area (population up to 55,000) as a whole, and were significantly higher in the core city of 45 hectares. As Helen Dingwall notes, 'Compressed by geographical constraints into a tiny area, the burgh had nonetheless a surprisingly complex social and economic composition'. This amply fulfils the Jacobs definition of successful city potential, discussed in the last chapter.[9]

The Restoration policy of creating separate royal capitals in Edinburgh and Dublin did much to reinforce Edinburgh's position: between 1679 and 1688, the College of Physicians, the Advocates Library and the Order of the Thistle were founded, while 'the Physic Garden and the Royal Company of Archers' were encouraged. Institutions can be major conduits of innovation, and also offer a secure base to the opinion formers and change agents so necessary for the spread of new ideas. This structural advantage was reinforced by the diffusion of practices known at one royal court to the others. This could

even reach down to fairly trivial levels of domestic industry. For example, Charles II sought the development of apiaries in Scotland as well as in London, and Sir John Foulis of Ravelston, who had a town house in Forrester's Wynd, kept bees at Ravelston on a systematic basis from at least 1681. We will be looking in more detail at the functionality of professions and associations in later chapters, but in terms of the biography of the city and its possibilities they were transformative, creating or developing a set of new hubs or networks with an unexpectedly cosmopolitan composition through which innovation and early adoption of new ideas and practices became possible. There was also a huge expansion in Scotland's internal marketplace: 298 'burghal markets and fairs' were licensed in the Restoration period, three times as many as in the previous ninety years. In 1665, the Scottish economy returned to growth, having been in continuous recession since 1638, a recession which would return after King James VII was deposed in 1689. Nonetheless, the preservation and augmentation of Scotland's major professions and institutions by the Union locked in some of these gains, and 'a critical mass of professional expertise was concentrated in Edinburgh as a direct result of the guarantees enshrined in the Act of Union'.[10]

Edinburgh had a distinctive quality born of Scotland's historic diplomatic, intellectual and commercial overseas networks. Its 'stacked apartments above merchants' booths' were laid out 'in the European manner, rank being defined by storey'. This was the feature particularly remarked on by visitors as comparable to Paris: as in that city, Edinburgh's close vertical environment of stacked living complemented its horizontal one of urban propinquity to create, as we shall see, 'a city bustling with creative energy ... an incubation of the kind of ideas that could revolutionize urban life'. As Robert Chambers noted, 'on account of the narrow limits of the streets and places of public resort, people all knew each other by sight'. To English visitors, it came as a considerable surprise that 'every Family, of the best rank, generally have but one Floor, some only half a Floor' in which to live. The Countess of Balcarres shared a close with milliners and tailors, and this was by no means unusual. Sometimes the merchants' booths themselves were stacked, as with the Luckenbooths near St Giles' which reached six floors in height, or the 'krames' or smaller booths in the Dutch fashion, which clustered there and round

the High Kirk. The grandest public architecture reflected the heritage of French influence: the Netherbow Port or gate which marked the division between Edinburgh proper and Canongate was modelled on the Porte St Honoré in Paris when it was built in 1606; the other city gates were the Bristo Port (1511), the West Port (1514) and Leith Wynd Port (1560). Other reminders of France – and the Netherlands – were found throughout early modern Edinburgh, such as Marie de Guise's palace at the top of the Lawnmarket, with its 'garden grounds sloping to the Nor' Loch behind', or the French Ambassador's chapel at 'the foot of Libberton's Wynd', as well as more mundane examples of relatively regular streetfronts. At the Restoration, large numbers of nobles and professionals who had been exiled in France or the Netherlands returned to Scotland, and, as we shall see, the pace of both cosmopolitan contact and innovation grew, with 'Scottish intellectual discourse . . . rendered cosmopolitan by frequent foreign travel'. As the Marquis of Argyle put it in the late 1660s, 'he that hath lived lock'd up in one Kingdome' was 'but a degree beyond a Country-man, who was never out of the bounds of his parish'.[11]

Cosmopolitanism in this era contained the implications of being open-minded and impartial, not subject to cultural prejudices, urbane and nowhere a stranger. The degree to which professional and noble Scots enjoyed educational, cultural, political and mercantile connexions abroad, quite different from the quasi colonial *de haut en bas* ethos of the Grand Tour, with its acquisition of objects abroad for British consumption and enjoyment, was one of the key denominators of difference in the social outlook of the Scottish capital. In the latest age of independent Scottish nationhood, the country had a global footprint, where 'intellectual, political, religious and commercial associations combined . . . to promote regular contact between Restoration Scots and an extensive overseas diaspora', which during the seventeenth century had begun to radiate into the nascent British Empire, though its European dimensions were to remain important into the nineteenth century.[12]

The City's Infrastructure

Edinburgh also had the inbuilt and later inherited advantages of housing the infrastructure of government and its national

institutions. These included, among many others, the 'Cunzie House' or Scottish Mint; the town houses of the archbishops before 1689; Parliament House, completed in 1639, whither up to 1,200 men on horseback and forty coaches processed at the Riding of Parliament; and the role of the High Commissioner, whose 'procession and the posting of royal proclamations were retained' after the 1707 Union. The Place Royale in Parliament Close had an equestrian sculpture of Charles II which was a lead replica of that at Windsor, 'the first depiction of a British monarch . . . as a Roman Emperor'; towards Holyrood there was the Canongate Kirk, built by James Smith in 1688–9 for James VII and still used by the Crown. From 1700, Old Bank Close was home to the Bank of Scotland, founded five years earlier, while private bankers such as John Coutts had begun to appear by the 1730s: in succession to the goldsmiths, private banks proliferated in eighteenth-century Scotland. The Company of Scotland, developed as a 'global trading vehicle', with a broader shareholder base than either the English East India Company or the Bank of England, was based in 'Milne's Square on the High Street'. Edinburgh's Post Office may have come late to the fray in the wake of Italian developments in the sixteenth century, but its eightpenny Edinburgh–London service in 1633 anticipated the Paris postal system by twenty years, though the three collections a day from Paris postboxes were to render the French capital's the first truly modern system in Europe. Edinburgh developed a sixpenny delivery service to Ireland in 1662 and within Scotland seven years later.[13] Post within Scotland (2d for the first 40 Scots miles and 1d for each subsequent 20) was established in 1669, standardised at 4d nationwide in 1695; in comparison, the London 'penny post' delivering across the city was established in 1680. It remained a sore point that despite the presence of an independent Scottish post office, the English Parliament had declared 'that the post should be under their sole power and direction' in 1649; the Edinburgh post office remained underdeveloped, with only just over 1 per cent of the London office's revenues at the time of the 1707 Union that brought an end to its independent operations three years later. The extent to which Scotland benefited from better contacts with France through the development of an international postal service in Paris towards the end of the seventeenth century was possibly another factor in the cosmopolitan character of the Scottish capital.[14]

At the mercat cross by St Giles' and Parliament Square, where 'proclamations and public acts are read and published by sound of trumpet', the city had its core locale of power and administration:

> Here is the great parade, where, every day, the gentlemen meet for business or news, as at an Exchange; the usual time of meeting is from eleven to one.

It was hardly surprising that such a densely populated, cosmopolitan and strongly associational city, which conducted so much business out of doors (including 'masquerades and serenades . . . through the town in the night with instruments of music'), should have become one of the centres for innovation and diffusion of ideas in eighteenth-century Europe. The removal of the mercat cross in 1756 (the same year of the last celebration of the old feast of Beltane, 1 May), four years after the Proposals for the New Town were published, was to mark the opening of a new era in the social circulation of Edinburgh.[15] The cross's removal was seen by some as the end of Stuart Scotland (James 'VIII' had been proclaimed there on a large carpet from the exchequer room table at Holyrood as recently as 1745) and the ascent of Great Britain: 'We heels o'er head are tumbled down,/ The modern taste is London town'. Whether this was the case or not, the cross's disappearance was part of a wider movement whereby 'Town crosses, the pre-eminent and usually the most readily visible civic symbol . . . disappeared from many burghs in the second half of the eighteenth century.'[16]

But it is at least arguable that the transformations heralded and aspired to by Sir Gilbert Elliot's/Lord Provost Drummond's proposals began much earlier. The return of the Stuarts from exile in 1660 was of great importance not only for the foundation of many of Edinburgh's institutions, but also, as has been suggested above, for the rapid influx of a range of highly cosmopolitan influences of exactly the kind to drive innovation through diversity. Edinburgh was not – like Paris, where the first guidebook appeared in 1684 – a tourist centre in these years, but its 'chief places' were nonetheless listed.[17] Charles II ended the 'Union' of the Commonwealth era (effectively an English takeover) and re-established the Scottish Episcopal Church, albeit in the face of Presbyterian hostility. From the late 1660s, moderate Presbyterians were increasingly drawn into

co-operation with the government, a process which arguably became most advanced in Edinburgh, and which helped, by easing sectarian tensions in the capital, to make it the most open city in Scotland to what we now call modernity. For many in England in the Union era, 'Edinburgh could never quite succeed in losing the taint of Episcopalian and courtly culture', with its hint of Jacobitism. Surprisingly to some, this was to prove to the city's benefit.[18]

Despite some desultory negotiations over potential Anglo-Scottish Union in 1668–70, Scottish policy and government largely continued on a distinct path under Charles II. If Charles in practice sought to maintain an independent Scottish kingdom while being open to other alternatives on a pragmatic basis (his interest in the 1669 Union talks may have been due to the room they could give him to alter the operation of Parliament in his own favour), his brother James was progressively more and more opposed to potential Union in principle, culminating in his 'Advice' of 1692. For James, the preferable solution was 'internal freedom of trade for the three kingdoms and the colonies, an imperial trading system'. Scottish participation in this system on its own terms had 'priority over institutional convergence or . . . full economic union', and James was able to convince the English Privy Council to allow Scots to share from the 1670s in the activities of the Royal Africa Company and Hudson Bay Company, and to trade freely in New York. Following a 1681 report from the Committee for Trade which noted 'growing dependence on English markets' in Scotland, James 'duly authorized Scottish ventures in South Carolina in 1682 and East New Jersey from 1685'. Scots Law was initially practised in the South Carolina jurisdiction. The stage was set for the development of the Company of Scotland. Soon its Darien venture in central America was bringing 'pieces of gold' from the colony home to 'the coffee-houses off the High Street'.[19]

It is easy to overlook, not least because of the financial collapse that followed, the immense patriotism which suffused Scottish efforts at Darien, and the brief hope inspired that the SCOTCH-INDIAN-COMPANY might 'Saint-Andrew's Flag without delay . . . over all the world display', making 'both the INDIES pay tribute to Clyde,/From whence we'll diffuse it upon our Forth's side'. This would, broadsides argued, be an enterprise which would sink party divisions of 'Papist, Whig, or Tory' in the general ascendancy of the Scottish nation:

> To *SCOTLAND's* just and never-dying Fame
> We'll in ASIA, AFRICA and AMERICA proclame
> *Liberty! Liberty!* nay, to the shame
> Of all that went before us;
> Wherever we plant, TRADE shall be free . . .[20]

The argument for colonisation in the name of 'Liberty' was made by other publications too, which stressed the Scottish colony's role in restoring 'Indian sovereignty' to 'a free people . . . living under . . . their own rightful leaders and the jurisdiction of their own laws'. Indeed, it has been argued that 'For many of the Scottish settlers, to meet the Indians was to meet a more golden . . . version of themselves.' The Company of Scotland had some 3,000 shareholders, as opposed to 1,188 for the East India Company and 1,267 for the Bank of England. Given Scotland's much lower population, it is clear that the Company captured the imagination of a broad swathe of the elite, and even the middling sort: the painter Thomas Warrender subscribed £100, for example. The Company was never, however, able to fulfil its global ambitions because 'most of the capital was spent on the Darien colony'. For its part, the Spanish administration viewed the Scots as buccaneers and their settlement an act of piracy, viewing their destruction as a priority. The Scots viewed the sea as open to mercantile innovation; the Spaniards as enclosing a territorial empire in their sole possession.[21]

However ridiculously overblown and hollow Scottish hopes at Darien seem in hindsight, it was surely a wise policy decision in its own interest for the British government not to encourage the re-capitalisation of independent Scottish trading companies in Edinburgh after the Union, even though the ideal of free and open global trade remained in the consciousness of Scotland, to be drawn on later by the writers of the Enlightenment. As it was, the Scottish governmental, mercantile, military and missionary presence in the British Empire acted as a vehicle for both national patriotism and international Britishness in a symbiosis disrupted, perhaps permanently, by the final British retreat from overseas in the 1960s and the linked rise of modern Scottish nationalism.

James's residence in Edinburgh in 1679–80 and 1680–2, in exile from the Exclusion Crisis gripping the English Parliament, was central to the further development of the professional infrastructure of the Scottish capital. James entered Scotland as Duke

of Albany and heir to the throne on 21 November 1679. During his time at Holyrood and as king, he would oversee the development of the Advocates Library, the Royal College of Physicians, printing and a number of other innovations, including 'the royal charter of the Edinburgh Merchant Company', granted on 28 November 1681, the day before the College of Physicians.[22] James also instituted the offices of Historiographer-Royal (1681) and Geographer-Royal for Scotland (1682), which remain live to the present day. The duke was likewise the force behind the commissioning of the de Wet portraits of the Stuart royal line at Holyrood, and the future king also promoted Scottish games such as curling (bringing in Irish players) and golf. His understanding of the need to extend the burgh (James supported the bridging of the Nor' Loch) arguably underpinned the later development of the New Town, which was certainly enabled by the king's Charter to Edinburgh of 25 September 1688, 'to extend its bounds on all sides, to make streets, acquire grounds and houses compulsorily and to levy taxes for the same'. After he returned to England permanently in May 1682, James continued to be interested in Scottish offices and appointments, including the nomination of Alexander Rose to be Principal of the University of Glasgow in 1684.[23]

James was building on developments which, influenced by the international disruptions of the Thirty Years War and the War in the Three Kingdoms, which displaced intellectuals and nobles alike, had begun to see innovative practice gathering pace in the Scottish capital. By 1656, there was a botanic garden in Black Friars Wynd, succeeded by the 1676 gardens at Holyrood and Halkerston's Wynd, which covered 2 hectares by the last quarter of the eighteenth century, with a 42 metre conservatory front and several thousand plant species. Dr Andrew Balfour (1630–94) and Sir Robert Sibbald (1641–1722) founded the *Hortus Medicus* in 1670, a medicinal plant garden possibly inspired by its Amsterdam predecessor, begun in 1638, or by those of Leiden (1590) or Padua (1545). Holyrood had also had a garden since the 1640s, while 'Heriot's yeards', by the school on Lauriston Place, had a garden with *'phisical, medicinal, and other herbs'* in 1661, which has been claimed as the 'first Botanic Garden in Scotland'. By 1683, a *Gard'ners Kalendar* was being issued in Edinburgh.[24]

Sibbald, unquestionably an Enlightenment figure whose reputation has been damaged by his Catholicism and patriotism

(he had a keen childhood memory of 'the tyme the Inglishes were storming the town' of Dundee), 'set off to study in Leiden' in 1660, before moving to Angers, where he graduated on 17 July 1662. While in France, he 'met and stayed with the great Scottish gardener Morison in Blois at the garden of the Duke of Orleans'. Sibbald's friend Andrew Balfour, son to Charles I's dispossessed Lord Lyon (Sibbald's father had been Keeper of the Great Seal, so the families had a degree of connectivity), had already studied under Morison, who in 1669 moved to a chair in Oxford and the direction of the major botanical garden in the British Isles. On returning to Edinburgh, Sibbald and Balfour made the most of their position in Restoration society by visiting the keen gardener Patrick Murray of Livingston (d. 1671), with whom they 'exchanged seeds and information'. Seedsmen already appear to have been in business in Edinburgh: Richard Henderson was selling seeds there in 1670; in 1681, Henry Ferguson, 'seed merchant, at the head of Black Friar's Wynd', produced 'a catalogue of seeds'. Sibbald and Balfour decided to create a physic garden, and engaged James Sutherland (1631–1719) to look after a plot of ground in 'the North Yardes in the Holyrood Abby' where 800–900 species were planted. Initially no more than twelve metres square, by 1675 the garden was ninety by fifty-eight metres, and the following year James Sutherland was made 'Intendant of the Physic Garden'. By 1695, the cost of bringing in 'forraigne plants and seeds' was a notable one for the burgh, but the Physic Garden in turn brought in income through sales: in 1691 alone, Sutherland 'supplied 45 varieties of trees and shrubs' to one customer, the Earl of Morton at Aberdour Castle. The garden was also used for teaching the 'rudiments of botany', instruction in the medical use of plants, and 'to provide pharmacists with fresh plants': a multiple role which embodied the 'useful learning' core to the Scottish Enlightenment. Sutherland compiled a catalogue of the then two thousand plants in 1683, while in 1700 (the year after it received the royal warrant) the garden's stock formed the basis for the College of Physicians' pharmacopoeia, which remained the standard text through many revisions until 1864. The integration of the physic garden with medical education was an innovative alignment foreshadowing the Temple of Science developments initiated by Johann Christian Senckenberg (1707–72) in Frankfurt two generations later.[25]

John Erskine, Earl of Mar (1675–1732), Jacobite commander in the Rising of 1715, in 1728 made a similar proposal to James's for the bridging of the Nor' Loch, involving a 'high-level bridge, more or less on the line of the future North Bridge'. Mar's plan 'inspired ... the vision' which later 'gripped the imagination of George Drummond and the Council'. Mar also developed innovative approaches to urban redevelopment based on 'compulsory purchase' and 'controlled decentralized expansion'. Although his more ambitious plans were not initiated, far less adopted in Mar's lifetime, the earl's mixture of patronage and innovation represented a continuation of the traditions and culture of the Restoration administration of Edinburgh which had done much to develop 'the facilities for a modern urban social life in transport, luxury goods, entertainment and education'. That pattern was to continue, in the face of opposition from many of the magistrates and Presbyterian clergy, long after the 'Glorious' Revolution. The nature of innovatory change established in the 1670s and '80s endured to sustain the ensuing developments of the Enlightenment: as Morrice McCrae suggests, James's rule was 'a brief period of enlightened government' and 'the institutions founded at this time were at the heart of a Scottish revival that led later to the Scottish Enlightenment'. Indeed, when *Proposals for carrying on certain Public Works* heralded the appearance of the New Town, the metropolitan world this historic text aspired to ('the magnificence of the court, the pleasures of the theatre, and other public entertainments') was very much that which had animated the ambitions of the Scottish capital a generation or two earlier. The fact that Elliot bemoaned the limits of the old city 'confined by the compass of the walls, and the narrow limits of the royalty' should be taken to an extent as being rhetorical rather than a statement of fact. Elliot himself, after all, belonged to this only apparently confined world of social interchange and opportunity, which was also arguably a powerful hub of 'network-driven, enclave-based migration' for the Dutch, French and English communities in the city.[26]

In the Old Town of Edinburgh, the development of professional and public health provision was preceded by legislation for the development of an infrastructure more conducive to public health. Here, the city benefited before 1707 from the presence of the Scottish Estates and the Privy Council, as it was clearly in the governmental interest to act to improve

the environment of its legislators and the infrastructure of the capital. This effect of political power on infrastructure is one of the hidden enablers of the diffusion of innovation: it is currently (2018) one of the key reasons why productivity is rising in London and the south-east, but generally stagnant elsewhere. In Edinburgh after 1707, some of the efforts of local elites were arguably directed at the replication of the benefits which a resident government had offered their predecessors. In addition, 'Edinburgh town council had a level of autonomy over its own affairs ... that brought it closer to its German rather than English counterparts'. The 'burgh was an effective lobbyist whose economic dominance enabled it to influence government policy'.[27]

There was a strong focus on urban improvement before 1700, arising from both the actions of the burgh and the government. The entry to Parliament Close was widened to nine metres after the fire of 1676, 'to admit of the passage of coaches'. Cattle drovers were required (though many ignored the requirement) to follow a set route 'up the Castle Wynd and down Bell-house brae to the flesh market or slaughter houses at the north loch', to avoid causing undue disturbances to the citizenry. It should not be thought that London was much cleaner at this time: in the 1740s, for example, 644,000 sheep and cattle a year were sold at Smithfield Market in the City, and there was a good deal of on-site slaughtering. In Edinburgh, animal slaughter was moved to the Nor' Loch much earlier (though offal and excrement remained a problem), and after the introduction of a water supply (see below) and the development in 1678 of a Cleansing Committee, 'street cleaning and public lighting of streets' was made a priority, not least due to Privy Council pressure: the leaders of Scottish society did not like getting dirty.[28]

In 1675, a water supply (it was historically difficult to secure good supplies on the high ridge of the city) began to be piped to the High Street from Toddie's Well in Comiston, a development supported by the 'hydrostatic knowledge' of George Sinclair, on the staff of the University of Glasgow. A reservoir on the top of the Royal Mile held around 200,000–225,000 litres of water. This enabled the initiation of street cleaning and similar hygienic measures. (Although there had been bath houses in the city since 1518, these expanded and by 1704 there were 'two fine Bagnios after the Turkish fashion' – Istanbul had introduced public baths in 1566 – in 'surgeons hall' in the city). 'At

least eight fountains' supplied water, while the Council soon 'found it possible to allow the use of the surplus water first to such trades as brewers then very gradually to private houses'. In 1682, thirty muckmen were appointed to clean the streets before 9am (7am in summer), headed from 1684 by a 'General Scavenger'; in the same year, 'the council . . . funded two new public privies'. In 1685, the throwing of refuse from windows was banned (apparently rather ineffectively), but from 1687 'streets and closes were raked and cleaned three times a week', while in 1692 the muckmen 'were given the additional responsibility of patrolling the streets between 9pm and midnight every Saturday to report on people pouring waste from their window' to the famous Edinburgh (and Antwerp) cry of *'Gardez l'eau'*. From 1687, '20 close carts' were put in place nightly by 10pm for rubbish removal. Receptacles for ashes and sweepings were put in each close. In 1688, 'the magistrates were given authority to compel the heritors of houses to make pavements before their tenements' and inhabitants were 'required . . . to keep vessels in their houses big enough to hold foul water for 48 hours'. Dirty water thrown from windows was banned – once again, together with rubbish – in 1701. By 1726 (the year after manure began to be sold commercially in the burgh), the streets were being cleaned every day except Sundays. Yet, despite the appointment of an Inspector of Cleansing in 1700, the limitations of these measures can be seen in the fact that proposals for improved street cleaning were being made as late as 1745.

Following the formal introduction of lanterns outside doors in the 1660s (some lighting had been in place in the Hie Gait a century earlier), a system of public street lighting also began to take shape by the end of the seventeenth century. Amsterdam and Paris introduced their first lighting systems in the 1660s. (Paris had 'true public street lighting' with nearly three thousand lanterns from autumn 1667, although there was an initial attempt at street lighting from the 1640s, while 'public torchbearers' guided the citizenry home for a fee.) In Edinburgh, 'public lamps were furnished to illuminate the winter nights' from 1688 (there were 107 streetlamps by 1747). London introduced 'the convex lamps of the City' in 1695 and 'globular' ones in the West End in 1709. The characterisation of Edinburgh as barbaric and squalid by some English visitors was at least as much a tactic for projecting their own superiority over its alien cultural qualities as an objective assessment. Moreover, the filthiness of London

was also proverbial: in 1714, 'the French envoy complained repeatedly about the effect on his breathing of the coal smoke that enveloped London', and later in the century the 'stench from corpses ... buried in shallow graves' was remarked on. Edinburgh's 'Europeanness in behavior, dress, fodder and speech was what struck visitors most forcibly ... English travellers could only describe the capital and its inhabitants by reference to foreign countries.'[29]

What is very clear from these developments is the fact that, as Bob Harris and Charles McKean have pointed out, 'the distinctive language of urban improvement was already very well established by the early eighteenth century'. Any view that the association of the Enlightenment with urban improvement belongs to a later era is clearly incorrect. Greyfriars was being modernised and enlarged by 1703, and improvements to channel the Nor' Loch were being made in the same decade. Allegations of Edinburgh's stagnation in the first half of the eighteenth century are manifestly overblown to the point of inaccuracy.[30]

If these public health measures (not always observed, it is true) began to promote a more hygienic city, health and safety was also important amid the closely packed 'lands' or flatted houses which were liable to both fire (such as the major conflagration of 1700) and collapse (as when the side wall of a six-storey land gave way in the High Street in September 1751). Fire risk was 'one of the great anxieties of the age', as was clear from the fate of London in 1666, although there was often long-term economic benefit from the 'creative destruction' of old properties. By 1675, 'over 8,000 homes had been rebuilt' in London, with workmen from Continental Europe and the English provinces bringing diversity to the city, including female plumbers, painters and smiths, and Huguenot ironworkers. Human casualties, on the other hand, were an irreversible tragedy, and the psychology of expectation due to fire risk was a key part of the outlook of citizenry in both Edinburgh and London (the fear of fire scarred the poet Thomas Gray (1716–71) for life, for example). The centrality of the threat of fire was born witness to in the birth of the London insurance market in 1710: the Sun Fire office was established that year in 'Causey's Coffee House near St Paul's'.[31]

In Edinburgh, the burgh authorities responded to the intense risk of fire by introducing early examples of both fire and planning regulations, the conflagration of 1700 being met with closely and intensively stipulated regulation of the use of naked

flames. In 1701, extensive new fire regulations prevented the use of candles in shops where combustibles were present, and limited fires to hearths. Such regulations can only have encouraged more socialising out of doors and in taverns. The city was supported in such ambitions for its infrastructure by the Scottish Parliament, which legislated as early as 1621 for all new domestic roofs in Edinburgh, 'being the heid burgh of this realme', to be leaded not thatched; in 1681, this legislation was extended by the 'Act anent thecking of houses in Edinburgh and some other Burghs royall', which 'obliged all heritors of thatched houses to replace the thatch with lead, slate or tiles within a year', though 'thatch could still be found throughout the city' many years later. In 1674, the Town Council encouraged a move from timber to stone in building, and on 7 May 1678, the Privy Council backed the Town Council's intention to ensure that all future building should be in stone. In 1644, ruinous houses had to be rebuilt within the year or they might become the property of the burgh. Other building requirements obliging proprietors to undertake the sale or repair of ruinous houses dated back to the 1640s, while in 1698 newbuild over five storeys was banned to improve the stability of the very tall lands or blocks of flats (it was ignored, however, both by Robert Mylne in 1701 and decades later by John Adam, whose Royal Exchange, built 1753–61, was up to twelve storeys high on the Cockburn Street side). The pressures brought by the burgh or Parliament on development were sustained by royal patronage, Privy Council support and professional clout. Robert Mylne, who had acted as Master Mason to the Crown in the redevelopment of Holyroodhouse under the direction of Sir William Bruce in the 1670s, 'began buying decrepit properties, tearing them down and building new stone structures around central courtyards' along the High Street. This was part of the often ignored large-scale construction and urban development in the Old Town between 1680 and 1750, which itself served to drive the local economy. Mylne's Court, the most famous of Mylne's developments, built in 1690, became one of '*the* places to live in early eighteenth-century Edinburgh', while Mylne himself may have stayed in Mylne's Close at 280 Canongate.

Elaborate building regulations and the drive towards consistency of practice supported by the Dean of Guild's Court succeeded earlier legislative practice in the eighteenth century and helped to support 'a kind of architectural uniformity later seen in more

striking form in the building lines of the New Town'. The Dean of Guild ordered 'road repairs', and support for the infrastructure continued to be a feature of Old Town life: in 1747, 'each coach' in the city was obliged to 'lay on the Easter Road to Leith ten cart fulls of gravel for every coach that has plied the streets yearly'. The engagement with the Scottish Estates in sustaining and developing this infrastructure was critical to the rapid improvement of the Edinburgh townscape, planned, and to an extent achieved, in the early part of our period. Later, the burgh's relatively extensive powers helped to secure it.[32]

As an infrastructure conducive to both public health and the enjoyment of public space developed, so leisure, education and transport became more established. John Row opened the first coffee house in the country, 'under the Piazza' in Parliament Close, in 1673. It was associated with radical sentiment, and the Privy Council ordered it to be closed in 1677; later, 'John's coffee-house in the Parliament Close' became a magnet for those opposed to the Union, who met there on a daily basis. Boarding was available in flats above coffee houses, and by the 1690s the Exchange Coffee House in the New Kirk parish was a fashionable resort. Coffee houses were also often locations for the exchange of varied business, much as goldsmiths' booths had been in earlier years.[33]

Transport grew increasingly sophisticated in the first half of the eighteenth century. In 1670, there had been a coach service between Edinburgh and Leith, costing S2s, and a six-person stagecoach to Glasgow once or twice a week; like the thrice-weekly £4 10s service from London, introduced in 1658, this did not endure.[34]

However, there were twenty hackney coaches in Edinburgh by 1673, though only fourteen by the 1740s, with a cost of a shilling from the High Street to the Cowgate or Grassmarket and 2s to Leith. The return journey to Glasgow (when available) took six days, but once again the possibility for heterophile circulation was underpinned by Edinburgh's capital infrastructure. Coachmaking began in Edinburgh in 1696, and Robert Gibb had a good deal of the business, buying Gibb's Close at 250 Canongate; Alexander Forsyth, another coachmaker, acquired property at 57 Canongate (Forsyth's Close from 1719). There was a Newcastle coach service from 1707 (it cost 30s for the three-day journey), and a fresh London coach service opened in 1712, at least a year after the London–Edinburgh coach from

the Black Swan in Holborn had begun to run. The Edinburgh–London service took thirteen days and still cost £4 10s return, but through lack of demand the service was again suspended. John Sommerville at 79 Canongate promoted coach services to London at various times from 1736 to 1754, though demand was still irregular, with no London coach in 1751. By 1754, however, there were twenty-two fortnightly coach departures a year for the imperial capital; in 1757, the trip took a mere 131 hours. A sedan chair service was also introduced in 1687. Paris had been the first with a 'rental service' of this kind in 1639, and had also introduced public transport by carriage by the beginning of the 1660s; in London at the beginning of the eighteenth century there were two hundred sedan chairs for hire, '300 from 1713'; Edinburgh had ninety in 1738, which was a higher coverage per head of population. Sedan chairs were numbered from 1738; coaches from 1747. In Edinburgh, the sedan chair service cost S7s (about 6½d at the then current exchange rate) for a journey from the Castle to the Abbey. Alexander Hay had the monopoly for eleven years, and kept chairs at six 'convenient stances' on what is now the Royal Mile, each with two men in attendance. Sedan chairs did not make an appearance in Bath and Bristol (at 30,000, the second-largest English city) until the middle of the eighteenth century (priced at 6d for 500 yards and a shilling for a mile). In the late 1730s, the Edinburgh chairs were priced at 6d for trips in the city and suburbs, 2s 6d for half a day, 4s for a day and £1 for a week's use: a rather cheaper rate. Sedan chairs cluttered up the streets of the capital, with petitions against their being placed 'before . . . houses and shops' in 1747 and 1749. Although Edinburgh was not leading innovation here, it nonetheless was once again an early adopter, possibly through awareness of its 'capital' status. Amsterdam, for example, was more resistant to coaches because of noise issues. The transport arrangements of the Scottish capital also bore witness to the degree of circulation within it, and the strength of its internal and external communication channels.[35]

Governance, Institutions and Networks

What made Edinburgh different from other cities in the British Isles outwith London in the 1680–1750 period was both the continued residence of a large proportion of the nobility, and

the size of the professional classes. The poll tax returns of the 1690s, which contain more than four thousand names, report many figures of title, as well as those belonging to families of title, while both noble and professional alike were animated by patriotic feelings towards their country. They were also living in close proximity, and were not seldom at least distantly related. People of title were spread throughout the city. In 1694–8, 28 per cent of persons with title were reported in Old Kirk parish (bordering on the Canongate at the south of the Hie Gait), 22.5 per cent in New Kirk (round St Giles' on both sides of the street), 18 per cent in Tron (south of what is now South Bridge), 14 per cent in College, 10 per cent in Tolbooth (Lawnmarket north), 6 per cent in Greyfriars (south towards Grassmarket, Greyfriars and Heriot's), and 1 per cent in Lady Yester's (south of Cowgate), and this of course excludes the nobility in the Canongate burgh. Also, many even from modest professions were relatively well-to-do. In 1698, in Lady Yester's Parish, Sir Robert Cheisly was assessed for 40,000 merks, William Steen, the Master of the High School, at 10,000, and Alexander Herriott, a teacher of book-keeping, at 5,000.[36]

Even after the deposition of James VII and the Union, these structures retained a great deal of their earlier power. Nicholas Phillipson's observation that the Enlightenment was 'an ideological creation of a local aristocracy and a dependent *literati*' keen 'to find a way of asserting their importance in a kingdom becoming a province' still has resonance; indeed, the position of the nobility was to an extent directly bolstered by the law (which of course the same nobility both made and administered), as with the Act Concerning Entails of 1685, which has been characterised as 'a device to protect the estates of an impoverished landed class from forfeiture, debt or profligate heirs'.[37] Within a nexus such as this, it was also important that Scotland had a long tradition of being governed by a single powerful noble, who held a huge range of patronage in his hands: the Duke of Lauderdale, the Earl of Mar, the Earl of Ilay, the Duke of Argyll, Henry Dundas. Just as 'the all-important backing of Lauderdale' was key for trade liberalisation measures with the Netherlands in 1672 (Lauderdale was, as we shall see, notoriously pro-Dutch), so Leiden-educated Ilay distributed thousands of jobs in the eighteenth century, and both he and his brother may have been influential in the founding of the Edinburgh medical school in 1726. Such power inevitably had

an effect on the social networks of ambition in the capital. The University was more closely controlled by the Town Council in Edinburgh than was the case in Glasgow, but many of the Town Council appointments to the University were themselves influenced by Ilay, such as William Wishart (Principal, 1715–29), William Hamilton (Principal, 1729–32), James Smith (Principal, 1733–36) and their successors. This was also true of many of the professorial appointments, not least in Divinity, although the Faculty of Advocates gained control of the History chairs in the 1720s. It is also noteworthy for the University's future involvement in the Enlightenment that 'Scottish university education cost perhaps a tenth of its English equivalent'.[38]

After the Union, the nobility continued to live not only in the Canongate, but in the heart of Edinburgh proper. Despite allegations as early as 1718 concerning 'a great decay of the inhabitants of this city', the recrudescence of upper-class occupation in the 1720s means that Gilhooley's 1752 Street Directory lists many names of the landed and lawyerly gentry: Lord Minto in Paton's Land, the Earl of Dalkeith in Kennedy's Land (next to Allan Ramsay the bookseller), Lady Balmerino and Lord Dun in Mylne's Square (both Jacobites); Dundas of Arniston in Carrubber's Close; the Marquess of Tweeddale in Tweeddale Court; Lord Milton, the Lord Justice Clerk, in Hyndford Close; Lady Lovat among six nobles in Blackfriars Wynd; the Countess of Balcarres in Dickson's Close; Lockhart of Carnwath in Niddry's Wynd/Carnwath's Court; Lord John Drummond in Parliament Close; Lord Belhaven in Libberton's Wynd; Murray of Broughton's wife at Baillie's Land in the Grassmarket; and many, many more. Susannah, Countess of Eglinton, and David Hume for a time shared a tenement at 225 Canongate opposite St John Street, an upmarket area, which was possibly the reason why it was chosen by Hume; at no. 1, Lord Monboddo hosted 'learned suppers', while the Masonic Lodge of Canongate Kilwinning No. 2 'was almost opposite Monboddo's house' on St John Street.

The Scottish nobility permeated the capital throughout, and it was impossible to mix socially in its tight spaces without interacting with them. Small wonder these mobile, highly educated and often patriotic people remained influential in the city. They were also highly visible in an age when clothing possessed an unequivocal social register: for example, the use of 'red-heeled shoes' as a marker of status, which derived from French practice.[39]

Figure 6 Tweeddale Court today. Author's image.

Among the professions, of which more in the next chapter, law and medicine both figured strongly, and were to the fore in developing *pro bono* and charitable practice to support the infrastructure of the city, which surpassed the 'fixed price' service for the short consultations provided in London at Westminster Hall.[40] As early as February 1682, two physicians from the College of Physicians, founded only three months earlier, were nominated to provide free healthcare to the poor in 'the Cittie and suburbs', and by 1705 there were surgeries for the poor of the capital on three afternoons a week. The Town Council appears to have funded the two physicians from the Fellowship dedicated to this work, which surely can only have helped relationships between the College and the burgh: indeed, an appeal by Archibald Pitcairne (1652–1713) and 'his friend the surgeon Alexander Monteith' to 'the Town Council for the provision of bodies for public dissection' was approved in 1694. This would, Pitcairne argued, 'if it be granted … make better emprovements in anatomie, than have been made at Leyden these thrittie years'. The long tradition of the provision of charitable professional services to the poor was found also in the legal profession, as we shall see. In any case, medical

costs were often modest even when they were billed: the goldsmith Colin Mitchell, for example, paid £1 5s 11d for thirty-nine separate prescriptions/supplies in 1746. The Town Council also granted pensions (in effect, long-term benefit payments) to the indigent: some 3–4 per cent of Edinburgh's population 'received regular pensions' in this way before 1700. Following the incorporation of the Merchant Company of Edinburgh by Royal Charter on 19 October 1681, only a few weeks before the College of Physicians, the Edinburgh Guildry granted pensions to merchant burgesses and their relicts and relatives who had fallen into poverty. On 22 January 1720, 100 merks was granted quarterly to Bailie John Duncan, 'now being reduced by providence', while in 1732, the £6 paid quarterly to Agnes Robertson, relict of John Gibson Deacon of the bonnet-makers, was 'rescinded in respect she is married'. On 30 March 1720, S£30 was granted to John Watson, a merchant burgess who had presumably fallen on hard times; this was commuted to £5 sterling (S£60) on 11 May, 'in respect he was dying'. Payments to widows of University professors could include hardship monies and an element of their husband's salary: while Magdalen le Mercies, widow of the Professor of Moral Philosophy, received £10 in 1736, in 1719, Margaret Puggart, relict of John Goodall, Professor of Hebrew, received £25 'on account of her indigent condition', including both an allowance for her 'husband's funeral charges' and 'the current half-year's sallarie'.[41]

Hospitals were built in succession to the older almshouses, including a small public one in Robertson's Close off the Cowgate in 1729 and its grander successor the Royal Infirmary. In 1725–7, subscriptions began to be raised for an Infirmary for the 'sick poor', which became the Royal Infirmary, itself based on the medical school at Leiden. By 1748, the Infirmary had superseded all the small charitable hospitals such as the six-bed 'Surgeons Hospital' 'for the poor'. A charity workhouse was opened in 1731 and an Orphan Hospital through donations in 1733, sixty-three years after the first Foundling Hospital was opened in Paris, but before Thomas Coram's London foundation of 1739. London had, however, had post-Reformation charitable hospitals in place from the sixteenth century.[42]

The social status of the law was high in Edinburgh – higher than in London, and closer to the status of the *noblesse de la robe* in France, if not indeed surpassing it. Some 60 per cent of lords of session (high court judges) were themselves drawn

from the Scottish nobility, while over two-fifths of (male only) advocates married the daughters of lairds, and a small minority those of earls or dukes. Through the Lyon King of Arms Act (1672), the legal office of the Lord Lyon controlled a 'Public Register of All Arms and Bearings in Scotland': the law guaranteed and recorded nobility, as well as being born to it, socialised in it and intermarried with it. Moreover, over 80 per cent of advocates seem to have married outside the burgh: in short, the heads of the legal profession in Edinburgh had strong family connections not only to the Scottish nobility, but also to the world outside Edinburgh. This was also often true of their education: between 1700 and 1750, 27 out of a sample of 31 advocates promoted to the bench had experienced higher education at Leiden, Groningen or Utrecht, while between 1670 and 1730, no fewer than 249 of those admitted advocate had been educated in the Netherlands. Between 1690 and 1730 alone, 658 Scots 'matriculated in the law schools' of these three universities, and law was the most popular subject studied by Scots in the Netherlands. Forty per cent of Scottish law students at Leiden (of which there were 449 between 1681 and 1730) became advocates. Yet equally, these confident and cosmopolite men lived in the centre of a compact Scottish city whose successful development they did much to support, for 'generations of College members influenced Edinburgh's built environment':

> The upper echelons of the legal profession tended to live in the heart of the burgh, with a concentration of advocates and writers to the signet in the New Kirk parish.[43]

The New Kirk parish (see above) was in the environs of what is now the City Chambers, close to the College of Justice. It was eminently possible for all advocates to stay in that area, for throughout the eighteenth century there were only some 75–100 members of the working bar in practice, and of these the top ten advocates, wealthier than many noblemen, frequently took 40–50 per cent of the business. But they were not the only rich lawyers, for 'by the 1690s the combined wealth of Edinburgh's 380 lawyers was greater than that of its 600 merchants'. The Advocates Library, founded by Sir George Mackenzie in 1680–2 as 'a modern Lyceum and a new Stoa', moved to the south-east of Parliament Square, at the centre of power in Scotland, on St Margaret's Day (16 November)

1682. St Margaret was patroness of Scotland and also deeply respected for her learning in the cultural memory of the country. By 1692, the Advocates Library had 3,140 volumes; by 1750, 20,000; by 1770 (by which time it had been catalogued by Thomas Ruddiman and Walter Goodall), over 30,000. If, as Jonathan Israel has argued, libraries were the sinews of the Enlightenment, Edinburgh had made a muscular start. This was no less true of private libraries such as those of Andrew Fletcher (6,000 volumes), Sir Andrew Balfour (3,500) and Dr Archibald Pitcairne (2,300).[44]

The Faculty of Advocates was a wealthy, influential and cosmopolite group with heterophile educational and family experiences and culture, while at the same time being professionally close-knit and homophilous, living in the same part of a physically small city almost on top of their place of business. Advocates were also central to the charitable culture and associational life of the city, having a thorough involvement in civic life. From its beginning, 'the Faculty required advocates to make regular contributions to its charity box "for the relief of decayed Advocates there wyfes children and known servants"' and provided 'free representation for the poor', a practice dating back to the sixteenth century. Indeed, the *pro bono* free legal aid practice of the legal profession continued to be delivered through the Poor Roll until as late as 1949. Among the many beneficiaries of legal aid were litigants in divorce cases, legal in eighteenth-century Scotland, where 83 per cent of the 904 cases from 1684 to 1830 ended in the dissolution of the marriage (somewhat less, though still significantly, successful were the 203 annulment and legal separation actions). In our period, men were 64 per cent of all pursuers, but a significant number of cases were initiated by women, and uncontested divorces could cost less than £5. A small number of advocates (and others such as Writers to the Signet, the Edinburgh legal society which historically had possessed sole rights to prepare government documents for the Crown's royal secretary, later the Secretary of State), 'were all nominated annually ... to act gratis for litigants on the poor roll'. This had significant social effects: for example, in the availability of relatively ready divorce in Scotland, including 'many middle-class people, and not a few quite humble ones who could divorce under the poor's roll, which was the equivalent of legal aid'. In addition, advocates were prominent in the infrastruc-

ture and associational life of the capital. In 1709, the advocate David Fearn printed *The Scots Post-man* three days a week, 'on which days he had a monopoly on the printing of news in the town', while six of the forty-six founding members of the Philosophical Society (founded 1731) were advocates. Fearn had a track record in this respect, having received handwritten news letters from London charting the progress of politics and the Irish war as early as 1690. Advocates invested heavily in the Canongate Theatre, which after 1751 'ended up in the ownership largely of members of the College of Justice'. They also sought to develop innovative civic institutions: for example, John Spottiswoode, Keeper of the Advocates Library from 1695 to 1723, 'wrote up proposals for a Society for Promoting and Improving Knowledge in the History of Scotland', and also supported the establishment of a (specifically sober) society for improvement.[45]

Members of the College of Justice (including the advocates) were excluded from the Town Council, which was a close-knit group of burgesses, self-elected and with a slight majority in favour of the merchants over the crafts. The grouping which controlled day-to-day Council business was more heavily biased in favour of the merchants, and there was pressure from the trades (see Chapter 3) to have increased representation on 'all committees'.[46] The members of the College and Faculty were thus more likely to gravitate to a wider, more cosmopolitan world of patronage and relative liberalism, and away from what could be seen as the narrow vision of the burgh. Aligned to both the Scottish nobility and the dignity and sovereignty of the magistracy associated with Roman society and their Roman law tradition, the judges and advocates of Scotland frequently saw themselves as a fount of authority and even government. After the end of the Scottish Parliament in 1707, Sir Francis Grant argued that there was no need for a legislature in Scotland because the College of Justice was 'one of the best constitute bodies in the world'. This tradition endured: later in the century Lord Kames was to regard judges (of whom of course he was one) as more responsive than legislators to societal development. In keeping with their role as an alternative parliament, members of the College of Justice proceeded through town in a parade 'bearing gowns, cravats and wigs, to Parliament House', much as the Scottish Estates had used to do, in a performative gesture of authority. They also retained

an ascendancy in the British administration in Scotland, with the government of the country often in practice in the hands of lawyers such as Andrew Milton, Lord Justice-Clerk then Keeper of the Signet, or Henry Dundas, Lord Advocate and Keeper of the Signet.[47]

Edinburgh's strong charitable ethos extended well beyond the professions into associational life. In contrast to tendentious claims that the Foundling Hospital *Messiah* charity concert in London in 1749 was a pioneering occasion, and 'the Live Aid of its day',[48] such assemblies were by then already frequent in the Scottish capital. In February 1740 alone there was both an Assembly for the benefit of *'Indigent Families'* (a regular feature of Edinburgh life at this time), priced at a handsome 10s 6d a ticket, and one by the Governor and Directors of the Musical Society for the benefit of the Royal Infirmary, more economically priced at 2s 6d a ticket. Musical assemblies were held for the benefit of the poor from c. 1730 onwards, and were being used systematically as an instrument of policy shortly afterwards: for example, 'during the severe winter of 1740 ticket proceeds were used to generate cash for poor relief'. On 13 June 1733, there was a special benefit performance of *The Beggar's Opera* in its June run for the Royal Infirmary by the 'Edinburgh Company of Players', while on 2 February 1736, Signora Violante (see Chapter 4) did a rope dance ('the performance of tricks on a tightrope') for the benefit of the poor, and on 23 April 1751, Ramsay's *Gentle Shepherd* was given a performance at the Canongate Theatre for 'the benefit of a family in distress'. When the new dancing Assembly was founded, 'the chief purpose which the promoters of the Assembly established in 1746 had in view was the raising of funds for charities', and sums were regularly handed over 'to the Infirmary and the Charity Workhouse' to further that end. The presence of Scottish nobility and the highly educated in the capital in disproportionate numbers provided the basis for charitable giving, their social capital being complemented by financial capital: in 1739, for example, the Jacobite nobleman Laurence Oliphant of Gask gave £5 for the 'Orphan-School and Hospital' of Edinburgh. Such 'celebrity' gifts were infused with the status of the giver and helped, as they would today in the wake of A-list gifters, to multiply more modest donations. In addition, the gift of a man like Oliphant would be an example to those of his political persuasion that charitable

giving for the infrastructure of the capital and the care of its disadvantaged was a good Jacobite habit.[49]

Collections were also held for those who had fallen on hard times: for example, in 1702 S£2,669 was raised for the *'relief of those who suffered by the blowing up of gun-powder in Leith'*. In time of dearth, arrangements were made for poor relief over and above the town pension, though there was often a strict demarcation between the deserving poor of Edinburgh and those of the Canongate. Residence in 'Canongate and Portsburgh ... North and South Leith' did not 'qualify for the full privileges of a burgess'. On the other hand, after the 1696 fire which destroyed the Canongate Grammar School, Edinburgh gave the schoolmaster a home in the city proper so that he could continue his work until a new site was found off Gilmour Street in 1704. Canongate crafts were considered superior, and the Edinburgh merchants declined 'to annex Canongate to the royalty of Edinburgh' in 1677 for fear of competition. Canongate masons had to pay to work within Edinburgh city limits; Canongate baxters might have their bread stolen; beggars tolerated in the Canongate might well find themselves arrested 'in the city proper', which kept a wary eye on 'vagabonds beggers poor and idle persones' and their 'theiveing stealing breaking of shops and houses and other gross abuses'. In 1701, an attempt was made to control the number of strangers in the burgh by an Act Against Landlords Letting of Houses &c to Strangers without Testificals, as 'the number of vagabonds Beggars poor and idle persons have of late increased in this place'. As numbers were 'Resorting from all quarters of the Kingdome to this Burgh' it was important that those coming to Edinburgh should have 'Sufficient means of their own or Lawful Callings'. The regulation of beggars was a key feature of seventeenth-century Edinburgh. In the famine year of 1697, there was a refugee camp for beggars in Greyfriars, which accommodated some three hundred.[50]

In the world of Edinburgh society, there were strongly delineated 'ins' and 'outs' in both formal and informal social demarcation. Particularly unwelcome were 'outlanders' from Glasgow and the west, even more than 'norlanders' with their 'fits' and 'gweeds'. The failed harvests of 1694–8 intensified the problem of destitution, and may have led to a catastrophic 15 per cent decline in the country's population, with the inevitable accompaniment of further economic weakness. In 1697,

non-Edinburgh residents were not admitted to the refugee camp for beggars at Greyfriars. The burgh authorities intervened in response to crises of this kind to offer controlled pricing of staples, such as meal, offered on occasion at a fixed price of S12s the Scots peck (9 litres in the case of meal, though 13 in those of barley and malt).[51]

Given the vast range of social classes living cheek by jowl within a small space, there was relatively little tension and violence in the Scottish capital. In rivalry with London (and possibly Paris, where statistics on 'baptisms, marriages, and deaths' had begun in the 1670s and '80s), from the early eighteenth century the Edinburgh press carried regular mortality reports and related statistics. Consumption (tuberculosis) and smallpox (a particular problem in the 1740s) were the major killers. On the other hand, the chances of violent death for the citizens of the capital was 9–10 per 100,000 in the 1750s; Edinburgh had only one murder from 835 burials in 1738. The overall violent death rate in the Scottish capital was far lower than the *murder* rate in contemporary Chicago, which had 781 murders from a population of 2.4 million in 2016, some 33 per 100,000. Antisocial behaviour could be found, though, as when the burgh noted on 23 October 1691 that 'many lewd and wicked boyes does by casting of stanes at the closs foots destroy and spoil the yeards belonging to the neighbours'. Life expectancy seems to have been better on average than was the case in London: some 14–17 per cent survived to be over 60, compared to 12.5–15 per cent in the imperial capital in 1735–40, although London did have double the (tiny) proportion of over-80s. Life expectancy in Scotland as a whole, though, seems to have been four to five years shorter than in England at this period. In 1746, in the aftermath of some poor harvests, Edinburgh achieved only 10 per cent over-60s (though a high 2 per cent of over-80s), with 46 per cent dying before five, while London managed 14 per cent with 43 per cent infant mortality, and Vienna 16 per cent with 47 per cent dying under five: 2.5 per cent of London and 4 per cent of Vienna's deaths were over 80. Infant mortality and sexagenarian survival rates appear to have been better in provincial towns than in either Edinburgh or London, with the north-east of Scotland up to ten years better off than Edinburgh.[52] The conditions in which the population of the Scottish capital lived were broadly similar. Edinburgh's rainfall in the eighteenth century was much as it is now (660 mm in

1764) and average temperatures ranged from 1–3 Centigrade in December, January, February and March to 13–15 Centigrade in June, July and August.[53]

Edinburgh in the Age of Union

Any evaluation of Edinburgh as a location for early Enlightenment innovation and development needs to take account of one of the *causes célèbres* in the years before the Union: the trial and execution in January 1697 of the student Thomas Aikenhead, who lived in a fourth-storey land near the Netherbow, for blasphemy. Huge 'significance has traditionally been invested' in this 'totemic case'. Aikenhead's fate has been taken as indicative of how unenlightened Edinburgh was before the Union.[54] However, judged on a closer reading of the evidence, it is arguable that Aikenhead's tragic cause should rather be read as 'a sign of a Presbyterian Kirk determined to assert its coercive authority' in a time of famine (seen by many Presbyterians 'as a providential judgement on a sinful nation') and consequent distrust in the established leaders of society. It was not in itself evidence of the widespread ascendancy of bigotry and superstition: one of the clear collateral indicators of this was the diminishing frequency of witch trials. Although the last of these in the capital was held in 1702, when Margaret Myles was hanged for the crime, there had at that time been very little legal activity involving witchcraft in Edinburgh since 1678. Women were no longer 'worryt' to death and then burnt on the Castlehill, and the deep pool in the Nor' Loch (now east Princes Street Gardens) called 'the Pot' – some 5 metres deep, compared to the metre typical of the loch's depth elsewhere – had long been used by suicides rather than for trying witches. Aikenhead's execution (which was confirmed by the narrowest of margins, a tiebreak vote in the Privy Council refusing a second petition for reprieve) was rather a sign of the power of new ideas than their weakness. It was the 'loose philosophical talk in Edinburgh that had the authorities so concerned' in the 1690s, and which helped lead to the passage of the 1695 Blasphemy Act, one of the effects of which was to precipitate 116 Jacobite Episcopalians into taking the oaths. Aikenhead's own view of humanity was a classically Enlightenment one: 'man's imaginatioun duely exalted by art and industry can

do any thing, even in the infinite power of God'. Apparently influenced by Baruch Spinoza (1632–77), whose mathematical concept of God was deemed to be heretical, Aikenhead's beliefs were themselves manifestations of the cosmopolite nature of Edinburgh's ideas, and within that the importance of the Netherlands as a source of influence. In this sense, certainly the sense argued for by Jonathan Israel, Aikenhead was a figure who may have belonged to the group of those radically re-envisioning society in the wake of Spinoza's legacy. Nor, if this was the case, was Aikenhead alone. Pitcairne, who equally 'probably thought mathematical arguments could establish the existence and attributes of God', was himself suspected of atheism, while John Craig (c. 1663–1731) published *Theologiae Christianae Principia Mathematica* in 1699, offering a relationship between geometry and theology.[55]

The Union of 1707 marked deep divisions in Scottish society, which were to persist for many years. Resistance to the Union was linked to the continuing promotion of Scotland's historic international links: in 1723, the Earl of Mar, for whom Scotland was 'my great passion & much at my heart ever almost since I remember anything', proposed a confederal monarchy of England, France, Scotland and Ireland to the Regent Orléans. As Daniel Szechi has demonstrated, revived concepts of political association with France were very much on the agenda in Scotland in the run-up to Union, while 'the Scots . . . viewed the Dutch as their principal trading partners', and questions were raised as to whether Scotland would not be better off becoming one of the United Provinces of the Netherlands than joining with England, or indeed entering a confederal arrangement. As negotiations progressed, the people of Scotland became widely involved, with farmers and artisans among the petitioners against it; there was even a suggestion (by the pamphleteer James Hidges) that the issue be put to the test in a referendum or 'direct vote' with universal male *and female* suffrage. The Edinburgh press was prevented from reporting the debates. In 1706, Daniel Defoe, acting as an English government spy, saw a crowd on the High Street cry out, 'No Union, No Union, English Dogs', and this was far from an uncommon sentiment. Even the General Assembly of the Kirk 'tho'' pressed to it, refus'd to set apart a solemn Day of Thanksgiving for the Union'.[56]

The Jacobites were 'unanimously against the Union'. As Daniel Defoe remarked, there was 'not a Papist, not a Jacobite,

not a Prelatist in Scotland, but what declared themselves against the Union', while Ramsay of Ochtertyre later noted that the Jacobites 'were all of them ... great enemies to the Union'; Mar's own Proclamation in the Jacobite Rising of 1715 declared that a Stuart restoration 'is the only way left to retrieve the unhappy Consequences of the Union ... and to prevent our posterity from being involved in endless miseries'.[57] To such as these, it seemed madness to place Scotland in the hands of a state which was its hereditary enemy: 'all persons and places of Trust and consequently our government itself were at the disposal of the ministers of a nation ever intent upon our ruin and destruction'.[58] On the other hand, the preservation of 'union in Britain against a Jacobite threat' provided a strong motive for the supporters of the measure, for whom – famously – it was a case of 'Trade with most, Hanover with some, ease and security with others, together with a general aversion to civill disorder', though Chris Whatley has argued that this seriously underestimates the religious dimension. Inevitably, the trades and professions of Edinburgh were also divided, not least because 'they must pay six pence for the Scots Pint of Ale, which they us'd to buy for Twopence'. For their part, the Edinburgh brewers resisted the visitations of English excisemen by stopping production. Mobs formed to support them (and to ask for their beer back), and 'by 1708, brutal attacks on customs and excise officers and anyone who dared to assist them carry out their duties were becoming everyday events'. Presbyterian ministers refused to baptise children 'Jacobina'; in 1711, the Faculty of Advocates voted overwhelmingly to accept the gift of a medal depicting King James 'VIII' from the Duchess of Gordon, before backtracking hurriedly in the face of political pressure.[59]

The bill to extend the Malt Tax to Scotland in 1713 was so explosive that the Earl of Seafield's move to introduce a bill to dissolve the Union in the House of Lords failed by only four votes. On 10 June 1713, King James's birthday, there was a 'Horrible Rackett' at Edinburgh:

> The streets were crowded with all sorts of People, hurraing & hollowing God save the King, & downe with Hanover, & the whiggs, playing and singing the old tune, The King shall enjoy his owne againe, & that of a new one which begins, 'We'll have no Prince Hanover Let James our King come over ...'[60]

Increasingly, the two causes of Jacobitism and opposition to Union were seen as one. As Margaret Stewart notes, 'the '15 Rising was primarily aimed at ending the Union'. Cess was raised in the localities on the pre-Union model, and even as late as 1745 the Jacobite army resuscitated pre-1707 pay differentials for its soldiers, to emphasise that this was a Scottish force. Many institutions retained loyalty to the old order, not least the Lord Lyon, a relative of Mar's, and the heralds, who proclaimed King James as late as 1745. In March 1716, a huge riot would take place in Edinburgh in response to the appearance of a Dutch officer in the British Army carrying plunder from the defeated Jacobite army.[61]

The printer Robert Freebairn, who had started his bookselling business in Parliament Close in 1704, turned his title of King's Printer to another king's service in 1715, when he became printer to the Jacobite administration of King James VIII at Perth, bravely putting his name to his productions and even printing a proclamation of James's intended coronation on 23 January 1716, which never took place. Although Freebairn acted subsequently as a Jacobite courier and agent in Rome, Urbino and Padua from 1717 to 1721, he then returned to work as a printer in Edinburgh. The experience abroad of Freebairn and others like him added to the strongly cosmopolite flavour of the capital, as we shall see in more detail in the next chapter.[62] The College of Physicians split into Jacobite and anti-Jacobite factions: interestingly, it was the former whose 'scientific position appears to have been with the Moderns', the latter for the Ancients. Pitcairne feared 'our Colledge should break'.[63] William Arthur, successor to James Sutherland in the Physic Garden, fled to the Continent after the failed attempt to take Edinburgh Castle for the Stewarts.[64] Throughout the 1720s, '30s and '40s, there were a large number of Jacobite 'sleepers' such as Freebairn in the capital, and these figures had a significant effect on the innovation, diffusion and international context of the Enlightenment. We will meet some of these figures in more detail in later chapters.

Outside some western Presbyterian districts, Scotland as a whole was riddled with Jacobitism in a way still not fully appreciated, so ingrained is the habit of cultural memory in creating a narrative of the past to support the present at the cost of history's losers. Even events which appear remote from explicit Jacobite politics, such as the riots which led to the lynching of the man whom Allan Ramsay called that 'crazy Brute' Porteous

in 1736 were linked to the underpinning view of smuggling as a political crime created by the unfair duties perceived to have been imposed – or threatened to be imposed – on Scotland since the Union of 1707. It was also the case that there remained a great deal of native patriotism in place, which, if not outright opposed to the Union, was suspicious of it. The 1737 *Proposals for Retrieving the Sinking State of the Good Town of Edinburgh* noted the 'declining state of the City . . . one visible Cause is, the Distance from the Seat of Government, and the want of Parliaments and Privy Council'. It was anxieties of this kind that helped to support the eventual development of the New Town proposals, and their implementation.[65]

The patriot qualities of the Scottish Jacobite leadership were strongly played on by press coverage, while in 1745 the serving Lord Provost, Archibald Steuart (1697–1780), brother-in-law to Sir Gilbert Elliot of Minto, was put on trial for his suspected collusion with the Jacobite army, but evaded conviction. The continuing sale of tartan after 1746 (the 'Edinburgh pattern' Jacobite tartan seems to have been introduced in 1713) was a form of mute political protest in the city: for example, a 'great Variety of the newest patterns of TARTANS' was advertised as being available from James Baillie's shop opposite the Tolbooth (an impertinent location for tartan sales) in the *Mercury* for 24 November 1748, just in time to make a purchase for St Andrew's Day. There was continuing unrest in the capital, with 'official concern about planned popular celebration to mark the acquittal for treason' of Archibald Steuart. In 1747, 'printed copies of a Jacobite handbill . . . were seized by local magistrates', and a number of 'coffee-house keepers' were 'examined about their provenance', showing how widely the five hundred copies printed had reached open 'public sphere' channels of communication. These political tensions reached down to a very personal level: in July 1747, a 'glazier' was 'called a "Hanoverian Bouger" and his wife a "damned Hanoverian bitch"'.[66] As Christopher Whatley, a historian of predominantly Whig historical sympathies, puts it: 'Scotland was not settled until the 1750s, and then only through the imposition of "systematic state terrorism" was . . . Jacobitism finally defeated.'[67] The importance of these deep-seated political tensions in the intellectual history of the Enlightenment is still underestimated. In the following chapters, we will see the significance of some of these divisions.

Notes

1. Charles McKean, *Edinburgh: Portrait of a City* (London: Century, 1991), 17; D. Bell, *Edinburgh Old Town* (Edinburgh: Tholis Publishing, 2008), 12, 14, 16–17, 101–2; Richard Rodger, *The Transformation of Edinburgh: Land, Property and Trust in the Nineteenth Century* (Cambridge: Cambridge University Press, 2001), 14. A Scots mile was 1,814 metres, about 1.125 English miles.
2. James Edgar, *History of Edinburgh* (n.p, n.d.), 216–17; James Ray, *A Journey Through Part of England and Scotland Along with the Army Under the Command of his Royal Highness the Duke of Cumberland* (London: Osborne, 1747), 84.
3. R. A. Houston, 'The economy of Edinburgh 1694–1763: the evidence of the Common Good', in S. J. Connolly, R. A. Houston and R. J. Morris (eds), *Conflict, Identity and Economic Development: Ireland and Scotland, 1600–1939* (Preston: Carnegie Publishing, 1995), 45–63 (54); Robert D. Anderson, Michael Lynch and Nicholas Phillipson, *The University of Edinburgh: An Illustrated History* (Edinburgh: Edinburgh University Press, 2003), 64.
4. McKean (1991), 15.
5. Edgar, *History of Edinburgh*, dedication; Bell (2008), 12, 14, 16–17; Lisa Kahler, 'Freemasonry in Edinburgh, 1721–1746: Institutions and Context', unpublished PhD (University of St Andrews, 1998), 19.
6. T. C. Smout, *Scottish Trade on the Eve of Union 1660–1707* (Edinburgh and London: Oliver & Boyd, 1963), 132, 188; Murray Pittock, 'John Law's Theory of Money and its roots in Scottish culture', *Proceedings of the Society of Antiquaries of Scotland* 133 (2003), 391–403 (396–8); William Irvine Fortescue, 'Black Slaves, Apprentices or Servants in Eighteenth-Century Scotland: Evidence from Edinburgh Newspapers', *BOEC* ns 12 (2016), 17–26 (17).
7. Thomas Piketty, *Capital*, tr. Arthur Goldhammer (Cambridge, MA: The Belknap Press/Harvard University Press, 2014), 251; Christopher J. Berry, *The Idea of Commercial Society in the Scottish Enlightenment* (Edinburgh: Edinburgh University Press, 2015 [2013]), 73; L. M. Cullen, 'The Scottish Exchange on London, 1673–1778', in Connolly, Houston and Morris (1995), 29–44 (29, 33); Leah Leneman and Rosalind Mitchison, *Sin in the City: Sexuality and Social Control in Urban Scotland 1660–1780* (Edinburgh: Scottish Cultural Press, 1998), 9; S. G. Checkland, *Scottish Banking A History, 1695–1973* (Glasgow and London: Collins, 1975), 76.

8. Edinburgh City Archives Moses Bundles VII 181/10, 12; McKean (1991), 99.
9. Helen Dingwall, *Late Seventeenth-Century Edinburgh: a demographic study* (Aldershot: Scolar Press, 1994), 9, 10, 20, 64, 71, 121, 142–3, 175, 279; Dingwall, *Physicians, Surgeons and Apothecaries: Medicine in Seventeenth-Century Edinburgh* (East Linton: Tuckwell Press, 1995), 20; R. A Houston, *Social Change in the Age of Enlightenment: Edinburgh, 1660–1760* (Oxford: Clarendon Press, 1994), 105; Peter G. Vasey, 'The Canonmills Gunpowder Manufactory and a Newly Discovered Plan by John Adair', *BOEC* ns 4 (1997), 103–6 (103); Richard Leppert, *Music and Image* (Cambridge: Cambridge University Press, 1988), 9; Mark Greengrass, *Christendom Destroyed* (London: Penguin, 2015 [2014]), 136; T. M. Devine, 'The Merchant Class of the Larger Scottish Towns in the Seventeenth and Early Eighteenth Centuries', in George Gordon and Brian Dicks (eds), *Scottish Urban History* (Aberdeen: Aberdeen University Press, 1983), 92–111 (93, 96–8, 107); T. M. Devine, *Scotland's Empire 1600–1815* (London: Allen Lane, 2003), 8, 31; Helen Smailes, 'David Le Marchand's Scottish patrons', unpublished paper (1996), 2; Richard Savile, *Bank of Scotland: A History 1695–1995* (Edinburgh: Edinburgh University Press, 1996), 11; Houston in Connolly, Houston and Morris (1995), 48; *The Edinburgh Gazette*, 6–9 November 1699; James Campbell Irons, *Leith and its Antiquities*, 2 vols (Edinburgh: Morrison & Gibb for the subscribers, 1897), II: 143; Jenny White, *London in the Eighteenth Century: A Great and Monstrous Thing* (London: The Bodley Head, 2012), 3.
10. Hugh Ouston, 'York in Edinburgh: James VII and the Patronage of Learning in Scotland, 1679–1688', in John Dwyer, Roger A. Mason and Alexander Murdoch (eds), *New Perspectives on the Politics and Culture of Early Modern Scotland* (Edinburgh: John Donald, n.d. [1983]), 133–55 (133, 149); T. C. Smout, 'Where had the Scottish economy got to by the third quarter of the eighteenth century?' in Istvan Holt and Michael Ignatieff (eds), *Wealth and Virtue: The Shaping of Political Economy in the Scottish Enlightenment* (Cambridge: Cambridge University Press, 1983), 45–72 (47); Fern Insh, 'An Aspirational Era? Examining and Defining Scottish Visual Culture 1620–1707', unpublished PhD (University of Aberdeen, 2014), 136; Una A. Robertson, 'An Edinburgh Lawyer and his Bees', *BOEC* ns 1 (1991), 79–81 (79–80); Rodger (2001), 13.
11. Hugo Arnot, *The History of Edinburgh* (Edinburgh: West Port Books, 1998 [1779]), 135; Ray (1747), 94; Brian Boydell, *A Dublin Musical Calendar 1700–1760* (Dublin: Irish Academic

Press, 2008), 24; Hamish Coghill, *Lost Edinburgh* (Edinburgh: Birlinn, 2014 [2008]), 16, 94, 106; Bob Harris and Charles McKean, *The Scottish Town in the Age of Enlightenment 1740–1820* (Edinburgh: Edinburgh University Press, 2014), 28, 56; Kahler (1998), 14, 16; Jerry Brannigan and John McShane, *Robert Burns in Edinburgh* (Glasgow: Waverley Books, 2015), 127; Houston (1994), 6; Joan Dejean, *How Paris Became Paris* (New York: Bloomsbury, 2014), 3, 4, 12; D. Bell, *Edinburgh Old Town* (Edinburgh: Tholis Publishing, 2008), 113. Chambers is describing the period c. 1770, but such remarks are every bit as relevant to the early eighteenth century, if not more so.
12. Clare Jackson, *Restoration Scotland, 1660–1690* (Woodbridge: The Boydell Press, 2003), 31.
13. Aonghus MacKechnie, 'The Earl of Perth's Chapel of 1688 at Drummond Castle and the Roman Catholic Architecture of James VII', *Architectural Heritage* XXV (2014), 107–31 (115, 127n); Coghill (2014), 80, 118; Houston (1994), 51–2, 205; *BOEC* XI (Edinburgh: T. & A. Constable, 1922), 140. Jackson (2003), 21; Greengrass (2015), 245; Dejean (2014), 123–4; Checkland (1975), 28, 69; Douglas Watt, *The Price of Scotland: Darien, Union and the Wealth of Nations* (Edinburgh: Luath Press, 2007), 13, 83, 211.
14. Arnot (1998 [1779]), 317–19; Lucy Inglis, *Georgian London: Into the Streets* (London: Penguin, 2014 [2013]), 22.
15. Daniel Defoe, *A Tour Through the Whole Island of Great Britain*, ed. Pat Rogers (Harmondsworth: Penguin, 1971 [1724–6]), 575, 578, 581; Arnot (1998 [1779]), 318–19. For the effect of the disappearance of the Scottish burgh mercat cross as a sign of authority and contested authority, see Harris and McKean (2014), 105; Ray (1747), 82.
16. See James Wilson's *The Last Speech and Dying Words of the Cross of Edinburgh*, NLS APS 4.83.4; Bob Harris, 'Landowners and Urban Society in Eighteenth-Century Scotland', *Scottish Historical Review* XCII:2 (2013), 231–54 (237). For the details of the declaration of James 'VIII', I am indebted to Deborah Clarke, Senior Curator of the Royal Collections at Holyrood.
17. See 'Local urbis Edinburgensis notabili digna', NLS Adv MS 28.3.12; Dejean (2014), 1.
18. Peter Jones, 'The Polite Academy and the Presbyterians, 1720–1770', in Dwyer, Mason and Murdoch (n.d. [1983]), 156–78 (157).
19. Alastair Mann, *James VII: Duke and King of Scots, 1633–1701* (Edinburgh: John Donald, 2014), 127–9; Allan I. Macinnes, 'William of Orange – "Disaster for Scotland?"', in Esther Mijers and David Onnekirk (eds), *Redefining William III: The Impact*

of the King-Stadtholder in International Context (Aldershot: Ashgate, 2007), 201–23 (205–6); Douglas Watt, *The Price of Scotland: Darien, Union and the Wealth of Nations* (Edinburgh: Luath Press, 2007), 13, 17.
20. *Trade's Release*, NLS Ry III.a.10, no. 83.
21. Bridget McPhail, 'Through a Glass Darkly: Scots and Indians Converge at Darien', *Eighteenth-Century Life* 18 (1994), 129–47 (137–8, 141); Watt (2007), 83, 211. I am indebted to the research of Oliver Finnegan, '"Saints turned freebooters": The Darien Venture, Piracy and the Nationalisation of Maritime Space, 1695–1702', unpublished paper, 2nd World Congress of Scottish Literatures, Vancouver, 23 June 2017. I am indebted to Helen Smailes for details on the Warrenders.
22. Savile (1996), 11.
23. Mann (2014), 122, 129, 137, 138, 139, 163, 164; David Allan, 'The Universities and the Scottish Enlightenment', in Robert Anderson, Mark Freeman and Lindsay Paterson (eds), *The Edinburgh History of Education in Scotland* (Edinburgh: Edinburgh University Press, 2015), 97–113 (101); Stuart Harris, 'New Light on the First New Town', *BOEC* ns 2 (1992), 1–13 (1); Dr Marguerite Wood, 'Survey of the Development of Edinburgh', *BOEC* XXXIV (1974), 23–56 (33).
24. Greengrass (2015), 187; Archibald Pitcairne, *The Phanaticks*, ed. John MacQueen (Edinburgh: Scottish Text Society, 2012), 158.
25. *The Autobiography of Sir Robert Sibbald* (Edinburgh and London, 1833), 13, 41; Royal *College of Physicians of Edinburgh: The Sir Robert Sibbald Physic Garden* (Edinburgh: Stationery Office, 1997), 3–4; A. D. C. Simpson, 'Sir Robert Sibbald – The Founder of the College', The Stanley Davidson lecture, *Proceedings of the Royal College of Physicians of Edinburgh Tercentenary Congress 1981* (Edinburgh: Royal College of Physicians of Edinburgh, 1982), 61–3; Morrice McCrae, *Physicians and Society: A History of the Royal College of Physicians in Edinburgh* (Edinburgh: John Donald, 2007), 7–10; Helen Dingwall et al., *Scottish Medicine: An Illustrated History* (Edinburgh: Birlinn, 2011), 53; *BR 1689–1701*, ed. Helen Armet (Edinburgh: Oliver & Boyd, 1962), 118; Priscilla Minay, 'Eighteenth and Early Nineteenth Century Edinburgh Seedsmen and Nurserymen', *BOEC* ns 1 (1991), 7–27 (7); E. Patricia Dennison, *Holyrood and Canongate: A Thousand Years of History* (Edinburgh: Birlinn, 2005), 99; Douglas Duncan, *Thomas Ruddiman* (Edinburgh and London: Oliver & Boyd, 1965), 24.
26. *BR 1689–1701*, 276–7; *BR 1681–1689*, lii; Houston (1994), 6, 31, 75, 76, 105, 227; Margaret Stewart, *The Architectural, Landscape and Constitutional Plans of the Earl of Mar, 1700–32*

(Dublin: Four Courts, 2016), 152, 154; A. J. Youngson, *The Making of Classical Edinburgh* (Edinburgh: Edinburgh University Press, 1988 (1966)), 3, 5; Thomas A. Markus, 'Introduction', in Markus (ed.), *Order in Space and Society: Architectural Form and its Context in the Scottish Enlightenment* (Edinburgh: Mainstream, 1982), 1–23 (5); Alex Benchimol, 'For "The Prosperity of Scotland": Mediating National Improvement – the *Scots Magazine*, 1739–1749', *Studies in Scottish Literature* 39 (2014), 82–103 (102); Richard Ovenden, 'Scottish Books in Early Eighteenth-Century Edinburgh: a Case Study', in Stephen W. Brown and Warren McDougall (eds), *The History of the Book in Scotland Volume* 2 (Edinburgh: Edinburgh University Press, 2012), 132–42 (132); Arnot (1998), 246–7; *The Caledonian Mercury*, 13 January 1735, 13 December 1739. For Catholics in the Canongate in 1703, v. NLS MS 3813 f. 6; Duncan (1965), 24; Roger L. Emerson, *Academic Patronage in the Scottish Enlightenment* (Edinburgh: Edinburgh University Press, 2008), 274; Thomas McCrae, 'Lord Kames and the North Bridge: Notes on the Scheme of 1754', *BOEC* XXIII (1940), 147–54; Morrice McCrae, *Physicians and Society* (Edinburgh: John Donald, 2007), 6; Stuart Harris, 'New Light on the First New Town', *BOEC* ns 2 (1992), 1–13 (1); Douglas Catterall, *Community Without Borders: Scots Migrants and the Changing Face of Power in the Dutch Republic, c. 1600–1700* (London, 2002), 344–5, cited in Steve Murdoch, *Network North: Scottish Kin, Commercial and Covert Associations in Northern Europe 1603–1746* (Leiden and Boston: Brill, 2006), 2.
27. Laura A. M Stewart, *Urban Politics and the British Civil Wars: Edinburgh, 1617–1653* (Leiden and Boston: Brill, 2006), 136, 317.
28. Wood (1974), 32; Stewart (2006), 137.
29. Dejean (2014), 132–5; White (2012), 10; Bob Harris, *A Tale of Three Cities: The Life and Times of Lord Daer 1763–1794* (Edinburgh: John Donald, 2015), 40–2; McKean (1991), 6, 19; *The Caledonian Mercury*, 7 January 1740; *BR 1689–1701*, 293; NLS MS 17602 f. 25; Ray (1747), 94; Arnot (1998), 194; Houston (1994), 169; Hentie Louw, 'Dutch Influence on British Architecture in the Late-Stuart Period, c. 1660–1714', *Dutch Crossing* 33:2 (2009), 83–120 (97); Finlay (2014), 3; Michael Graham, *The Blasphemies of Thomas Aikenhead* (Edinburgh: Edinburgh University Press, 2013 [2008]), 11; Coghill (2014), 233; *BR 1701–1718*, xxiv, xxx; Berry (2015), 2, 14; Jeremy Black, *Eighteenth-Century Britain 1688–1783*, 2nd edn (Basingstoke: Palgrave Macmillan, 2008 (2001)), 17; R. A. Houston, 'Fire and Faith: Edinburgh's Environment, 1660–1760', *BOEC* ns 3 (1994),

25–36 (26, 27, 33); Helen Armet, 'Notes on Rebuilding Edinburgh in the Last Quarter of the Seventeenth Century', *BOEC* XXIX (1956), 111–42 (111); W. N. Boag Watson, 'Early Baths and Bagnios in Edinburgh', *BOEC* XXXIV:2 (1979), 57–67 (57, 59); Daniel Defoe, *A Tour Through the Whole Island of Great Britain*, ed. Pat Rogers (Harmondsworth: Penguin, 1971 [1724–6]), 583; and Greengrass (2015), 10 for the bagnios; NLS MS 17602 f. 25; and Thomas Ferguson, *The Dawn of Scottish Social Welfare* (London and Edinburgh: Nelson, 1998), 138–9 for street cleaning; Mary Cosh, *Edinburgh: The Golden Age* (Edinburgh: John Donald, 2003), 2 for a dismissive attitude to the city in the first half of the eighteenth century; Wood (1974), 33; Bell (2008), 20.
30. Harris and McKean (2014), 493.
31. White (2012), 39, 180; Inglis (2014 [2013]), 16–19.
32. Graham (2013), 11; Coghill (2014), 53, 61; Houston (1994), 76, 107, 112; Harris and McKean (2014), 59; Robert Miller, *The Municipal Buildings of Edinburgh* (Edinburgh: Printed by Order of the Town Council, 1895), 112; Armet (1956), 112–14; *BR 1689–1701*, 285–6, 293; Whatley (2006), 192; Bell (2008), 21, 141–2; *Ancient Law and Customs of the Burghs of Scotland* Volume II AD 1424–1707 (Edinburgh: Scottish Burghs Record Society, 1910), 157; Edinburgh City Archives Moses Bundle VI: 162/6285, 164/6348. Greengrass (2015), 42 notes that 'construction was a motor of local economies' in early modern Europe in general.
33. Sacheverell Sitwell and Francis Bamford, *Edinburgh* (London: Faber, 1938), 162–3, 194; Marie Stuart, *Old Edinburgh Taverns* (London: Robert Hall, 1952), 15, 133; Edinburgh City Archives SL225.
34. *An Inventory of the Ancient and Historical Monuments of the City of Edinburgh with the Thirteenth Report of the Commission* (Edinburgh: Royal Commission on the Ancient Monuments of Scotland/HMSO, 1951), li.
35. *The Edinburgh Courant*, 25–28 July 1707; *BR 1681–1689*, liii; Edgar, *History of Edinburgh*, 336–9; Brown, 'Newspapers and Magazines', in Brown and MacDougall (2012), 354; Arnot (1998 [1779]), 317; John H. Jamieson, 'The Sedan Chair in Edinburgh', *BOEC* IX (1916), 177–234; Vanessa Brett, *Bertrand's Toyshop in Bath Luxury Retailing 1685–1765* (Wetherby: Oblong, 2014), 111; Smout (1963), 10; Dejean (2014), 125–6; White (2012), 10; Edinburgh City Archives Moses Bundle VI: 164/6324, 6347.
36. Edinburgh City Archives SL 225/3/1 ('List of the Names and Qualities of the Pollable Persons Within the College Church Pariche in the City of Edinburgh'); SL 225/3/2/1/1-50; SL 3/2/2

('List of the Polable Persones in the Lady Yester's Parish Given up Conforme to the Act of Parliament in Anno 1698 as Follows'); SL 225 (Name Index for Poll Tax Returns).
37. Nicholas Phillipson, quoted in Emerson (2008), 3; and Phillipson, 'Lawyers, Landowners, and the Civic Leadership of Post-Union Scotland', *Juridical Review* (1976), 97–120 (113).
38. Emerson (2008), 212, 231, 233–6, 257, 273; Dingwall et al. (2011), 41; Smout (1963), 17; Bruce Lenman, *Enlightenment and Change: Scotland 1746–1832* (Edinburgh: Edinburgh University Press, 2009 [1981]), 255.
39. J. Gilhooley, *A Directory of Edinburgh in 1752* (Edinburgh: Edinburgh University Press, 1988), 58, 65–9, 71, 75, 77, 80; Stana Nenadic, 'Necessities: Food and Clothing in the Long Eighteenth Century', in Elizabeth Foyster and Christopher A. Whatley (eds), *A History of Everyday Life in Scotland, 1600–1800* (Edinburgh: Edinburgh University Press, 2010), 137–63 (148); Brannigan and McShane (2015), 84–5; BOEC XI, 78–9; Law (1965), 11, 59; Elizabeth Einberg, *William Hogarth: A Complete Catalogue of the Paintings* (New Haven: Yale, 2016), 19.
40. Inglis (2014 [2013]), 95.
41. Dingwall (1994), 247 ff, 256–7, 268; Dingwall (1995), 119, 121; Dingwall et al. (2011), 53–4; Pitcairne (2012), xl; James Colston, *The Guildry of Edinburgh: Is it an Incorporation?*(Edinburgh: Colston & Co., 1887), 79, 122–3, 142, 156; NAS RH 15/176/4 for Mitchell's pharmacy bills.
42. McCrae (2007), 58–62; Dejean (2014), 205; A. Logan Turner, *Story of a Great Hospital* (Edinburgh: Oliver & Boyd, 1937), 14, 17, 42; Law (1965), 44.
43. Finlay (2014), 16–17, 35, 38; Jackson (2003), 20; Robert Feenstra, 'Scottish-Dutch Legal Relations in the Seventeenth and Eighteenth Centuries', in T. C. Smout (ed.), *Scotland and Europe, 1200–1850* (Edinburgh: John Donald, 1986), 128–42 (132); Phillipson (1976), 107, 120; Mijers (2012), 41–2.
44. Finlay (2014), 139; Graham (2013), 14; Duncan (1965), 25; Arnot (1998 [1779]), 171; Robertson, (2005), 113; Jackson (2003), 27; Stewart (2016), 221.
45. Finlay (2014), 23–4, 49, 51, 52–3, 255; McElroy (1969), 54, 227; Lenman (2009 [1981]), 21; Leah Leneman, *Alienated Affections: The Scottish Experience of Divorce and Separation, 1684–1830* (Edinburgh: Edinburgh University Press, 1998), 13, 15–16; NLS Adv MS Ch. A. 109-24; NRS RH 15/85/2 ('News Letters addressed from London to David Fearn').
46. Kahler (1998), 18; Jacqueline Hall, 'Corporate values in Hanoverian Edinburgh and Dublin', in Connolly, Houston and Morris (1995), 114–24 (118); Law (1965), 11.

47. Finlay (2014), 33, 62, 93–4; Berry (2015), 5.
48. *The Telegraph*, 14 April 2014.
49. NLS Adv MS 25.9.9 f. 24; NLS Adv MS 82.3.5 f. 190; *The Caledonian Mercury*, 29 January, 5, 25 February 1740; Dibdin (1888), 43, 47, 69; Roger L. Emerson and Jenny MacLeod assisted by Allen Simpson, 'The Musick Club and the Edinburgh Musical Society', *BOEC* ns 10 (2014), 45–105 (52); Bill Findlay, 'Beginnings to 1700', in Findlay (ed.), *A History of Scottish Theatre* (Edinburgh: Polygon, 1998), 1–79 (61); James H. Jamieson, 'Social Assemblies of the Eighteenth Century', *BOEC* XIX (1933), 31–91 (76–7); Houston (1994), 119, 269; Whatley (2006), 153.
50. *The Caledonian Mercury*, 5 February 1740; *BR 1701–1718*, ed. Helen Armet (Edinburgh: Oliver & Boyd, 1967), xlii; Houston (1994), 6, 31, 75, 76, 105, 119, 227, 269; Whatley (2006), 153; H. M. Anderson, 'The Grammar School of the Canongate', *BOEC* XX (1935), 1–25 (13–14); *BR 1689–1701*, 276–7; Marguerite Wood, 'Survey of the Development of Edinburgh', *BOEC* XXXIV (1974), 23–56 (34); Dennison (2005), 99; Edinburgh City Archives SL 149/2/4.
51. *BR 1689–1701*, 276–7; Houston (1994), 6, 31, 75, 76, 105, 227; Markus (1982), 1–23 (5); Alex Benchimol (2012), 102; Richard Ovenden, 'Scottish Books in Early Eighteenth-Century Edinburgh: a Case Study', in Brown and McDougall (2012), 132–42 (132); Kahler (1998), 111; *The Caledonian Mercury*, 13 January 1735, 13 December 1739; *The Edinburgh Flying-Post*, 23–25 May 1709; Macinnes (2007), 217. For Catholics in the Canongate in 1703, v. NLS MS 3813 f. 6.
52. *The Caledonian Mercury*, 30 December 1736, 4 January, 10 April, 11 June 1739; *The Scots Magazine*, 1739: 622–6; 1746: 678; *BR 1689–1701*, 78; Dejean (2014), 12–13; R. E. Tyson, 'Contrasting regimes', in Connolly, Houston and Morris (1995), 64–76 (69–71); Ferguson (1948), 73, 111–12. For Chicago, see 'On murderous streets', *The Economist*, 1 July 2017, 37; for figures for Penrith and Whitehaven, see Black (2008 [2001]), 15; for the north-east of Scotland, see Tyson, 71.
53. *BR 1689–1701*, 293.
54. Allan, in Anderson, Freeman and Paterson (2015), 99.
55. Graham (2013), 43, 61, 81, 107, 115, 155–6; Macinnes (2007), 217 for Presbyterianism and the famine; George F. Black, *A Calendar of Cases of Witchcraft in Scotland 1510–1727* (New York: New York Public Library, 1938), 78, 82; Coghill (2014), 73–4; MacQueens (2009), xxiii–xxvi, xxx; Malcolm Fife, *The Nor' Loch: Scotland's Lost Loch* (Lancaster: Scotforth Books, 2004 [2001]), 25–7, 44–5.

56. Stewart (2016), xxv, 115; *Remarks and Collections of Thomas Hearne*, ed. C. E. Doble, Volume II (Oxford: Clarendon Press, 1886), 12; Daniel Szechi, *Britain's Lost Revolution* (Manchester: Manchester University Press, 2015); Macinnes (2007), 202, 238. On the referendum issue, I am grateful to the work and conversation of Karin Bowie, including her unpublished essay on 'Public, People and Nation in Early Modern Scotland'.
57. Daniel Defoe, *The History of the Union between England and Scotland* (London: John Stockdale, 1786), 224, 280; NRS GD 241/380/14; Whatley (2006), 11; John Ramsay of Ochtertyre, *Scotland and Scotsmen in the Eighteenth Century*, introduced by David J. Brown, 2 vols (Bristol: Thoemmes Press, 1996 [1838]), II:476.
58. NLS MS 17498 f. 145.
59. Karin Bowie, *Scottish Public Opinion and the Anglo-Scottish Union 1699–1707* (Woodbridge: Boydell & Brewer/Royal Historical Society, 2007), 75, 110; Whatley (2006), 15; George Baillie of Jerviswood, quoted in Smout (1963), 261; *The Medal* (London: E. Curll, 1712), 5.
60. *Hearne's Remarks and Collections*, Volume IV, ed. D. W. Rannie (Oxford: Clarendon Press, 1898), 203–4.
61. Chris Whatley, 'Reformed Religion, Regime Change, Scottish Whigs and the struggle for the "Soul" of Scotland, c. 1688–c. 1788', *Scottish Historical Review* XCII (2013), 66–99 (68); Stewart (2016), 108; Sir Malcolm Innes of Edingight, 'Ceremonial in Edinburgh: The Heralds and the Jacobite Risings', *BOEC* ns 1 (1991), 1–6 (1, 4); Daniel Szechi, 'Retrieving Captain Le Cocq's Plunder: Plebeian Scots and the Aftermath of the 1715 Rebellion', in Paul Monod, Murray Pittock and Daniel Szechi (eds), *Loyalty and Identity: Jacobites at Home and Abroad* (Basingstoke: Macmillan, 2010), 98–119 .
62. W. J. Couper, *The "King's Press" at Perth, 1715–6* (Perth: privately printed, 1919), 11; and 'The Pretender's Printer', *Scottish Historical Review* 15 (1918), 106–23 (107, 111, 115).
63. MacQueens (2009), 13; *The best of our owne: Letters of Archibald Pitcairne, 1652–1713*, ed. W. T. Johnston (Edinburgh: Saorsa Books, 1979), 44.
64. MacQueens (2009), 13; Emerson (2008), 274.
65. NLS MS 2968 f. 25; *Proposals for Retrieving the Sinking State of the Good Town of Edinburgh* (Edinburgh: Davidson & Trail, 1737), 4.
66. 'Notes on Provost Stewart's actions in 1745', NLS MS 16971 f. 1; Bob Harris, *The Scottish People and the French Revolution* (London: Pickering & Chatto, 2008), 21.

67. Christopher A. Whatley, 'Order and Disorder', in Elizabeth Foyster and Christopher Whatley (eds), *A History of Everyday Life in Scotland, 1600–1800* (Edinburgh: Edinburgh University Press, 2010), 191–216 (191).

3 Trades and Professions

Traders and Merchants

Edinburgh's tightly controlled burgess network, which was regulated by the Town Council, strongly defined the middle orders. It also controlled the limits of what was politically tolerable for those looking to make their way in society via the trade and craft incorporations of the city: Chirurgons and Barbouris (who separated in 1722), Goldsmythis, Skinners and Furriers, Hammermen, Wrights and Masons, Tailors, Baxters, Fleschouris, Curdwainers, Wabstaris, Waekaris [hatters], Bonnet-Makers, and Dyers and Candlemakers. Control of the system was strongly identified with the exercise of political control on a wider stage, as burgess privileges and licensing were an established route to patronage. On 9 May 1660, three weeks before Charles II landed in England, the Town Council 'ordained all burgess and guild brother tickets to be written out in the King's name, as formerly "befoir the invasion of the English"'.[1]

There were about two thousand burgesses in the city in the 1660s, but their number and ability to exercise monopoly declined with time. As the historian Rab Houston has pointed out with regard to the end of the seventeenth and beginning of the eighteenth centuries, about 10 per cent of burgesses were excused the political oaths to make allowances for those whom it was desired to incorporate irrespective of their (usually Jacobite) politics, while conversely, oaths might be strictly administered with the goal of excluding someone. In the world

of Edinburgh society, there were strongly specified 'ins' and 'outs' in both formal and informal social demarcation. Being a burgess 'enhanced individual status by giving access to social contacts, power through office holding and employing, economic opportunities, and welfare services'. The Council licensed foreign craftsmen, which gave them a route into Edinburgh society and patronage, and, significantly, women also received burgess licences. On 8 September 1708, licence was granted 'to Elizabeth Skeen, daughter of the deceast Mr Thomas Skeen, advocate, to trade in this city, liberties and priviledges thereof, and that during all the days of her life', while on 10 August 1709, the Council granted 'licence to Sarah Dalrymple ... to use her trade of japanning as a burges of this city all the days of her lifetime ... providing always she employ the freemen of this city for the timber work'. Shorter licences were also granted for seven years, and women burgesses were expected to remain unmarried.[2]

The growth of both an independent newspaper and a thriving printing business based on publishing and official and professional markets was another distinctive feature of Edinburgh, and it led to substantial cultural change. Many involved became wealthy: the publisher William Donaldson and the bookseller John Johnston were assessed at £41 7s 9d and £46 7s 6d respectively in the 1711–12 stent rolls (the equivalent of modern rates or council tax), compared to the Countess of L(inl)ithgow at £38 8s 6d, John Scougall the portrait painter at £22 10s 6d, and the periwigger Allan Ramsay at £10 (this placed Ramsay roughly at the halfway point of his trade by prosperity only two years after he had entered it). The printer James Watson, so important to the cultural rebirth of vernacular Scots, was assessed at £24.

The rehabilitation of Scots as a literary language owed a good deal to Watson and other Edinburgh printers, as well as to its association with a classical tradition. Scoto-Latinists such as Sir Robert Sibbald even argued that the Roman frontier had been at Perth, not the Antonine Wall, in order to associate the core of Scotland with Roman influence: in this, Sibbald was in fact closer to the verdict of modern scholarship than much of the intervenient orthodoxy has been. Scots Latinity received a boost from the political changes of the 1688–1715 era, for its analysis was that 'as the Stuarts were exiled by the Hanoverians, so Latin ornament deserted Scotland to be replaced by the prosaic imitation

of Augustan English'. In response, crossover genres familiar in Latin arrived in Scottish literature, not least in Edinburgh, like the *rus in urbe* Scots poems of Robert Fergusson.[3]

Other trades supplied the exotica and luxury goods which underpinned the development of wealthy and cosmopolite tastes, which were part of the 'increasingly elaborate networks of economic obligation and variegated skeins of knowledge transfer' consequent on growing modernisation, mass production and global trade.[4] Despite much public and associational meeting being on a footing of relative equality, there were also strong marks of social distinction present throughout Edinburgh society, notable in both consumer goods (see below) and interior decor. James Norie and Roderick Chalmers advertised their 'mock Arras Hangings, Representing Forrestry, History Hunting Fields &c done upon Canvas, which looks as well as any true Arras' intensively, running an advert in *The Scots Courant* on twenty-four occasions in 1710–11 alone. Bernard Messink sold 'the only true Italian sort of Flock Work for Hangings for Rooms, or Skreens' from 'his dwelling House in Edinburgh, at the Sign of the Angel, in the Luckenbooths, the second Story of the Land'. Colin Mitchell, 'Gold Smith at the Head of the Cannoyet', supplied metal furniture and also 'Rozetta Silk plaid' at £2 2s and an easy chair for 27s 6d (brass castors 9s 6d extra). Alexander Brand charged Sir William Bruce no less than £389 15s for the preparation and supply of soft furnishings and almost 160 skins of leather; a follow-up order for thirty-five skins came to £42 and £1 13s delivery. Goldsmiths continued to flourish and produce outstanding work: Robert Gordon's 1743 account for a dinner service to Sir John Kennedy of Culzean outlines a basic price of £21 16s 2d, plus an additional £6 4s for materials and labour and £1 5s for a 'sagrine case for holding them'.[5] Bonds might be payable in sugar as well as cash, and the Laigh coffee house was a frequent place for transacting business.[6]

Consumption of fruit – not least imported fruit – was a clear marker of social status as 'demand for fruit and vegetables was ... rising faster than population', not least when, as in 1734, only one cargo of fruit reached the city (there were major shortages in imported fruit). Domestic fruit (strawberries, gooseberries, cherries, apricots, peaches, plums) was presumably in readier supply. Fresh fruit and nuts were key markers of status, with peppers, pears, nuts and walnuts all for sale at Leith, and

Figure 7 The Jolly Judge: a 'laigh' or basement-entry tavern, still doing good business today. Author's image.

Cadiz oranges at 1s a dozen. For those who did not fancy the trip to Leith, wholesalers and retailers like William Carmichael or Mr Sheils could offer citrus fruits, walnuts, chestnuts, raisins, almonds and sherry from their outlets in the city centre. Sheils was selling lemons, oranges, three kinds of pear and almond, raisins, pippins, walnuts and chestnuts near the Cross in the winter of 1734–5, despite the lack of imports that year. Sherry could also be purchased, and Jamaica rum at 8s the English gallon 'for ready Money only', while English produce such as 'Kentish pippins' and 'best Cheshire Cheese at three pence half-penny per Pound' also appeared on sale, perhaps an incipient sign of the prestige attributed to southern practice (as well as produce) as the century progressed. Claret was retailing at 2s 6d the Scots pint or joug (1696 ml) in 1712, reduced to 2s in the summer, with Bordeaux 'better than any in the Kingdom' available from Mrs Henshaw's opposite the Tolbooth at 28s the pint. Account books of merchants such as the vintner Robert Brown show a flourishing trade with large wine bills (for example, £4 3s 11¾d for a cask of 34¾ pints of brandy at 29d the pint, invoiced on 18 May 1725). In 1716, James Freebairn

reminded the Earl of Mar that he had furnished him with 18 dozen of wine and port at £18 all in. Order slips with only the century printed (for example, 17–) also appeared, as invoicing and receipting expanded. Trade and the supply of trade was becoming a major market.[7]

Global trade was also beginning to bring a greater range of exotica to Edinburgh. In 1695, 'a manufactory opened in Leith for the production of combs, and other small articles in horn, tortoiseshell and ivory', while in 1688, 1,788 'puppets for children' were landed in Leith, and 182 tusks by the *African Merchant* in a single voyage in 1700.[8] 'Orange, Limon, Citron and Myrtle-Trees, Coffee-Trees and several Kinds of flowering Shrubs' were sold by roup (auction), so great was the demand. The Dean of Guild's nieces in Edinburgh ordered 45kg of coffee for their coffee-shop from Andrew Robertson, a Scottish merchant in Rotterdam, who also supplied ten thousand hawthorns together with twenty peach and twenty pear trees to the Earl of Leven, Governor of Edinburgh Castle. Gardening was becoming increasingly popular among households enjoying long 'backs' of open land down to the Nor' Loch; by 1725, manure was being advertised for general sale. Archibald Eagle became the 'official seedsman' of the Honourable the Society of Improvers (three hundred members, 40 per cent of them nobility), while David Dowie supplied larches to the Atholl estate and William Hamilton (who supplied the Countess of Hopetoun) had his gardening business taken over by his wife when he died; she supplemented it by greengrocery. Seedsmen also supplied gardening centre equipment, as with the 'pair Garden sheers' ordered by William Adam from the seed merchant Arthur Clephane or the six nesting boxes supplied by Clephane for £1 4s in 1717. Clephane also supplied the trade, the gardener George Miller ordering 10lb of 'Firr Seed' from him on 8 February 1724.[9]

Auction houses began to be established in the capital. Perhaps one of the first was that of Reverend David Freebairn (1653–1739) 'on the North side of the High Street opposite the Guard' 'next Stair to the Ship Tavern', which began to be advertised in the Edinburgh press by the 1690s.[10] Book auctions were one of Freebairn's specialities, and the Edinburgh market was very prominent, producing printed catalogues at an early date. Archibald Pitcairne (1652–1713) offered to buy books at auction in Edinburgh for the very metropolitan Sir Hans Sloane (1660–1753), writing to Sloane that 'I wish you could be at

Figure 8 A modern reinterpretation off the Canongate of an eighteenth-century Edinburgh garden, stretching down the 'backs' from Canongate above the Nor' Loch. Author's image.

the pains to make a list of what books ye desire to have and send it to me' (Sibbald too was a correspondent of Sloane's). Pitcairne was himself an avid collector, like his patriot contemporary Andrew Fletcher of Saltoun (1653–1716), with a library so extraordinary that Peter the Great acquired it on the doctor's death, and incorporated it into 'the newly-founded (1714) Library of the Russian Academy of Sciences'.[11]

Bookselling auctions were far from the only ones held in the capital. On 20 January 1737, Allan Ramsay and William Hamilton were scheduled to host an auction of books (including, of course, Ramsay's *Scots Proverbs*, 'Just published'), pictures, medals, watches, clocks, rings, jewels, silver plate and arms. The commission was 2s in the £ for sales under £3 and 1s in the £ above. The art market was also highly developed, as we shall see in the next chapter. A housing and commercial property market was also beginning to be in evidence by the 1690s: lands were not necessarily self-contained, and separation by flats on different floors seems to have been increasing. Gladstone's Land, the merchant's house on the Lawnmarket, with its seven-metre frontage and depth of nineteen metres,

Figure 9 Gladstone's Land (without shop front), still standing today. The depth of the shadow gives a sense of the darkness that would pervade many Edinburgh houses in 1700, even in sunlight. Author's image.

providing on each floor a square metreage larger than a modern new-build detached house, was much larger than most properties on the market.

Sales were by auction, and included properties such as a third-storey flat 'at the Head of Chalmers's close' for £170; commercial property like the Assembly-Hall and the Tavern in New Assembly Close for £900 (£75 rental income a year); the Laigh House in Bell's Wynd for £30; and cellars for £7–£10 each. First-storey and top-floor flats in the same close sold for £144 and £96 respectively, a premium for the drawing-room position even greater than that obtaining in today's market. Developers such as John Hamilton built speculatively for sale, and home improvements were not infrequently carried out: a 1722 purchase of a new kitchen chimney was accompanied by an order for a new door lock at S£2 8s. The flats in the six-storey land and 'roof-house' he built at the end of the seventeenth century at Burnet's Close (a typical first-floor apartment had a 5.5 metre dining room, two four-metre bedrooms facing east and west, a chamber with a closet and a nine-square-metre kitchen and pantry) were sold to writers, merchants, advocates,

a minister and the Deacon of the Surgeons. A six-apartment flat on the fourth storey bought by a lawyer sold for 4,000 merks, S£2,666 or about £220 sterling. Fittingly, in view of all this vulnerable real estate, the first insurance office in the city opened in 1719.[12]

Edinburgh's population in our era was multicultural to an extent not always understood today, and this too had an effect on its business and professional environments, driving innovation through the heterogenous experience of change agents. Outside London, the Scottish capital was the major centre for Dutch influence in the British Isles from 1660. The extensive trade between Scotland and the Netherlands, the centrality of Dutch higher education in the lives of Edinburgh's elites, the return of Royalist exiles (and later the departure of Presbyterian ones) and the long- established presence of Dutch painters were all key factors. The degree of cosmopolitan exchange was probably greater proportionately than in the imperial capital itself. Despite Charles II's 1672 declaration 'welcoming immigrants from the Low Countries to settle where they pleased' (Charles had a history of supporting the naturalisation of foreigners), 'London's enormous size possibly inhibited co-operation of the kind that existed in Dutch towns between *inwoners* and newcomers'. This was not so clearly true in Edinburgh, a city both much smaller and more religiously and socially congenial to many of the Dutch. Charles clearly favoured the naturalisation of foreigners 'of the Protestant religion as shall come and dwell in our kingdom of Scotland, declaring we will give them the free and public exercise of their religion in their own language'.[13]

Charles II and his supporters had spent significant time in exile in the Netherlands, and their influence was felt in the British Isles on his return. The sash window was introduced in both England and Scotland, while Dutch classical architectural styles melded with influence from elsewhere on the Continent. The Royal Society discussed 'the virtues of Dutch brick-making practice'. As in England, Dutch artists had been prominent in Scotland from the early seventeenth century: Abraham von Blijenberck's painting of Drummond of Hawthornden and Daniel Mytens' of the Duke of Hamilton are only two examples. Mytens, who worked in London until 1634, also portrayed Charles I: this 1628 painting is still in the Royal Collection.

Scotland had also had links with international art dealing going back to the 1640s. In 1646, Montrose man John Clerk

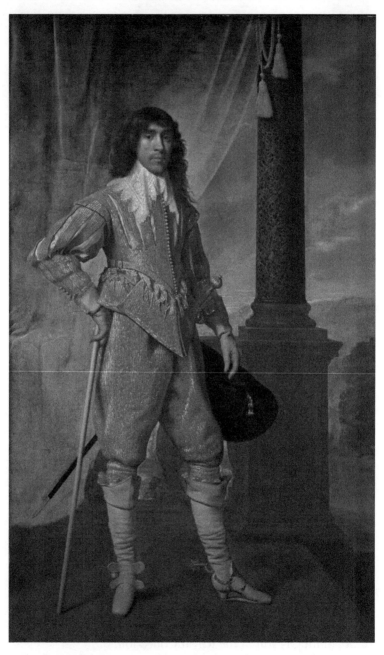

Figure 10 *The Duke of Hamilton* by Daniel Mytens. By courtesy of the National Galleries of Scotland. PG 2722.

(1611–74) sold up his French dealing business and bought an estate at Penicuik, some fifteen kilometres from Edinburgh, which still remains the seat of his family. From the 1660s, Dutch painting was prominent in John Clerk of Penicuik's collecting, and he became 'the first individual to operate a successful business by importing art from the continent to Scotland', with Netherlandish art predominating. Early as this was, there were precedents: Thomas Cunningham was involved in Dutch art sales 'to collectors in Scotland' as early as 1650.[14]

In the later seventeenth century, the leaders of Dutch art included at least three significant painters of Scottish origin or descent: William Gouw Ferguson (b. c. 1623, fl. 1648–95), Francis de Hamilton (fl. 1640–95) and James de Hamilton (c. 1640–1720). James in his turn fathered a whole dynasty of painters, the last of which, Philippe, died in 1750. There were strong personal and commercial networks, with a significant Scots community in the Netherlands, including a good number of hardcore Presbyterians. In Scotland itself, England's Dutch wars under Charles II were an attack on Scotland's 'best customers', although they were not universally unpopular in Scotland: the Episcopalian Archbishop of Glasgow thought that a Dutch victory would unleash radical Presbyterianism in Scotland and 'excited the people to a new rebellion'. Scots volunteers served with the Dutch forces against Charles II's England. South of the border, a significant part of English opposition to admitting Scots to the colonial trade was the view that this would be 'tantamount to admitting the Dutch under a flag of convenience', though in point of fact (to take one example) both countries were in the same boat, for neither England nor Scotland's fishery companies 'could operate independently of Dutch fishing expertise'. Nonetheless, given some of the attitudes to foreigners present in England, the fact that the Scottish Parliament had encouraged Flemish weavers to settle as early as the 1580s and that as late as the 1740s Dutch 'master weavers' were retained by the Board of Trustees for Manufactures in Scotland to instruct local talent, the attitude to the Netherlands north of the border was sufficiently friendly to be suspect. Scots also served in the Scots Brigade in the Netherlands.[15]

Trade was the major engine of contact between Scotland and the Netherlands. The stone for Amsterdam town hall (1648–65) came from Culross in Fife, from the quarry owned by Alexander Bruce, 2nd Earl of Kincardine (1629–81), while as early as

1612, Scottish glassmakers 'had established a glass-house in Zeeland', a Dutch province with a particularly close relationship with Scotland. Up to one in ten of the population of the port of Veere (where there had been a Scots mercantile settlement for centuries) were Scots, and there was also a 'Scottish mercantile community' at Rotterdam. Scottish merchants such as Thomas Johnson continued to be active in the Netherlands well into the eighteenth century, although after 1725 Dutch fiscal policy greatly diminished 'the value of the concessions granted to Scottish merchants'. Between 1680 and 1686 alone, 'over 1,500 ships sailed from Scotland to Dutch ports', with Leith being the main point of departure. Clerk of Penicuik, with his strong interest in the Dutch art market, himself sailed in about ninety ships, and on peak trading days in Veere there were up to thirty Scottish vessels in the harbour, even though Veere itself could have less than 50 per cent of the Scottish Zeeland trade.

The Netherlands were over-producing art for the domestic market and were keen to export both paintings and painters: between the 1650s and 1700, 'approximately 116 painters from the Netherlands visited or emigrated to England' alone, while there was a sense that native talent was being squeezed out. Scottish 'merchants went to the United Provinces to learn their trade', later becoming prominent figures in their home country or links between markets in the two countries: James Hume learnt book-keeping at Dordrecht before being 'used as a merchant contact by Andrew Russell of Rotterdam'. The staple of Veere, a contract of restrictive trade between Edinburgh and the Dutch port which enabled it to enjoy 'the monopoly of Scottish trade' and where the Scots church was 'usually careful to follow the Kirk in doctrinal matters', was only finally cancelled in 1799, while the formal title of Conservator of the Scottish Privileges there lasted to 1847. As late as the American War of Independence, the Scots merchants at Veere were diverging from the British government's foreign policy.[16]

What we would today call globalisation was thus very much part of the life of the Scottish capital. The merchant Alexander Pembroke sold 'Fine Dutch Quills' at 'his shop a little below the Red Lyon foregainst the Luckenbooths', while William Park the '*Comb-maker*' boasted that he '*for the Insight of his Trade, has Travelled most places, as Germany &c*'.[17] Dutch financial innovation was also an important driver of change in Scotland.

John Holland (c. 1658–1721), whose English father fought with the Dutch in 1665 and who moved to the Netherlands in the 1670s, became important in the early development of the Bank of Scotland (1695): although Edinburgh lacked London's stock exchange, roups of Bank of Scotland stock were made at coffee houses, for example that of 15 July 1709 at the Royal Coffee House. The Bank's first accountant, George Watson (1645–1723), had been educated at a merchant house in the Netherlands in the 1670s: indeed, some twenty Scots went thither every year to study accounting and trade, which no doubt helped to lead to the establishment of the commercial schools in Scotland. Between 1675 and 1725, there were 825 Scottish students at Dutch universities, including 422 studying law, while Herman Boerhaave (1668–1738) alone taught 244 Scottish students medicine at Leiden between 1701 and 1738.[18] International staff and student mobility was a two-way street: there were extensive Scottish staff in the Huguenot academies (including seven principals) and Scots helped to found Continental universities, as William MacDowell did at Groningen. As Andrew Mackillop puts it:

> The departure between 1680 and 1730 of just over 1,000 Scots students to the great Dutch universities amounted to a strategy of enhancing human capital . . . There can be little doubt that the early Enlightenment in Scotland owed part of its character and timing to this intellectual mobility.[19]

There was significant support for such mobility from the diasporic or sojourning Scottish community in Continental Europe, where Scots (often in exile for political reasons) were active in the service of the state and mercantile enterprise in France, the German states, Italy, Scandinavia, Poland and Russia. To take two examples, Donald McEwan was a jeweller in St Petersburg celebrated in poetry by Allan Ramsay, while Robert Broun, a Scottish merchant in Poland, left £500 sterling to fund a bursary for both a Scot and a Pole to study at the University of Edinburgh, where the first student from Poland was accepted on 30 November 1715.[20]

John Maitland, 1st Duke of Lauderdale (1616–82), effective head of the king's administration in Scotland from 1660 to 1680, himself had close links with the Netherlands, including a collection of Dutch art, and was painted by the Flemish

immigrant painter Jacob Huysmans (c. 1633–96) in 1665. As was often the case in the century that followed, Lauderdale's 'strongly nationalist' outlook was the counterpart of his Scottish internationalism.[21] Alexander Bruce, Earl of Kincardine, himself married to a Dutchwoman, Veronica, the daughter of a merchant, Cornelius van Aerssen van Sommelsdyck, recommended John Slezer (the Dutchman, or just possibly German, who produced *Theatrum Scotiae*) to Lauderdale. Kincardine collaborated with Dutch scientists, sharing with Christiaan Huygens (1629–95) the credit for inventing the pendulum clock. He was also one of the co-founders of the Royal Society, and had a wide mercantile network across northern Europe from Ireland to Bremen, of which he was 'a merchant citizen'. Sir William Bruce (1625/30–1710), his cousin (and also cousin to the Earl of Ailesbury), lived in Rotterdam in the 1650s, returning after the Restoration to become Scotland's major late seventeenth-century architect, with a glittering career which included becoming Lyon King of Arms in 1675 and a Privy Counsellor in 1682. Bruce was responsible for the restored and extended Palace of Holyroodhouse in 1671–9, which itself was redolent of then-recent Dutch buildings, including Maastricht Town Hall, and for Thirlestane (for Lauderdale), Craigiehall (for Annandale) and Hopetoun House, among other buildings. He was a friend of James Sutherland, the intendant of the Edinburgh Botanic Garden, itself in part influenced by the horticultural developments in the Netherlands, which had already led to the infamous 1637 tulip mania, and Sibbald dedicated some of his work to Bruce. John Hay (1626–97), 1st Marquis of Tweeddale, appointed Bruce, and also patronised a range of Flemish and Dutch artists whose connectivity to his patronage may owe more than a little to the Scoto-Dutch links of Bruce. Bruce was painted by John Michael Wright (1617–94), the King's Painter, who had been apprenticed in Edinburgh to the Scottish portraitist George Jamesone in 1636, and was subsequently in Italy before working for Charles II. Bruce used Dutch artists on Holyrood, commissioned Dutch carvers at Kinross House (Peter Paul Boyse and Cornelius Vanerven), and may have recommended Jacob de Wet (c. 1610–c. 1690), whom he also worked with, to James as Duke of Albany. De Wet 'migrated from the Netherlands upon the invitation of Sir William Bruce' in 1673, and was employed as a court painter by Charles II before being contracted to paint the sequence of 110 Scottish royal portraits

Figure 11 Holyrood following Bruce's alterations, drawn by Paul Sandby, c. 1750 (detail). By courtesy of the National Galleries of Scotland. D 2654.

at Holyrood on 26 February 1684, a task for which he was paid £240 and supervised by John Drummond (1649–1714), son to the Earl of Perth.[22]

The link between the network of Edinburgh art dealing, painting and commissioning and the nobility was a close one; but it was also close to the Stuart royal family. To take only one key event and point of contact, James, Duke of Albany and the future James VII, was shipwrecked with John Hope of Hopetoun (1650–82) and Sir James Dick of Prestonfield (c. 1644–1728) in the *Gloucester* off Yarmouth on 6 May 1682. Hope drowned, but the link between James and Sir James Dick intensified, and Hope's wife, Lady Margaret, commissioned Bruce to design Hopetoun, while Prestonfield (formerly Priestfield) House, built at almost the same time by Bruce for Dick, shares many of its features. Dick had supported some of the cleaning up of the Hie Gait financially, and was a known urban improver, while the Hope family were early industrialists who owned the Leadhills mines managed by Allan Ramsay's father. Later, his grandson, Allan junior, was to paint the Earl of Hopetoun. Such connexions are suggestive. Lady Margaret Hope herself worked actively with Bruce on the commission for the house, and 'the Amsterdam painter, Philip Tideman' (1657–1705) was commissioned to provide thirty-seven canvases to decorate Hopetoun in 1703. The Hope family collection at Hopetoun reflects other

strong links between Scottish and Dutch visual culture: from Jan Wyck's *Greenwich and Whitehall* to Albert Cuyp's *Landscape with Cattle* and Philip Wouverman's *Courtyard Scene*, the main state rooms at Hopetoun and the cupola representing the apotheosis of the Hope family all bear witness to Scottish art's Dutch and Flemish connexions. There is an Antwerp tapestry, *The Cherry Seller*, in the west wainscot bedchamber.[23]

The case of John Drummond (1675–1742), son of George, 5th Drummond of Blair-Drummond, seems not to have been an untypical example of Scoto-Dutch exchange which stretched across the nobility into a merchant career. Drummond went to Amsterdam in 1693 to develop a mercantile career, returning to the British Isles in 1702 as Robert Harley's agent, and eventually utilising his contacts to become a Director of the English East India Company in 1722. However, while Drummond might be viewed as an early example of a Scot who made the successful transition from European to imperial commercial interests, he also kept his earlier contacts alive, becoming a commissioner at Antwerp in 1731. He extended patronage to and via Lord Provost Drummond and Sir John Clerk of Penicuik, secured the Edinburgh merchant John Halliburton (a member of the Jacobite Lodge in Rome) a writership in Madras, and sat at the hub of both older Scottish and newer British patronage networks until almost the end of his life.[24]

There were many citizens of other states and subjects of other monarchies in Edinburgh, where they often received extensive support from the Scots. The Huguenot community had been coming to the capital since the late sixteenth century, when they were 'central to the brilliant court culture of James VI'. The extensive interests Edinburgh merchants had in northern French markets via Dieppe, Rouen and the erstwhile Protestant stronghold of La Rochelle also played their part, while Scottish merchants also 'dominated in Bordeaux'. The historically privileged position of Scottish nationality in France meant that in the seventeenth century Scots in France 'continued to receive equality of treatment with French subjects in terms of inheritance', with no need to undergo formal naturalisation. To an extent, the process was a mutual one. A 'French congregation' was established in Lady Yester's Kirk in the Scottish capital, where there had been a precursor Huguenot congregation and charitable donations for French Protestants as far back as 1607. As part of their integration into the capital, French artists seem to have

been obliged to take on Scottish apprentices, with 'the Lord Provost . . . assisting in the production of a Scottish talent pool'. Local tradesmen such as David Le Marchand, Nicolas Heude or Hardie (d. 1703), the gilders Henry and Michael Hue or Huie, the jeweller Louis Justie, the clockmaker Paul Roumieu (an elder in the French congregation at Lady Yester's) and the japanners Jacques Hue and Luresset developed the range of skilled trades available, benefiting from the patronage of Edinburgh's disproportionate number of wealthy and noble individuals, including Clerk of Penicuik and possibly James Hamilton of Bangour, who had ten japanned armchairs in his 'house-hold plenishing' at his death in 1706. Heude came to Scotland from London under the patronage of Queensberry in 1682 and was employed in Drumlanrig. In 1694–5, Nicholas Dupin and Denis (De) Manes set up two mills near Edinburgh as part of 'the Scots White Paper Manufactory'. In 1690, the Huguenot minister had an annual salary of S£800 granted to him by the Scottish Parliament 'out of the new imposition on wines'. His countrymen and women were also supported by more humble natives of the city: in April 1693, William Mitchell the baker 'decreed that on his death one storey of his tenement in Forrester's Wynd be made over to the French Church "for the use of the poor"'. Invariably 'improvers or innovators', these refugees were strong contributors to the economic well-being of the Scottish capital. As Sir Robert Sibbald put it in 1696, they had brought 'severall manufactures . . . which we had not befor'. An 'Act for the Naturalization of several Foreigners' (including Sir John Medina, merchants, a confectioner, a watchmaker, a painter and a musician) was passed before the Union in 1707, leading all those named to be 'hereby Naturalized as native born subjects of the Kingdome of Scotland'.[25]

Professions: The Kirk

In the years after 1661, when the Episcopal Church had been established in Scotland, attacks on Episcopalian clergy were widespread. In Edinburgh, a 'tumult of local women' threatened Edinburgh Episcopalians in 1674. Episcopalian clergy were beaten in East Lothian by irate Presbyterians in 1668, while in 1674, Presbyterian worshippers fired on Scottish government troops in West Lothian. In 1679, Presbyterians threatened to

murder the Lord Provost of Edinburgh 'unless he promised to cease suppressing conventicles' and the Archbishop of St Andrews, James Sharp, was of course killed in the same year in front of his daughter by Presbyterian fanatics, as part of an escalating series of reprisals for the introduction of the 1670 Clanking Act against conventicles, and the attempt to make all religious observance conform to state requirements. Such a view was intolerable to many, as it smacked of too much influence by a moderate and even Popish laity in the godly affairs of the Kirk. Presbyterians who resisted such interference with fanatical force found themselves sent to the West Indies and American colonies.[26]

The Revolution of 1688–9 led to the destruction of the established Episcopal government in Scotland and its replacement by Presbyterianism. From the 1660s, moderate Presbyterians prepared to engage with the state had been tolerated by the Episcopalian administration, but initially no such reciprocal toleration was offered when Presbyterianism was re-established in 1690. Commissions for Visitation (based on their 1640 Covenanter predecessors) were set up north and south of the Tay, with the aim of expelling Episcopalian clergy from their livings, a task which was often carried out with a degree of brutality and relish over many years. The language the Presbyterian Kirk used was often more ameliorative than this reality. As Jeffrey Stephen puts it:

> The church consistently expressed its readiness to acquiesce in [King] William's policy of incorporating Episcopalians into the Church. However, it regarded William's terms and conditions for admission as unsatisfactory.

And so the Episcopalians mostly stayed out, although there was 'concessionary legislation' in the 1690s allowing some to return, while in 1703 there was an attempt at 'allowing toleration of Episcopalian clergy and congregations' by the Earl of Strathmore, with the Earl of Cromartie's support. The measure was opposed by Argyle and the Earl of Marchmont. In Pitcairne's view, 'in Scottish political and religious life toleration of any kind was an impossible dream'. Many years later, Hume's opinion that 'monotheism is naturally associated with intolerance' may have been influenced by, if it did not derive directly from, the Scotland of his childhood.[27]

There were thirty ministerial charges in the Presbytery of Edinburgh itself, though one, Campvere, was in the Netherlands, and already occupied by a Presbyterian at the time of the Revolution: there were a number of extreme Presbyterians, no doubt embittered by exile, among the Scottish expatriate community in the Low Countries. Three of the livings in Scotland were vacant at the time of Presbyterian restoration: one, the Tolbooth Kirk, was held by the Town Council's own nominated Presbyterian, Thomas Wilkie, appointed in 1687. The other twenty-five clergy were all deprived to make way for Presbyterians. In the countryside, Episcopalians survived rather longer, Archibald Muir only being deposed in 1719 for offences including stating that 'the king [George I] had no more right to his crown than had the moorcock'.[28]

Presbyterian ministers drew significantly more equal stipends than their Anglican equivalents south of the Border, but nonetheless lay patronage remained a sore issue, increasingly so after 1730 when lay patrons began to assert their rights with increasing vigour.[29] Patronage disputes centred on the rights of lay heritors to present clergy to livings, which was seen by many Presbyterians as a violation of Andrew Melville's 'Twa kingdoms' rule, with its implication of the separation of Church and State. There were three basic models for the process leading to the presentation of ministers to livings in Scottish Presbyterian thought: these were popular election (posited by John Knox, and a position which was close to Congregationalism); election by elders ratified by heads of households (Andrew Melville's view); and election by heritors and elders, which was the Parliamentary approach of 1689–90. Lay patronage, though favoured for its conservatism and reinforcement of the values of order and moderation, violated all of these approaches, though election by heritors was liable to morph into lay patronage by stealth through the creation of shadow superiorities or 'parchment barons' by landowners wishing to create a class of technical heritors who would support their interests.[30]

A number of extreme Presbyterians, who refused to accept a settlement which provided for allegiance to a monarch who had not signed the Solemn League and Covenant, stood apart from the newly established Presbyterian Kirk, and there were two further secessions in our period, both relating to the patronage question. The first 'Secession of the Associate Presbytery', as it was called, came in 1733 in opposition to lay patronage. The

second division came in 1747 from within the seceder community over whether or not to take the oath necessary to becoming a burgess in Edinburgh, Glasgow or Perth, which, as we have seen at the opening of this chapter, was a significant route into (lay) patronage. The Anti-Burghers thought that taking the oath might 'imply approval of the establishment in the Church of Scotland', which, being already Seceders, they could not accept. They therefore 'set up the General Associate Synod and claimed to be the authentic continuation of the Seceder body'. Small wonder that a more Moderate, latitudinarian Presbyterianism should gain ground in Enlightenment Edinburgh in the face of such activity as this, although the Seceders had a number of strongholds across Scotland which indeed gained in strength rather than weakened as time advanced, with thirty-six congregations in 1740 and ninety-nine by 1760.[31]

Presbyterianism of one kind or another remained dominant in Edinburgh, although substantial bodies of Episcopalians survived: as elsewhere, they were usually Jacobites. Alexander Rose (1646–1720), the deprived Episcopalian bishop of the capital, continued to live in the Canongate and function as de facto first bishop (Primus) among the Episcopalians, setting up a continuing congregation at Old St Paul's.[32] Although far more circumspect than the governments of her Stuart predecessors, Queen Anne's administration displayed sympathy with the Scottish Episcopalians, a sentiment only circumscribed by their continuing adherence to Jacobitism. For their part, the Episcopalians did all they could to confuse themselves with the Church of England in Anglican minds. The case brought by the Presbytery of Edinburgh against James Greenshields, who was 'encouraged to set up services using the English liturgy in a private house ... in Edinburgh,' was defended by the Episcopalians by their claiming that the (increasing numbers) of Anglican Englishmen in Scotland 'were neither free nor safe to worship after the manner of their national church'. This resonated with its target English audience, and Greenshields won his appeal to the Lords on 1 March 1711. As Jeffrey Stephen remarks, 'key to winning his case was his identification with the Church of England'. It was the Union it largely opposed that gave the Episcopalian Church an opportunity to improve its position under Anne.[33] The Scottish Toleration Act of 1712 'officially broke the Kirk's monopoly on legal religious patronage' and the resulting 'first public appearance of Edinburgh's Episcopal

clergy in surplices in October 1712' provoked fury. Of greater long-term consequence was the move towards Anglican practices in presentations to church livings. The Patronage Act of 1712 restored lay patronage in the Presbyterian Kirk to landowners from a mixture of Presbyterian heritors and Kirk elders. When it began to be enforced systematically by Ilay and by a wider range of landowners it began to have significant impact, culminating in the 1733 secession.[34]

In 1716, there were still thirty Episcopalian clergy in Edinburgh, but on 10 July 1719, a month after the defeat of another Jacobite Rising at Glen Shiel, proceedings began against a number of them, with an appearance in front of magistrates in 1720. Among those cited were William Abercrombie, David Lawrie, Andrew Cant, David Rankin, James Hart, Jasper Kellie, Dean of Dunblane in Hyndford's Close, and Adam Peacock. Andrew Lumsden and David Freebairn (later an Episcopalian bishop) in Bailie Fyfe's Close were also cited, and Thomas Mowbray and George Young were imprisoned in the Tolbooth for six months and their meeting houses closed.[35]

In Leith, Robert Forbes, later Bishop of Caithness and author of *The Lyon in Mourning*, was central to the Episcopal ministry, and indeed to disaffection in the capital, being arrested for Jacobitism on 7 September 1745, barely a week before the city fell to the Jacobite army. Forbes baptised at least one baby with the name of 'Jacobina' in Leith on 2 July 1740; Restalrig too was a Jacobite stronghold. There were just over a hundred Easter communicants in the Episcopalian congregation at Leith, and typically (for example in 1738) 40–50 baptisms a year. Forbes played a significant role in the development of the Scottish Communion Office in 1764, and was a Usager, that is, supportive of the reintroduction of a number of Catholic practices to Episcopal worship. Such was the sectarianism of the day that he re-baptised Presbyterians on occasion.[36]

A greater concentration of moderate opinion in Edinburgh may have led to somewhat greater lenity to Episcopalians than was the case elsewhere. Indeed, 'the Fund for relief of Indigent Episcopal Clergy', of which the Jacobite Sir Stuart Thriepland became Praeses on 2 November 1756, was very much part of the social life of the capital, meeting on a regular basis at the Exchange Coffee House and elsewhere in the city. As early as 1710–11, the Catholic thinker Sir Robert Sibbald had led support for the relief of the Episcopal clergy. But although

these were notably sympathetic figures, there was a broader lack of engagement, with sectarian squabbling among the wider professional, cosmopolitan and wealthy society of the capital. An argument between a Presbyterian and an Episcopalian minister over the 'divine right of episcopacy' in (probably) an Edinburgh bookshop on 9 June 1703 ended not, as might have been expected, with bystanders taking sides, but by a view from other customers that this 'was not a Business to be debated in a Shop'.[37]

Methodists were active in Edinburgh from 1751, but made little headway, and the first Baptist Church did not appear until 1765. Very few Catholics were in residence in the capital, despite the short-lived attempt to promote 'Catholic literature and *objets de pieté*' through Edinburgh's booksellers under James VII. This was largely an elite venture: in 1703, there were only about forty Catholics in the Canongate.[38] It was also a resented intrusion, and offending pious accessories were a target for attack: on 15 March 1704, a range of sacred Catholic objects were ordered to be burnt at the Cross. The capital remained important for Catholics, however, and was made a mission city by the Church, served by the Vicar Apostolic of the Scottish mission or his co-adjutor.[39] Following the Union, there was a move in 1708 to unite the Catholic Church north and south of the Border, but the Scots Colleges abroad and others successfully resisted this, and as a consequence the Catholic Church in Scotland remains independent today. Permission was granted to David Brown, a Jew, to live and trade in Edinburgh in 1691, and Moses Moscas became a burgess in 1698, so there was clearly at least a small Jewish community in the Scottish capital.[40]

From the 1690s, the Presbyterian Kirk of Scotland dominated many other aspects of professional and social association in Edinburgh, in a manner difficult to appreciate today. The Tron Kirk was popular with the 'nobility': in 1726, Lord Minto's pew there had a rental value of S£26 and Charles Areskine, the Solicitor-General's, S£18. Seats were sought after and changed hands among a restricted elite. In 1689, Lord Cardross rented Queensberry's seat, the marquis having moved out of the parish; in 1694, the Countess of Argyle took over the Countess Dowager of Mar's seat in the Tron; in 1703, the Earl of Glasgow took over the Earl of Marchmont's; the next year, the Earl of Eglintoune assumed a place in the room of the

Earl of Buchan. Occasionally, 'mix and match' arrangements were reached: on 8 May 1695, Lord Belhaven was to occupy Lady Castlehaven's pew 'upon condition that Lady Castlehaven and her grandchildren shall be accommodated in said seat when they come to church'. More 'up and coming' advocates tended to worship at the New Kirk.[41] This socially gradated Presbyterianism was very marked in the capital, and was part of its historic compromise with a more moderate outlook, with its implied or explicit acceptance of secular hierarchies.

From the 1690s, the Scottish Parliament incorporated 'the Kirk by law established' more and more into the heart of the nation. In 1693, the Act for Settling the Quiet and Peace of the Church gave presbyteries censorial control over schoolmasters, while the 1696 Act for the Settling of Schools gave the Kirk ministers a position of oversight with regard to the educational system. The benefits of lay engagement were also seen in the 1696 arrangements, as heritors could support and pass on 'half of their tax burden for the school stipend' of 100–200 merks for the schoolmaster to their tenants. In essentials, this legislation of the Scottish Parliament remained the 'legal basis of parochial education until 1872'. The engagement of the Kirk in the governance of secular society made it hard indeed to avoid lay patronage as the necessary quid pro quo of clerical social power, even though many Presbyterians did not see it that way. The age of the Covenant and the Kirk as a self-proclaimed national defender against Stuart crown policy was gone: now the Kirk was the establishment.[42]

The growth of Moderatism in the Kirk was an important feature of life in Edinburgh, for ultimately Moderatism had a strong connexion with political and social power, and thus with the capital. It was noteworthy that the term 'Moderate', although not applied to a party in the Kirk as such before John Witherspoon used it to describe a distinct group in 1753, first appeared with application to those of a 'polite, ecumenical outlook' in the seventeenth century.[43] Despite the relative unwillingness of some scholars to take the Moderate party back before the age of Witherspoon, it has been argued that William Carstares (1649–1715), Principal of the University of Edinburgh from 1703 and four times Moderator of the General Assembly from 1705, was 'the first of the Moderates'. His biographer, Esther Mijers, concurs with that view. Of Covenanting stock, Carstares was a student at Utrecht in 1669 and in exile in

Leiden in the 1680s. He worked as a Huguenot spymaster before returning to Scotland as Chaplain to King William, to whom he was close. Carstares – a supporter of patronage, though he later changed his mind – was nicknamed 'Cardinal Carstares' in Scotland: as the figure who associated restored Presbyterianism with state power (while holding out against William's desire for a settlement including Episcopalians), Carstares represented the kind of Erastian Presbyterianism so distrusted by traditional 'true believers'. As such, he was most arguably a Moderate.[44]

This first generation of Moderatism was tolerant towards 'defeated opponents', and this gradually shifted towards the 'absence of dogmatism' as the dominant party in the Kirk began 'first to control, and then to displace those who inherited the strong convictions of Covenanting days'. Scottish church historians have identified the Moderates as the dominant party in the General Assembly of the 1720s. One of the leading exemplars of this group was William Hamilton (1669–1732), a man of Covenanter stock, Minister of Cramond, then from 1709 Professor of Divinity at Edinburgh, becoming Principal in 1730. In 1712, Hamilton became Moderator of the General Assembly, an office he was to hold on four subsequent occasions. His students 'numbered two hundred . . . among them was the future Professor Leechman as well as most of those who later were counted Moderates'. Many Rankenian Club members were also students of Hamilton, while Hamilton's son held the suspiciously un-Calvinist office of Dean of the Order of the Thistle; Robert, his grandson, was President of the Royal College of Physicians of Edinburgh, and the philosopher William Hamilton was a great grandson. Robert Wodrow (1679–1734), guardian of seventeenth-century Presbyterian memory, first christened Hamilton's students 'New Lights', a term later widely used of theologically liberal Presbyterians. Wodrow thought that Hamilton had abandoned Calvinism without clearly stating the new position he had adopted.[45]

Evangelical revival made less of an impact in Scotland than in England, as there was no direct equivalent to the secularising Latitudinarianism of the career clergy of the south whose livings were becoming increasingly comfortable as a result of rising rentals. But the missions of George Whitefield and the Marrow episode (the Marrowmen were supporters of a form of antinomianism that may have underlain the characterisation of Gil-Martin in James Hogg's *Private Memoirs and Confessions*

of a Justified Sinner) were often sceptically treated by moderate Presbyterians like Allan Ramsay, whose characterisation of the 'canting' Marrowmen and 'George Whitefield the Strolling Preacher' demonstrate no great enthusiasm for their uncompromising revivalism. Ramsay sent a satirical Marrowman ballad, *The Right Reverend Robin Ralpho*, to his friend Sir John Clerk. This group, and their core text, *The Marrow of Modern Divinity* (1718), were seen as an example of the kind of threat from which lay patronage could protect the Kirk.[46]

Whitefield was invited to Scotland in 1741–2 by the Seceders, but his insistence on preaching to other groups led this righteous fragment to denounce him as 'doing the work of Satan'. Be that as it may, Cambuslang was among the beneficiaries. William McCulloch and George Whitefield's preaching there in 1742 became known as the so-called 'Cambuslang wark', where 'intense emotional experiences of divine grace were central', and it made a huge impact on many, particularly in the West of Scotland. The 'wark' faced attacks on two fronts, however. William Robertson was unsurprisingly a sceptic, and the Moderate values of 'an enlightened, tolerant Scottish kirk serving as a bulwark of virtue and stability' in the face of evangelical enthusiasm, even when expressed with more catholic sympathies, gained ground steadily in the Edinburgh of the 1750s. It arguably remained the case, however, as Nicholas Phillipson has pointed out, that 'neither the moderate nor the orthodox Presbyterian communities succeeded in rebuilding the *theological* foundations of Scottish Presbyterianism'. As a result, Moderatism was as much a compromise with the diminishing standing of the Kirk as a restatement of its values. For the Kirk was less and less a saving remnant and more, as we have seen from the careers of Moderators like Carstares and Hamilton, an institution governed by, from and through other professions, whether the University or 'the predominance of Edinburgh lawyers among the ruling elders who were commissioners at the Assembly'.[47]

Richard Sher, whose work I discussed in the last chapter, rightly implies that the increasing convergence of churchmanship and the professions in the persons of the Moderate literati represented a new phase in the development of the Enlightenment in which the portrait by Sir Joshua Reynolds of William Robertson 'with clerical gown, writing materials, and powdered wig' is 'symbolic of the Moderates' commitment to religion, learning,

and politeness'. Long interested in Presbyterian order in preference to the rights of dissent, the Moderates came to envisage a 'polite' clergy whose virtues would be aligned with those of civility and rational enquiry. With figures such as Hugh Blair, Alexander Carlyle, John Home and William Robertson among its ministers, and George Drummond, Gilbert Elliott and Andrew Pringle among its laity, operating together in a strongly associational and, to some, 'deplorably incestuous' network, its ration of force to space as a movement ensured its final victory in the capital. By the time of the Douglas controversy of 1756, the 'narrow, intolerant, scholastic, theocratic style of Scottish Presbyterianism' which Allan Ramsay and many others had battled against, was on its way out, in Edinburgh at least. The first phase of the Enlightenment, the process whereby the Scottish capital arrived at the stage of formal Moderatism and the rise of the Select Society, has been the subject of this book. Central to it is the association, hybridisation and fusion of the professions with each other, a process which intensified the networking and cross-cutting generation of ideas that provided the infrastructure of the Enlightenment Moderates. The Kirk was central to this: it no longer stood apart.[48]

The University

Through their own existence and strength, the professions sustained many of the networks through which patronage successfully emplaced itself. Historians such as Roger Emerson have argued that figures like Archibald Campbell (1682–1761), Earl of Ilay (from 1743, Duke of Argyll), largely in control of patronage in Scotland for all but five years between 1725 and 1761, 'altered the social outlook of the country' by the preferences he displayed (not least to Leiden alumni, being one himself) in allocating the thousands of jobs which depended on him. Even patronage that did not flow directly through Ilay – for example, that of the Town Council over the University of Edinburgh – was influenced by the Argyle family, though the Town Council's often relatively reactionary Presbyterianism probably rendered the University unduly conservative in certain areas, especially after it had been purged in what its former Principal, Alexander Munro, described as a *Presbyterian Inquisition*, in an anonymous pamphlet of that title, published in 1691. The *Commission*

for Visiting Universities Colledges & Schools, set up on 4 July 1690, had over sixty members: its chair the Duke of Hamilton and two of its leading nobles, the earls of Crawford and Argyle, had all been 'in exile in the Netherlands in the 1680s'. The aim of the Commission was to root out

> ... persons they find to be erroneous, scandalous negligent insufficient or disaffected to their Majesties government and who shal not subscryve the said confessione of faithe and swear and subscryve the said oath of all alledgeance ...

This offered the Commissioners a wide remit, which they took some advantage of. The 'core of the Edinburgh committee' of the Commission was Gilbert Rule (1629–1701), a 'strict Presbyterian', who promptly replaced Alexander Munro as Principal of the then 'largely Jacobite' University with himself. Pitcairne and Sibbald were among those who resigned from the University before they were expelled. Perhaps because the 'Episcopalian intellectual establishment' used 'Dutch textbooks', the Commission of Visitation, despite their own experience of exile in the Netherlands, attacked some aspects of Dutch higher education practice in the early 1690s. If this was their motive, it was another sign of their 'Presbyterian zeal'.[49]

The reclamation of a largely Jacobite-leaning University of Edinburgh for Presbyterian orthodoxy was only gradually reversed to a degree by processes of patronage. Its more immediate effect was to increase the importance of the professions vis-à-vis the University in the creation and sustenance of intellectual networks, but it also, although intermittently, opened the way for a more moderate Presbyterian approach which enabled Edinburgh to have ambitions beyond those of the other universities in Scotland – to be indeed a 'national academy' on the model of Leiden. Once again, the extent of cultural cosmopolitanism in Edinburgh supported change. Just as Dutch influence was shared by Episcopalian and Presbyterian alike, so a moderate way forward on Dutch-influenced lines was found by the immensely powerful William Carstares, educated at Edinburgh, Utrecht and Leiden, who succeeded Rule as Principal of the University in 1703. At the time of this preferment, Carstares had long been King William's effective political manager in Scotland.[50]

Carstares was thus irreproachably Williamite, but at the same time a 'religious moderate' who favoured 'moderation

and toleration', who 'sought to emulate the example of the Dutch universities, and of Leiden in particular, in Scotland'. He became increasingly influential in higher education circles. Indeed, his brother-in-law became Principal of Glasgow, where there was an unsuccessful effort to develop a more specialised teaching system before 1700. Taking advantage of controversies over curriculum change following the disruption caused by the Visitation Commission, during the 1690s Carstares became an advocate of appointing Dutch professors to Scottish chairs. Although he never succeeded in gaining the cosmopolitan stamp he wished to put on Edinburgh's professoriate, his advocacy of specialised appointments as Principal and his ending of the old generalist Regent system from 1708 opened the University to Continental practice and paved the way for the closer future integration of the professions into Scottish higher education. A Dutch educational background became a major advantage in gaining employment at the University. Carstares' 'Consideration and proposals for Encouraging of parents in sending their sons to the University of Edinburgh' was, together with the plan to introduce student facilities such as riding and fencing, a deliberate effort to attract English students to study in the Scottish capital.[51]

A Mathematics chair had been created at Edinburgh as early as 1674, and one for Ecclesiastical History in 1702.[52] After Carstares became Principal, the pace quickened. Three chairs of Law were established by 1722; Moral Philosophy and Logic & Metaphysics both gained chairs from 1708, followed by universal History in 1719 and Botany (a suitable tribute to Edinburgh's civic innovation in this field) in 1738. The disciplinary specialisation which the Enlightenment was in the end to create and which in its turn undermined the possibility of the unified fields of enquiry that supported that Enlightenment, was well under way by the end of our period.[53]

Once the University had begun to engage with the College of Physicians and a professional degree in Medicine had been set up from the 1720s, it was remarkably successful and a pioneer of internationalism: only 21 per cent of Edinburgh medical graduates from 1726 to 1799 were Scots, a smaller proportion than the percentage of Irish students. Glasgow was also successful in the international field. Indeed, it is a surprising fact, as David Allan has pointed out, that the universities of Scotland were as successful at internationalising in the eighteenth century

as they are today. As they internationalised, however, the flow of Scottish students to the Netherlands began to dry up, and by 1760–70 a new phase was beginning where Scots abroad were sending their sons to Scotland for higher education, rather than Scots in Scotland sending them to the Netherlands.[54]

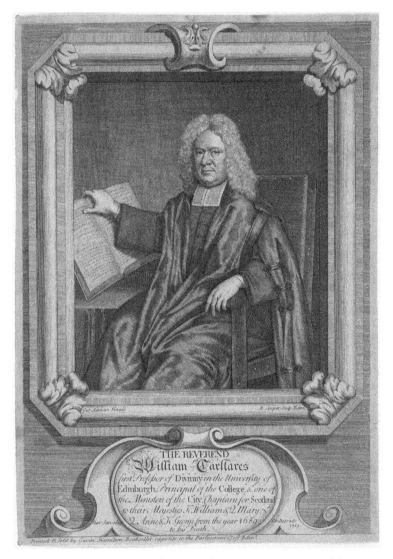

Figure 12 *William Carstares* by Richard Cooper. By courtesy of the National Galleries of Scotland. SP II 17:1.

Carstares had enlisted both the Town Council and the Secretary of State in support of his reforms, but after his death (which coincided with the Rising of 1715) there was a Presbyterian reaction as elements of the Town Council sought to regain influence over the University as a domestic, civic and Presbyterian institution rather than as a cosmopolitan and international one. Nonetheless, court and Ilay nominees prevailed over Town Council ones for the top job on many occasions. William Wishart (1660–1729), Principal of Edinburgh from 1715 following his election by a Council packed by Ilay, was six times Moderator of the General Assembly. Three of the next four Principals were Ilay's men, though they became of a yet more moderate tendency after Wishart: for example, John Gowdie (1682–1762), Principal from 1753, had opposed the Marrowmen in the 1720s. Noble patronage helped to ease the University's transition to being the intellectual powerhouse it has become by the mid-eighteenth century, though Town Council influence could be argued to have held it back in our period.[55]

Law and Medicine

Patronage also existed across professions as well as from lay sources, for example, in the control that the Faculty of Advocates gained over the History chair in Edinburgh in the 1720s: indeed, 'one of the springboards' to patronage 'was the existence of a dominant legal profession in Scotland'. Even for medical chairs, 'a candidate's politics and his connections were always of interest'.[56] Members of the professions in Scotland could themselves belong to the class that exercised patronage, of course, not least among the Advocates themselves. The Faculty had taken a decisive role in Edinburgh University in 1710, with one of their number, James Craig, becoming the inaugural appointment to the chair of Civil Law and beginning the 'regular institution or system of lectures' in 'the sciences of the Roman law, and the municipal law of Scotland', the first in the country. This chair itself followed the creation of the Regius Chair of Public Law in 1707. Barely thirty years after the major codification of Scots Law by Viscount Stair in 1681, it had entered the professional curriculum of the capital's university – though it was George Mackenzie's *Institutes*, not Stair's, that was the primary teaching text.[57]

The early occupants of the Regius Chair of Law bore out both the cosmopolitan nature of the law in Scotland and the strong crossover between the nobility and the professions evident there: indeed, that crossover was itself in large part the reason why Edinburgh and the other Scottish universities became 'schools of professional training', in contrast to the much less vocational higher education offered by Oxford and Cambridge. Useful learning was a core element in the practice of Scotland's elites long before it became the moniker of the Royal Society of Edinburgh and the University of Strathclyde. Charles Areskine (Regius Chair 1707–34) studied in Leiden, serving as Solicitor General then Lord Advocate of Scotland, before reaching the bench as Lord Tinwald: he was a member of both the Musical and Philosophical societies; William Kirkpatrick (1734–5), also educated at Leiden, was the younger brother of Sir Thomas Kirkpatrick of Closeburn, whose family included the cousin of Robert the Bruce; George Abercromby (1735–59), educated at Groningen and Leiden, was the son of Mary Duff of Braco, of the Earl of Fife's family. This connectivity with elites was reflected in the wider Faculty too: 'between 1690 and 1730 sons of peers and baronets constituted between 27 and 35 per cent of all intrants' to the Faculty of Advocates, while 40 per cent of advocates between 1660 and 1750 were educated in the Netherlands.[58]

Among the professions, the social standing of physicians was high, while surgeons enjoyed a standing closer to physicians than was the case in England. In the 1690s, there were some thirty-three physicians and twenty-three surgeons in Edinburgh.[59] The College of Physicians (of whom all its initial Fellowship had 'gained their medical qualifications outside Scotland') passed the Great Seal 'upon the 29th of November, 1681, being St Andrew's Day [sic]',[60] six years after the opening of the first 'bedlam', the predecessor of the mental hospital, in the city. The College's establishment as a self-consciously 'metropolitan' medical college for Scotland was significant in marrying the narrative of patriotism to that of improvement. Here we can see the hand of its founder, Sir Robert Sibbald, who brought an old royal warrant of James VI enabling the development of such a College to the attention of his grandson, James as Duke of Albany. Having 'founded a medical- *virtuoso* club' in 1679–80, Sibbald then made contact with James through his physician, Sir Charles Scarborough. Sibbald showed him the 'warrand of

James the Sixt . . . King [sic] James . . . said with much satisfaction, he knew his grandfather's hand, and he would see our byseness done'. The Surgeon-Apothecaries and their allies in the University, burgh and guilds opposed the College, but were overruled by the Scottish Privy Council, acting in the interests of the Crown.[61]

The local relatively conservative (and usually Presbyterian) forces continued to struggle against innovatory change for another sixty years and more, perhaps gaining in power for a brief time after the abolition of the Privy Council in 1708 in the aftermath of the Union. In this case innovation, in support of Sibbald's proposal to establish the College, came about through the pressure exerted by the Duke and the Privy Council; in 1682, Sibbald was created 'Physician to the King and Geographer Royal'. Sibbald began the endowment of the College of Physicians' library and later (1698, 1701) went on to champion the development of a Royal Society of Scotland, as well as (in his 1683 prospectus for a Scottish Atlas) planning a vast two-volume study of Scotia Antiqua and Scotia Moderna, the latter volume of which would have in some respects anticipated Sinclair's *Statistical Account* of more than a century later; Sibbald also took a leading role in annotating John Slezer's *Theatrum Scotiae*. The Scotia project remained incomplete, however, and Sibbald's own career took a major downturn after a mob forced him to flee Edinburgh in the wake of his conversion to Catholicism in 1686. Though he returned, things were never the same for him again.[62]

From 1684 to 1695, the leading Episcopalian Jacobite, Archibald Pitcairne (1652–1713, formerly Professor at Leiden) was Secretary to the College of Physicians, which had premises and a library on Fountain Close on the south side of the High Street from 1704, the year before it began examining MDs of the University. Pitcairne was another 'proto-Enlightenment man' whose politics have tended to exclude him from consideration as an Enlightenment figure proper. He himself was evidence of the lack of barriers between the professional aristocracy and the nobility, his daughter marrying the 5th Earl of Kellie in 1731. When the University of Edinburgh came to appoint its first Professor of Anatomy in 1722, he too had studied at Leiden. Indeed, of the seventy Fellows of the College of Physicians between 1681 and 1725, thirty-six had spent some time at Leiden, and thirty-one were graduates of Rheims.

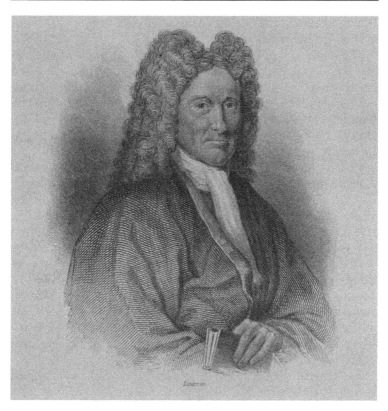

Figure 13 *Sir Robert Sibbald* by William Home Lizars. By courtesy of the National Galleries of Scotland. SP III 51:1.

While Rheims was influential, twenty-nine of its thirty-one graduates in the College had themselves previously studied at Leiden, which between 1681 and 1730 educated far more Scots than the smallest of the Scottish universities (King's College, Aberdeen). Leiden was in effect Scotland's sixth university, being so influential on the professions in Scotland that it can be said to have changed the culture of Edinburgh. There were 361 Scottish medical students alone at Leiden between 1681 and 1730; just under half of the original Fellowship of the Royal College of Physicians of Edinburgh were Leiden graduates, as were the first three professors of Medicine at the University of Edinburgh. One of the small canals at Leiden was in fact called *Schottendyke*, 'the result of many Scottish students going there to study merchant trading and commerce as well as medicine'.

When Leiden introduced bedside medical training in 1714, Edinburgh followed by 1721.[63]

The initial committee of the Royal College of Physicians had met at Sibbald's lodgings, so the administration of the College had been both social and professional, involving closely linked figures: not only Sibbald, but also Thomas Burnet (1638–1704), Andrew Balfour (1630–94) and Archibald Stevenson (1630–1710), later Pitcairne's father-in-law. Burnet was son to Robert, Lord Crimond, and brother of the baronet Sir Alexander Burnett of Leys and of the celebrated Anglican bishop Gilbert. Balfour was likewise brother to a baronet and was sometime governor to the Earl of Rochester. As ever, the professional leadership of the capital was deeply intertwined with Scotland's noble elite.

Within Edinburgh itself, the medical profession's adoption of a wider professional and associational culture seems to have been every bit as strong as that of the law. Two years after the Edinburgh Hospital for the Sick Poor was set up in 1729 (it became the Royal Infirmary in 1736), the Edinburgh Medical Society was established to publish case notes and 'to disseminate medical knowledge and facilitate clinical and scientific discussion'. During the period 1732–44, the Medical Society produced the *Edinburgh Medical Essays* 'in six volumes'. In 1737, it was superseded by the Philosophical Society, which 'remained predominantly a medical society throughout its existence' until it merged into the new Royal Society of Edinburgh in 1783. Professional rivalry between the Physicians and Surgeons was also ameliorated by the establishment of an association specifically intended to 'cement the friendship' between these branches of medicine, while after 1760 no fewer than six medical clubs and societies were set up in Edinburgh. The associational realm crystallised common endeavour and helped to make the rapidly developing medical profession increasingly powerful, integrated, modernised and state-of-the-art.[64]

Schools

The teaching profession was also undergoing rapid development. While heavily dominated by the Presbyterian establishment, especially in the parish schools (private foundations such as Heriot's Hospital had, by contrast, Episcopalian links), the profession was innovative in a number of areas. There had been

a teacher of French in Edinburgh as early as 1574. Geography began to be taught as a separate subject from 1715 (one thinks of the internationalism displayed by the Scottish press in the period), while innovation in other areas included the teaching of English via 'the collation of extracts', a method first introduced in 1737 by the Edinburgh schoolmaster John Warden, and one whose tendency to establish the new metropolitan English of polite usage in Edinburgh helped to support the development of elocution in the capital, a process that began in the 1720s (see Chapter 4) and was in place in 1748, some time before Sheridan's more famous classes in the capital.[65]

The Merchant Maidens' Hospital was set up in 1694 by Mary Erskine's mortification of 10,000 merks specifically to be 'a hospital for female children', 'for Maintaining and Educating poor young Children of the female Sex'. Scottish parliamentary legislation protected it: the 'Act in favour of the Maiden Hospitall founded by the Company of Merchants of Edinburgh & Mary Erskine' of 1707 gave it rights to land free 'of all publick burdens' and the power 'to purchase & acquire Lands

Figure 14 Heriot's Hospital, now George Heriot's School, still a monument to seventeenth-century architecture in Edinburgh. Author's image.

Tenements' and other property. It was the scions of the nobility and wealthy professionals and merchants who set up these schools (although the Trades Maiden school of 1704 also benefited from Erskine's support), beginning with Heriot's, modelled on Christ's Hospital. Erskine herself was a cousin of the Earl of Mar, while the eponymous founder of George Watson's College in 1723 was himself the treasurer of Mary Erskine's Trust and the accountant of the Bank of Scotland, as well as having interests in woollen manufacturing, shipping, bookselling, merchant banking and property. The Edinburgh Merchant Company schools were the products of the same group of people with the same outlook as we have found earlier in this study: an outward-looking cosmopolitan elite with strong links to the old Scotland. In the same decade as Mary Erskine's was founded, 'French, Italian, fencing and dancing schools appeared in Edinburgh' to provide a market for the surplus income of the 'landowning and professional classes'. Interestingly, the Merchant Maidens' Hospital would only employ men as teachers 'if a suitably proficient woman could not be obtained'. Education could also be cosmopolitan: in 1734, 'book-keeping' began to be taught in Edinburgh, together with elementary business studies, by a merchant returned from Rotterdam.[66] Even the orphanages of the city saw the children fed to a reasonable standard: in 1739–40, the children of Dean Orphanage had 1,930 calories a day, with some 15 per cent being meat, fish or dairy products.[67]

Schools were also agencies for the social inclusion so key to adult clubs, professions and associations: pupils of the middling ranks in society might sit in school 'between a youth of ducal family and the son of a poor cobbler': indeed, the Marquis of Tweeddale attended the High School in Edinburgh as late as the 1760s. The first charity school in Edinburgh 'opened in 1699'. The Burgh authorities in Scotland were often suspicious of private schools, and teaching in their own schools was quite strongly regulated from the 1720s.[68]

Specialised schooling nonetheless developed very rapidly in the Scottish capital. Forbes and Bernard's school in Niddry's Wynd (later in Bull's Land 'over against the Tron church') taught French, Latin and Italian, and a fuller French-medium curriculum, in the 1740s and 1750s. John Gibson 'taught ladies to paint on silk' and also to carry out 'japanning' and 'shell-flower work'; Cornforth Gilson, Precentor to the New Kirk, was 'appointed by the Town Council to teach Church music',

while Mrs Ainslie kept a domestic science day school for girls in College Wynd, with a boarding house in Marlin's Wynd. Dancing masters were frequently French, and this could extend into cookery. Mr Hautbois taught 'cookery and pastry' in the Canongate before becoming cook to the Duke of Albemarle; while the apparently more local Mrs Wilkie was 'Keeper of a Pastry School' in Marlin's Wynd. Some of these teachers were pioneers (Thomas Braidwood taught the deaf and dumb from the 1760s); some, such as Stephen Demainbray, who kept a boarding school for girls in Bishop's Land and was 'later Tutor to the Prince of Wales and Astronomer at Kew', were individuals distinguished for their scholarship.[69]

One has only to examine the interaction between the trades, merchants and professions evident above and in educational foundations such as Heriot's, Mary Erskine's and Watson's to understand that the cosmopolitan nature of the Edinburgh trades and the capital's merchants, combined with the cosmopolitan nature of higher education and its related professions, fed directly into a range of leading international provision and innovative practice. The sweet spot when the Edinburgh nobility and senior professionals bolstered the reputation and status of a capital still tied strongly to Continental trade and education, not only laid the foundations for, but itself provided, the smart city of Edinburgh's Enlightenment. Enough of the inheritance of political power and its accumulation of financial and social capital in a context of international horizons remained after 1707 to support continuing development of the mediation of systematised technologies and professional practices into the realm of systematisation of ideas. The legacy of Scotland's royalist capital was not played out.

Notes

1. James Colston, *The Incorporated Trades of Edinburgh* (Edinburgh: Colston & Co., 1891), 7, 65; Sir James D. Marwick, *Edinburgh Guilds and Crafts* (Edinburgh: Scottish Burgh Records Society, 1909), 176, 196–7.
2. R. A. Houston, *Social Change in the Age of Enlightenment: Edinburgh, 1660–1760* (Oxford: Clarendon Press, 1994), 31; R. A. Houston, in S. J. Connolly, R. A. Houston and R. J. Morris (eds), *Conflict, Identity and Economic Development: Ireland and*

Scotland, 1600–1939 (Preston: Carnegie Publishing, 1995), 50; Marwick (1909), ibid.
3. Anne MacLeod, *From an Antique Land* (Edinburgh: John Donald, 2012), 17; James E. Fraser, *From Caledonia to Pictland: Scotland to 795* (Edinburgh: Edinburgh University Press, 2014 [2009]); Peter Jones, 'The Polite Academy and the Presbyterians, 1720–1770', in John Dwyer, Roger A. Mason and Alexander Murdoch (eds), *New Perspectives on the Politics and Culture of Early Modern Scotland* (Edinburgh: John Donald, n.d. [1983]), 156–78 (173); Edinburgh City Archives SL 35/1/37 (Stent Rolls July 1711–1712).
4. Mark Greengrass, *Christendom Destroyed: Europe 1517–1648* (London: Penguin, 2015 [2014]), 32.
5. *The Scots Courant*, 10–13 November 1710; 24–26 September 1711, and 1710–11 passim; RS RH 15/176/2,3, 5 (Mitchell Papers); Joe Rock, 'Robert Gordon, goldsmith and Richard Cooper, engraver: A glimpse into a Scottish atelier of the eighteenth century', *Silver Studies* (2005), 49–63 (50); NRS GD 29/432/4-5 (Bruce of Kinross Muniments).
6. National Records of Scotland RH 15/32/7.
7. *The Edinburgh Courant*, 10–12 May 1708; *The Edinburgh Flying Post*, 22–25 March 1709; *The Scots Post-Man or the New Edinburgh Gazette*, 3–5 June, 24–26 June 1712; Houston, in S. J. Connolly, R. A. Houston and R. J. Morris (eds), *Conflict, Identity and Economic Development: Ireland and Scotland, 1600–1939* (Preston: Carnegie Publishing, 1995), 59–60; NRS GD 1/1401/1/29-35; HMC Stuart II: 233.
8. Helen Smailes, 'David Le Marchand's Scottish patrons' (unpublished paper, 1996), 6; T. C. Smout, *Scottish Trade on the Eve of Union 1600–1707* (Edinburgh and London: Oliver & Boyd, 1963), 172.
9. *The Caledonian Mercury*, 4 January, 28 February, 13 April 1725, 13 January 1735; *The Thistle*, 20 November 1734, 23 July 1735; T. C. Smout, 'Scottish-Dutch Contact 1600–1800', in Julia Lloyd Williams, *Dutch Art and Scotland: A Reflection of Taste* (Edinburgh: National Gallery of Scotland, 1992), 21–32 (24); Priscilla Minay, 'Eighteenth and Early Nineteenth Century Edinburgh Seedsmen and Nurserymen', *BOEC* ns 1 (1991), 7–27 (8, 16, 18); NRS RH 15/32/7/32; 15/32/9, 10 (Clephane Papers).
10. *The Edinburgh Gazette*, 20–23 March 1699 No. 7; 12–15 June 1699 No. 32; 3–6 July 1699 No. 38; 11–15 April 1700 No. 119; *The Scots Courant*, 11–13 July 1711 No. 910.
11. Archibald Pitcairne, *The Latin Poems*, ed. John and Winifred MacQueen (Arizona Centre for Medieval and Renaissance Studies: Royal Van Gorcum, 2009), 28; Charles W. J. Withers,

Geography, Science and National Identity: Scotland since 1520 (Cambridge: Cambridge University Press, 2001), 84.

12. *The Caledonian Mercury*, 25 November 1736; 27 May, 11 July 1751; *The Edinburgh Gazette*, 1–4 May 1699 No. 20; 9–13 November 1699 No. 75; Jeremy Black, *Eighteenth-Century Britain 1688–1783*, 2nd edn (Basingstoke: Palgrave Macmillan, 2008 [2001]), 78; Helen Armet, 'Notes on Rebuilding Edinburgh in the Last Quarter of the Seventeenth Century', *BOEC* XXIX (1956), 111–42 (131-2); *An Inventory of the Ancient and Historical Monuments of the City of Edinburgh with the Thirteenth Report of the Commission* (Edinburgh: Royal Commission on the Ancient Monuments of Scotland/HMSO, 1951), lxix, 75; NRS RH 15/32/7/2. Ramsay himself was involved in producing casts in bas relief of coins and gems at this date (Margaret M. Smith et al., *Index of English Literary Manuscripts* Vol. III (London: Mansell, 1992), 187).

13. See Edinburgh University Library Laing MS IV.24.5.17; David Ormrod, 'The Art Trade and its Urban Context: England and the Netherlands Compared, 1550–1750', in Jeremy Warren and Adriana Turpin (eds), *Auctions, Agents and Dealers: The Mechanism of the Art Market 1660–1830* (Oxford: Beazley Archive/Wallace Collection, 2007), 11–19 (18). For Charles II's support for foreign settlers in Scotland, see HMC 72, *Report on the Laing Manuscripts Preserved in the University of Edinburgh*, 2 vols (London: HMSO, 1914), I:376.

14. John Purser and David McGuinness, *The Georgian Concert Society Programme Notes 28 March 1998*; Fern Insh, 'An Aspirational Era? Examining and Defining Scottish Visual Culture 1620–1707', unpublished PhD (University of Aberdeen, 2014), 152, 164, 181, 188; Peter Blom, *Scots Girn about Grits, Gruel and Greens: Four Centuries of Scots Life in Veere*, tr. James Allan (Veere: Stichting-Veere-Schotland, 2008 [2003]), 15.

15. Henie Louw (2009), 'Dutch Influence on British Architecture in the Late-Stuart Period, c. 1660–c. 1714', *Dutch Crossing* 33:2 (2009), 83–120 (88, 92); Smout (1963), 18, 196; Richard L. Greaves, 'Conformity and Security in Scotland and Ireland, 1660–85', in Elizabethanne Boran and Crawford Gribben (eds), *Enforcing Reformation in Ireland and Scotland, 1550–1700* (Aldershot: Ashgate, 2006), 228–50 (231); Vanessa Habib, 'William Cheape of the Canongate, an Eighteenth-Century Linen Manufacturer', in *BOEC* ns 5 (2002), 1–12 (2); Allan Macinnes, in Esther Mijers and David Onnekirk (eds), *Redefining William III: The Impact of the King-Stadtholder in International Context* (Aldershot: Ashgate, 2007), 205; Esther Mijers, 'News from the Republick of Letters': Scottish Students, Charles Mackie and the United

Provinces, 1650–1750 (Leiden and Boston: Brill, 2012), 2; Claire Tomalin, *Samuel Pepys: The Unequalled Self* (London: Penguin, 2003 [2002]), 180. I am indebted also to Esther Mijers' unpublished paper at the 2nd World Congress of Scottish Literatures in Vancouver on 22 June 2017: 'After Rotterdam: The Internal Dialogue of Scottish Diaspora Returnees'.

16. Adriaan van der Willigen and Fred G. Meijer, *A Dictionary of Dutch and Flemish Still-life Painters Working in Oils, 1525–1725* (Leiden: Primavera Press, 2003), 82, 99–100; T. M. Devine, *To the Ends of the Earth: Scotland's Global Diaspora* (London: Allen Lane, 2011), 26; Warren McDougall, 'Gavin Hamilton, John Balfour and Patrick Neill: a Study of publishing in Edinburgh in the 18th century', unpublished PhD (Edinburgh, 1975), 33; David Ormrod, in Jeremy Warren and Adriana Turpin (eds), *Auctions, Agents and Dealers: The Mechanism of the Art Market 1660–1830* (Oxford: Beazley Archive/Wallace Collection, 2007), 17; Thomas M. Bayer and John R. Page, *The Development of the Art Market in England: Money as Muse, 1730–1960* (London and New York: Routledge, 2016 [2011]), 17–18; John Davidson and Alexander Gray, *The Scottish Staple at Veere: A Study in the Economic History of Scotland* (London: Longmans, Green & Co., 1909), 13–14, 137, 211, 253, 262–3, 268; J. Lloyd Williams, 'The import of art: the trade for northern European goods in Scotland in the seventeenth century', in Juliette Roding and Lex Heerman Van Voss (eds), *The North Sea and Culture (1550–1800)* (Hilversum: Verloren, 1996), 298–323 (302); Smout, in Williams (1992), 21–32 (21, 22); Mijers (2012), 29, 49, 59; Friends of Dundee City Archives: http://www.fcda.org.uk/veere/veere_13pdf.

17. *The Edinburgh Courant*, 25–28 July 1707 No. 298; *The Edinburgh Flying Post*, 1–3 March 1709, No. 50.

18. Alan Cameron, *Bank of Scotland 1695–1995: A Very Singular Institution* (Edinburgh and London: Mainstream, 1995), 18–19; Richard Savile, *Bank of Scotland: A History 1695–1995* (Edinburgh: Edinburgh University Press, 1996), 6, 10; *The Scots Post-Man, or The New Edinburgh Gazette*, 28–30 June 1709 for the Bank of Scotland roup; Feenstra (1986), 130; Smout, in Williams (1992), 27–8.

19. Alexander Broadie, 'Introduction: Seventeenth-Century Scottish Philosophers and their Universities', in Broadie (ed.), *History of Universities* XXIX/2 (2016), 1–12 (6); Marie-Claude Tucker, 'Scottish Masters in Huguenot Academies', idem, 42–68 (65–6); Andrew McKillop, '"As Hewers of Wood and Drawers of Water": Scotland as an Emigrant Nation, c. 1600 to c. 1800', in Angela McCarthy and John M. Mackenzie (eds), *Global Migrations: The*

Scottish Diaspora Since 1600 (Edinburgh: Edinburgh University Press, 2016), 23–45 (29).
20. Dimitry Fedosov, *The Caledonian Connection: Scotland-Russia Ties: Middle Ages to early Twentieth Century* (Aberdeen: Centre for Scottish Studies, 1996), 75; *BR 1701 to 1718*, xxi.
21. D. D. Aldridge, 'The Lauderdales and the Dutch', in Juliette Roding and Lex Heerma van Vos (eds), *The North Sea and Culture (1550–1800)* (Verloren: Hilversum, 1996), 286–97 (287, 291).
22. Sara Stevenson and Duncan Thomson with John Dick, *John Michael Wright: The King's Painter* (Edinburgh: SNPG, 1982), 11, 40, 66; Ailsa Hutton, 'Re-Viewing history: antiquaries, the graphic arts and Scotland's lost geographies, c. 1660–1820' (unpublished PhD, University of Glasgow, 2016), 36, 42–8; Charles Wemyss, 'Merchant and Citizen of Rotterdam: The Early Career of Sir William Bruce', *Architectural Heritage XVI* (2005), 14–30 (20); Konrad Ottenheym, 'Dutch Influences in William Bruce's Architecture', *Scotia-Europa interactions in the late Renaissance, Architectural Heritage* XVIII (2007), 135–49 (135, 138–9); N. H. Walker, *Kinross House and its Associations* (published privately, 1990), 29; John Lowrey, 'The Influence of the Netherlands on Early Classicism and the Formal Garden in Scotland', *Scottish Society for Art History Journal* Vol. 1 (1996), 21–34 (24); Insh (2014), 55, 63–4, 124; EUL Laing MSS La.IV.24.8 ff. 195–8. I am indebted to Clarisse Godard Desmarest for additional research on Bruce in her unpublished paper, 'Educating the Heir to a Scottish Estate in the late 17th Century', 2nd World Congress of Scottish Literatures, Vancouver, 22 June 2017.
23. Basil Skinner, 'Philip Tideman and the Decoration of Hopetoun House', *Scottish Society for Art History Journal* Vol. 1 (1996), 11–19 (11, 12).
24. George McGilvary, *East India Patronage and the British State: The Scottish Elite and Politics in the Eighteenth Century* (London and New York: Tauris, 2008), 1, 2, 5, 56–7, 65; John Ingamells, *A Dictionary of British and Irish Travellers in Italy 1701–1800* (New Haven and London: Yale University Press, 1997), 445.
25. David Dobson, *Huguenot and Scots Links 1575–1775* (Baltimore: Clearfield, 2005), 54; *Proceedings of the Huguenot Society of London* Vol. 19 (1952–8), 220; D. E. Easson, 'French Protestants in Edinburgh (1), *PHSL* 18 (1947–52), 325–44 (329, 330); Bruce Lenman, *Enlightenment and Change: Scotland 1746-1832*, The New History of Scotland, 2nd edn (Edinburgh: Edinburgh University Press, 2009 [1981]), 251; Smailes, 'David Le Marchand's Scottish patrons' (1996), 1, 3, 4, 5, 7, 8; see also Siobhan Talbott, *Conflict, Commerce and Franco-Scottish Relations, 1560–1713*

(London: Pickering & Chatto, 2014), 29, 146; *The Acts of the Parliaments of Scotland XI* [1707], 484–5/90; Insh (2014), 192; Francis Bamford, 'Some Edinburgh Furniture-Makers', *BOEC* XXXII (1966), 32–53 (39, 41). NRS GD18/4592/3 (Aikman correspondence); NRS CC 8/12/5 (Commissary Court Warrants of Inventories).

26. Richard L. Greaves, 'Conformity and Security in Scotland and Ireland, 1660–85', in Elizabethanne Boran and Crawford Gribben (eds), *Enforcing Reformation in Ireland and Scotland, 1550–1700* (Aldershot: Ashgate, 2006), 228–50 (232, 233, 244, 248); Alexander Raffe, *The Culture of Controversy: Religious Arguments in Scotland* (Woodbridge: The Boydell Press, 2012), 214.
27. Archibald Pitcairne, *The Latin Poems*, ed. John and Winifred MacQueen (Arizona Centre for Medieval and Renaissance Studies: Royal Van Gorcum, 2009), 19; Pitcairne, *The Phanaticks*, ed. John MacQueen (Edinburgh: Scottish Text Society, 2012), xiv, xix, 104; Jeffrey Stephen, 'Defending the Revolution: The Church of Scotland and the Scottish Parliament, 1689–93', *Scottish Historical Review* LXXXIX:1 (2010), 19–53 (23); Ian Whyte, 'Ministers and Society in Scotland 1500–c. 1800', in Colin MacLean and Kenneth Veitch (eds), *Religion* (Scottish Life and Society: A Compendium of Scottish Ethnology 12), general editor Alexander Fenton (East Linton: Tuckwell Press, 2006), 433–51 (441); Alexander Broadie, *The Scottish Enlightenment* (Edinburgh: Birlinn, 2001), 125. For earlier visitations, see Steven J. Reid, '"Ane Uniformitie in Doctrine and good Order": The Scottish Universities in the Age of the Covenant, 1638–1649', in Broadie (ed.), *History of Universities* (2016), 13–41 (26).
28. Andrew Drummond and James Bulloch, *The Scottish Church 1688–1843: The Age of the Moderates* (Edinburgh: Saint Andrew Press, 1973), 6; Esther Mijers, 'After Rotterdam'.
29. Whyte, in MacLean and Veitch (2006), 439; Andrew Drummond and James Bulloch, *The Scottish Church 1688–1843: The Age of the Moderates* (Edinburgh: Saint Andrew Press, 1973), 56.
30. Richard B. Sher, *Church and University in the Scottish Enlightenment* (Princeton: Princeton University Press, 1985), 48.
31. Henry R. Sefton, 'Presbyterianism', in MacLean and Veitch (2006), 127–42 (133); Andrew Herron, *Kirk by Divine Right* (Edinburgh: Saint Andrew Press, 1985), 19, 72–3; Drummond and Bulloch (1973), 51.
32. Ann Shukman, *Bishops and Covenanters: Religion and the Church in Scotland 1688–1691* (Edinburgh: Birlinn, 2012), 108–9.
33. Jeffrey Stephen, *Defending the Revolution: The Church of Scotland 1689–1716* (Farnham: Ashgate, 2013), 168–71, 180, 182.

34. Daniel Szechi, *1715* (New Haven: Yale University Press, 2006), 68; Sher, (1985), 24, 47, 68.
35. Daniel Szechi, 'Retrieving Captain Le Cocq's Plunder: Plebeian Scots and the Aftermath of the 1715 Rebellion', in Paul Monod, Murray Pittock and Daniel Szechi (eds), *Loyalty and Identity: Jacobites at Home and Abroad* (Basingstoke: Palgrave Macmillan, 2010), 98–119 (107); Edinburgh City Archives Moses Bundle VII 198/7138.
36. Angus Macintyre (ed), *Registers of the Episcopal Congregation in Leith* (Edinburgh: J. Skinner & Co., 1949), 4–6, 23.
37. NLS Adv MS 16.2.1 f.9; Raffe (2012), 26.
38. NLS MS 3813 f. 6; Peter F. Anson, *Underground Catholicism in Scotland 1622–1878* (Montrose: Standard Press, 1970), 82.
39. BR 1701–1718, 69; Clotilde Prunier, *Anti-Catholic Strategies in Eighteenth-Century Scotland* (Frankfurt: Peter Lang, 2004), 29, 40.
40. John R. Watts, 'Roman Catholics in Scotland: Late Sixteenth to Eighteenth Centuries', in MacLean and Veitch (2006), 143–69; also in the same volume, James A. Whyte, 'Other Christian Groups', 235–55; Kenneth Collins, 'The Jews in Scotland', 256–80; Tom McInally, *The Sixth Scottish University: The Scots Colleges Abroad: 1575 to 1799* (Leiden and Boston: Brill, 2012), 164.
41. Michael Graham, *The Blasphemies of Thomas Aikenhead* (Edinburgh: Edinburgh University Press, 2013 [2008]), 16; John Finlay, *The Community of the College of Justice: Edinburgh and the Court of Session, 1607–1808* (Edinburgh: Edinburgh University Press, 2014 [2012]), 42–3, 45; Revd D. Butler, *The Tron Kirk of Edinburgh* (Edinburgh and London: Oliphant, Anderson & Ferrier, 1906), 227, 229, 231, 237, 238.
42. Alexander Law, *Education in Edinburgh in the Eighteenth Century* (London: University of London Press, 1965), 15; Donald J. Withrington, 'Church and State in Scottish Education Before 1872', in Heather Holmes (ed.), *Institutions of Scotland: Education* (Scottish Life and Society: A Compendium of Scottish Ethnology 11), general editor Alexander Fenton (East Linton: Tuckwell Press, 2000), 47–64 (52); R. D. Anderson, *Scottish Education Since the Reformation* (Dundee: Economic and Social History Society of Scotland, 1997), 5.
43. Thomas Ahnert, *The Moral Culture of the Scottish Enlightenment 1690–1805* (New Haven and London: Yale University Press, 2014), 66–7.
44. Drummond and Bulloch (1973), 21–3, 37; Mijers, 'After Rotterdam'.
45. Drummond and Bulloch (1973), 21–3, 37.

46. Ramsay, *Works*, III: 244, 250; NRS GD 18/4341; Sher (1985), 49.
47. Sher (1985), 31, 35; Elspeth Jajdelska, '"Singing of Psalms of which I could never get enough": Labouring Class Religion and Poetry in the Cambuslang Revival of 1741', *Studies in Scottish Literature* 41 (2015), 88–103 (90); Nicholas Phillipson, 'Foreword', in Jean-François Dunyach and Ann Thomson (eds), *The Enlightenment in Scotland: national and international perspectives* (Oxford: Voltaire Foundation, 2015), xiii–xv (xiv); Drummond and Bulloch (1973), 36, 51–2; John R. McIntosh, *Church and Theology in Enlightenment Scotland: The Popular Party, 1740–1800*, Scottish Historical Review Monographs (East Linton: Tuckwell Press, 1998), 11.
48. Sher (1985), xi, 50–7, 73; David Allan, 'The Universities and the Scottish Enlightenment', in Robert Anderson, Mark Freeman and Lindsay Paterson (eds), *The Edinburgh History of Education in Scotland* (Edinburgh: Edinburgh University Press, 2015), 97–113 (107). The Reynolds portrait of Robertson is in the National Galleries of Scotland.
49. Roger L. Emerson, *Academic Patronage in the Scottish Enlightenment* (Edinburgh: Edinburgh University Press, 2008), 7, 9–10, 212, 231, 233–5; Esther Mijers, 'The Netherlands, William Carstares, and the Reform of Edinburgh University, 1690–1715', *History of Universities* XXV/2 (2011), 111–42 (115–17).
50. Mijers (2011), 111, 113, 121, 124.
51. Mijers (2011), 111, 115, 125, 128, 130, 131–3.
52. Alexander Law, *Education in Edinburgh in the Eighteenth Century* (London: University of London Press, 1965), 22–3; Roger Emerson, 'The Contexts of the Scottish Enlightenment', in Alexander Broadie (ed.), *The Cambridge Companion to the Scottish Enlightenment* (Cambridge: Cambridge University Press, 2003), 9–30 (19); Jones, 'The Polite Academy and the Presbyterians, 1720–1770', in Dwyer, Mason and Murdoch ([1983]), 157.
53. James Scotland, *The History of Scottish Education*, 2 vols (London: University of London Press Ltd, 1969), I:141.
54. Pitcairne (2012), xxxiii; Morrice McCrae, *Physicians and Society* (Edinburgh: John Donald, 2007), 89; Gerard O'Brien, 'Scotland, Ireland, and the antithesis of Enlightenment', in Connolly, Houston and Morris (1995), 125–34 (133); Allan, in Robert Anderson, Mark Freeman and Lindsay Paterson (eds), *The Edinburgh History of Education in Scotland* (Edinburgh: Edinburgh University Press, 2015), 101, 110; Jones, in Dwyer, Mason and Murdoch ([1983]), 156; Mijers (2012), 193.
55. John Finlay, *The Community of the College of Justice: Edinburgh and the Court of Session, 1687–1808* (Edinburgh: Edinburgh

University Press, 2014 [2012]), 98; Allan, in Anderson, Freeman and Paterson (2015), 98; R. K. Hannay, 'The Visitation of the College of Edinburgh in 1690', *BOEC* VIII (1916), 79–100 (79); Mijers (2012), 115.
56. George McGilvary, *East India Patronage and the British State* (London and New York: Tauris, 2008), 203; Emerson (2008), 257, 273.
57. Alexander Fraser Tytler, *Memoirs of the Life and Writings of the Honourable Henry Home of Kames*, ed. John Valdimir Price, 2 vols (London: Routledge/Thoemmes, 1993), 11; John Cairns, *Enlightenment, Legal Education, and Critique* (Edinburgh: Edinburgh University Press, 2015), 40–1.
58. Cairns (2015), 87–95; Nicholas Phillipson, 'Lawyers, Landowners, and the Civic Leadership of post-Union Scotland', *The Juridical Review* (1976), 97–120; R. D. Anderson, *Scottish Education Since the Reformation* (Dundee: Economic and Social History Society of Scotland, 1997), 16; Smout, in Williams (1992), 29.
59. Helen Dingwall, *Physicians, Surgeons and Apothecaries: Medical Practice in Seventeenth-Century Edinburgh* (East Linton: Tuckwell Press, 1995), 1; Leah Leneman and Rosalind Mitchison, *Sin in the City: Sexuality and Social Control in Urban Scotland, 1660–1780* (Edinburgh: Scottish Cultural Press, 1998), 9.
60. *The Autobiography of Sir Robert Sibbald* (Edinburgh and London, 1833), 31; Helen Dingwall et al., *Scottish Medicine: An Illustrated History* (Edinburgh: Birlinn, 2011), 53.
61. Sibbald (1833), 30; A. D. C. Simpson, 'Sir Robert Sibbald – The Founder of the College', The Stanley Davidson Lecture, *Proceedings of the Royal College of Physicians of Edinburgh Tercentenary Congress 1981* (Edinburgh: Royal College of Physicians, 1982), 59–91 (64–5); Clare Jackson, *Restoration Scotland, 1660–1690* (Woodbridge: The Boydell Press, 2003), 29; Withers (2001), 71.
62. Sibbald (1833), 37; Morrice McCrae, *Physicians and Society: A History of the Royal College of Physicians in Edinburgh* (Edinburgh: John Donald, 2007), 11, 27; Simpson (1982), 71; Dingwall et al. (2011), 54; Withers (2001), 71–3, 82. See Hutton (2016).
63. Dingwall (1995), 107; Dingwall et al. (2011), 41, 53; McCrae (2007), 58; Mijers (2012), 38, 41, 43.
64. Jacqueline Jenkinson, *Scottish Medical Societies 1731–1939: Their History and Records* (Edinburgh: Edinburgh University Press, 1993), 10–11, 13, 29; Emerson, in Broadie (2003), 20.
65. John Strong, *A History of Secondary Education in Scotland* (Oxford: Clarendon Press, 1909), 142; Lindy Moore, 'Urban Schooling in Seventeenth and Eighteenth-century Scotland',

in Anderson, Freeman and Paterson (2015), 79–96 (85); Law (1965), 150, 157.
66. *The Acts of the Parliaments of Scotland* XI [1702–7], 487/95; Scotland (1969), I:83, 93; Pitcairne, *The Latin Poems* (2009), 379; Law (1965), 105; Moore, in Anderson, Freeman and Paterson (2015), 89, 91; Les Howie, *George Watson's College: An Illustrated History* (Edinburgh, 2006), 1; Revd Edwin S. Towell, 'The Minutes of the Merchant Maiden Hospital', *BOEC* XXIX (1956), 1–92.
67. *BR 1689–1701*, xxvi; Finlay (2014 [2012]), 255; David D. McElroy, *A Century of Scottish Clubs 1700–1800*, Vol. I (Edinburgh, 1969), 232; A. J. S. Gibson and T. C. Smout, *Prices, food and wages in Scotland 1550–1780* (Cambridge: Cambridge University Press, 1995), 248–9; Christopher J. Berry, *The Idea of Commercial Society in the Scottish Enlightenment* (Edinburgh: Edinburgh University Press, 2015), 11; Hamish Coghill, *Lost Edinburgh* (Edinburgh: Birlinn, 2014 [2008]) 60; Alistair J. Mann, *James VII: Duke and King of Scots, 1633–1701* (Edinburgh: John Donald, 2014), 138; Christopher A. Whatley, *The Scots and the Union* (Edinburgh: Edinburgh University Press, 2006), 367; Emerson (2008), 9; John Robertson, *The Case for the Enlightenment: Scotland and Naples 1680–1760* (Cambridge: Cambridge University Press, 2005), 111–12. See also 'Exhibition celebrating 450 years of the Trades of Edinburgh', 1–31 August 2012 at the Trades Maiden Hospital.
68. Scotland (1969) I: 80; Moore, in Anderson, Freeman and Paterson (2015), 82, 88; Law (1965), 104.
69. Alexander Law, 'Teachers in Edinburgh in the Eighteenth Century', *BOEC* XXXII (1966), 108–57 (113, 117, 123, 126, 128, 129, 132, 136–8, 155).

4 The Arts

Art: Culture and Collections

The growing circulation of visual art and its widening appearance in domestic collections and public display is an important moniker of the advance of consumerism, cosmopolitanism and innovation. What once had been (and for much of the eighteenth century still remained) an international aristocratic pastime suffused itself steadily into the houses and purchases of the professional well-to-do, bringing with it variety of origin, variety of subject, and whole new genres which could inflect the manner in which indoor and outdoor environments were represented and understood as they came under the control of society's elites. Such new images could, in their turn, embed the centrality of questions of landscape, geographical conditions and human societies in the ideas of Enlightenment thinkers who moved in intellectual spheres much removed from the visual arts.

Artistic representation was thus a way both of owning through sight and of seeing through the eyes of others, both the colonising gaze and the visual mechanics of sympathy. The viewer of a painting was like Adam Smith's third-party conscience, surveying, discriminating, judging and sympathetically engaging. Sometimes the questions raised to the viewer were living and flexible, sometimes textual and symbolic. Paintings in particular genres could be ordered by lot for interior decoration: any difficulties over import duties (gradually being eased in England) could be addressed by imitations carried out by local artists,

either of particular paintings or of general styles. In 1691, Sir James Dick relied on his bailie Alexander Brand's taste in selecting paintings to furnish his stairs: Brand was himself a manufacturer of decorative leatherwork, such as Dick had brought, probably from the Netherlands or Flanders, for his previous house in 1676. Brand likewise chose Flemish or Netherlandish pictures for the new Prestonfield stairs. In 1692, Brand supplied '91¼ skines of Gold Leather' to the architect Sir William Bruce (1630–1710), some of which seem to have come from the Netherlands, in a series of bills for interior decoration which totalled £433 8s. In 1729, Sir James Rochead of Inverleith (1702–37) paid the painter William Robertson for ten paintings, at a total cost of £11 4s: these included three still lifes, a seascape and a pastoral, together with five classical paintings on love-related themes. Sir John Clerk of Penicuik ordered a *Leda and the Swan* and *Diana Bathing* from William Aikman at £3 the pair, as well as *Judith & Holofernes's Head* by Imperiali, supplied by Aikman for £4 (the total order was £35 12s). Such variety of seeing the world differently through different eyes had not been available a century earlier: it was part of the cosmopolitanisation of domestic life, whereby 'what people wear, the things they use and handle, the rooms they live in, so matter to them that they do, in some sort, turn into the people'.[1]

Dutch art, often in the shape of still life or landscapes (itself a Dutch term), was highly influential on Scottish native styles, while Dutch painting of estates or castles was a style imported into Scotland. Alexander Keirincx (1600–52) had been granted a 'royal commission by Charles I for ten landscape paintings' and painted the king's houses in Scotland (such as Falkland and Seton). Keirincx's *Ten Views* 'paved the way for the phenomenon of house portraiture much later in the century', while Charles I's own enthusiasm for 'exclusively Netherlandish' landscape painters may also have played its part in the later popularity of this style in Scotland. Jan Voorsterman and John Wyck's *Stirling Castle* (1719) and the truly remarkable range of images of the Yester estate (the Tweeddale seat) produced in 1685–90 both bear witness to this tradition. While 'naturalism was considered to be the defining characteristic of Dutch art' in this era, trompe l'oeil painting such as was practised by Cornelius Gijsbrechts or Samuel van Hoogstraten was also influential, being taken up by still-life painters in Scotland, perhaps most prominently by Thomas Warrender (d. c. 1715), who was a

Figure 15 Thomas Warrender's depiction of political conflict, party propaganda, ribbons and playing cards (party playing cards became popular in the era of the Popish Plot, 1678–81). By courtesy of the National Galleries of Scotland. NG 2404.

Guild Brother painter in Edinburgh. Warrender's 1692 *Still Life* embodies the politically divided state of Scotland in the wake of the massacre of Glencoe: its documents refer to sectarian and political division; its playing cards to the destination of the Crown as a game of chance; its blue and white ribbons to party colours. The handwritten letter to Warrender above a watch may refer not only to the passing of time, but to the Massacre of Glencoe, which took place early in that year.[2]

Dutch landscape painting can also be argued (together with the French and other influences that became more prominent in the eighteenth century) to have driven Scottish practice. Given the number of cathedrals, churches and castles already in decay through Reformation, conflict and economic decline, Scottish landscapes offered a ready-made laboratory for the picturesque, as was visible as early as the 1680s Yester paintings' focus on the ruined thirteenth-century Goblin Ha', in Yester's grounds. Sir William Bruce was a pioneer here, with his alignment of the main vista at Kinross with the ruins of Lochleven Castle. 'Dutch gardens' were also created at Craigiehall. In the aftermath of

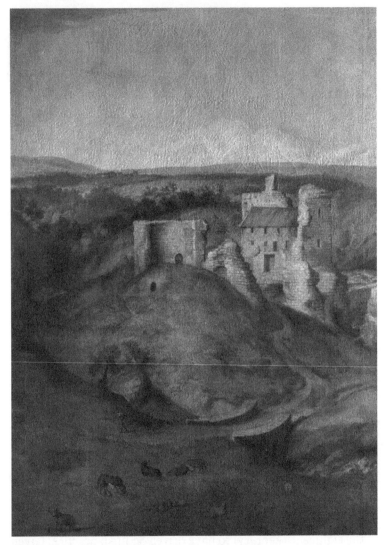

Figure 16 *The Ruined Castle of Goblin Ha'*: Scottish history as picturesque in the seventeenth century. Dutch School. By courtesy of Yester House.

the Revolution of 1688–9, William and Mary 'had no interest in building projects in Scotland', and, despite the ascent of a Dutch monarch to the throne, there was a general diminution of activity.[3]

With the Dutch artists who practised in Scotland there came elements not only of artistic but also of cultural practice. Art auctions had been known in the Netherlands from at least 1600, though one appears to have been held at Brugge as early as 1457. The Dutch market was highly developed, with paintings sold 'by book dealers, in pubs . . . by dealers in religious objects, second-hand merchandise . . . jewellers, flower dealers and frame makers'. From such a position of strength it was easy to develop, and in the early stages dominate, an export trade. Auctions appeared (initially on a fixed-price basis) in London by 1674 at the latest (1676 for books, though there had been bookselling as early as the 1630s). Edward Millington's Vendu, the first established auction house, opened in 1692. Other sales took place through coffee houses: landscapes, history painting and still life seemed to dominate the extensive Dutch offerings, as was to be the case in Scotland, where Dutch paintings frequently arrived as part of a more general cargo of luxuries.[4] In England, 92 per cent of advertised auctions between 1660 and 1699 were in London (88 per cent of the total being for books or art), but, despite the stricter control exercised by the Town Council, Edinburgh was close on the English capital's heels, with coffee-house auctions from the 1680s, earlier than the first auctions in the German states. One March 1697 auction 'At the Auction-house, over-against *Gladstone's* Land' (a socially prestigious space) was dominated by Dutch art. There is no reason to think this untypical of the capital's art market, although, interestingly, the 1702 Glasgow picture auction seems to have been much less cosmopolitan. The Gladstone's Land auction was six times the size of the early Glasgow venture, with 441 paintings for sale in all. As a 'gathered collection' auction (as opposed to a 'posthumous roup') it resembled modern practice. The instructions accompanying this auction make it clear both that many of the clients were expected to be country gentlemen and that English clients were expected, for exchange rates with sterling currency are advertised. Auction evidence suggests a significant country-house market.[5]

Country gentlemen had a great deal of wall to cover in their houses. Dick of Prestonfield's order of a job lot of Flemish or Dutch paintings in 'Lively Light colours' for Prestonfield (which had had a Dutch garden designed for it) was part of what seems to have been an established practice of using 'landscape art . . . as house decoration', also evident in the case of Scottish

EDINBURGH,

At the Auction-house, over-against Gladstones Land, in the Land-Mercat. *On* Wednesday, *being the* 3 *of* March, 1697. *will be sold by* Auction, (*or who bids most*) *a curious Collection of Pictures, of all sorts and sizes, some fit for Halls, Stair-Cases, Chambers and Closets; the Sale beginning at* 10. *and lasts till* 12. *in the Forenoon, and from* 3. *till* 5. *in the Afternoon, and so continue till all are Sold. The Pictures may be Viewed, and Catalogues had at the place of Sale.*

Conditions of Sale.

1. THat whoso bids most is the Buyer; but if any difference arise by two more claiming any Lot, then the Picture to be re-expoſed.
2. That the Buyers be pleaſed to give their Names, and places of abode, and pay down a third part of the value of what they buy, if deſired.
3. That the Buyers pay for, and take away what Pictures they ſhall buy within three days after the Sale is ended, the Buyer paying Portridge.
4. That no perſon advance leſs than Six Pence *Sterling* n any Lot expoſed to Sale.
5. That all *Scots* and *Engliſh* light Money will be taken at 5 ß. 4 d. *per* Ounce, making but one Weighing of a greater or leſſer Sum: *Engliſh* Miln'd Crowns will be taken at 5 ß. 6 d. and *Guinea's* at 24 ß. *Sterling.*

Note, That if any ſhall buy any Pictures, and deſire to have them Packed up in Caſes, to ſend them into the Countrey, they may have them ſo done by the Undertaker, they paying only for the Caſes and Charges, otherways happening.

Figure 17 Notice of Gladstone's Land auction (1697). By courtesy of the Earl of Leven and the National Records of Scotland. GD 26/13 item 271 p. 1.

artists such as James Norie (1684–1757). Norie and Roderick Chalmers (c. 1683–1746) advertised in *The Scots Courant* nine times in 1711 alone regarding their ability to supply

> all sorts of the finest mock Arras Hangings, representing Forrestry, History, Hunting, Fields &c done upon Canvas, which looks as

well as any fine Arras, and better than any mock Arras whatsomever, that comes from London or elsewhere, Painted and Sold at as easy a Rate as anywhere in North Britain, by James Norie and Roderick Chalmers above the middle of Dickson's Closs, opposite to the Bishop's Land, where all Sorts of House Paintings are likewise performed by them.

Such a practice blurred the distinction between fine art and interior decoration. As in London, sales in Edinburgh were frequently through coffee houses, and in terms of domestic art, portraiture was dominant. Auctions were advertised in the press, and viewing might be several days beforehand.[6]

Roderick Chalmers had been a Freeman of the Incorporation of Wrights and Masons of St Mary's Chapel (1475), which had come to include painters, as it incorporated 'all those who take part in securing or making beautiful an edifice'. Both Chalmers and Norie were admitted to the Wrights and Masons in 1709. Norie, who lived opposite St Mary's Chapel in St Mary's Wynd, was himself 'founder of a firm of decorative painters' with Chalmers. Some of their work was very workaday: in 1736, Norie and Chalmers were paid £36 3s 6d for 'whytning all the [New] Church & Isle and colouring the low part of the stone walls and backsides of the lofts . . . painting the outsides of the seats, stairs, passages . . . & c637 yds wainscot color in oyl'.[7] On the fine-art side of affairs, Norie was 'responsible for some of the earliest paintings of the Highland landscape': the landscape was 'a form of art then very fashionable in and about Edinburgh, more especially applied to the landscapes of private dwellings'. Norie's shop was close to Ramsay's, to whom he was personally close: he was witness at Agnes Ramsay's baptism on 10 August 1725.[8]

Dutch interiors and their portrayal in the overproducing market of Dutch painting provided a window on the imperial trade of the Netherlands, with objects brought across the globe by Dutch trade and power visibly domesticated into the footprint of a few square metres. Artworks and the art market themselves were a form of heterophilia which underpinned the generation of new ideas not only because of their range of subjects, but also due to their conjunction of the familiar and unfamiliar, the 'dizzying foreshortening of perception' which symbolised in a small space the shrinking world which was the accompaniment at home of exploration, trade and empire overseas. Moreover,

while the art market expanded it remained a marker of social status, which gave the unfamiliar approaches, representations and perspectives of which it consisted and whose development it influenced a reflected version of that status too. The 'property of strangeness' in the unfamiliar objects which betokened status offered a visible hint of the cosmopolitan experience of their owners. The fourteen 'little pictures' and ten japanned armchairs in the inventory of the advocate James Hamilton of Bangour (valued at four figures among many other inventories of significant size) in 1706 bore witness to the use in Edinburgh of techniques and images which brought the practices of the world to Scotland.[9] There are estimated to have been 'as many as 25,000 paintings hanging in Scotland at the end of the seventeenth century' as part of the articulation of both 'collecting for knowledge' and 'the establishment of status'.[10]

In 1693, the Flemish portrait painter John Medina (1659–1710) visited Edinburgh on the persuasion of the Secretary of State, the Earl of Melville, settling there permanently the following year on the invitation of Margaret, Countess of Rothes, and becoming both naturalised and the foremost portrait painter in the city (his son later restored de Wet's royal portraits, which are still extant in Holyroodhouse). Medina charged 5 guineas (£5 5s) for a small portrait, 10 guineas (£10 10s) for a large portrait, and 3 guineas for cleaning, mending and varnishing the Town Council's portrait of Queen Anne. His flat, one of the 'artists' homes spread out along High Street', had some seventy paintings in it. Medina also had close connexions with the Clerks of Penicuik, and took on Sir John Clerk's cousin, William Aikman (1682–1731), as an apprentice: Aikman later painted the 1st Earl of Hopetoun, a painting still in the dining room of that house, as well as many portraits of the Clerk family. When Medina died, his estate was worth S£14,180, well into six figures in today's money. His widow carried out a sale of paintings from their flat on the second floor of 'the first Stone Land above the Tron Church' before flitting on Whitsunday 1711. The come-on (as ever) was that the Pictures were to be 'sold cheaper than they can be had anywhere else', though since these were originals this was rather an illusory market comparator.[11]

Both paintings and, increasingly, prints were thus widely owned in Edinburgh as signs of social demarcation and success; as in London, 'painting was on its way to becoming an

Figure 18 *Self Portrait* by Sir John Baptiste de Medina. By courtesy of the National Galleries of Scotland. PG 1555.

upper-class fashion'. Italian painting became increasingly fashionable in the years following 1700, together with a generally wider range of artistic outputs, such as the '*Drawings, Statues, Busts, Bass Relieves* ... Intaglio and Italian Prints' 'collected and done' by William Mosman (1700–71) at Rome and sold by Allan Ramsay, Gavin Hamilton and Balfour on 19 February 1740. In what seems to have been an innovative move, the painter offered a guided tour of his own consignment. Mosman was himself in attendance to support the two viewings on the

16th for what was clearly an important auction, demonstrating both the growing prominence of Italian art in Scotland and the growing centrality it possessed in the careers of Scottish artists. These artists themselves were increasingly part of a hybrid Scoto-Italian cultural world, one also reflected in music and of a piece with the Scoto-Roman ethos of Scots law and public life. Unlike the English Grand Tourist, for example, Scots who went there were rather less likely to see Italy as a fallen and corrupt reminder of the fragility of greatness. This was in part because a political alternative for Scotland was based there.[12]

There was a significant crossover between the rising importance of Italy as a place of artistic training and experience and the sizeable Scottish expatriate community in the Italian states. Nearly all of these were linked in some way to the Jacobite court and its patronage networks operating from the Palazzo del Re in Rome from 1719. There was, however, already a Scottish network in Italy before the court moved there. The Aberdonian architect James Gibbs (1682–1754) was in Rome in 1703–8, while John Gordon (1644–1726), the erstwhile Episcopal Bishop of Galloway who converted to Catholicism, lived in Rome from 1702 until his death. Scottish art auctions often contained a Jacobite element reflective of the politics of the expatriate community: for example, Lots 30, 171 and 186 in the 1697 Gladstone's Land auction or Lot 59 in the 1760 Hamilton and Balfour auction.[13]

The Jacobite expatriate community and its links to Scotland lay at the heart of many of Scottish art's European networks. John Urquhart of Cromarty (1696–1756), who fought at Sheriffmuir and was a captain in the Spanish service, made contact with William Mosman in Rome, who was at that time 'working in the studio of the painter, Francesco Fernandi, better known as Imperiali', probably because Cardinal Imperiali was 'protector of the Scottish nation and a close confidant of the Stewart court'. In short, 'Imperiali' was a mild codeword for Francesco Fernandi's (1679–1740) politics and Scottish links. Fernandi (who also trained Sandy Clerk, Sir John's half-brother, William Hoare and Allan Ramsay) helped Patrick Duff (Urquhart's cousin) redevelop Culter House from 1729, while Mosman copied the Jacobite pictures Urquhart wanted to collect in the early 1730s. Urquhart himself was painted by Francesco Trevisani and commissioned Pompeo Batoni (1708–87), Imperiali's pupil. Forty-one of Urquhart's collection

of paintings (eventually sold in a Hamilton and Balfour auction at Holyrood on 10–13 January 1757, including Imperiali's *Saviour in the Garden* to Hopetoun) were exhibited at Robert Gordon's Hospital in Aberdeen in 1738, the year before Sir John Clerk of Penicuik met Urquhart.[14] William Aikman's brother John (1679–1752) was a merchant in Leghorn (Livorno), at this time a major trading port which promoted intercultural and artistic relations with Tuscany in general; the family remained in business there until 1770. Leghorn itself was an entrepôt for the Scottish community in Italy.[15]

Figure 19 *Self Portrait* by William Aikman. By courtesy of the National Galleries of Scotland. PG 309.

Scots visiting the Italian states were very likely to be drawn into the web of artistic, gentry and political association in place among their fellow countrymen there, whether sojourners or permanent exiles, as were many of those arriving in Italy after the defeat of the Jacobite Rising of 1715 from some of the most well-connected noble families in Scotland. Alexander, Lord Forbes of Pitsligo (1678–1762), colonel in 1715 and later general of horse in the Jacobite army in 1745, was in Venice, Bologna, Rome, Livorno and Genoa in 1718–20; Alexander Gordon, Marquis of Huntly (c. 1678–1728), William Livingston, 3rd Viscount Kilsyth (1650–1733), James Livingston, 5th Earl of Linlithgow (d. 1723), James Seton, 3rd Viscount Kingston (1667–1726), James Murray, 'Earl' of Dunbar (c. 1690–1770) and the 5th Earl of Traquair, the 6th Earl of Mar, the Earl of Perth and Lords Edward, John and William Drummond and the 9th Earl Marischal between them spent some fifty years in Italy. Charles Forbes of Brux was Secretary to King James, and the Edinburgh financier John Law met James in Venice more than once in the 1720s, where one of the Hamilton family was lieutenant-general in the forces of the Venetian republic, 'among a group of Jacobites come from Florence'. One of these was Andrew Hay (1690–1754), a pupil of Medina in Edinburgh, who supplied Edward Harley with pictures and subsequently became a 'portrait painter and dealer'. James Gibbs, who later did architectural work for the Harley family, acted as a courier for a consignment sent from Hay at Rome to Harley on 2 January 1716. In an age when 'being an art dealer was ... a fairly standard disguise for eighteenth-century espionage', Hay was pretty clearly 'a Jacobite agent'. He was not alone. From 1717 to 1721, the Edinburgh printer Robert Freebairn was at Rome, Urbino and Padua acting as a Jacobite courier. Like Pitsligo, Freebairn subsequently returned to Scotland.[16]

These networks continued throughout the century. In 1737, John Murray of Broughton attended the Jacobite Lodge in Rome (frequented in 1735–6 by Mosman) before returning to Scotland the following year as the main Jacobite agent in the country, and a key operational mastermind of the 1745 Rising. John Alexander (1686–1767) went to Rome to study in 1711 and was from then on under the patronage of Alexander, 5th Marquis of Huntly and 2nd Duke of Gordon (mentioned above), for whom he acquired pictures in Italy. He also helped the Marquess of Annandale to form a major art collection, and was carrying out

commissions for Mar in 1718. Through Gordon, Alexander became friends with Cosimo III de' Medici, the Grand Duke of Tuscany, who owned both Aikman and Medina's self portraits, which Gordon gifted to Cosimo in 1716. Co-founder of the Academy of St Luke (see below), Alexander had a 'partiality for Mary Queen of Scots', and painted pictures which had her as the subject (as did Medina's son, who manufactured copies of engravings of Mary). Indeed, Alexander planned 'to paint the life of Mary Stewart', saying that 'if my performance could equal my love and esteem for her glorious memory, I am confident I should equal Raphael and Titian'. King James himself allegedly received a portrait of Mary 'from St Andrews Church in Antwerp', obtained for him by Mar. This Marian flurry may have initiated the development of history painting among Scots in exile; certainly it was interesting that James Boswell's (1740–95) 1765 commission to Gavin Hamilton (1723–98) was on a related subject, *The Abdication of Mary Queen of Scots*, and that Alexander Runciman (1736–85) converted from being a decorative to a history painter in Italy, before returning to paint an Ossianic cycle in Penicuik House in 1773.[17]

John Alexander's daughter Isabella married the Jacobite painter Sir George Chalmers (c. 1720–91). John's son Cosmo Alexander (1724–72), who was named after the Grand Duke or the Duke of Gordon, shared a house in the Strada Felice in Rome with Fr Patrick Leith SJ after he and his father's flight following the Forty-five, and copied Caravaggio's *Woman teaching a Girl to Sew* for Alexander Hay of Drummelzier (1701–89), a fellow Jacobite exile. Cosmo later painted in the Netherlands, where his subjects included Adrian Hope, a Scoto-Dutch scion of the Hopetoun family. In 1754, Cosmo became more financially secure on inheriting a house from James Gibbs on the latter's death. Like Cosmo, Gibbs was an Aberdonian, and had himself been a trainee priest at Rome before meeting his lifelong patron, the Earl of Mar, in 1709, who promptly got him his first role, the surveyorship of Stirling Castle, in the same year. The sheer scale of Gibbs' Jacobite connectivity is still underestimated.

In 1767, Anne Forbes (1745–1840), the granddaughter of William Aikman, met the Jacobite exile and architect James Byres (1734–1817), a trader in antiquities, and went on to spend four years in Italy, sharing a house with Alexander Runciman and his wife: Runciman in his turn had been a pupil of James Norie, one of the co-founders of the Edinburgh Academy of

St Luke. This was a name which continued to have cultural resonance in the city, a 'St Luke's Club' 'for the Promotion and discussion of all matters connected with the fine Arts' being founded on the original academy's centenary on 26 October 1829, with thirty-eight members, including Henry Cockburn and James Nasmyth, Alexander's son and the inventor of the steam hammer. Connectivity of this kind affected later generations of Edinburgh Scots on the Continent also: for example, Patrick Moir took Sir William Forbes (1739–1806) to Abbé Waters' house in Rome to see his collection of Stuart portraits: they met Archibald Skirving (1749–1819) and others there. Such encounters could be replicated manifold: a strongly networked group of Scottish exiles or sojourners engaged in heterophile art appreciation, education and trade created an artistic, commercial and political series of dyadic and networked relationships with gentry and artists in Scotland which lasted across generations.[18]

Since the Jacobite court patronised artists and made extensive use of art for propaganda purposes, and since Edinburgh was at the heart of the development of and market for Scottish art, it was almost inevitable that a network of artists and dealers arose who operated between the Italian states and the Scottish capital. Scotland, after all, was critical to the hopes and ambitions of the Stuarts. James 'attached considerable importance to commissioning original portraits of himself and his family, to be distributed in multiple copies and engraved, to thank influential friends' and to inspire his supporters.[19] Whether 'given away as diplomatic presents' or 'engraved and sent over to England and Scotland in multiple quantities', images of the royal Stuarts were central to the initial phase of the Jacobite art trade from the early 1690s onwards. In November 1695, Norbert Roettiers was 'appointed engraver-general' to the Stuarts and personally 'smuggled several thousand . . . medals' in the latter half of the 1690s. Allan Ramsay's extensive dealing in and reproduction of (largely unidentified) medals is interesting in this context.[20]

And it was not only the royal family who were portrayed: around 1716, Pierre Parrocel painted George Keith, the Earl Marischal (c. 1692–1778), 'before a romanticised mountain setting', in a very early example of the association of mountains and liberty. The transference of the language of mountains from sacred to secular aspiration, so typical of the Revolutionary era in France, was presaged by Scottish politics in the first

half of the eighteenth century, a period which led to the presence of many 'Montagnard' Jacobite exiles in France and more widely on the Continent. It is arguable that the popularity of foreign landscape painting in Scotland from the late seventeenth century on developed a domestic taste for the representation of Scotland's own landscapes (for example, Norie's Highland landscapes) and of new ways of envisioning them. Since, as Sir Keith Thomas has pointed out, the ascription of picturesque and sublime value to landscape can be found in the late seventeenth century (William Bruce was an early innovator here), and given that the art trade itself was closely linked to the politics of Scottish patriotism after 1707, there are a number of interesting and suggestive interactions here which would repay further investigation.[21]

In 1719, Francisco Trevisiani (1656–1746) portrayed Marjorie Hay, Countess of Inverness (d. 1766), with white roses and carnations, emblems of the Stuart cause and its restoration. In 1739, Domenico Dupra (1689–1770) painted members of the 'Society of Young Gentlemen Travellers at Rome', prominent Scots associated with the Jacobite cause such as Lord John Drummond (1714–47) and Lord Elcho (1721–87), for propaganda purposes. Five of these paintings were bought by the economist and Jacobite exile Sir James Steuart of Goodtrees, Bart (1712–80). Meanwhile, not only Dupra but also painters such as Antonio David (1684–1756) and Trevisani 'owed their British commissions to the Stuart Court', and helped provide some of its propaganda in return.[22] Their market, as well as the more general Scoto-Italian art market, was supported and sustained by Scots trading, frequently as a cover for other activities: Scots virtuosi such as William Duguid FRS acted 'as a double agent in Italy while practising as a jeweller'. Other silversmiths and jewellers, like Robert Gordon (?1716–67), who operated from a shop south of the Mercat Cross 'somewhere near the head of Borthwick's Close' in Edinburgh, were possibly Jacobite 'sleepers'. Gordon had 'a distinctly Jacobite lean' and possibly intruded Jacobite symbolism in his sauceboats or milk jugs, one of which has a fish handle and lion-paw feet (the king returning from overseas).[23]

On his return to Edinburgh in 1711, Aikman painted the leading Jacobite lady, the Countess of Panmure, and his fame increased to the point where he replaced John Scougal as the burgh painter in 1717. Scougal had at one time had a lucrative

practice worth 10,000 merks (S£6,666) in his city centre studio and gallery opposite St Giles' in Advocate's Close, which was arguably the first art gallery in the British Isles. The innovation of urban Edinburgh in collecting and collections is marked in this and other contexts: it was a key product of the city's cosmopolitan links and the development of intellectual dynasties there in the first age of Enlightenment. Scougal's grandson-in-law, Andrew Bell, was to produce some of the first issues of the *Encyclopedia Britannica*.[24]

Just as Medina had introduced ideas in painting from the Netherlands, so Aikman did from Italy. Aikman had been elected to 'the Society of St Luke' in Rome, and in 1724 was steward at their annual feast. The 'Accademia da Santa Luca' had been founded as an association of Roman artists in 1577; St Luke was the patron as he was alleged to have painted the Blessed Virgin Mary. The idea had spread to the Netherlands, where there were St Luke societies in Amsterdam and elsewhere by the late sixteenth century, which had been involved in some of the earliest developments of the Dutch art market, such as the 'biannual auction sales held by the Dordrecht Guild of St Luke', although the guilds in general had a conservative attitude to sales channels.[25] Dordrecht was also a location for Scottish mercantile engagement with the Dutch art market. In England, where drawing and painting manuals were in circulation in the first quarter of the seventeenth century and early academies can be traced back to Henry Peacham at the beginning of the seventeenth century, the Virtuosi of St Luke was founded in 1689, following from earlier suggestions such as that of John Evelyn in 1662 for a 'publick academy'. This group promoted a scheme to found an English Academy towards the end of the reign of William II and III, and a 'drawing class at Christ's Hospital was established on a permanent basis' from 1705 (it had existed in some form from 1692), while 'a private academy of art in Great Queen Street' followed in 1711, opening on 18 October, being the feast day of St Luke. This idea was shortly to spread to Scotland, with the foundation of the country's first art school in 1729, to which I shall turn shortly. Although London was important, almost certainly the very rapid adoption of innovation in Edinburgh was due to its Dutch, French and, by 1720, rapidly growing Italian links. The evidence here can never be final, but it is noteworthy that provincial England was much slower to react to innovation in this sphere: a similar

development in Birmingham in 1760–2 was more to answer 'the growing demand from local industry for able designers' than for education in the fine arts, and in that sense was more akin to the 1760 Trustees Academy in Edinburgh, discussed below.[26]

The Edinburgh Academy of St Luke, Scotland's first art school, co-founded on the saint's feast day of 18 October 1729 by a number of artists and cultural entrepreneurs, was intended to create 'a public Academy whereupon every One that inclines on application . . . shal be/Admitted', once again displaying the inclusiveness of Edinburgh society. The motivation for founding the Academy may well have included acknowledgement of the signs of a growing crisis in the numbers of painters in Edinburgh in the aftermath of the Union, with nineteen registered at the guild Incorporation of Wrights and Masons of St Mary's Chapel in 1709 and seventeen by 1721, but only nine to eleven by 1727. More immediately, perhaps, it seems to have been the engraver Richard Cooper (1701–64) who acted as its key promoter, a Londoner who only arrived in Edinburgh as an adult. Notwithstanding this, it is important to note that the Academy of St Luke represented a major departure for Edinburgh, as it was aimed (unlike the Incorporation, which was a more mixed or trade body) towards international standards of fine-art practice.[27]

The co-founders of the Academy, which prized the 'Antique Models' and 'the best Masters of Foraigne Schools', included Roderick Chalmers, Ross Herald and portraitist (whose advert with Norie was discussed above). Chalmers's father, Captain Patrick Chalmers, gave his name to Chalmers Close in the city. Roderick was secretary to the Academy and the father of George Chalmers (1718–91), who was trained by Ramsay the younger and was Cosmo Alexander's brother-in-law. George was certainly a Jacobite, and so was Roderick, who 'painted the armorial escutcheons' for the funeral of the 4th Earl of Traquair in 1741 and proclaimed Charles Edward in 1745: his father had been killed at Sheriffmuir in 1715. Both Ramsays (father and, by his patronage, his son, who was only sixteen) were co-founders of the Academy. Others included William Robertson the painter whom we met above, the architect William Adam (1689–1748), Gilbert Elliot of Minto (1693–1766), who was close to Ramsay and was brother-in-law to Archibald Steuart of Mitcham (1697–1780), Lord Provost in 1745, Alexander, later 6th Earl of Galloway (c. 1694–1786) and Charles, later 5th Earl

of Traquair (c. 1694–1764). Other founders included Alexander Guthrie, the merchant Thomas Trotter (1685/6–1767), James Norie and John Alexander.[28]

William Denune, the Edinburgh portraitist, and Andrew Hay (1690–1754), the erstwhile expatriate Jacobite art dealer and now member of the London Virtuosi of St Luke, were also co-founders: Denune, who painted in the style of Aikman and Medina, had an uncle who came from Bruce of Kinross's family, and himself practised in the Canongate, where he probably painted the Jacobite ideologue Thomas Ruddiman in 1749. Like the Worthies, the Academy brought together aristocrats, shopkeepers and painters in a socially inclusive fashion. It also brought together a group with London experience (for example, Cooper, Hay) and those with Italian experience linked to the Jacobite court (for example, Alexander, Hay again, Traquair). This group all had a diversity of personal background and experience – as well as multiple dyadic links through merchant networks, politics and the Wrights and Masons incorporation – that fed the major, if in the end short-lived, innovation of the Academy of St Luke.[29]

In the 1720s, Cooper's uncle William was 'involved in the arts, as a member of . . . the first St Martin's [Lane] Academy' (founded in 1720), and Cooper may have been in attendance there before coming to Edinburgh 'shortly after' 1725. In Edinburgh, Cooper engaged in engraving work, a trade practised in the Scottish capital since the 1680s. Edinburgh was now in the early stages of the process of becoming a centre for engraving: as John Guy put it a century ago, 'no other city in the Empire outside of London can present a record in the art of engraving at all approaching that of Edinburgh'. Cooper's by no means insignificant output included 'almost all the published music in Scotland between 1728 and 1750', and he carried out a number of commissions, including painting at Traquair. In 1729, Cooper became treasurer and 'drawing master of the Edinburgh School of St Luke'. Allan Ramsay junior was a student at the school, which met initially in Mortonhall's and Thomson's Chambers, and 'occupied rooms in the University buildings between 1731 and 1733'. There seems to have been raised artistic activity in the city generally: on 1 September 1730, for example, a range of new paint colours was advertised in *The Caledonian Mercury*. Richard Cooper was later in Rome with an Edinburgh printer named Guthrie in 1735 (Cooper

either went there with him or met him there). This may have been Alexander Guthrie, the co-founder of St Luke's Academy, who may also have been the same Guthrie who was in attendance on King James in 1751. Guthrie 'persuaded' Cooper 'to resume his profession in Edinburgh', where in 1736 'Robert Strange became his apprentice . . . and was encouraged to work from prints and drawings collected by Cooper in Italy'. Cooper bought a house 'on the south side of the Canongate from John Grierson, Deputy Clerk of the Burgh' in May 1735, with a 'back' which ran 140 metres south to the Cowgate: a huge urban garden. Cooper, James Norie and Andrew Hay were all members of the Jacobite-leaning Canongate Kilwinning Lodge (discussed in more detail in the next chapter), as were four other members of the Academy of St Luke. A Jacobite enclave or cluster grew up round this house opposite Canongate Kirk. Cooper carried out painting of the Traquair coat of arms in 1738, and the Countess of Traquair (the earl was also a co-founder of the Academy, of course) subsequently rented Cooper's house in the Canongate in 1754. Cosmo, John Alexander's son, also carried out painting commissions for the Traquair family, as did Roderick Chalmers, as was noted above. Cooper's property transactions certainly cast a long shadow: James Gentle of Gentle's Close at 120 Canongate, who bought property here from Cooper, later helped Burns 'get permission to erect the tombstone over the grave of Robert Fergusson'.[30]

Robert Strange (1721–92) married Isabella, the sister of Andrew Lumisden (1720–1801), whom Dr Alexander Cunynghame (1703–85), later Sir Alexander Dick of Prestonfield, recommended to Charles Edward as his assistant secretary in 1745 when the Jacobites occupied Edinburgh (Cunynghame had himself been recommended to the prince by the Earl of Dunbar). Cunynghame (who came from a Jacobite family) had earlier been cicerone to the young Allan Ramsay on his visit to Italy and the Jacobite Court and Lodge, discussed in Chapter 5 below.

Ramsay junior studied under 'Imperiali', and was in Rome shortly after William Mosman, who had 'kept company' there with John Clerk of Penicuik's son, James (1709–82), also a co-founder of St Luke's Academy. In 1736, Ramsay painted Katherine (Kitty) Hall of Dunglass, later wife to the Jacobite William Hamilton of Bangour. William and Kitty seem to have been part of the society who frequented Ramsay the elder's house at Luckenbooths and then on Castlehill. Gavin Hamilton

in his turn painted William. Later, David Allan dedicated his preface to his 1788 illustrated edition of Ramsay's *Gentle Shepherd* to Gavin Hamilton, going on to plan a cycle of paintings of Mary, Queen of Scots. All these individuals were closely connected elements in an Italian-based network linked both to the Edinburgh art world and to the Jacobite court, though not all had Jacobite sympathies.[31]

Andrew Lumisden remained in Stuart service until 1768, becoming secretary to King James and a major artistic patron in his own right. Through his and the Jacobite court's jurisdiction over passports of admission to the Papal States, Lumisden controlled a large and effective network of contact and dependency, which he used in part to promote art and probably to identify couriers between Scotland and Italy. At Rome, Lumisden formed a close professional relationship with the painter Anton Raphael Mengs, and recommended James Byres, Edward Cunningham, Colin Morrison, George Willison and other Scottish artists to him; Lumisden also supported Cosmo Alexander and the female artists Katherine Read (1723–78), to whom he supplied 'a teacher, a patron and a cicerone', and Anne Forbes, and was at the heart of developing 'the business of performing useful introductions and arranging patronage' for 'artists of Jacobite sympathies'. Strange joined Lumisden in 1747 and was friends with the Jacobite Sir Stuart Thriepland (who studied with Strange at the *Ecole de Dessein* in Rouen) and Gavin Hamilton. George Chalmers was associated with Lumisden's group by 1750, by which time he (Chalmers) had already met Cosmo Alexander, whose sister Isabella he was to marry. Chalmers was in his turn also close to Alexander Hay of Drummelzier and the Earl of Winton, the most senior Jacobite exile to act as his patron; Winton had introduced Ramsay junior to the Jacobite Lodge in Rome.[32] Lumisden retained an interest in contemporary Scottish writing: his sister sent him James Macpherson's *Fingal* in 1763, and it may have been Lumisden who suggested to Boswell that he visit Corsica, with the support of Sir John Dick at Leghorn (Livorno), who was Cunynghame's cousin. Not only was Lumisden involved in the Scottish art trade to Italy and vice-versa: he also seems to have arranged the importation of Scottish produce such as shortbread for the delectation of his fellow exiles.[33]

Robert Strange acted as engraver for Charles Edward in the 1745 Rising and went into exile thereafter: his famous

propaganda print of the prince, *Everso Missus Succurrere Seclo* (sent to succour a ravaged land, a legend first used of Charles II), designed for an English audience, may derive from what is now thought to be a Ramsay portrait of Charles Edward, made at Holyrood in 1745 in response to an invitation from Iain Ruadh Stiùbhart; five years later, it was the source for a Jacobite badge distributed to supporters.[34] Strange's own fine-art engravings were popular in Scotland: one 1760 letter shows him dispatching forty-nine sets to various Scottish customers. A few years later he was more or less back in the good books of the British government: however, even after 1788 he was recorded groaning when prayers were said for George III in Old St Paul's Church. Ramsay junior himself was in touch with John Clephane FRS FRCP (1705–58), a medical graduate of St Andrews and Antwerp who was in turn a friend of David Hume. Clephane was the son of the Adjutant General in the Jacobite army in 1715 (who himself had shared a house with the Jacobite Earl of Southesk in the Strada Vittoria in Rome in 1721), and the son spent several periods of time in Italy, where he collected paintings, using John Blackwood, a Scottish picture dealer in Italy, as his supplier.[35]

Cosmo Alexander received from the Jacobite court help with a commission from the Earl Marischal to finish Placido Constanzi's *Battle of Bannockburn*, an early example of the new Scottish move into history painting.[36] George Chalmers produced a Jacobite painting (*A Shepherdess spied upon in a Landscape*, 1760) based on *The Gentle Shepherd*, Ramsay's play which Strange's wife (an enthusiastic speaker of Scots) and Lumisden's sister Isabella claimed to have by heart. In such a manner the pastoral, the Doric and the Jacobite were brought together in Scottish art. As in the case of Aikman, the networked interconnections between those with widespread and shared associational and cosmopolitan experiences which transcended background, nationality and profession had their effect both on and beyond the world of art.[37]

In 1734, Allan Ramsay the elder acquired some fifty-five by thirty metres of ground on which to build a house and studio for himself and his son (the 'Artist of the Castle-hill') from 'Robert Hope, surgeon in Edinburgh', possibly a scion of the Hope of Rankeillor or Hope of Hopetoun families with whom Ramsay's ancestry and career were alike intertwined.[38] The 'Guse Pye' (Goose Pie) house built on the site (possibly influenced by the

Figure 20 *Charles Edward Stuart* by Allan Ramsay. By courtesy of the National Galleries of Scotland. PG 3762.

Tower of the Winds at Athens and more clearly by James Gibbs's design for James Johnston's Octagon Room at Twickenham) was transferred from the older to the younger Ramsay in 1741, two years after Ramsay's 'town house and shop' were advertised for sale through *The Caledonian Mercury*. The Guse Pye seems, at any rate latterly, to have had a kitchen and scullery in the basement, a lobby, dining room and study on the ground floor and a drawing room on the first floor.[39] Ramsay's son stayed there during the 1745 Rising, when the house was burgled by British troops. The earliest remaining image of the house is in fact Paul Sandby's, who was well aware of its iconic status, and possibly its role in the Rising of 1745.[40]

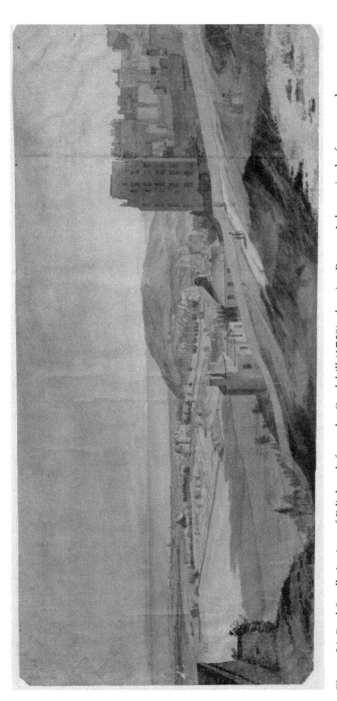

Figure 21 Paul Sandby's view of Edinburgh from the Castlehill (1750), showing Ramsay's house in the foreground. By courtesy of the British Library.

The Trustees Academy for 'twenty boys or girls', with a maximum period of study 'four years, that being deemed sufficient for any boys or girls, of moderate capacity, acquiring a knowledge of drawing sufficient to assist them in their respective occupations', was a somewhat more artisanal successor to St Luke's Academy, and was innovative in that it was a pioneering example of higher education for women. Tuition was provided free, and followed on another Edinburgh innovation in opening up painting competitions to both men and women from 1755. Although 'women were ultimately excluded' from the Trustees Academy from the mid-1780s on, a significant number of women studied there in the early years, including the period after Alexander Runciman, Robert Norie's apprentice and later a partner in the Norie painting firm, became its master in early 1772. In such simple and restrained terms the transformative power of Enlightenment thought and language made itself felt. Edinburgh's international background and networks, history of political oppositionalism and innovative institutional formation all served in the end to sustain dynamic and what we would now identify as progressive values. 'Information and liberality from abroad', Dugald Stewart's formulation, described the intellectual life of the Scottish capital, but far from 'mirroring the metropolis' in Roy Porter's dismissive formulation, Edinburgh was generating its own version of metropolitan life, where exchange with other European centres was as sustaining as that made possible by London.[41]

Theatre and Music

The Restoration of 1660 saw the restoration of the theatre in Edinburgh, which had been in abeyance in Scotland since the Union of the Crowns in 1603. The London theatres of the period 'were converted indoor real tennis courts', and likewise the Tennis Court theatre north-west of Holyrood (at the Watergate, the principal eastern entry to the Canongate with a pond for watering horses, beyond White Horse Close) was the main performance space of Restoration Edinburgh (Falkland Palace's surviving court will, as John MacQueen points out, 'give some idea of the structure').[42] Plays also began to be put on once more at Blackfriars Wynd in 1662. The London theatres expanded from 1660, with Lincoln's Inn Fields theatre opening in 1661,

the Theatre Royal in Drury Lane in 1665, the Haymarket in 1720 and Covent Garden in 1732. Edinburgh moved more slowly. The Scottish capital had had plays put on in the sixteenth century, and under royal patronage all the way to 1603, with the 'English Comedians' coming to Holyrood (and indeed to a public 'pastyme hous' in Blackfriars Wynd) three times in the 1590s. After James VI had gone to London, the drama had fallen into desuetude, except for the spectacle provided for Charles I's Scottish coronation on 15 June 1633, where Mercury led a line of 107 Scottish kings in procession from the Elysian fields, and a group of Ancient Worthies appeared, including Duns Scotus, Gavin Douglas and Hector Boece.[43] John Ogilby (1600–76), the Scots impresario who helped to plan Charles II's coronation celebrations, 'built a playhouse in Dublin' in the 1660s: theatrical activity was always easier outwith Scotland. The Kirk had attacked publicly advertised performances in the 1590s, and with no court support (James had paid for the fitting out of the house in Blackfriars Wynd) the theatre in Edinburgh had been too exposed to its enemies.[44]

Tennis Court patrons may have been 'exclusively the nobility', but the recrudescence of court culture had its effect on a wider public, and the burgh began to license players from the 1660s onwards, albeit on an intermittent basis. In 1663, William Clerke's *Marciano* was produced at the Tennis Court, followed by Thomas Sydserf's *Tarago's Wiles* five years later. Clerke's play was clearly a pro-Stuart allegory, while Sydserf had fought for the king with Montrose: the political colour of the Scottish Restoration stage was very plain, as it was to remain in later works, such as those of Archibald Pitcairne. By the late 1660s, Sydserf was managing the Tennis Court Theatre and also, apparently simultaneously, 'managed an acting company based in Edinburgh's Canongate'. A playhouse was certainly operating in the Canongate in 1669, while there was a 'dancing master' and 'a principal dancer' in 1664. Productions were also expanding: between 1669 and 1672, quite a number of plays were put on, for example, *Macbeth* on 9 March 1672. In its early stages, the Edinburgh Restoration theatre can be seen as part of that normalisation of high culture across all three of their British kingdoms which the later Stuart governments practised, while keeping the political arrangements of each separate. Some aspects of the culture of the capital in the 1670s and 1680s can also be seen as an Episcopalian regime reaching out to moderate

Presbyterians in co-operation through shared cultural institutions. The extent to which adjacency to power helped to create moderate theological positions in cultural and political actors was explored in the last chapter. Certainly there were signs of this crossover in the make-up of the Country party led by the Duke of Hamilton in the last Scottish Parliament. As Thomas Ahnert has recently noted, the 'term "Moderate"' had already begun to comprehend those of a 'polite, ecumenical outlook' in 'seventeenth-century texts', long before John Witherspoon characterised it as a party in 1753, and Edinburgh was the key location for this earlier group also.[45] Allan Ramsay himself, after all, was a Presbyterian, but very much one who could be considered a Moderate, with his dislike of 'sour pedants & Ingnorant [sic] Bigots'.[46]

In 1681, when James was in exile at Holyrood during the Exclusion Crisis, Nathaniel Lee's *Mithridates of Pontus* was staged at the Tennis Court for the Queen's birthday, with an epilogue by Dryden: we presume the admission cost was 2s 6d sterling in this and later eighteenth-century performances, though it is noteworthy that Dryden presumed it was 2s 6d Scots (that is, 2½d sterling). In the same year, a play put on at Kelso Grammar School was performed afresh in Edinburgh, 'some of the Kelso students having then entered Edinburgh University'. Schools frequently put on plays as a means of training for public speaking. Irish actors came over, while Princess Anne herself acted in a play in Edinburgh on 15 November 1681.[47]

There was also a good deal of popular theatre on the streets, with quack doctors, musicians and players all performing from temporary stages – a situation not dissimilar to that prevailing in London. Again, the Crown authorities tried to force the pace of acceptance of these developments by the burgh. In 1673, 'Edward and James Fountaines, masters of the revels, produced, before the Town Council, letters from His Majesty's Privy Council, empowering them to set up a stage in any part of the city'. The magistrates objected, and it is not clear how effective this move was, though some performances seem to have occurred in the late 1670s. Temporary staging nonetheless became a significant feature of street theatre. On 17 March 1682, the burgh authorities gave permission for a twelve-metre temporary wooden house to be placed on the High Street below Blackfriars Wynd for performances; it was removed in October. A stage was also set up at Niddry's Wynd, and in addition a

temporary 'theatre' was erected for the King's Birthday celebrations 'a little below the crose' on 29 May 1684. In that year, the two companies of comedians in existence, the King's and Duke's, amalgamated. There is much less evidence of theatrical performance for the quarter of a century after 1689 (Sydserf's Canongate troupe seems to have gone into abeyance about this time), although the theatre at the Royal Tennis Court seems to have survived until around 1715, and there were apparently performances outside the burgh, *The Scots Post-Man* noting on 4 October 1711 that it was 'reported, that ANTHONY PARSONS is gone from Edinburgh, to Mount Publick Stages in the Country'.[48]

Rope dancing and acrobatics and 'comic plays, juggling acts, acrobatics' were all in evidence, while 'a tightrope walk across the High Street was a particular favourite'. Indeed, in Edinburgh as in London, 'balancing and cavorting on a suspended rope was one of the most popular amusements of the day'. Edinburgh was also alleged to have more dancing masters per capita than anywhere else in Great Britain.[49] Private teachers of French, maths, book-keeping and much else all flourished and advertised themselves in the press.[50]

Madame/Signora Violante (1682–1741), a 'tight-rope artiste' thought to be too fond of showing her legs, had a track record in unlicensed theatre in Dublin (where in her later career she put on a *Beggar's Opera* for children, presumably with some scenes cut!), Cork, London, Bristol and Edinburgh. As is so often the case, the article on her in the *Oxford Dictionary of National Biography* focuses on her London activities to the exclusion of almost everything else: this framing of careers in London terms is one reason why careers elsewhere can be seen as 'dependent on London for professional performers and repertoire' by music historians of the period.[51]

In 1715, Signora Violante set up some theatricals at the foot of Carrubber's Close (135 High Street), in a building which has since disappeared into Jeffrey Street, by Old St Paul's Church, 'the retreat of the last faithful remnants of the Jacobites in 1688'. An isolated pro-Jacobite performance may have been put on in the close during the 1715 Rising, while plays such as Alexander Fyffe's *The Royal Martyr, King Charles I* (1705) as well as Pitcairne's *The Phanaticks or Assembly* and *Tollerators and Con-Tollerators*, a play set on 10 June, James VIII's birthday, clearly indicated the underlying politics of the theatre. In

December 1715, there also seems to have been some evidence of a company of Comedians being active 'at the back of the foot of the Canongate', probably 'at the Old Magazine House', where plays including Farquhar's *The Beaux Strategem* and Congreve's *Love for Love* were performed.

In 1724–5, Anthony A(l)ston came to Edinburgh, possibly with a London Company of Comedians, following a chequered career including performances in the American colonies. Aston used Skinner's Hall at 44–46 High Street (also used for concerts) for at least some of his performances, and Ramsay wrote a prologue for one of the plays Aston produced. He also taught elocution in the city, forty years before Sheridan's more famous classes. Despite initially enjoying the support of the Edinburgh magistracy in 1726 against an attempt to suppress him by the master of the revels, Thomas Johns, in 1727 the new burgh authorities disowned the verbal commitment of their predecessors and padlocked Skinner's Hall after a performance of Congreve's *Love for Love*. Aston raised an action in the Court of Session on the grounds that he had prior permission from the magistracy to put on plays, and that as a free subject of Great Britain he could in any case put on plays if he chose. The magistracy responded by relying on their prerogatives of local control. Although the Court of Session found for Aston, the Edinburgh authorities returned to the fray on 1 December 1727 with a complaint that Lady Morrison, who lived in the house beneath Skinner's Hall, was fearful lest the large audiences (an interesting detail: Aston was evidently a threat because of his popularity) should collapse her ceiling. Defeated, Aston left the capital after April 1728.

It was noteworthy, however, that whereas the local and more strongly Presbyterian middling sort attacked his theatre, it was recorded as being frequented by 'persons of quality and distinction'. The court inheritance of the Edinburgh theatre meant that it received strong gentry support, not least – though by no means always – from those sympathetic to the House of Stuart, who opposed the Union. The same happened with music, where civic complaints against 'concerts of music' and musical instrument playing in the streets were obliquely contradicted by noble patronage: for example, Argyle sponsored a concert in the Royal Tennis Court in 1705, for in these spheres aristocratic Whigs were closer to their Jacobite rivals in culture than they were to the local Presbyterian bourgeoisie. The nobility, well travelled

and cosmopolite by comparison with some of Edinburgh's local power brokers, continued to provide a locus of resistance to more conservative and inward-looking burgh practices.[52]

Boundaries between music and the theatre were not clearly fixed in this era. In this context, it was perhaps no surprise that formally constituted musical and theatrical performances began to emerge in a linked form in the 1720s. Music lessons had been available from at least the 1660s, and the 'first public concert in Edinburgh seems to have occurred in 1693', organised by the city's 'already fairly numerous' collection of music teachers. By 1695, a Music Club was meeting in Patrick Steill's Cross Keys tavern in Old Assembly Close on a weekly basis, with a membership including the usual suspects such as Pitcairne (Steill's friend and fellow Jacobite) and Dr Patrick Abercrombie (another Jacobite patriot), Sir Gilbert Elliott (1651–1718) and Sir John Pringle (1662–1721), as well as out-of-town figures such as William Seton of Pitmedden (1673–1744). Ramsay became a member in 1720. This grouping seems to have held an annual St Cecilia's Day concert from 22 November 1695 (in which William Thomson, c. 1695–1753, the author of *Orpheus Caledonius*, later sang as a boy), while musical bells were commissioned for the burgh in 1699: in the eighteenth century, there was a £5 fee for playing them. The St Cecilia's concerts (following on from the events scheduled by the Gentlemen Lovers of Musick in Stationers' Hall from 1683) were to be annual in Edinburgh up to 1728.[53] Public concerts of music began to be held 'each Saturday in Mr. Badham's House in Bailie Fyfe's Closs, opposite to the Head of Black-Frier's Wynd' from December 1699.[54] The first recorded music school in the city opened in the 1690s, while by 1707 music-making had become sufficiently popular for *The Edinburgh Courant* to advertise 'all Sorts of Haut Boys Flageolets and Flutes . . . Sold als [sic] Good and Cheap as at London' by Jonas Lilie in the High School Yards.[55]

Music teachers seem often to have used Scots tunes 'as instrumental practice pieces'. In 1701, Skinner's Hall, later used by Aston's theatre, hosted one of the St Cecilia's Day concerts with 'Noblemen and Gentlemen', which was followed by a visit to 'the Ship Tavern' in Old Stamp Office Close. Handel and Corelli, later referenced by Ramsay, were both played at the Cross Keys. Scottish material seems to have been played too, though Allan Ramsay's allusion to *'Pibrough'* was fanciful:

there were no pipers, though pipe tunes may have been adapted for fiddle. Ramsay was correct, however, in seeing a hybridising spirit at work among his fellow members ('And with the delicate Italian song/mix Cowdenknows', as he wrote in 1719). Ramsay himself was almost certainly an innovator here, in his work with Lorenzo Bocchi and no doubt others: Matthew Gelbart attributes to Ramsay the original case in defence and support of the hybridisation which, as David Johnson argues, came to characterise the distinctiveness of eighteenth-century Scottish music, 'poised interestingly – and at times perilously – between the European and the native Scottish musical traditions'.[56]

The Music Club was thus a group with a significant amount of heterophile experience, a certain degree of which is effective in diffusing innovatory activities. The gathering at the Cross Keys became too large, with sixty-one subscriptions in 1726–7, and in March 1728, a formal Musical Society was set up at St Mary's Chapel in Niddry's Wynd, 'where Steill's concerts had been held ten years before'. The initial joining fee was a guinea. This Musical Society was initially limited to seventy (male, though men and women both seem to have been present at the earlier meetings), and boasted Francesco Barsanti, Adam Craig, Alexander Stuart and William McGibbon, all key presenters and developers of Scottish music in the eighteenth century, among its performers. McGibbon was 'principal violin until his death in 1756', being paid £25 a year, although musicians might make £200 to £400 a year, including concert fees, which bore comparison with the University professoriate and the better-off clergy; Stuart was employed between 1726 and 1736, and his settings for Ramsay's songs seem clearly to have been linked to his Music Club work. Bocchi, who arrived in Edinburgh around 1720 with the tenor Alexander Gordon (c. 1692–1754/5), a Scotsman who had worked in Italy, sought to develop public concerts in Edinburgh. Women musicians were employed, but apparently only as singers; while at least one castrato, Benedetto Baldassare, was engaged, being paid £105 in 1732–3. There was a flourishing musical instrument business in the city: to take one example, 'Thomas Fenton Harpsechord Maker' of Leith, who advertised in *The Scots Courant* in 1718–19, had his workmanship attested by Steill and others. The initial membership of the 1727 Musical Club was 67, rising to 69 in 1728, 98 in 1744 and eventually 150 in 1755. In February

1729, on his withdrawal from the business of concert host, Steill held a roup of his surplus instruments.[57]

From 1727, the reformed Musical Society was something of an elite group, being, as were so many clubs and associations, dominated by lawyers and nobility. It was also cosmopolitan: 14 out of its first 57 subscribers had international experience. In 1728, there were 25 lawyers and 14 noblemen/gentlemen in its membership of 69; in 1744, 35 lawyers and 25 nobles among its 98 members. Its first three governors were Alexander Bayne, Advocate and Professor of Scots Law, Thomas Pringle WS and Lord Drummond: together these men held office for almost thirty years between 1728 and 1755. There was a medical contingent, and the Musical Society was involved in the opening of the Royal Infirmary on 2 August 1738. Sir John Clerk of Penicuik was a member, as were Lord Monboddo, Lord Elcho, Lord Dun, Lockhart of Carnwath, the Earl of Kilmarnock, Adam Ferguson and Lord Kames. Eight members of the Musical Society were also members of the Rankenian Club (see Chapter 5) and fifty-seven of the Honourable Society of Improvers, but by the 1750s and thereafter it was the crossover with the Select Society that was particularly striking, with up to 123 members in common between the two associations. The Musical Society was also closely linked to the Freemasons and met on Lodge premises: Grand Master Masons were prominent in its membership in the early years. The Grand Lodge of Scotland itself was founded on St Andrew's Day, 30 November 1736, while William Boyd, the Jacobite Earl of Kilmarnock and leading Freemason, was to become a noteworthy figure in the Musical Society, as in Lodge Canongate Kilwinning No. 2, in the years leading up to 1745. As in the case of the theatre, the Musical Society was patronised by many among the domestic nobility and their artistic supporters as a continuation of court society by other means and in opposition to the spirit of many among the local middling sort.[58]

The performance repertoire of the Society from the beginning included 'Ladies concerts'; by 1748–52, these were the majority of concerts performed. By the end of the 1760s, the Society was putting on thirty-nine concerts a year. The music 'was overwhelmingly instrumental', including sonatas by McGibbon and Vivaldi's concertos, but also included were William Thomson's *Collection of Scots Songs* (published in 1734) and an increasing proportion of Handel's work. On 27 April 1754, the Society

took up Handel's offer 'to let the Gentlemen of the Musical Society at Edinburgh have any of his compositions that they want'. The 'participation of foreign, usually Italian, performers was considered a necessity', and this despite the association of Italian opera with decadence made by Joseph Addison and others in England from 1711 onwards. One intriguing possibility is that the 'baroque sexuality' of Italian music actually hybridised very well with the somewhat bawdy nature of Scottish popular song. Within Scotland, bagpipe and violin were seen as types of union between 'ancient traditions and natural simplicity on the one hand, and sensibility and refinement on the other'. True to this ethos in a post-Union world, there was much resetting of bagpipe music for fiddle. The Society's performances were reasonably popular, with oratorio ticket sales ranging from forty to almost 350. The latter was a formidably large number, representing 1 per cent of the adult population of Edinburgh.[59]

In the years to 1727 in particular, Ramsay was an unequivocal supporter of the Musical Club, selling the music in his shop. Although there was pressure on the burgh authorities to take action against 'concerts of music', there was less hostility to these than to the theatre. The same was true of Signora Violante's dancing school (which Alexander Carlyle attended as a boy) and her public dancing, which in one 1736 rope dance concert at the Old Assembly Hall included a sword dance and a dance with boys fastened to her feet. Ramsay took advantage of this inconsistency. Already accused by Wodrow of using his new circulating library (discussed in Chapter 6) to lend 'villainous, profane and obscene books', the poet colluded to challenge opposition to the theatre 'by putting on a . . . music concert with the stage play as a second feature'. This activity, while common following the 1737 Licensing Act in order to evade its terms, seems to have occurred earlier in Edinburgh than elsewhere. Ramsay was clearly interested in developing domestic singing led by women, as he did in the *Tea-Table Miscellany* and in integrating song into drama. The poet demonstrated this most visibly in introducing songs into the 1729 edition of *The Gentle Shepherd*, a ballad opera destined to become 'the most popular pastoral in eighteenth-century British theatre', and one which became popular among the people of Scotland in general.[60]

Intriguingly, it seems as if Bocchi and Gordon may have had a role in the creation of the ballad opera format. On 12–14 June

1722, *The Edinburgh Evening Courant* announced that 'Mr Gordon is to publish Proposals for the Improvement of Musick in Scotland, together with a most reasonable and easy Scheme, for establishing a Pastoral Opera, in Edinburgh.' Although these Proposals do not survive, Bocchi's settings for Ramsay (which certainly include the setting for 'soprano, unison violin, and continuo' for 'Blate *Johnny*' in the 1723 *Tea-Table Miscellany*) may have included work on the 1729 *The Gentle Shepherd*, while Gordon 'may have been in Queensberry's retinue', and Queensberry was the patron of John Gay. Whatever the details of these intriguing connexions, it is clear that an Italian with experience in Ireland and Scotland (Bocchi), a Scotsman with experience in Italy (Gordon) and Allan Ramsay combined to create major innovations in the performative style and contextual placement of Scots song. As a 'cellist of distinction, Bocchi was ideally placed to engage in the 'cello accompanied by the harpsichord 'with a Thorow-bass', for which he set Ramsay in 1725–6 and which became a staple of Scottish song performance until the rise of the pianoforte. John Steill sold these settings 'with Instrumental Parts after the Italian manner, the words by Mr Ramsay'. Fusion music had arrived.[61]

Steill's tavern (where Pitcairne and Ramsay both drank, as did Patrick Abercrombie, author of *Martial Atchievements of the Scottish Nation*) was also home to 'Pate Steill's Parliament', an anti-Union debating society, and Steill subscribed to Ramsay's 1721 and 1728 volumes. Ramsay probably met both Alexander Stuart and Richard Cooper at Steill's tavern evenings, where of course William Thomson, who was to provide music for some of Ramsay's tunes, as Stuart did also (though some of these may derive from Bocchi), had also performed. Ramsay sold Thomson's *Orpheus* and Stuart's settings for the *Tea-table Miscellany* songs – intriguing but minus instrumentation or lyrics (a traditional Ramsay trick, used also in the 1729 *Gentle Shepherd*, to try to get customers to buy them separately via the fifth edition of the *Tea-Table Miscellany*, published that year) – from his shop. Throughout his long career, the poet was very much a man of the immediate environs of this milieu, keeping premises opposite Niddry's Wynd and latterly at the Luckenbooths, where he stayed in a first-storey flat at the east end of the building, at the entry to Parliament Close, bought for £570 sterling from Alexander Brown in 1724, which became 'the rendezvous for the wits of the city'. This was a closely knit

environment. Ramsay's father-in-law, Robert Ross, had lived in Blair's Close on the Castlehill, no more than four hundred metres away.[62]

Dancing schools had been in existence since the 1680s, with a Dancing Academy set up in Old Assembly Close in the West Bow by 1710, or shortly afterwards. In 1723, a New Assembly opened 'in the great hall in Patrick Steil's Close', with Ramsay writing a poem, *The Fair Assembly*, in its support. The Countess of Panmure wrote to her exiled husband that this 'Assemblie . . . I believe will take very well in spight of the Presbyterian ministers' railing at it . . . Old Reeky will grow polit with the rest of the world. I wish you were here to see it.' She later became a Director of the Assembly herself. Dances appear to have been fortnightly, as there were 255 meetings of the Assembly between 1723 and 1733. Meetings were normally at 4pm on Thursdays, and after a first half of minuets and a break for 'tea, coffee, chocolate and biscuits', 'Country dances' succeeded until 11pm. British cloth only was to be worn on specified occasions. The Assemblies were noted for their 'rigid formality' by English visitors, but nonetheless provided an opportunity for young people to enjoy each other's company in relative freedom. Rather like the music societies, the Assembly divided its attentions between the classical and Continental, and the autochthonous and Scottish. This was arguably an echo of practice on the Continent, where the exiled Stuarts might have 'been responsible for introducing the English country dance to Italy', and at any rate more certainly introduced Scots dances: in Scotland in 1745, Charles Edward danced an (intriguing) 'strathspey minuet', which was apparently 'a show-piece for solo fiddle'; Iain Ruadh Stiùbhart (1700–52), who commanded the Edinburgh Regiment in the 1745 Rising, 'led the country dances at the court balls' which may have been held at Holyrood. Dance tunes were linked to Scottish songs, and the Duke of Perth was only one of the Jacobite aristocrats who was interested in Scottish tune collections and development – development which would go on to define the future of the Scottish song tradition.[63]

In 1736, the Assembly moved to new premises between Bell's Wynd and Stevenlaw's Close. Lady directresses originally dominated the Assemblies, their numbers being augmented by male directors after 1746. The directresses democratically took turns in presiding over the dancing: that was, however, more or less the only thing that was democratic about them. The limitations

of characterising the Edinburgh Assembly as 'provincial' in metropolitan terms can be seen through a roll call of the directresses from 1723. Their numbers, besides the Countess of Panmure herself, included Lady Elizabeth Drumelzier, daughter of Viscount Kingston; Lady Newhall; Lady Dalrymple, wife to the Lord President; Elizabeth, Countess of Glencairn; Anne, Countess of Hopetoun; Elizabeth, Countess of Leven; Lady Minto; Lady Kilkerran; Lady Henrietta Campbell, daughter to the Earl of Breadalbane; Lady Prestongrange; Lady Pitfour; Lady Sinclair; and the Hon. Miss Nicky Murray, sister to the Earl of Mansfield and Jacobite Earl of Dunbar. The social background of the male directors was less exalted, for among Lord Drummore, Lord Minto, Lord Edgehill and the son of the Earl of Haddington were to be found the bookseller Gavin Hamilton and the merchants Hugh Clark and William Douglas. William Hamilton of Bangour was among those who frequented the Assemblies, as did Oliver Goldsmith when he came to Edinburgh in 1753. Booksellers sold tickets, which at 2s 6d a head were indicative of the upmarket clientele expected, and indeed the number of couple who could be accommodated on the dance floor was very limited. Charitable giving was, however, a central purpose of the Assemblies, and extended beyond Edinburgh in reflecting a wider mission, with charity balls being held in aid of Musselburgh Harbour (1748) and, later, Kinghorn in Fife. The Music Society sometimes performed in the Assembly Rooms: for example, on the occasion of a Royal Infirmary benefit concert held at 5pm on 29 February 1740, so these associations were very close to each other. It was this legacy which led to the George Street Assembly Rooms of 1783 being the 'largest in Britain', Bath only excepted.[64]

As regards the repertoire of the Assemblies, the balance between minuets, with their slow and constrained two-bar dance units and their redolence of French court culture, and country dances with their 'social, informal and interactive' character and 'phrase lengths four times those for the minuet', was a performative version of the Auld Alliance and Scoto-French cultural interchange. If the minuet implied loyalty to the Crown and the formality of 'douce' and 'naturalized control', the country dance – and, from mid-century, the strathspey and reel – broke open this model of restraint in the performance of a more uninhibited self, a vision of which Burns takes the opportunity to present in *Tam o' Shanter*. It could, moreover,

be argued that the Scottish country dance was a metaphor for innovation in its own right:

> The country dances' progressive movement, where each couple in turn took each position in the hierarchy of couples, where gaiety and speed overwhelmed formality, where each dance was different from the last, together expressed the fetishization of change itself.[65]

The incorporation of country dancing into the fashionable world of the Assembly was an extension of its social sphere and scale, as well as a disruptive, patriotic and egalitarian intervention in its inherited formalities. It was – if by no means unique to Edinburgh – an innovation, just as from the mid-eighteenth century *volkisch* Scottish tunes such as the strathspey would come from almost nowhere, as an invented tradition to embed the 'natural' qualities of Scottishness and its performance in the programmes of polite assemblies, with the very names given to such dances reflecting their gentrification.[66] In other spheres too, the Assemblies were sometimes repositories (as were the later concerts) of patriotic display. The requirement for wearing British cloth (see above) seems sometimes at least to have been give a specifically Scottish slant, hence Allan Ramsay's 'Ode on the Ladys being all dressed in Scots Manufactory at ane Assembly Febr 15th 1728', to be set to the Jacobite air 'O'er the Hills and far away'. Ramsay in fact wrote an explicitly Jacobite song to this tune, 'The Royall Youth may now advance'.[67] Elsewhere, Ramsay criticised 'base foreign fashions' in 'Tartana': he need not have worried so soon perhaps, for in 1747 'nine-tenths of the ladies' in Edinburgh 'still wore plaids, especially at church'.[68]

By the 1720s, Ramsay's poetry, born of that 'Love to my Countrey which ever Blazes in a Scots Breast', had already won him many patrons among the natural supporters of music and the theatre, with three dukes and many other noblemen among the subscribers to his poems. These included a number of prominent Jacobite or crypto-Jacobite figures, such as the Duke of Chandos, the Countess of Panmure, Lord Lovat, Lord Deskford, Lord Dun, Lord John Drummond, Sir John Wedderburn, Lockhart of Carnwath, Chevalier Andrew Ramsay, Thomas Ruddiman and James Hepburn of Keith, and close neighbours such as Walter Boswall and Robert Dundas of Arniston, then Lord Advocate. This was a group with strong social capital

and many leaders of opinion from a heterophile range of backgrounds: the adoption of vernacular poetry at this social level was critical in its diffusion and adoption in a manner in which earlier practitioners like James Watson had never succeeded. Ramsay was careful to balance his status as a Scots poet with more 'polite' one-off productions like his masque 'Perform'd at the Celebration of the Nuptials' of James, Duke of Hamilton, and Lady Anne Cochran in 1723. The revival of the status of Scottish literature in Scots which had begun with Watson's *Choice Collection*, was built on by 'my Thought in my native Dialect' advocated by Ramsay in the Preface to his 1721 volume of poems, and reinforced by the poet's friend Sir John Clerk of Penicuik's (1676–1755) claim that 'Middle Scots was "genuine Saxon" in its purest form'. Ramsay claimed Scots words were of equal classical merit to English, being simply a variant, the Doric rather than Attic of Anglophone tongues. Scots words, he argued, 'become their Place as well as the *Doric* Dialect of *Theocritus*, so much admired by the best Judges'. When it came to collections of song, this point was rammed home, as Ramsay anticipated Johann Herder (1744–1803) in his alignment of native voice and national self. As Leith Davis has argued with respect to *The Tea-table Miscellany* (1723–37), 'the Scottish dominate the English songs, making the latter's musical contribution appear minimal'.[69]

John Aikin wisely remarked later in the century that Ramsay's Scots 'gives a kind of foreign air that eludes the critic's severity': the poet's focus on Middle Scots as the 'classic' variety of the language was a shrewd part of this strategy. Indeed, Ramsay overtly Scotticised previous collections of proverbs such as James Kelly's in his own collection of 1737, distributing them directly from his shop through chapmen in order to maximise circulation (and thus his own profit), while embedding them in Scots tradition more widely. Ramsay's *Proverbs* influenced many subsequent collections, and indeed, as Ronnie Young has argued, may have been designed in part to lay claim to the status of being the voice of the people.[70]

In claiming classic status for his synthetic and quite heavy vernacular Scots ('the Beauties of ... Mother Tongue ... much fuller than the *English*'), Ramsay prepared the ground for greater acceptance of the strangeness of Scots to an English speaker while nonetheless demanding their acceptance in a post-Union environment. This was an approach rhetoricised by his

description of Scots as a *'British'* language. The (bowdlerised) Glossary which Ramsay innovatively introduced to his 1721 *Poems*, much like the editing and altering of earlier Scots texts in *The Evergreen* and *Christ's Kirk on the Green* from 1716, seemed to confirm by its very scholarly apparatus the status that Ramsay claimed for the Scots language in poetry, one confirmed by his 'early romantic' practice of collecting Scots songs. Ramsay had earlier taken advantage of local printers like John Reid of Bell's Wynd and his family to produce some of his work for the popular broadside market: *Maggie Johnstone's elegy* appeared in a second edition in this format on 30 July 1713. A variant *Elegy on Lucky Wood*, lamenting the post-Union loss of social status of the Canongate, 'O Cannygate poor Ellritch hole', was another of Ramsay's popular broadside productions in this mode. 'Almost sixty per cent' of the surviving Scottish broadside songs 'specify their accompaniment to a named air', and this pattern of publication may have influenced Ramsay in his presentation of the *Tea-Table Miscellany*, a genteel British title which paradoxically promoted a patriotic Scottish tradition. The *Miscellany* itself made an allusion to polite society in its title which was, despite Ramsay's bowdlerisations, undercut by the strongly vernacular nature of its contents. However, the allusion Ramsay made was also to domestic and female society, and female singing and playing in the domestic environment seems to have been growing at this time: the *Tea-Table Miscellany* was designed, with Ramsay's customary acuity, for this market, which in time hardened into the domestic artsong tradition of performance. In later years, James Boswell (1740–95) was to 'come to Prestonfield on a Saturday evening' to hear Lady Janet Dick 'sing and play': as a child, Ramsay had made her a 'favourite doll', depicted in her picture by William Millar.[71]

Ramsay's innovations in linguistic and cultural practice were transformative, but they were also rooted in less developed practices connected to similar themes from elsewhere in the British Isles. John Gay's *Shepherd's Week* of 1714 was 'in part a burlesque of Ambrose Philips's verse pastorals', with 'intensive use of folklore, folk dialect, and folk customs'. It provided a basis for a good deal of Ramsay's interest in pastoral and the Doric, as perhaps did Joseph Addison's 'particular delight in hearing ... songs and fables ... most in vogue among the common people', in his 1711 essay on 'The Ballad'

in *The Spectator*. As with the career of Richard Cooper, the heterophile influences of English playwrights and periodicals, together with those of Bocchi and Anderson, helped galvanise change in Scotland. Moreover, Joseph Addison's use of 'music in the public domain' was closely related to Ramsay's own incorporation of Scottish song and music into his *oeuvre*. It was nonetheless a stroke of genius on Ramsay's part to convert the idea of 'the rusticity of the Doric' in the English debate into a defensive characterisation of Scots as a Doric tongue in comparison to 'Attic' English, in so doing transferring 'the oral language to his writings'.[72] In this, Ramsay was following James Watson's *Choice Collection*, which 'asserted Scotland's authentic indigenous voice against the *faux* Scots of the London publishers', and supplementing it by engaging with the era and values of *The Spectator* in a transformative way. Ramsay, however, was more skilled, like his son after him, in the programmatic and conceptual than Watson had been, being careful to blend English, Classical and Continental strains into what was ultimately an uncompromisingly Scottish cultural model, and one which, as far as the writing of poetry in Scots goes, has endured to the present day.[73] Milton was also an influence: Lycidas's role as a 'Dorick lay' underpinned Ramsay's approach to pastoral elegy,[74] though his skill with the varying registers of his native Scots served to allow him to layer tone and ironic detachment on an ostensibly serious topic, as he was arguably to do in 'Richy and Sandy', the elegy on Addison.[75]

The association of Scottish subject matter with pastoral in London broadside culture was also a noteworthy source for Ramsay's re-presentation of Scotland. This metropolitan characterisation of Scotland as pastoral led in part to the Highlandisation of Scotland in the British gaze as, 'since the English saw the Scots as natural innocents or unruly barbarians, it was easy to identify them all with the Highlanders'. Henry Playford 'was among the first to do so publicly' in 1700. It was very much in the nature of Ramsay that he should absorb existing practice and prejudice of this type and recast it as an enduring linguistic and cultural innovation for the purpose of revivifying Scottish language and culture in Edinburgh and beyond. The linkage of Scots music as well as poetry with 'artless simplicity' and 'remote antiquity' was to remain very powerful throughout the eighteenth century, to the time of Macpherson's

Ossian and beyond. In this sense, Ramsay's achievement as a poet and playwright is intimately connected to his success as an entrepreneur of Enlightenment cultural infrastructure in library, theatre and elsewhere. Far from Scottish Romantic features (song-collecting, rural artlessness, the equation of the native with both classlessness and the supernatural) as being at odds with Enlightenment values, they provided a protective native authenticity for the inception and adoption of borderless and cosmopolitan practices. Ramsay was both intensely a Scottish particularist and equally dedicated to maintaining Scotland as an internationally normative society.[76]

Ramsay's subscribers may have included many great names, but the poet was also intensively networked with other groups clustered in the densely populated Scottish capital, such as the Royal Company of Archers, which had taken Ramsay into membership as 'Bard to the Royal Company' on 13 July 1724: he amply repaid them with the patriotic 'Archers March' and 'Poem on the Royal Company of Archers', printed in *The Caledonian Mercury* of 12 July 1726. Here too, Ramsay may have been expressing his loyalty to those who had first worked to incorporate him in Edinburgh society. Pitcairne had previously been a member of the Archers, as were some of the hottest among the Jacobites, such as Erskine of Dun; James and Robert Freebairn; Hepburn of Keith; James Keith, the Earl Marischal's brother; Laurence Oliphant, ygr of Gask; James Stewart, son to the Earl of Traquair; and David Thriepland. The Archers themselves were not above theatricals: on 10 July 1732, they went to see a staging of *Macbeth*, while on 5 August 1734, James Freebairn, son to Robert the Jacobite printer, 'made a present to the Council of a French drammatick poem, composed by him on the late parade of the Company'. The poem concerned was all in favour of 'de coeurs Ecossois ... La liberté du Pays, et vos anciens droits', and this was very much of a piece with the politics of the Archers. Not in themselves an innovative body in ideas terms (though they were in terms of prizes and ceremonials), their members nonetheless supported innovatory developments if they could be seen as reinforcing the socio-cultural ethos of the old Restoration capital.[77]

The initial 1725 version of Ramsay's *Gentle Shepherd* pastoral (the MS is endorsed with Ramsay's wry comment 'SUPER FYN Poetry nae doubt') with four *Tea-Table Miscellany* songs may have been performed in Edinburgh, but the play is better

known as the ballad opera which had the number of its songs increased to twenty-two after the October 1728 performance watched by the boys of Haddington Grammar School. Both Haddington and Dalkeith grammar schools put on a number of plays between 1724 and 1731. No doubt the friendship between Ramsay and John Leslie, master of Haddington Grammar School from 1720 to 1731 (he moved to Dalkeith in 1731, where his pupils performed Vanbrugh's *The Provok'd Husband* only three years after its Drury Lane premiere), had a significant role in the performance of Ramsay's play in schools: a dyadic tie supporting the spread of theatrical performance and the development of ballad opera. The new version of Ramsay's ballad opera was premiered in Edinburgh at the Tailors' Hall (Tailors' Close, 137 Cowgate, a few steps from the Old Post House stairs and close, and not far from the Meal Market stairs) by the Haddington Grammar School pupils themselves on 22 January 1729.[78] Tailors' Hall (then 'Taylors-hall') was a location used for theatrical performances from 1727 to 1753, though more intermittently in the years after the opening of the Canongate theatre at 196 Canongate South (Old Playhouse Close) on Richard Cooper's land, which he leased 'to the Edinburgh Company of Comedians for twenty-five years'. In fact, after 1749, Tailors' Hall was in part economically supported by a lease on the brewery occupying its Cowgate frontage to Thomas Trotter, whom we have already come across as a co-founder of the Academy of St Luke in 1729. The associational, networked and dyadic connexions are all obvious here. Hangman's Close was nearby, with Old Assembly Close running down to 158, where Patrick Steill still kept the Cross Keys inn, and where the Musical Society had once met. This was a brewing and foodstuffs district, an advantageous location for Trotter's lease: both Campbell's Close at 145 and Scott's at 123 were home to breweries, as was Dick's Close, slightly farther off at 195 Cowgate. Old Fishmarket Close ran down to 144 Cowgate from the High Street.[79]

The schoolboys officially received the credit for the development of Ramsay's initial conception into a fully fledged ballad opera, but it is more plausible to suppose that the influence of Anderson, Bocchi and John Gay, who visited Edinburgh in the spring of 1729, were also key. Equally, Gay's choice of repertoire in *The Beggar's Opera* seems to owe quite a bit to Ramsay's earlier work (and possibly Anderson's 1722 Proposals), so the

influence was mutual, as Jeremy Black has suggested. Gay had been working on *The Beggar's Opera* since the 'early summer of 1727', and it opened at Lincoln's Inn Fields on 29 January the next year. He was soon flushed with the success of a near-record sixty-three consecutive performances of his masterwork, which had also been played between thirty and fifty times in 'all the great towns of England'; in the summer, Gay was in Bath while the opera was being performed, and indeed it was staged at Haddington Grammar School before the end of 1728, as well as on forty occasions in Dublin between March and the end of December. From the beginning there had been a Scottish connexion: the Duke of Argyle attended the premiere of Gay's opera in London, and it was the Duke and Duchess of Queensberry who intervened on the author's behalf when he found his sequel *Polly*, 'almost ready for rehearsal' as he told Swift at the beginning of the month, was suppressed by the Lord Chamberlain on 12 December, in a move widely seen to have been inspired by Walpole. The duchess intervened strongly on Gay's behalf and 'was extruded from the Court and her husband resigned his appointment as Vice-Admiral of Scotland as a gesture of support for her, and for Gay'.[80]

Without further hopes of preferment, Gay went to stay with the Queensberrys in Burlington Gardens in early 1729, and thence accompanied them to Scotland, where by 8 May the national position on copyright (Edinburgh was a home for print piracy) had inflamed him sufficiently to pursue 'about twenty lawsuits with booksellers for pirating his book'. Gay seems to have been lodged in the top floor in the Canongate opposite Queensberry House, although he also spent some time in Drumlanrig in Dumfriesshire with his noble patrons, whence 'the beloved Mr Gay' visited Clerk of Penicuik. On Whitsunday 1729, Ramsay wrote to Sir John, 'I am the more pleased with my Self when you tell me of my general Likeness to Gay . . . I should have much Pleasure when you do me the honour to make me acquainted with him', and Ramsay may thus have met Gay first at Penicuik House. In Edinburgh, Gay also visited Ramsay's shop in the Luckenbooths: the Duke of Queensberry was a subscriber to Ramsay's *Poems*, and Ramsay had written a pastoral to the duchess ('Why from us does Clarinda stray') in 1723. Gay is reputed to have read *The Gentle Shepherd* in Ramsay's shop, and to have drunk with the Scottish poet at Jenny Ha's at Callender's Entry in the Canongate and opposite Queensberry

House, a haunt of Jacobites and dispossessed Episcopal clergy. Unquestionably, Ramsay drove innovation on the stage in a dyadic and mutually influential and reinforcing professional relationship with John Gay, who returned to London in June. Ramsay did not see him again, although he wrote a pastoral elegy on the English satirist when he died in 1732.[81]

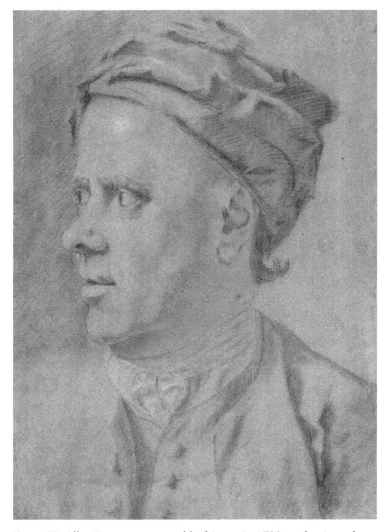

Figure 22 Allan Ramsay portrayed by his son in 1729, at the time of Gay's visit. By courtesy of the National Galleries of Scotland. PG 2023.

Ramsay was serious about his intentions in *The Gentle Shepherd*, and aware both of current practice on the London stage and the difficulty of staking high cultural claims for vernacular pastoral. He sought to overcome both obstacles. While 'harlequin' as a style – 'a familiar signifier, denominating a stance of irony, mockery, or satire' – had become very popular on the London stage following *Harlequin Sheppard*, a comic portrayal of the career of the notorious thief Jack Sheppard, in 1724, Ramsay was emphatic that 'Learning's our Aim' and that we should 'allow no thought so mean/That any here's to act the *Harlequin*' (it is just possible that 'Shepherd' in the play's title is an allusive pun on the famous robber's harlequin; Macheath was based on Jack Sheppard in Gay's opera). True to his word, Ramsay injected references to Tasso, Guarini and Spenser into *The Gentle Shepherd*, in order to make good the claim for Scottish literature as a distinctive and hybridised strain in European culture. Ramsay had promised such an approach in his Musical Club poem of 1719, where he stated that the 'Dialect of the golden age' will give Corelli 'as good fate/In Scotia's glens as Umbria's green retreat'. Ramsay also began to design a high cultural version of the English characterisation of Scotland as 'the pastoral, the innocent, the rustic, even the wild', which enabled him to use a genre intended to stereotype his country as one suitable to both defend and exalt national distinctiveness. The eastern quality of pastoral's reputed origins and Theocritus' status as court poet in Egypt seemed to reinforce the foundation myth of Scotland's Egyptian origins (Scota, the daughter of Pharaoh), and helped Ramsay's Scots pastoral to claim classicism and exoticism simultaneously. Moreover, pastoral was already strongly associated with Scotland as a genre in broadside publication, and had become politicised as referential to the Stuarts during the Exclusion Crisis. Ramsay was continuing to create a language in which Scotland could express itself, one recognisable in its generic structures to those who were spectators of the country, but also one which expressed the national pride of its inhabitants.[82]

Ramsay may have started working on *The Gentle Shepherd* in 1724; the initial version was completed on 29 April 1725 and ready for production that year. Ostensibly set at the time of the Restoration, the play's Jacobitism was openly apparent to those who cared to look beyond its surfaces. Ramsay's exiled laird (a disguised reference to Charles II and beyond him James 'VIII')

'Sir William Worthy' took his name from the Worthies Club. As late as 1820, the play was performed on King James 'VIII's birthday, 10 June.[83]

The Gentle Shepherd was produced in what was quite strongly a Jacobite context in Edinburgh, which had its communication channels intensified both by the importance of the cause to its supporters and its necessarily clandestine nature. *The Caledonian Mercury* (named for the original paper edited by Sydserf in 1661), printed from 1720 in the Parliament and Carrubber's Close (where Ramsay was later to establish his own theatre) by William Adams junior,[84] was reporting the doings of King James 'VIII' in its November 1721 number. From February the next year it was also being sold by the Jacobite bookseller Alexander Symes in the Parliament Close: Symes and two other booksellers were also selling a true and impartial life of Archbishop Sharp in June 1723 as an unashamed piece of pro-Episcopalian propaganda. In January 1724, the passionately committed Jacobite Thomas Ruddiman took over the *Mercury*, which was produced in Ruddiman's works on the fourth storey of the turnpike at the foot of Morocco's Close, opposite the head of Libertoun Wynd, near the Lawnmarket. On 1 March 1725, the paper noted that James Freebairn (whom we saw above in connexion with the Archers) was both teaching French and providing a translation of a Life of Mary, Queen of Scots from that language, while the English Jacobite printer Nathaniel Mist was in contact with the *Mercury*. On 27 April, Lord Belhaven's patriot speeches against the Union were advertised in the *Mercury* as being available at St John's, Muirhead's and the Laigh coffee houses, and for sale at John Moncur's printing house opposite the head of Forrester's Wynd. On 22 June, the paper advertised *The Gentle Shepherd* as just published and available from Ramsay's own shop at the 'South-side of the Crosswell' for a shilling (Ramsay indeed seems to have made theatrical performance wash the hands of his shop, as he regularly sold play scripts there). Ramsay was in very political company in the pages of the *Mercury*, which made its traditional patriotic politics very clear in much of what it carried. He was also extremely close to Ruddiman as its printer. Ruddiman had edited Pitcairne's poems and provided the glossary to Gavin Douglas's *Aeneid* of 1710, which Ramsay used as a basis for his 1721 glossary on his own poems. Moreover, Ramsay had taken the Easy Club nom-de-plume of 'Gavin Douglas' at Ruddiman's

suggestion. Ruddiman may also have provided Ramsay with Greek and Latin epigraphs, and in any case printed the 1721 Quarto *Poems*, the 1724 duodecimo *Tea-Table Miscellany*, and the 1725 duodecimo *Gentle Shepherd*, the fair copy MS of which was presented to the Jacobite Susanna, Countess of Eglinton (who had a house at 225 Canongate and was Richard Cooper's patron), on 2 March 1737.[85]

As an art dealer, Ramsay was also in touch with members of the Scottish Jacobite art network in Italy: for example, with John Clephane, as discussed above. The Jacobite network was also strongly connected to the performing arts. On 11 February 1745, Otway's *Venice Preserved*, a play with strongly established Jacobite credentials, was played at Tailors' Hall in what was to be a momentous political year.[86]

William Hamilton of Bangour, Ramsay's friend and a Jacobite poet, compared with more party spirit than critical sense to Dryden by *The Caledonian Mercury*, had contributed both to *The Tea-Table Miscellany* and a long address to the Countess of Eglinton in the 1726 second printing of *The Gentle Shepherd*.[87] The play itself adopts the pastoral rurality which had often come to characterise Scotland, but marks a new and clear ideological direction by turning it into a statement of the simplicity, honesty and comparative classlessness of the country as a society united in community. From the first, *The Gentle Shepherd* was probably sold through the London market, initially perhaps through James McEuen's shop there. Ramsay's songs went on to appear in twenty-seven ballad operas by Cibber, Fielding, Gay and many others, while *The Gentle Shepherd* itself was performed at least 148 times in England and Scotland before the accession of Queen Victoria.[88]

The values of Ramsay's drama are (like Gay's) in opposition to the administration of Robert Walpole (Prime Minister 1721–42), but they are stronger political meat than that, with the Jacobite and patriot message barely suppressed. Set in a native rather than imaginary, removed or exoticised pastoral environment, *The Gentle Shepherd* clearly adopts pastoral both for political ends, and also to celebrate Ramsay's friends and fellow Worthies, being set in all probability in the countryside round the great houses of Penicuik and New Hall.[89] When Sir William Worthy returns, it is 'in low disguise' (III.i.9) and 'from ambition free' (III.i.45); Patie, his disguised heir, has equally shown these virtues, which reflect the partial classlessness

aspired to by Edinburgh associational society and evident in Ramsay's own career. The Scots that the poet uses is itself synthetic, light enough to be comprehensible to a non-Scots audience, marked enough to give a sense of the distinctiveness of the country and its projected values. Unlike much traditional pastoral, a sense of locality is deliberately cultivated: Patie has sold his lambs 'At the West-port' (I.i.56), while Roger offers Patie a gift of tartan, the patriot garb (I.i.149–56). The traditional location of the pastoral in the area round Carlops and New Hall also evidenced its revolutionary quality as a piece of art, not set in a remote or imaginary, but in an identifiable and immediate, locality. The fertility and success of the community is strongly identified with restoration and the return of the rightful heir, and perhaps it is no coincidence that it was a shepherd's call, 'Hooee uncos' (away with the strangers, spoken of an intruding flock) which was used as a Jacobite codeword (incidentally by Andrew Lumisden's cousin, Katherine Bruce of Clackmannan, for whom it was a daily favourite). Patie's first speech presages that restoration as it notes 'This sunny morning' which 'puts all nature in a jovial mood' and sets the plants rising. Spring, love and political renewal are all aligned.

The news at the beginning of Act II 'that our laird's come hame' (II.i.36) sets the scene for restoration and renewal, and an end to the acts of Scotland's 'vile oppressors' (II.i.18), whose exactions are both financial and corrupt, including the implications of 'a racket rent' (II.i.43) and the malt tax (II.i.67). Symon's starting to brew on the news that Sir William is returning is a pretty plain allusion to the very contemporary controversy over Walpole's determination to extend the malt tax to Scotland. The implication is that a Jacobite restoration, like that of Sir William, will end unfair taxes on Scottish land and produce, and native economic concerns ('How sells black cattle? What gie's woo this year ?'(II.i.50)) will be restored to centre stage. Soon both sheep and malt (in the shape of haggis and beer) are ready to 'drink our Master's health and welcome-hame' (II.i.79). The land will be renewed; even the shepherds will feel younger (II.i.88). Lest the implications for a contemporary audience are missed, within a few dozen lines Mause rams them home:

> 'Peggy, here the King's come,
> Peggy, now the King's come;

> Thou may dance, and I shall sing,
> Peggy, since the King's come.
> Nae mair thy hawkies shalt thou milk,
> But change thy plaiding-coat for silk,
> And be a lady of that ilk,
> Now, Peggy, since the King's come.' (II.iii.5–12)

The love scene between Patie and Peggy which follows, praising as it does the 'westlin winds', the birds and their song and Peggy herself, is fairly clearly the model for Burns's early song, 'Now Westlin Winds', which of course uses the name 'Peggy'. From this point on, the story moves to its conclusion, as disguises are removed, Scotland and fertility restored, all made plain that was hidden, and a marriage between Patie and Peggy (named for St Margaret, the patroness of Scotland, whose saint's day had recently been moved to King James's birthday) to crown and end all.

Despite the departure of Aston, the theatre and the 'Company of Comedians' continued in Edinburgh from about 1730 (with an abortive start in 1728–9), playing at Tailors' Hall. Ramsay took over their management in 1732; the next year he was described as 'Master of the Play House', a founder of the Edinburgh Players, and was issuing season tickets for a run of 'Fifteen different Plays', while selling playscripts from his shop.[90] Richard Cooper, who had published and illustrated Ramsay's poems, may have designed the scenery at the Playhouse. Cooper was certainly fond of design, having employed William Delacour (1710–68), the Huguenot 'designer and drawing master', as scene painter in his own garden. Under Ramsay between 1732 and 1735, the Company evaded opposition by offering the play as a free entertainment after a concert, for which they charged 2s 6d for the pit and boxes, 1s 6d for the gallery. This practice became common after the 1737 Licensing Act: for example, the Bath theatre relocated to the Assembly Rooms and effectively became a musical society.[91]

Music was thus closely related to the circumstances of performance and was incorporated into the plays themselves. Here too, Cooper may have been influential. Not only did he illustrate Ramsay's books and lease ground to the theatre; he also had been in the Musical Society and the Archers. Cooper's illustrations for Alexander Stuart's *Musick for Allan Ramsay's Collection* appear to advertise the instrument maker Thomas

Fenton, who tuned instruments for the Edinburgh Musical Society in 1730–1, while Cooper also produced the Society's first violinist William McGibbon's *Six Sonatas for Two German Flutes* in 1729. In his hybridisations of concert and theatre, Ramsay was beginning to push the genre of ballad opera even further, and it may have been hard in some circumstances to tell where the concert ended and the play began. *The Beggar's Opera* was staged in 1733, *The Way of the World* in 1734, while on 3 January 1735, the Comedians played *The Tempest* with alterations by Davenant and Dryden, incorporating a musical interlude with a setting by Purcell. *The Relapse* followed on the 9th, and Southerne's anti-slavery play *Oroonoko* was performed on 22 January. The complexity of the scenery (possibly by Cooper) for *The Tempest* – the sea in particular – was such that 'no Person whatever can be admitted behind the Scenes'.[92] The Edinburgh theatre under Ramsay's management had been hosted by the Freemasons of Dundee in 1734: this indeed was part of another innovatory development by the poet, whereby the Edinburgh theatre protected and projected itself by going on tour not only to Dundee, but also 'Montrose, Aberdeen, Newcastle and Scarborough', possibly supported by local booksellers or Freemasons. Cooper's influence may have led to another innovation: Ramsay's organisation of 'visits of London theatre companies to Edinburgh'.[93] Cooper went to Rome in 1735, and performances at Tailors' Hall were suspended from 1735 to 1741, but resumed in December of the latter year under Thomas Este's management, with tickets on sale in coffee houses: as John Ware wrote to John Murray on 28 October 1740, 'I hear they are once more going to attempt a Play house to be made of the Taylor's Hall'. Este also offered music concerts and continued as manager until his death in 1745.[94]

Ramsay stood at the heart of a group who were determined to maintain the cultural potential of the Restoration capital deep into the Union era. On the back of his touring theatre policy, he championed the theatre as a sign of Edinburgh's metropolitan potential in unequivocal terms:

> the City of Edinburgh will Reap the Benefits in Particular since it will not only engage our own Gentlemen and Ladys to water within our walls but also bring many of a Polite Tast from the Northern Countys of England who will Rather Chuse to come 50

or 100 miles North to Edinburgh as to travel 200 miles South to London where all the needful Supports & comforts of Life are not a whit Better or more aboundant but much more expensive.

'The metropolis of a Nation', Ramsay concludes, 'should be encouraged in every thing that is Improving & Pleasing.' It is very telling that when Elliott's *Proposals* for the New Town were written less than twenty years later, at the core of the metropolitan qualities to be emulated lay 'the pleasures of the theatre, and other public entertainments' suitable to maintain the interest and 'splendour and influence' of 'people of rank'. Ramsay's formulation of a northern cultural metropolis clearly foreshadows the vision of Sir Gilbert Elliott and Lord Provost Drummond with respect to the New Town.[95]

Ramsay's mission to set up Edinburgh's first permanent theatre was thus clearly an expression of innovative cultural nationalism, linking identified need to commercialisation, but it was also diffused through his role as a broker of social capital across multiple networks. He faced opposition from the closely knit burgh authorities, but was supported by the leading opinion- formers of the day. Ramsay himself wrote to the Earl of Ilay that he had been 'Induced to take upon him the management of the Play house of Edinburgh' 'at the desire of Several of the best familys of Scotland'. Ilay would have been in a position to know the truth of this, and it seems clear that once again the Scottish nobility were combining with their artistic supporters to encourage innovative development in the face of local opposition from the civic authorities and their allies. Far from the University being an unequivocal source of Enlightenment in the city, as many accounts suggest, it (as something of a creature of the Town Council at this date) petitioned against Ramsay's playhouse. Ramsay responded angrily against that 'bit School that they nickname a Coledge' and gave it as 'my opinion that we had better want this Same Shadow of a university, as to turn our Town into a Sour dul hole'. For Ramsay, the University was on the side of 'Gloomy Enthusiasm', as opposed to 'a good number of Gentlemen & Ladys' who supported his plans for a theatre.[96]

In early 1736, Ramsay had set up his own theatre in Carrubber's Close, calling it 'The New Theatre'. He rented the space 'from the wright and builder, Charles Butter', whom Ramsay 'paid ... to fit the space out for theatrical

performances'. The Carrubber's Close space had been in operation as a theatre at least intermittently from 1715 (Signora Violante performed there from 9 to 25 February 1736, shortly before the alterations commenced) but was for the first time turned into a definitively bespoke space. Butter seems to have raised the roof in the Carrubber's Close tenement, creating a larger performance space (as Joe Rock has argued, the basic shape of the theatre may have survived to be photographed as the home of the Carrubber's Close Mission). Season tickets were offered on 16 September at 30s for the first forty, and £2 2s thereafter: an 'early bird' offering which is surely one of the first of its kind. Ramsay was always adept at marketing and the commercialisation side of innovative practice. The opening offer on 8 November was George Farquhar's *The Recruiting Officer*, with a ballad opera, *The Virgin unmask'd*, as its companion piece; *The Caledonian Mercury* trumpeted that this, the first permanent theatre in Edinburgh, was as good as any small theatre in 'the three Kingdoms': Ruddiman's Jacobite claque was swinging into action.

Ramsay may have used the ensuing publicity to support a forthcoming auction, at which his *Scots Proverbs*, 'just published', would be for sale. However, the opposition from the Kirk and the burgh authorities was stark, strong and immediate. The Licensing Act of 10 Geo II c.28 (24 June 1737) gave them the excuse they needed. This Act gave 'the two patent houses [Drury Lane and Covent Garden] a monopoly of theatrical entertainment (other than musical) for the winter season . . . from September to May'. This heavily pro-London legislation was eagerly seized on by the Presbyterian opponents of theatre as a reason for closing down Ramsay's operation when it had barely begun, in an early example of the willing collusion of Scottish local government in its own provincialisation. The effects of the Act closed theatres at York and Bath, but Bristol and Norwich survived, while in London, Samuel Foote was able to put on political satire at the Haymarket after he acquired it in 1749. Edinburgh's authorities, however, gold-plated the Act to shut Ramsay down. The Act barred both opera and musical interludes in plays from performance 'for Hire, Gain, or Reward', so giving precious little room to manoeuvre for the theatre and its supporters when strictly applied. To survive, the theatre would have needed the support of a local magistrate, but this it was not likely to get. Ramsay objected to the

preference given to London theatres by the Act, and turned to MPs and noble supporters like Lord Glenorchy to try to keep the theatre open: hundreds signed a petition. On 28 June 1737, the poet wrote to Alexander Cunynghame (later Sir Alexander Dick of Prestonfield) that

> I am particularly attacked by a certain act against our own publick Theaters having a Set of Players under my management I should be Sory to see them driven to Beggary now when I had last year opt a braw new House for them.

Ramsay asked Dick 'if a licence from the Ld Chamberlane can be had'. As Ramsay noted to Clerk of Penicuik the next year, the Licensing Act did not stop players enjoying 'the Liberty allowd in all the chief towns in England' to perform, in contrast to Edinburgh, where 'hot clergy' and their burgh allies made it impossible.[97]

But Ramsay's attempts, including an appeal to Ilay on 8 December 1737, were powerless against the combination of London privilege and Presbyterian prejudice. Despite attempts by the players themselves to keep the theatre going, which led to a brief reopening from 5 to 23 January 1739, 'municipal officers attempted to arrest members of the cast' and the theatre collapsed. On 7 April, Ramsay wrote in rage that 'a few sour pedants & Ingnorant [sic] Bigots ... this week have been drawing up pitifull petitions, against the encouragement of chearfull virtue, & the most Rational amusements ... they are a Seditious crew, who will be the ruine of this poor Town if they get their will'. The battles that Ramsay was fighting were similar to those faced by the Moderate party in the 1750s: like them, he objected to 'a narrowness of spirit that too much prevails and makes us generaly too confounded in our thoughts & sentiments and is the bane of friendly Love & generous behaviour'. The hall fitted out by Butter for a theatre became a chapel.[98]

In December 1757, both the Edinburgh and Glasgow presbyteries issued a further 'denunciation of playhouses', but by then matters had moved on, and Edinburgh's theatrical life was established. When Moderate Presbyterian ministers began to write plays, as with John Home's *Douglas*, premiered in Edinburgh in the Old Playhouse Close in 1756, the writing was on the wall, not least because the play was supported by the Argyll interest. Even for Home, however, there was a battle to fight in

which he was sustained by his Moderate allies (one reading of *Douglas* involved Blair, Carlyle, Ferguson, Home, Hume and Robertson) against the 'Admonition and Exhortation' of the Edinburgh Presbytery, which identified theatre as a 'superfluous upper class luxury', a telling criticism given what has been evidenced here as to the social background of its supporters. But the eventual defeat of conservative elements in the city had been to a significant extent due to the innovations of Ramsay and Cooper, though at a high personal cost ('for my private part will be a very deep loser and know no way how to help it', Ramsay observed). The noble support Cooper and Ramsay received was no longer, as it had been for Sibbald, sufficient to displace the power of the burgh authorities, as Edinburgh was no longer a royal capital: however, they represented innovation and its diffusion, in the end diffused too early beyond the point of sustainability.[99]

The art world and art trade, theatre, music and their associated groups were critical to the development of Edinburgh as a capital of innovation at the end of the seventeenth century and in the first half of the eighteenth century. Their cosmopolitanism, heterophile and at the same time homophilously interlinked memberships, together with the driving force of figures like Ramsay and Cooper, all served to create an associational world rich in the interchange and representation that sustains wider worlds of intellectual culture. We know this today, but still do not always evaluate the Enlightenment in terms of the conditions underpinning the contemporary innovations with which we are familiar. In Eric Friedenwald-Fischman's words:

> There is no discipline that nurtures and sparks the cognitive ability to imagine, and unleashes creativity and innovation, more than arts and culture. There is no approach that breaks barriers, connects across cultural differences, and engages our shared values more than arts and culture. There is no investment that connects us to each other, moves us to action, and strengthens our ability to make collective choices more than arts and culture.[100]

As Stéphan Vincent-Lancrin and Ellen Winner argue, 'Artists are role models for innovation in our societies ... "education in the arts is more important than ever. In the global economy, creativity is essential"'.[101] It was that creativity and the conditions for the growth, circulation and interchange of ideas which

Ramsay and those like him brought to the Scottish capital in the early years of the eighteenth century.

The theatre was only one of the aspects of the development of a distinctive cultural infrastructure in the Scottish capital in this era, but it was not, as we shall see elsewhere in this study, untypical. While there is a good deal of truth in the conventional view that the Scottish Enlightenment was engendered by a middle-class intellectual and professional elite, the key continuing role of the Scottish nobility who retained a primary identification with Scotland can be – and usually is – underplayed, especially insofar as they provided a not insignificant amount of the patronage, subscription and circulatory support to professional social networks, clubs and societies. These were, as Jon Mee argues, an 'associational world' which became 'part of the urban renaissance in the broadest sense'.[102] It is to this associational world – the world of taverns, clubs and Freemasonry – that we now turn in our exploration of Edinburgh in the first age of Enlightenment.

Notes

1. Edinburgh City Archives J25 bundle 41a; 'Accompt of pictures from Aikman' [1723], National Records of Scotland GD 18/4567/4592/1; GD 29/432/1-5; Marion Lochhead, *The Scots Household in the Eighteenth Century* (Edinburgh: The Moray Press, 1948), 13; Brian Cowan, 'Areas of Connoisseurship: Auctioning Art in Late Stuart England', in Michael North and David Ormrod (eds), *Art Markets in Europe, 1400–1800* (Aldershot: Ashgate, 1998), 153–66 (154, 156); David Ormrod, 'The origins of the London Art Market, 1660–1730', idem 167–86 (168, 170); J. Lloyd Williams, 'The import of art: the trade for northern European goods in Scotland in the seventeenth century', in Juliette Roding and Lex Heerma Van Voss (eds), *The North Sea and Culture (1550–1800)* (Hilversum: Verloren, 1996), 298–323 (300).
2. Olaf Koester, *Painted Illusions* (London: National Gallery, 2000); Fern Insh, 'An Aspirational Era? Examining and Defining Scottish Visual Culture 1620–1707' (unpublished PhD, University of Aberdeen, 2014), 127; Richard P. Townsend, 'Alexander Keirincx's royal commission of 1639–1640', *Leids Kunsthistorisch Jaarboek* XXII (2003), 137–50 (137, 139, 144, 146). For the Yester estate images, see Scottish National Portrait Gallery 2366 and linked paintings.

3. Tom McInally, *The Sixth Scottish University* (Leiden and Boston: Brill, 2012), 77; Laura A. M. Stewart, *Urban Politics and the British Civil Wars: Edinburgh, 1617–1653* (Leiden and Boston: Brill, 2006), 112; Howard Colvin pointed out the potentially picturesque qualities of Bruce's architecture.
4. Ed Romein and Gerbrand Korevaar, 'Dutch Guilds and the Threat of Public Sales', in Neil Marchi and Hans J. Van Miegrot (eds), *Mapping Markets of Paintings in Europe, 1450–1750*, Studies in Urban History 6, (Turnhout: Brepols, 2006), 165–84 (172, 175); also Brian Cowan, 'Art and Connoisseurship in the Auction Market of Later Seventeenth-Century London', idem, 263–82 (264); I. Bignamini, 'The "Academy of Art" in Britain before the Foundation of the Royal Academy in 1768', in Anton W. A. Boschloo et al., *Academies of Art Between Renaissance and Romanticism*, Leids Kunsthistorisch Jaarboek V–VI (1986–7), 434–50 (439); Anne Meadows, 'Collecting Seventeenth-Century Dutch Painting in England 1689–1760', (unpublished PhD, University College London, 1988), 41, 96; Thomas M. Bayer, 'The Seventeenth Century Dutch Art Market: The Influence of Economics on Artistic Production', *Athena* X (1991), 21–7 (22); Anthony Griffiths with Robert A. Gerard, *The Print in Stuart Britain 1603–1689* (London: British Museum, 1998), 14; Williams in Roding and Van Voss (1996), 315.
5. Iain Pears, *The Discovery of Painting: The Growth of Interest in the Arts in England, 1680–1768* (New Haven and London: Yale University Press, 1988), 57–8. See National Records of Scotland CC 8/12/5 and GD26/13/271 (Leven and Melville Muniments), a 1690s auction catalogue which advises on the procedure to be undertaken when pictures are 'Packed up in Cases, to send them into the Countrey'. I am grateful to Helen Smailes for identifying the modern nature of the Gladstone's Land auction, and to her phrasing of the issue.
6. See *The Edinburgh Courant*, 23–25 April 1705; *The Scots Courant*, 11–14 May, 18–20 July 1711; *The Scots Courant*, 9–11 May 1711 and other issues.
7. Edinburgh City Archives J25 D. Gild Scs; James Colston, *The Incorporated Trades of Edinburgh* (Edinburgh: Colston & Co., 1891), 65. See *The Scots Courant*, 9–11 May 1711, for an advertisement for Norie and Chalmers's shop.
8. Anon., *James Norie: Painter 1684–1757* (Edinburgh: privately printed, 1890), 1, 3. I am grateful to Helen Smailes for further information; see also Joe Rock, 'Richard Cooper Senior (c. 1696–1764) and his Properties in Edinburgh', *BOEC* ns 6 (2005), 11–12 (12); Anne MacLeod, *From an Antique*

Land (Edinburgh: John Donald, 2012), 10; Robert Brydall, *Art in Scotland* (Edinburgh and London: Blackwood, 1889), 108. See also Joe Rock, 'Richard Cooper', *Scottish Archives* 8 (2002), 71–81 (71); Edinburgh University Library MS La IV.24.7.54.
9. Patrick Mauries, *Cabinets of Curiosities* (London: Thames & Hudson, 2011 [2002]), 66, 216; NRS CC 8/12/5.
10. NRS GD 26/13/271 (Leven and Melville Muniments); NRS GD 331/31/37 (Dick Cunyngham Muniments); Sander Varst, 'Off to a new Cockaigne: Dutch migrant artists in London, 1660–1715', *Simiolus* 37:1 (2013–14), 25–60 (30–3); Adriana Turpin, 'The Value of a Collection: Collecting Practices in Early Modern Europe', in Bert de Munck and Pries Lynn (eds), *Concepts of Value in European Material Culture, 1500–1900* (Farnham: Ashgate, 2015), 255–84 (260, 265, 279); Christopher A. Whatley with Derek Patrick, *The Scots and the Union* (Edinburgh: Edinburgh University Press, 2006), 106. I am grateful to Helen Smailes for further information.
11. Cowan, in Marchi and Miegrot (2006), 266–8; Lisa Kahler, 'Freemasonry in Edinburgh, 1721–1746: Institutions and Context' (unpublished PhD, St Andrews, 1998), 260; Michael North, 'Auctions and the Emergence of an Art Market in Eighteenth-Century Germany', in Marchi and Miegrot (2006), 285–302 (285); Rosalind K. Marshall, *John de Medina 1659–1710* (Edinburgh: National Gallery of Scotland Scottish Masters, 1988), 12–13; Richard H. Saunders, *John Smibert: Colonial America's First Portrait Painter* (New Haven and London: Yale University Press, 1995), 9; *The Scots Courant*, 7–9 May 1711; ECA J25 (Town Council Minute of 5 May 1702); National Library of Scotland 1.42 (29).
12. *The Caledonian Mercury*, 7 February 1740; *The Edinburgh Evening Courant*, 15 March 1760, has a fragile and incomplete copy of a catalogue of a 19 March sale of Italian, Scottish and French art by Hamilton and Balfour: thanks to Helen Smailes for this information. See Jeremy Black, *The Grand Tour in the Eighteenth Century* (Stroud: Sutton, 2003 [1992]).
13. NRS GD 26/13/271, 1–6.
14. James Holloway, 'John Urquhart of Cromarty: An Unknown Collector of Italian Painting', in *Scotland & Italy: Papers Presented at the Fourth Annual Conference of the Scottish Society for Art History 1989* (Edinburgh, 1989), 1–13 (1–2, 5, 7, 10–12); Timothy Clifford, 'Imperiali and his Scottish Patrons', in Roberto Paolo Ciardi, Antonio Pinelli and Cinzia Maria Sicca (eds), *Pittura Toscana E Pittura Europea Nel Secolo dei Lumi* (Pisa, 1990), 41 ff (43–5).

15. EUL Laing MSS La. IV.20 A7 f.2; John Ingamells, *A Dictionary of British and Irish Travellers in Italy, 1701–1800* (New Haven and London: Yale University Press, 1997), 11.
16. Ingamells (1997), 314–15, 461, 475, 539, 573, 576, 579, 589, 597, 603, 604, 641, 644, 690; National Archives SP 99/61 f. 332; Pears (1988), 77–8, 81.
17. Helen Smailes and Duncan Thomson, *A Celebration of Mary Queen of Scots: The Queen's Image* (Edinburgh: Scottish National Portrait Gallery, 1987), 61, 107, 108, 112, 155; Stuart Papers HMC VII:5; Ingamells (1997), 685.
18. *James Norie: Painter 1684–1757* (Edinburgh: privately printed, 1890), 3; Ingamells (1997), 475, 691–2; NLS MS 3912 f.37; Margaret Stewart, *The Architectural, Landscape and Constitutional Plans of the Earl of Mar, 1700–32* (Dublin: Four Courts, 2016), xxvii, 230; I am indebted to Helen Smailes for further information. Byres retained live Jacobite contacts abroad: V. Pablo Coen, 'Andrea Casali and James Byres: The Mutual Perception of the Roman and British Art Market in the Eighteenth Century', *Journal for Eighteenth-Century Studies* 34:1 (2011), 291–313 (299) for his Watkins Williams Wynn links.
19. Edward Corp, *The Stuarts in Italy, 1719–1766: A Royal Court in Permanent Exile* (Cambridge: Cambridge University Press, 2011), 11, 101–3, 278.
20. NRS GD18/4340; Edward Corp et al., *A Court in Exile: the Stuarts in France, 1689–1718* (Cambridge: Cambridge University Press, 2004), 183, 185–6.
21. The Parrocel portrait is PG311, Scottish National Portrait Gallery; Keith Thomas, *Man and the Natural World* (Harmondsworth: Penguin, 1987 [1983]), 260.
22. Edward Corp, *The King over the Water: Portraits of the Stuarts in Exile after 1689* (Edinburgh: Scottish National Portrait Gallery, 2001), 78–80, 102–4; Edward Corp, *The Stuarts in Italy, 1719–1766: A Royal Court in Permanent Exile* (Cambridge: Cambridge University Press, 2011), 7.
23. Ingamells (1997), 317, 894; Joe Rock, 'Robert Gordon, goldsmith and Richard Cooper, engraver: A glimpse into a Scottish atelier of the eighteenth century', *Silver Studies* (2005), 49–63 (52–3, 55).
24. I am indebted to Helen Smailes for this information: see her 1996 unpublished paper on 'David Le Marchand's Scottish patrons'.
25. Ed Romein and Gerbrand Korevaar, 'Dutch Guilds and the Threat of Public Sales', in Marchi and Miegrot (2006), 165–84 (171, 174, 184); David Ormrod, 'The Art Trade and its Urban Context: England and the Netherlands Compared, 1550–1750',

in Jeremy Warren and Adriana Turpin (eds), *Auctions, Agents and Dealers: The Mechanism of the Art Market 1660–1830* (Oxford: Beazley Archive/Wallace Collection, 2007), 11–19 (14).
26. I. Bignamini, 'The "Academy of Art" in Britain before the Foundation of the Royal Academy in 1768', in Anton W. A. Boschloo et al., *Academies of Art Between Renaissance and Romanticism*, Leids Kunsthistorisch Jaarboek V–VI (1986–7), 434–50 (435–40, 442, 445); James Holloway, *William Aikman 1682–1731*, Scottish Masters 9 (Edinburgh: National Gallery of Scotland, 1988), 15; Kit Wedd with Lucy Peltz and Cathy Ross, *Creative Quarters: The Art World in London from 1700 to 2000* (London: Merrell; Museum of London, n.d.), 42.
27. ECA SL 34/1/3 and SL 34/1/5/13, 16; NRS CC 8/8/121/555; EUL MS La. IV 24.7.58.
28. Ingamells (1997), 13; Joe Rock, 'The Decorated Room at Moray House, c. 1706–c. 1710', *BOEC* ns 12 (2016), 1–16 (11–12).
29. Holloway (1988), 12.
30. EUL MS La. IV. 24.1, 1, 6–9; James Dennistoun, *Memoirs of Sir Robert Strange*, 2 vols (London: Longman, 1855), I: vii, 21–3; II: 35–6, 279; Ingamells (1997), 239; Joe Rock, 'Richard Cooper', *Scottish Archives* 8 (2002), 71–81 (71, 72, 73, 75, 77–8); Rock (2005a), 11–14, 16–17; Rock (2005b), 62; Rock, 'Richard Cooper Sr and Scottish Book Illustration', in Stephen W. Brown and Warren McDougall (eds), *The History of the Book in Scotland* (Edinburgh: Edinburgh University Press, 2012), II: 81–90 (81, 83); https://sites.google.com/site/richardcoop erengraver/cooper-s-early-years-in-england; Timothy Clayton, *The English Print 1688–1802* (New Haven and London: Yale University Press, 1997), 3; Vic Gatrell, *The First Bohemians* (London: Penguin, 2014 [2013]), 173; John C. Guy, 'Edinburgh Engravers', *BOEC* IX (1916), 79–113 (79–80, 113); *BOEC* XI (1922), 170; Margery Morgan, 'Jacobitism and Art after 1745: Katherine Read in Rome', *British Journal for Eighteenth-Century Studies* 27:2 (2004), 233–44 (233–4); Hugo Arnot, *The History of Edinburgh* (Edinburgh: West Port Books, 1998 [1779]), 218: Charles Dibdin, *The Annals of the Edinburgh Stage* (Edinburgh: Richard Cameron, 1888), 65.
31. NRS GD 110/946/2; Ingamells (1997), 216, 685; Smailes and Thomson (1987), 82. I am indebted to Helen Smailes for further information. For Hamilton's life, see Nelson Bushnell, *William Hamilton of Bangour: Poet and Jacobite* (Aberdeen: Aberdeen University Press, 1957).
32. Morgan (2004), 233, 234, 238. I am indebted to Helen Smailes for the Rouen reference.

33. NLS MS 14261; Ingamells (1997), 616–17; Dennistoun (1855), I: 206–7, 253, 311; Rock (2002), 78 for the 1755 commissions.
34. Duncan Thomson authenticated the original portrait as Ramsay's: see *The Culture Show: The Lost Portrait of Bonnie Prince Charlie*, BBC2, 22 February 2014.
35. Ingamells (1997), 214, 216; Bushnell (1957), 89; Dennistoun (1855), II: 303–4.
36. Ingamells (1997), 12, 192, 448.
37. Dennistoun (1855), II: 35–6, 143–5.
38. Helen Armet, 'Allan Ramsay of Kinkell's Property on the Castlehill', *BOEC* XXX (1959), 19–30 (20).
39. NLS MS 2903 f.6v (plans for installing gas lighting in Ramsay Garden, 26 August 1834); Murray Pittock, 'Allan Ramsay', *Oxford DNB*; Patricia R. Andrew, 'Four Statues and a Landslip: Allan Ramsay, John Wilson, Thomas Guthrie and Charity', *BOEC* ns 12 (2016), 65–82 (65–7).
40. Iain Gordon Brown, 'Allan Ramsay's Rise and Reputation', *The Walpole Society* 50 (1984), 209–47 (229, 230n); Bushnell (1957), 128n.
41. EUL MS La IV. 24.8. 341; Arnot (1998 [1779]), 422; Patricia Brookes, 'The Trustees' Academy, Edinburgh – 1760–1801: The public patronage of art and design in the Scottish Enlightenment' (unpublished PhD, Syracuse, 1989), 152, 158–9, 164, 168, 224–30; Roy Porter, *Enlightenment: Britain and the Creation of the Modern World* (London: Penguin, 2001 [2000]), 40, 242.
42. MacQueen (2012), lxi.
43. John Jackson, *The History of the Scottish Stage* (Edinburgh: Peter Hill, 1793), 7.
44. Dibdin (1888), 13, 20, 21, 24; Findlay (1998), 39–40; Anthony Griffiths with Robert A. Gerard, *The Print in Stuart Britain 1603–1689* (London: British Museum Press, 1998), 184.
45. Dibdin (1888), 26–7; Roger L. Emerson and Jenny Macleod with Allen Simpson, 'The Musick Club and the Edinburgh Musical Society', *BOEC* ns 10 (2014), 45–105 (49); Bill Findlay (ed.), *A History of Scottish Theatre* (Edinburgh: Polygon, 1998), 62–3, 68, 71; Thomas Ahnert, *The Moral Culture of the Scottish Enlightenment 1690–1805* (New Haven and London: Yale University Press, 2014), 35–6, 66–7; Sara Stevenson and Duncan Thomson with John Dick, *John Michael Wright: The King's Painter* (Edinburgh: Scottish National Portrait Gallery, 1982), 78–9; John MacQueen (ed.), *Tollerators and Con-Tollerators: a comedy attributed to Archibald Pitcairne* (Columbia: South Carolina Libraries, 2015), 7.
46. NRS GD 45/14/437 (Allan Ramsay, 7 April 1739).

47. Dibdin (1888), 26–34; Findlay (1998), 57, 61, 71, 73. See also Sacheverell Sitwell and Francis Bamford, *Edinburgh* (London: Faber, 1938), 171; Ian Brown, 'Allan Ramsay: Theatrical Impresario', unpublished paper, Association for Scottish Literary Studies annual conference, Edinburgh, 10 June 2017.
48. *BR 1681–1689*, liii, 112; Sitwell and Bamford (1938), 171; *The Scots Post-Man*, 4–6 October 1711, 250.
49. Dibdin (1888), 26–7; R. A. Houston, *Social Change in the Age of Enlightenment: Edinburgh, 1660–1760* (Oxford: Clarendon Press, 1994), 205, 216, 220; Bill Findlay, 'Beginnings to 1700', in Bill Findlay (ed.), *A History of Scottish Theatre* (Edinburgh: Polygon, 1998), 1–79 (61, 73); Morrice McCrae, *Physicians and Society: A History of the Royal College of Physicians in Edinburgh* (Edinburgh: John Donald, 2007), 18; Alexander Law, *Education in Edinburgh in the Eighteenth Century* (London: University of London Press, 1965), 191; David Johnson, *Music and Society in Lowland Scotland in the Eighteenth Century* (Oxford: Oxford University Press, 1972), 33–4; Ricky Jay, *Extraordinary Exhibitions* (New York: Quantuck Lane Press, 2005), 22–3.
50. *The Caledonian Mercury*, 1 March 1725; *The Thistle*, 13, 20 November 1734.
51. Roger Fiske, *English Theatre Music in the Eighteenth Century* (London: Oxford University Press, 1973), 102; for the 'dependency' of Edinburgh, see Rachel Cowgill and Peter Holman (eds), *Music in the British Provinces, 1690–1914* (Aldershot: Ashgate, 2007), xxii.
52. Dibdin (1888), 37–40; Jerry Brannigan and John McShane, *Robert Burns in Edinburgh* (Glasgow: Waverley Books, 2015), 109; Adrienne Scullion, 'The Eighteenth Century', in Findlay (1998), 80–136 (87, 89); Sir Daniel Wilson, *Memorials of Edinburgh in the Olden Time*, 2nd edn (Edinburgh and London: Adam & Charles Black, 1891), 42, 89; Terence Tobin, *Plays by Scots 1660–1800* (Iowa City: University of Iowa Press, 1974), 19; Houston (1994), 205; MacQueen (2015), 13, 19; Brown, 'Allan Ramsay: Theatrical Impresario'.
53. Arnot (1998 [1779]), 221; Emerson et al. (2014), 45–7, 54–5, 65; W. Forbes Gray, 'The Musical Society of Edinburgh and St Cecilia's Hall', *BOEC* XIX, 189–245 (192); Bryan White, '"A pretty kind of Musical Friends": The Ferrar brothers and a Stamford Music Club in the 1690s', in Cowgill and Holman (2007), 9–44 (9); ECA Moses Bundles VI: 173/6818. Tobin (1974), 27 attributes plays in conjunction with concerts to Thomas Este in 1737. William Tytler seems to have 'had access to the original programme' for his *Life of Henry Home*

(1807) (Jennifer Macleod, 'The Edinburgh Musical Society: Its Membership and Repertoire 1728-1797', unpublished PhD, University of Edinburgh, 2001, 22).
54. *The Edinburgh Gazette*, 11-14 December 1699, No. 84.
55. *The Edinburgh Courant*, 28-30 July 1707.
56. Johnson (1972), 30, 33, 34; Johnson, *Scottish Fiddle Music in the Eighteenth Century: A Music Collection and Historical Study*, 3rd edn (Edinburgh: Mercat Press, 2005 [1984]), 1; Matthew Gelbart, *The Invention of 'Folk Music' and 'Art Music'* (Cambridge: Cambridge University Press, 2007), 31; Macleod (2001), 22-3, 26, 30, 60, 141, 190; Emerson et al. (2014), 47, 52, 54; *The Scots Courant*, 10 December 1718, 23 January 1719.
57. Macleod (2001), 22-3, 26, 30, 60, 141, 190; Emerson et al. (2014), 47, 52, 54; *The Scots Courant*, 10 December 1718, 23 January 1719; Peter Holman, 'A Little Light on Lorenzo Bocchi: An Italian in Edinburgh and Dublin', in Cowgill and Holman (2007), 61-86 (61-2). I am grateful to David McGuinness and Aaron MacGregor for additional information arising from their contribution to the Ramsay symposium at the University of Glasgow on 9 December 2016.
58. MacLeod (2001), 23, 26, 30, 33, 52, 53, 188, 194-5, 199-201, 236-7, 238, 240, 241, 243, 246, 254, 309; Emerson et al. (2014), 51.
59. McLeod (2001), 58, 69, 100, 101, 123, 184, 287-8; Pierre Dubois, *Music in the Georgian Novel* (Cambridge: Cambridge University Press, 2015), 19, 20, 35, 75.
60. NLS ACC 9546 for the MS of Ramsay's 1719 poem to the Musical Club; *BR 1689-1701*, xxxvii; Houston (1994), 205-9, 216, 220; Arnot (1998 [1779]), 212, 214, 221; Dibdin (1888), 35, 48-9; Gray (1933), 194, 204; Sir Daniel Wilson, *Memorials of Edinburgh in the Olden Time*, 2nd edn (Edinburgh and London: Adam & Charles Black, 1891), 42-3, 89; Scullion (1998), 93; Margaret Oliphant, *Royal Edinburgh* (Twickenham: Senate, 1999 [1890]), 422; Marion Lochhead, *The Scots Household in the Eighteenth Century* (Edinburgh: The Moray Press, 1948), 276.
61. Holman, in Cowgill and Holman (2007), 64-6, 73-4, 77.
62. Emerson et al. (2014), 46; Andrew Gibson, *New Light on Allan Ramsay* (Edinburgh: William Brown, 1927), 27, 28, 32, 73; Jennifer MacLeod, 'The Edinburgh Musical Society', *BOEC* ns 19, 31-91 (65); Gray (1933), 194; Johnson (1972), 33-4; email from Professor Kirsteen McCue to the author, 15 November 2012; Arnot (1998 [1779]), 221; Edinburgh Burgh Sasines Register B22/2/23; NRS GD18/4364; Bushnell (1957), 16; Holman, in Cowgill and Holman (2007), 72.

63. James H. Jamieson, 'Social Assemblies of the Eighteenth Century', *BOEC* XIX (1933), 31–91 (36, 39, 89); Rosalind K. Marshall, *Women in Scotland, 1660–1780* (Edinburgh: National Galleries of Scotland, 1979), 69; *The Caledonian Mercury*, 25 February 1740; Jane Clark, 'The Stuart presence at the opera in Rome', in Edward Corp (ed.), *The Stuart Court in Rome: The Legacy of Exile* (Aldershot: Ashgate, 2003), 85–93 (92); Bushnell (1957), 62. I am grateful to Rosemary Coupe's work in this area.
64. Jamieson (1933), 45, 47, 49, 60, 71, 72, 87–90; Bob Harris, *A Tale of Three Cities: The Life and Times of Lord Daer 1763–1794* (Edinburgh: John Donald, 2015), 47; HMC 72: 412 (Laing II).
65. Richard Leppert, *Music and Image* (Cambridge: Cambridge University Press, 1998), 89–90, 94, 96, 97; Mary Cosh, *Edinburgh: The Golden Age* (Edinburgh: John Donald, 2003), 21.
66. See Murray Pittock, 'Introduction', in *The Scots Musical Museum*, 2 vols (Oxford: Clarendon Press, 2018), I:1–40.
67. IELM II:219. For 'O'er the Hills' as a Jacobite air, see Pittock (ed.), James Hogg, *The Jacobite Relics of Scotland First Series* (Edinburgh: Edinburgh University Press, 2002), 51, 442–4; *The Works of Allan Ramsay*, ed. Burns Martin and John W. Oliver, Vol. I (Edinburgh and London: Blackwood [1945]), xviii, xix; *Works*, ed. Alexander M. Kinghorn and Alexander Law (1970), Vol. IV: 173.
68. John Ramsay of Ochtertyre, *Scotland and Scotsmen in the Eighteenth Century*, introduced by David J. Brown, 2 vols (Bristol: Thoemmes Press, 1996 [1838]), II:87.
69. *James Watson's Choice Collection of Comic and Serious Scots Poems*, ed. Harriet Harvey Wood, 3 vols (Edinburgh: Scottish Text Society, 1977 [1709–11]), Vol. II; Ramsay, *Works*, IV:274; EUL La II.212 f.20; Davis, *Borders of Romanticism*, 191; Murray Pittock, *Poetry and Jacobite Politics in Eighteenth-Century Britain and Ireland* (Cambridge: Cambridge University Press, 2006 [1994]), 150.
70. John Aikin, *Essays in Song-Writing*, 2nd edn (Warrington: William Eyres, 1774), 34; Rhona Brown, 'Literary Communication and Commemorations in the Edinburgh Cape Club', *Journal for Eighteenth-Century Studies* 38:4 (2015), 525–39 (526); Ronnie Young, '"The Book o' Maybes is very braid": Ramsay's Scots Proverbs and Enlightenment Print Culture', unpublished paper, 'Scotland 1715–1780: Literature, Culture, Art, and Music', Association for Scottish Literary Studies Annual Conference, 10 June 2017.
71. Ramsay, *Works* I:xviii–xix; NLS Ry. III.a.10 no. 112; EUL La II.212 f. 10; Thomas G. Rosenmeyer, *The Green Cabinet*:

Theocritus and the European Pastoral Lyric (Berkeley and Los Angeles: University of California Press, 1969), 10; Adam Fox, 'The Emergence of the Scottish Broadside Ballad in the late Seventeenth and early Eighteenth Centuries', *Journal of Scottish Historical Studies* (2012), 169–94 (174–5); Marshall (1979), 9.
72. Woodhouselee in Ramsay, *Works*, IV:55.
73. Alexander Pope, *The Dunciad in Four Books*, ed. Valerie Rumbold (London: Longman, 1999), 378; *Critical Essays from the Spectator by Joseph Addison*, ed. Donald Bond, 36; Brown and McDougall (2012), 9.
74. Rosenmeyer (1969), 93, 113.
75. Indeed, dating back as far as Oliphant (1999 [1890]), 422.
76. Gelbart (2007), 29, 64; Tytler 'A Dissertation on the Scottish Musick', in Arnot (1998 [1779]), 372–83 (372).
77. J. Balfour Paul, *History of the Royal Company of Archers* (n.p., 1875), 71, 286–7, 310, 358, 359, 360, 361, 363, 364, 365; Jamieson (1933), 89; Dibdin (1888), 43.
78. Fiske (1973), 111; Dibdin (1888), 41, 43; EUL La II. 212 ff 1-35; J. McKenzie, 'School and University Drama in Scotland, 1650–1760', *Scottish Historical Review* XXXIV (1955), 103–21 (105–6, 109–10); Holman, in Cowgill and Holman (2007), 76–7; Ian Brown, 'Allan Ramsay as Theatrical Impresario', 10 June 2017.
79. Dibdin (1888), 43; *BOEC* XI (1922), 137, 163, 170; Rock (2012), II:83.
80. Lewis Melville, *Life and Letters of John Gay* (London: Daniel O'Connor, 1921), 80, 85, 95, 98, 100; Calhoun Winton, *John Gay and the London Theatre* (Lexington: University Press of Kentucky, 1993), 39, 90, 112, 129, 134; Bob Harris and Charles McKean, *The Scottish Town in the Age of Enlightenment 1740–1820* (Edinburgh: Edinburgh University Press, 2014), 365; Jeremy Black, *Eighteenth-Century Britain 1688–1783*, 2nd edn (Basingstoke: Palgrave Macmillan, 2008 [2001]), 172; Holman, in Cowgill and Holman (2007), 77.
81. Melville (1921), 110–11; 'Kate and Susan, A Pastoral to the Memory of John Gay, Esqr', *Works*, III:225; Wilson (1891), 108; NRS GD 18/4323, 4337, 4361 (Clerk of Penicuik papers).
82. Gelbart (2007), 29, 31, 46; John O'Brien, *Harlequin Britain* (Baltimore: Johns Hopkins University Press, 2004), xxiv; Winton (1993), 121; NLS ACC 9546; *Works*, IV:103, 135.
83. Marie Stuart, *Old Edinburgh Taverns* (London: Robert Hale, 1952), 155–6; NLS MS 5657 f.187.
84. Adam Fox, 'The Emergence of the Scottish Broadside Ballad in the late Seventeenth and early Eighteenth Centuries', *Journal of the Scottish Historical Society* (2012), 169–94 (174).

85. *The Caledonian Mercury*, 28 April 1720; 14 November 1721; 17 June 1723; 13 January 1724; 4 January, 1 March, 27 April, 22 June 1725; Douglas Duncan, *Thomas Ruddiman* (Edinburgh and London: Oliver & Boyd, 1965), 4, 47, 49, 57, 75, 78n, 166–7, 170–2; BOEC XI (1922), 166; NLS MS 15972.
86. Ingamells (1997), 214–16; BOEC XI (1922), 170; Findlay (1998), 68. For the Jacobite symbolism of *Venice Preserved*, see Paul Monod, 'Pierre's White Hat: Theatre, Jacobitism and Popular Protest in London, 1689–1760', in Eveline Cruickshanks (ed.), *By Force or By Default? The Revolution of 1688–1689* (Edinburgh: John Donald, 1989), 159–89.
87. NLS MS 15972; Rock (2005a), 11–23 (12); BOEC XI (Edinburgh: T. & A. Constable, 1922), 78–9; Murray Pittock, 'William Hamilton of Bangour', *Oxford DNB*.
88. I am very grateful to Steve Newman for this information.
89. Robert Cochrane, *Pentland Walks with their Literary and Historical Associations*, ill. George Shaw Aitken (Edinburgh: Andrew Elliot, 1930), 101.
90. Judy Preston, 'Thomas Wright's Edinburgh Almanack, 1733', in BOEC ns 9, 115–21 (119); *The Caledonian Mercury*, 2 January 1735; Rock (2005), 15; Dennistoun (1855), II:144; Scullion, in Findlay (1998), 93; Tobin (1974), 24.
91. Rock (2005b), 58; *The Caledonian Mercury*, 2 January 1735.
92. Rock (2012), 81–90 (85–6); BOEC XI (1922), 167.
93. Harris and McKean (2014), 365: Scullion (1998), 93; Dibdin (1888), 45; *The Caledonian Mercury*, 13 August 1734.
94. BOEC XI (1922), 167; Dibdin (1888), 44–5, 53; Scullion, in Findlay (1998), 95; Tobin (1974), 106; NRS 15/10/42/1.
95. NLS MS 2233 f. 28; A. J. Youngson, *The Making of Classical Edinburgh* (Edinburgh: Edinburgh University Press, 1988 [1966]), 4, 10.
96. NLS MS 17604 f. 26; NLS Adv MS 23.3.26, ff. 21, 23, 27 (Eaglescarnie papers); Richard B. Sher, *The Enlightenment and the Book* (Chicago: University of Chicago Press, 2006), 22.
97. NRS GD 331/5/25; Cecil Price, *Theatre in the Age of Garrick* (Oxford: Blackwell, 1973), 52, 84, 175, 180; *The Caledonian Mercury*, 4, 25 November 1736; Dibdin (1888), 47, 49, 50, 51; *The Caledonian Mercury*, 16 September 1736; Rock (2005), 15; Scullion, in Findlay (1998), 93; Ramsay, *Works*, IV: 207–9; NRS GD 18/4342 (Ramsay to Clerk of Penicuik, 31 October 1738); Ian Brown, unpublished paper, presented at Association for Scottish Literary Studies annual conference, 10 June 2017.
98. NRS GD 45/14/437; Ramsay, *Works*, IV: 207–9; *These Fifty Years: The Story of the Carrubber's Close Mission Edinburgh* (Edinburgh: The Tract and Colpartage Society, 1909), 19.

99. Rick Sher, *Church and University in the Scottish Enlightenment* (Princeton: Princeton University Press, 1985), 77–9; NRS GD 18/4342; Ian Brown, unpublished paper, 10 June 2017.
100. Eric Friedenwald-Fishman, 'No art? No social change. No innovation economy', *Stanford Social Innovation Review*, 26 May 2011.
101. http://oecdeducationtoday.blogspot.co.uk/2013/06/arts-education-in-innovation-driven.html#sthash.4BcsIX9C.dpuf
102. Jon Mee, 'Introduction' to *Journal for Eighteenth-Century Studies* (special issue on Networks of Improvement) 38:4 (2015), 475–82 (477).

5 Taverns, Associations and Freemasonry

Clubs and Associations

The importance of clubs and associations in generating the intellectual climate of Enlightenment Edinburgh has been taken as a given ever since the pioneering work done by David McElroy in the 1950s.[1] The mechanisms by which they initiated innovation and promoted its diffusion have been less well explored, though networks and an imprecise alignment with that useful but inexact concept, 'the public sphere', have formed much of the basis for evaluating the importance of associational life, both in Edinburgh and elsewhere. The exploration of the nature of Edinburgh clubs and societies, and the reasons for their significance, soon brings us back in fact to ground already familiar from earlier chapters. Many clubs and associations provided cross-fertilisation between the nobility, the professions, merchants and trade: indeed, 'democratic rules of membership' were a persistent feature of Edinburgh clubs, for 'all citizens had a role to play in power games . . . political influence was by no means confined to the elites and it certainly did not flow only in one direction'. Edinburgh was not alone in this: in London, too, 'the metropolitan hierarchy . . . proved permeable at every level, and permeability was lubricated by foreign influence'. The two capitals were very much alike.[2]

As we have already seen, the professions which were central to the strength of Edinburgh's innovation and development from 1660 to 1750 were also to the forefront of the intense intellectual and associational life which came to character-

ise the city. They formed an early alliance with the patriotic impulses of the native nobility in the development of organisations which would come to transform themselves into the clubs and societies of eighteenth-century Edinburgh. At least one antiquarian club seems to have been active in the 1690s, and this was followed by Scottish Jacobite and Whig clubs (such as the 'Society for Endeavouring Reformation of Manners' (1699), and the Associated Critics and the Rankenian, both dating from 1716–17), then by intellectual organisations such as the Honourable Society of Improvers in the Knowledge of Agriculture in Scotland (1723) and, lastly, quasi-academies such as the Society for the Improvement of Medical Knowledge (1731) and the Philosophical Society (1737). These societies often comprised men of differing political opinions, but began to develop (as the Philosophical Society did) a new language of civility which preserved a civilised and pluralistic exchange through the proscription of religious or political debate, and which formed the basis for elements in the worldview of Adam Smith in his *Theory of Moral Sentiments*, first published in 1759.[3]

Of the forty-six founding members of the Philosophical Society in 1737–8 (which included James Earl of Morton as President, Lords Aberdour and Hope and Sir John Clerk of Penicuik and Colin Maclaurin as secretaries), six were members of the Faculty of Advocates, and thirty-three of them had been members of other known clubs previously, a very strong and iterative network. Half the membership came to be doctors or advocates, but the range of topics in the Society's ten or so meetings a year was impressively diverse. The major professions also controlled recreational as well as intellectual space: after 1751, Canongate theatre itself 'ended up in the ownership largely of members of the College of Justice'.[4] Edinburgh blurred the boundary between sociability and professional development: for example, the Medical Society published case histories. This had been going on for a long time: the Trained Bands of Edinburgh were both a professional organisation (receiving a Constitution from the Town Council in 1663) and a social one. From 1687, their Society of Captains had a 'monthly meeting': the supper bill for its sixteen members on one occasion included twenty-eight bottles of claret (56s), five of wine and negus (12s), two pint bottles of claret (12s), one bottle of hock (4s), five bottles of rum for punch (30s), with 7s 4d for beer and porter. Supper was 55s, and the total food bill (including jelly, raisins, and almonds

and biscuits) was £3 10s 10½d; drink was £6 1s 4d, plus a shilling for broken glasses. Sociability – which might be a polite term for it – was a given out of such gatherings.[5]

The strong links between powerful members of the professions and gentry, often with international experience, thus served to give the transformative strength required in the development of innovatory practice in 'the uniqueness of the city's intellectual life in the urban congestion of the Old Town'. This was further reinforced by kinship relations which were not so close as to be introspectively homophile, but provided weak kin-based ties which sustained professional and social networks built on shared interests. To take only a very few examples of this, William Cullen was cousin to John Millar, William Robertson to Robert Adam, and Colin MacLaurin was the great uncle of Agnes Maclehose, Burns's Clarinda. Joint membership across the universe of relatively small clubs and societies intensified the effects of these mutual relations.[6]

The clubs, taverns and societies of Edinburgh have been characterised as functioning 'as a highly creative, popular, and thus effective response to the hegemony of English power'. This is perhaps over-simplistic: most, if not all, of these associations were patriotically Scottish, but a large number of these operated within a British political context which recognised the challenges and opportunities of post-Union society. There were, however, some which directly opposed the new settlement of the state, such as the Knights of the Horn, founded in 1705 ('to put to the horn' was to outlaw). A February 1707 broadside, *The Knights of the Horn Orders Address to the Fruit Maids of Edinburgh*, became the basis for a number of anti-Union songs:

> This Nations Sins are many fold,
> And *Scotland* has no name,
> Since Honours cast in a new Mould,
> And Chastities a Stain.
> How Men and Women did behave,
> I'll tell you Sir's the manner
> When *Wallace* and the *Bruce* did live,
> And I was a Dame of Honour.

The Horn Order owed 'its inception mainly to the exertions of John, third earl of Selkirk' and was active at the time of the Union; its title was later used to refer to 'promiscuous dancing',

an interesting example of the interlinking of political oppositionalism and the performing arts, which we have seen above in Chapter 4.[7] The popularity of clubs such as the Horn was crucially important in the light of their limited membership: Edinburgh clubs and associations often had between forty and seventy members, so while socially inclusive to an extent in terms of merit, they nonetheless represented an elite. They were also driven by environmental considerations: there was little available space for domestic socialising in the vast, narrow, tall and crowded lands round the Hie Gait.

The Royal Company of Archers (founded in 1676), and strongly associated with Jacobitism, boasted a huge spectrum of membership. Queen Anne gave them a royal charter in 1703, and a tartan uniform – signifier of Scots patriotism – followed. Indeed, in 1715 the still-life painter Richard Waitt painted James 'VIII' in the uniform of the Royal Company, in a clear hint of its loyalty to the Stuarts in the year of the great Rising.[8] But this political linkage was already well established. Viscount Tarbat was Captain-General of the Archers in 1703; Erskine of Dun joined on 20 May 1704; Pitcairne became a member on 19 April 1708; Hepburn of Keith on 8 June 1713; John Stewart, son to Traquair, on 1 March 1714; Francis Bruce of Clackmannan on 7 July 1714: all were well-known Jacobites. Laurence Oliphant of Gask, lieutenant-colonel of the Perthshire Horse and Jacobite Governor of Perth in 1745, was inducted on 12 January 1716. In 1718, James Francis Edward Keith, the Earl Marischal's brother, joined; in 1725, Alexander Bannerman of Elsick's brother and son: the son was colonel of his regiment in the 'Forty-five Rising, while his father had been quartermaster in 1715. On 30 August 1725, Alexander MacDonald of Sleat joined; in 1728, David Thriepland of the Jacobite Fingask family; on 11 June 1733, the day after King James's birthday, Murray of Broughton, who was to be Secretary to Charles Edward in 1745, joined; in 1734, Allan Ramsay the painter became an Archer, Richard Cooper having entered the Archers on 17 April 1732. In 1741, William Drummond, whose father and uncle both commanded in the 'Forty-five, became a member, as did the younger Gask (his Act of Admission of 16 July survives), soon to be a captain in Jacobite service. Lord Elcho, the Jacobite Lifeguard commander, followed soon afterwards, as did George Lockhart younger of Carnwath, who served as ADC in the 'Forty-five Rising. If these men were associating to form

the bodyguard to their sovereign, it is all too clear which king they intended to defend the interests of.

In 1745, the year of the major Jacobite Rising, the Company's Minutes are 'judiciously brief'; in 1746, Murray of Broughton was expelled for turning King's Evidence against Lord Lovat, and even in the aftermath of the 'Forty-five, the Archers were sufficiently unabashed to elect Captain MacDonald, an officer of the Royal Scots in the French service, to membership on 22 August 1747. Even the seal of the Archers demonstrated their politics: a man in a philabeg under a tree with broadsword and targe, the insignia of the patriot Jacobite. Incidentally, the philabeg (*feileadh beag*) or short kilt was on the seal of the Archers before the time – just before the 'Forty-five – when it is generally supposed to have been introduced. The Archers adopted tartan as their uniform in 1713, which may be the year of the development of a distinctive Jacobite sett in Edinburgh which is now once more available. The tartanry of James's court at Holyrood had shown that tartan was 'clearly beginning to be the cloth of the Stuart legitimist party during the Exclusion Crisis', and it uniformed Lowland soldiers in Dundee's army in 1689 and became the default uniform of Jacobite armies there-

Figure 23 Edinburgh pattern (Jacobite) tartan. Author's image.

after. The Archers were at the heart of this world of visual if mute sedition.[9]

The Easy Club was founded on 12 May 1712, with Pitcairne, Ruddiman and Ramsay among the usual suspects in its membership, as well as – reputedly – other prominent Jacobites such as Patrick Abercrombie (1656–c. 1716), author of *Martial Atchievements of the Scots Nation* (1711–16), major donor to the Jacobite Rising of 1715 and strong opponent of Union. The Easy Club itself seems to have descended from the Greppa, at which Pitcairne presided, which had opened in the premises previously occupied by John's Coffee House under the piazza 'at the north-east of Parliament Close'. The howff there, known as the Greping Office, was composed of dark underground chambers. Its name has sometimes been attributed as a reference to groping in the dark, although the allusion to a brothel by Pitcairne may be nearer the mark. Strongly Jacobite and anti-Union, the Greping Office was 'a high Tory refuge',[10] and portrayed as 'Hades' by the Whigs. Under Mistress Henderson ('the Greppa' (bawd?)), it had its heyday in the 1690s. She sold wine at S20d a pint, undercutting the normal price of S32d, especially, it seems, when she knew that the arrival of new French wine was imminent, and wanted to clear out old stock.[11]

The Easy Club itself was apparently so named because of the outlook on life common to its members, who 'look upon ourselves as the best constitute most harmonious aggreable [sic] and happy corporation in the 3 kingdoms'. As 'George Buchanan' (John Ferguson), its Secretary, wrote to *The Spectator* in asking for advice on 'the best methods and Rules to be observed in a Society of our Constitution' on 15 August 1712, 'none of ane empty quarreling temper can have the privilege of being a member'. Initially its small membership ('Our Club consists just now of Eight members') took *noms de plume* from both English and Scottish history: James Stuart was 'Rochester', Pitcairne was 'Heywood', Mr Edgar was 'Sir Roger L'Estrange', Allan Ramsay 'Isaac Bickerstaff' and John Fergus (we are not absolutely certain of this identification) was 'George Buchanan', the only originally Scottish figure. With the exception of Pitcairne, it is likely that some of the more socially prestigious members ascribed to the Club, like Abercrombie, were occasional visitors only, if that.[12]

While it is widely recognised that the Club's shift from English to Scottish *noms de plume* which occurred shortly

after Pitcairne's death on 20 October 1713 was a watershed – perhaps a political watershed – in the Easy Club's development, not enough attention has usually been given to the continuation of 'Buchanan' in both stages of the Club or to the implications of the earlier English names. 'Rochester' (Stuart became 'Lord Napier' in 1713), the name of the legendary rakehell English peer and favourite of Charles II, was suggestive not only of the Greping Office links of the Easy Club, but also of Rochester's close connexion in his later poetry to adaptations of broadsides, an innovative practice that Ramsay was soon to initiate in Scotland. Indeed, *Maggie Johnstone's elegy*, a second edition of which dated 30 July 1713 is in the Club papers, seems first to have been published in broadside form.[13]

'Sir Roger L'Estrange', meanwhile, was the name of the famous Royalist and Jacobite English journalist, who had recently (1704) died at a great age. L'Estrange had both been a moderate in religion and an innovator in culture, supporting the development of Thomas Britton's London concerts from 1678 and writing against the Protestant fanaticism of the 'Popish Plot'. 'Isaac Bickerstaff', meanwhile, was the pseudonym used by Swift (himself suspected of being a Jacobite, a question not yet resolved) on All Fools' Day (1 April) 1708, a year before Richard Steele utilised the name in *The Tatler*. In Swift's hands, 'Bickerstaff' veiled a bitter satire against fortune-telling by the 'Starmonger and Quack' John Partridge: Ramsay's initial adoption of the name could thus be read as an espousal of rational values, opposed to superstition and religious fanaticism. Pitcairne's 'Heywood' was a reference to Thomas Heywood (c. 1570/75–1641), today most famous as the author of *A Woman Killed with Kindness* (1607), and was thus a tribute to Pitcairne's status as a playwright. Once again Heywood was a notable Stuart Royalist who wrote for Queen Henrietta's men under Charles I and whose masque, *Love's Mistress*, was reputedly seen by Charles I and his queen three times in little more than a week. All these figures, therefore, were associated with the Stuart dynasty (George Buchanan had been James VI's tutor), and also largely with music, theatre and a moderate, rational and sceptical politics far removed from the restrictive fanaticism of some contemporary Presbyterianism, and also mockingly doubtful of superstition. Pitcairne's own plays give vent to these values, as does his poetry: and given the *noms de plume* adopted by the Club membership, it seems fairly clear

that, while the Addisonian and Steeleite world of *The Spectator* and *The Tatler* was referenced, the central point of the initial names chosen by the Easy Club was to honour Pitcairne and the values of the Royalist world he represented, both culturally British and patriotically Scottish.

In this sense, Pitcairne's death brought about, not just a volte-face to a patriotic Scottish series of monikers, but a deeper crisis. While Ramsay changed his name to 'Gavin Douglas' (itself a tribute perhaps to Pitcairne's classicism, since Douglas was the first translator of Vergil into the vernacular in the British Isles), 'Roger L'Estrange' became 'Michael Scott', the cosmopolitan Scottish alchemist of the thirteenth century. Other new names such as 'Blind Harry', 'Sir William Wallace' and 'Lord Belhaven' evinced a strongly patriotic commitment (Belhaven had given a major anti-Union speech in 1706 and the 'perfidy, pride, and hatred of England' was referenced by the Club), but, after a 'poetick war', possibly a flyting (an insult competition carried out in verse), involving Ramsay and James Stuart, there was no meeting from early 1714 (close to the time of public clashes between Jacobites and Whigs in the city) until 6 December. The hiatus may have been accidental, but it also covered the period from growing awareness of Queen Anne's failing health to the safe – or apparently safe – succession of George I. A Club with such Royalist and Jacobite antecedents, especially one which petitioned the king against Union in 1715, might have found it politic to lie low at such a time.[14]

Some commentators have long doubted that the Easy Club was politically Jacobite, a case I argued in print as long ago as 1990, but there is unequivocal evidence available. Ramsay wrote a distinguished elegy for Pitcairne, which was read to the Club on 18 November 1713. It was headed by a quote from Gavin Douglas's *Aeneid*:

Sum yonder bene for reddy Gold in Hand,
Sold and betrasit there native Realme and Land.

The elegy is modelled on *Aeneid* VI, the descent into Hades (possibly also a joking reference yet again to the Greping Office), and there Pitcairne's ghost finds 'Those noble Scots, who for their country's good,/Had sacrificed their fortunes with their blood', the exact opposite of the values of the opening quotation of the elegy.[15]

So much is known, but although these references look fairly clear-cut, their politics was veiled and has been disputed. But there is more to be said. 'George Buchanan', acting as Secretary, wrote a verse epistle of thanks to Ramsay as the 'Ingenious Authore of a Poem To the memory of Dr Pitcairn', offering him:

> The praises just of those who Loyall are
> And for their native soil have such a Care
> As Dare in midst of Danger still Defend
> Their Darling liberty from having End
> That unborn eyes may the Heroes know
> To whom old Scotland did its freedom Owe.

'Buchanan' goes on to say:

> And than att last by whom was basely Sold
> For the dire thirst and Love of English Gold
> That they may hate their Execrable name
> For Bringing on them poverty and Shame.
> Then shall you be by all Good men Caressed
> Your Easy Club by Loyall Souls adresd
> Who with your wished for Company are Blessd.[16]

Whatever its syntactic or poetical limitations, the message of the poem and its politics are absolutely unequivocal in their Jacobite patriotism. 'Buchanan' was also responsible for the Club's address requesting repeal of the Union on 9 February 1715, and was interlocutor in the veiled, but Jacobitical, poetic dialogue with Ramsay called 'The Lamentation', written four days before the battle of Sheriffmuir in the same year. Edinburgh itself was a hotbed of Jacobite unrest in these years; the streets had been crowded with supporters of King James and opponents of Union on the Jacobite king's birthday in 1713; a 'Pretenders Club' was reported by government agents in 1715, and the next year there were hundreds of Jacobite refugees in the city. 'Liberty' gloves (the word was embroidered on the inside of the wrist) were being sold in Edinburgh in 1713–14, and the 1713 tartan available in the city mutely announced the political resistance Ramsay was celebrating in his poetry. The Easy Club were more than grateful. On 2 February 1715, Ramsay became the Club's poet laureate, foreshadowing his election to the same role with respect to the Archers some years

later: he wrote a poem to them, published in the Jacobite paper *The Caledonian Mercury* on 12 July 1726.[17]

The Easy Club was on the small side for Edinburgh clubs, with between six and twelve members. There were many other clubs of a definitive political colour. One of the major impulses for the foundation of clubs and societies was a patriotic one, as was the case with John Spottiswoode's proposals for a 'Society for Promoting and Improving Knowledge in the History of Scotland'. Others, such as the 'Society for Endeavouring Reformation of Manners' (1699–1700), were more conventionally British in their context, reflecting contemporary concerns throughout the island.[18] The Rankenian Club, largely Scottish and Whig, was dedicated to 'mutual improvement by liberal conversation and rational enquiry', and had nineteen founder members when it was established in 1716. Like many other clubs, it was home to a close-knit elite, including Colin MacLaurin, William Wishart (c. 1692–1753), Principal of the University of Edinburgh; George Turnbull (1698–1749); Alexander Cunyngham (1703–85); Professors John Stevenson (1695–1775) and Charles Mackie (1688–1770); and Alexander Boswell, fifth Baron Auchinleck (1706–82).[19]

On the death of her husband the architect Sir William Bruce in 1710, Magdalen Scott, Lady Bruce, moved to Leith and set up 'her Jacobite cell, one of the most notorious in Scotland', which 'provided open house for Jacobite refugees' and, later, lodging for Bishop Forbes, author of the Jacobite memorial account *The Lyon in Mourning*. Scott also frustrated searches for female Jacobite sympathisers from her Leith base. Other Jacobite clubs included the Buck Club, which met 'weekly for supper in Parliament Close'. Its membership included Lord Elcho and Murray of Broughton: sixteen of its twenty-one members fought in 1745. The Associators included even more of the usual suspects, including the Duke of Perth, Lord John Drummond, Charles Stuart, Lord Linton, fifth Earl of Traquair, and Donald Cameron younger of Lochiel. Thomas Ruddiman was the 'Father of' the Rankinian Club (not to be confused with the Whig 'Rankenian'), which was full of 'keen Jacobites'. Founded in 1722, it met in Kennedy's Close at Thomas Rankin's house, and its meeting fee was 2d. The politicisation of club space, and its associated close space, reflected the wider politicisation of society, in which a shared infrastructure of civility both supported and concealed deep and essential differences,

enabling them both to continue and also to be obscured. There were of course clubs which were designed only to attract fellow-travellers, like the Whig Revolution Club.[20]

Many other clubs like the Worthies, which met 'once a week in an upstairs room in a tavern in Leith, decorated with Aikman's portraits of the members', were politically mixed. The Worthies themselves were predominantly Whig (Duncan Forbes of Culloden, Sir Gilbert Elliott of Minto), but not exclusively so: the chief requirements were to be among 'the most distinguished characters of their country at that time'. The social mixture of clubs like the Worthies reflected a rejection of both social and political calibration in defining what constituted these 'most distinguished characters'. This in its turn was a tribute to the intellectual openness of the society that spawned them and to the growth of its values of tolerant and incorporating civility as a socially unifying force across violent political divides: a lesson their modern successors could do with learning afresh.[21]

Alexander Carse's famous portrayal of The Worthies, with Allan Ramsay reading *The Gentle Shepherd* to the assembled membership, showed the intricate and close networking which routed all kinds of innovation in Edinburgh (Ramsay's in-joke in naming one of the key characters in his pastoral Sir William *Worthy* after the club was only one sign of references for coterie audiences within publicly performed works). Aikman painted the 1st Earl and Countess of Hopetoun, while Ramsay's son painted the 2nd Earl: there was plenty of net worth in the networks represented by the Worthies. The Carse painting's embedding in the library ceiling at New Hall was the physical counterpart of the embedding of intellectual bourgeois society into the social circles of the nobility in Edinburgh, for both alike contained the defenders of cosmopolitanism and culture. Carse's painting is a tribute to Aikman, whose portraits among the Worthies include John Forbes of New Hall, Duncan Forbes of Culloden (his cousin), the future Lord President, Sir Gilbert Elliott of Minto and Dr Alexander Pennecuik: the Pennecuik family had themselves sold New Hall to the Forbes in 1703. The Worthies, like many Edinburgh clubs, are depicted as having a membership which in the interests of intellectual pursuits crossed social divides that outsiders might imagine to be ineradicable: noblemen listened to booksellers. It has been argued that Aikman's portraiture 'sought an improved clarity and truthfulness of depiction' linked to 'a sympathy with the empiricism

of Newton and Locke', and one can certainly argue the case for his lasting influence on a style of Scottish portraiture, outwardly transparent and inwardly complex, like the Scottish Enlightenment itself. Aikman's clarity about the transcendence of humanity over rank and ability over class are core representations of Enlightenment value, and of the connexion of artistic and associational realms.[22]

The Beggar's Benison, the infamous Fife sex club whose sex toys and rituals still attract attention in exhibitions, had an Edinburgh branch, which split off in uncertain circumstances to become the Wig Club of Edinburgh, who – with the upper half of their bodies, at least – enjoyed 'Souter's Clods' rolls.[23] More decorously, the 'Fair Intellectual Club', founded by 'three young women in May 1717' and with a membership of only nine, who were to be initially no older than twenty, later twenty-four, so that they would not have husbands to confide in, has remained one of the most celebrated clubs of the early era. An account of the Club by 'a young Lady' was published in the 8–10 December 1719 edition of *The Edinburgh Evening Courant*. One of the Club's interesting features was its dedication to allowing women freedom to discuss the major issues of the day, for 'we thought it a great Pity, that Women . . . should not also be more eminent in Virtue and good Sense, which we might obtain unto, if we were industrious to cultivate our Minds, as we are to adorn our Bodies'. The Constitution of the Club called on its members, 'being sensible of the Disadvantages that our Sex in general, and we in particular labour under', should be 'ambitious to imitate the laudable example of some of our Brethren, that make the greatest Figure in the learn'd and polite World'. Club members took the view that 'it is an Injustice' to deprive women 'of those Means of Knowledge' which advantaged men:

> Or, why should base, invidious Man deny
> The Search of Truth, to their discerning Eye?
> Why, when ingenit Reason shoots her Ray
> To light us all, are they forbid the Day?
> Why should th'implanted Energy of Mind
> Grow faint and slaken in the Female-Kind?

One cannot be too sure about what really went on from single and well-publicised accounts of this kind, but the Fair Intellectual Club appears to have been an Edinburgh avatar

of the values of equality and the case for female higher education. Such engagement with these values can be seen later in the century, for example, in the Pantheon debating society, which admitted women to membership two years after it was formed. Moreover, the Fair Intellectual Club shared the strong commitment to charity we have already seen in other associations, and in the professions. Its subscription of ten shillings was to be allocated 'for the Use of the Poor, as we shall direct'. Its pioneering qualities were the subject of a 2014 play by Lucy Porter, produced by Stellar Quines at the Tron theatre: Edinburgh present celebrating Edinburgh past.[24]

Sporting associations were also important nodes in the network of Edinburgh society. Racing had long been popular with the Stuart monarchs, and indeed they may have transmitted their enthusiasm for it to England during the seventeenth century. In the first half of the eighteenth, 'Leith Races ... remained the largest and most popular meeting'. A bowling club was formed at Haddington in 1709, and the increasing popularity of the sport led to the establishment of the 'Edinburgh Society of Bowlers' later in the century. The 'oldest golf club with a continuous history in the world' began in Edinburgh as the 'Edinburgh Burgess Golfing Society at Bruntsfield Links' in about 1735; in 1744, the Company of Gentlemen Golfers in Edinburgh set out their 'Articles and Laws in Playing at Golf' which codified the sport, which they played on Leith Links. These rules were written by John Rattray, later out in the Rising of 1745. Cricket probably arrived with the British army of occupation in 1746 and the years that followed – the game 'seems to have been played by soldiers in Perth in 1750' and aristocratic Scots took it up later in the century; women also seem to have played the game. The Archers themselves, of course, had an explicit sporting side, and still compete for the Musselburgh Arrow (1603), one of the oldest archery trophies. They set up butts west of Parliament House in 1713, and these, despite the crowded nature of the environs, seem to have sufficed them until 'Thomas Hope of Rankeillor offered land at Hope Park, now the Meadows, in 1726'.[25]

The famous Select Society was instituted on 2 May 1754 by Allan Ramsay junior, with Hugh Blair, Alexander Carlyle, Adam Ferguson, David Hume, Lord Kames, Adam Smith, William Robertson, Sir Alexander Dick and Lord Auchinleck, Boswell's father, among its extraordinarily distinguished membership.

The Select ('select but not elect', conservative Presbyterians joked) had initially fifty members, growing to eighty-three by early 1755 and 130 by 1759: measures were taken to restrict numbers in early 1757, at which time the office of President became restricted to six members who served on a rotating basis. The Society was from the beginning placed on a strong constitutional footing centred on a major national institution, meeting 'at the Advocates Library every Wednesday evening, at six o clock', with a 'season' running 'from the twelfth day of November to the twelfth day of August'. Letters of explanation were required for absence. It was initially strongly democratic: not only were peers as notable as the Duke of Hamilton and Earl of Lauderdale members alongside ministers like Alexander Carlyle on less than £100 a year, but the Select was also originally without a permanent or term-appointed set of office-bearers: 'each member shall preside in his Turn'. In all, there were some sixteen noblemen, eleven titled, among the membership, with fourteen advocates, six ministers and three academics (including those who held more than one role). There were hardly any physicians or surgeons. A subject for debate was set every week – sometimes on successive weeks if the matter proved to be sufficiently meaty – and once again the principles of intervention in the debate were expressed democratically: 'each person may speak three times in a debate, and no oftener; the first time fifteen minutes, and ten minutes each of the other times'. Fifteen- and ten-minute sandglasses were placed before the President for the purposes of timekeeping.[26]

Although the Select Society lies at the edge of the chronological window for this study, it is discussed here because it marks for many scholars a watershed between Old and New Edinburgh in church, architecture, outlook and ideas: in short, the point of transition to the core era of the Enlightenment. Membership was from the beginning as the title promised, 'Select'. Members Robertson, Hugh Blair, Alexander Wedderburn and Adam Smith were all among those responsible for producing the first *Edinburgh Review* in 1755, which, like not a few innovative developments before it, was opposed by traditional Presbyterian 'Auld Licht' opinion. On 4 December 1754, David Hume chaired a debate on 'Whether we ought to prefer ancient or modern manners with regard to the condition and treatment of women'.[27] There were certainly more than a few 'modern manners' on show. Major Enlightenment figures such as James

Beattie, James Boswell, Adam Ferguson, David Hume and Lord Kames joined together to offer sponsorship and support for the staging of a play by Jean Marischal, thus helping a female playwright to access the stage. This is intriguing in view of the interest in proto-feminist topics listed to be addressed by the Select.[28]

The issue of women's rights was one of the most intriguing debating topics for this all-male society, and it was not infrequently raised: 'Whether Divorces by mutual consent should be allowed?'; 'Whether is the succession of females of advantage to the publick?'; 'Whether can a marriage be happy when the wife is of an understanding superior to that of the husband?'; and most striking of all, 'Whether it would be of advantage to Society that the women held places of Trust and Profit in the State?' are all examples of topics debated by the Select.[29]

The 'Questions to be Debated at the Select Society' (the list of those proposed or which had been debated was composed on 20 July 1762) also included many other topics which would at the time, and sometimes even now, be classed as entirely progressive. Some of them, such as 'Whether the Differences of national Characters be chiefly owing to the nature of different climates, or to moral and political causes?', were classic questions of the Enlightenment era. Others, such as 'Whether do we excel the ancients, or the ancients us, in knowledge & arts?', might have taken place in the previous century. Some bore on the anxieties of the costs of the Seven Years War, such as 'Whether the paying off the National Debt would be of advantage to Britain?' Others related to major contemporary issues: 'Whether the institution of Slavery be advantagious to the free?' [sic] was one of these, as was a Union of the American colonies. In other topics, reservations were expressed about capital punishment for theft and the treason laws, while the issue of 'Whether honours ought to be saleable?', a very twentieth-century topic, was proposed for discussion but not debated. The topic of 'Whether a general Naturalisation of foreign Protestants would be advantageous to Britain?' was so popular it was returned to in successive meetings. It was of course policy (see Chapter 2) under the Restoration government of Charles II.[30]

The Select Society has long been seen, at least since the publication of Richard Sher's *Church and University in the Scottish Enlightenment* (1985), as a key agent in turning the tide against Auld Licht Presbyterianism in the capital and its associated spheres of patronage. While acknowledging earlier 'New Licht'

figures like Leechman and Hutcheson, Sher argues that 'the turning point was the 1750s', when the Select Society membership was central to the arguments for Moderatism, lay patronage and a Scottish militia. In Sher's influential model, the Presbyterian Moderates of the Select Society utilised Edinburgh's inherited network of institutional and professional merit and patronage, seeing their salaries jump between the key years of 1757 and 1764. Hugh Blair's salary doubled in these years, while Adam Ferguson's rose at least fivefold and William Robertson's at least sixfold; John Home, whose 1756 play *Douglas* the Select had defended from traditionalist Presbyterian attack, scooped £600 a year as Conservator of Scots Privileges at Campvere. To its opponents, the Select was a 'dictatorial club' that promoted its own members and their pluralist, partly secular values: if Robertson 'could make a name for himself in the republic of letters without compromising his church or his calling' that was surely only because he had compromised the integrity of both, as these were understood by traditional Presbyterianism. As Sher argues, 'Once the Moderate literati . . . had gained control of the academic and ecclesiastical establishment, they were in a position to provide an institutional foundation for the cultural values in which they believed', becoming in the process 'considerably more successful than most European *philosophes* at institutionalizing their values during their own lifetimes'. There is certainly an argument that, liberal as its values generally were, the Select Society provided and demanded a greater degree of unity in its cultural and political outlook than its more politically divided predecessors.[31]

While there is much to be said for Sher's model (it explains, for example, the Select's extension of its remit and goals evident in its foray into funding for 'the encouragement of Arts, Sciences and Manufactures', passed on 5 March 1755 with Robertson in the Chair), it does perhaps share with other models of the Scottish Enlightenment a sense of miraculous advent. In reality, the 'Enlightenment' was not the invention of gifted individuals or artificially colligated movements with shared goals, but was a product of the infrastructure, circulation, association, population and urban culture of the city, operating innovatively through individuals, networks and associations in a way which would be familiar, as this book has throughout sought to demonstrate, to more recent scholarly accounts of urban creativity and its causes. However tempting the prosopography of personalities or ideas

might be, it was the structures of Edinburgh culture, history and society that underpinned the changes that so many have found – looking at them in greater isolation – remarkable.[32]

Taverns and Coffee Houses

From an early date, coffee houses in both England and Scotland were strongly associated with oppositional politics, whether radical Whig or (as was the case later) Jacobite. There was a strong crossover between coffee-house and tavern culture: indeed 'the coffeehouse was a public house much like the alehouses, inns, and taverns ... [it] did not look much different from taverns and alehouses on the outside, or even on the inside ...'. In Edinburgh as in London, coffee houses were used for the promotion of auctions. The first Edinburgh coffee house, John's of 1673, 'under the Piazza' in Parliament Close, turned into a tavern; other coffee houses, such as Balfour's or the Exchange Coffee-house between Craig's Close and Old Post Office Close, followed. Coffee houses could also, like inns, offer boarding in upper flats. Food was prepared 'in the French method', and English visitors such as Joseph Taylor in 1705 remarked on this. Lodgings might be high in the relevant land, which kept one clear of the noise of the streets to some extent, but could also present a challenge to the inebriated traveller on the journey to bed. Coach travellers booked travel at coffee houses, and concert tickets were sold there (for example, from McLurg's at the Cross in 1704).[33]

Taverns were frequently below street level (known as 'laigh'), and occasionally this once-common arrangement survives in contemporary Edinburgh: the Jolly Judge in James Court off the Lawnmarket is one well-known example. Women ('Luckies' as they were called) were frequently tavern keepers (and sometimes bawds), and, if sociable, taverns were also relatively private spaces, often being 'below street-level' in order to be 'removed from prying eyes'.[34] Drinking was a nightly pastime for shopkeepers and professionals alike, while during the day the 'meridian' (12 noon) was celebrated, about half an hour after the 'gill-bells' proclaimed the taverns were preparing for it. At 10pm, there was a drum for curfew, and this was typically the end of the day's festivities. The full participation of women in drinking and jollity often charmed visitors.[35]

Among famous inns and taverns of the time (taverns were customarily larger and often had private meeting rooms, but this distinction is far from absolute), the Coach and Horses was at the head of the Canongate, as was the Black Bull in Bell's or Gullan's Close. Lucky Dunbar's tavern was in the alley between Liberton and Forrester's Wynd; Gossy Don's, in Don's Close, opposite the Luckenbooths. The King's Head Inn stood at the Cowgatehead, with Pollock's near it; the Baijen-Hole below street level 'east of Forrester's Wynd' (a 'bejan' was a first-year student). Robert Clerk had his tavern in Parliament Close, while 'Samuel's ale-house' was 'under the Piazza at the entry to the close', where the Greppa had been: another laigh tavern. The Piazza was 'a large arcaded building facing the east end of St Giles'; 'Cassie's ale-house' was at the entrance to the Close proper, while Johnnie Dowie's in Libberton's Wynd was a favourite 'meridian' resort for the Faculty of Advocates. Dowie's 'Nor' Loch Trout' was in fact 'stuffed haddock fried with breadcrumbs and butter', good ballast for the amount of drink taken. The Cross Keys in Old Assembly Close was the haunt of Steill and his musical fraternity. Vintner's shops such as Lucky Thom's (off the Cowgate in Lucky Thom's Close) doubled as small taverns, while Lucky Spence's, just outside the gates of Holyroodhouse, offered other business for gentlemen.[36]

Edinburgh was the national centre of public-house and coffee-house life: in 1730, there were 266 licensees who could sell ale in the capital, 'of whom twenty-eight ... were female'. The light twopenny ale was typical and popular (hence Allan Ramsay's reference to it in his Elegy on Maggy Johnston): in the peak year of 1720, 520,478 barrels were 'brewed and paid duty in Edinburgh'. Business – particularly legal business, a tradition which lasted in Scotland up to the 1970s – was frequently conducted in inns or taverns. Women frequently drank there, even 'ladies of good rank', who enjoyed the parties and socialising as much as anyone else.[37]

Among party taverns was Walker's, for 'Gentlemen of the [Jacobite] Party', and Jenny Ha's (roughly where Clarinda's tea-room is now), where Gay and Ramsay may have drunk together, and where Jacobite songs were sung by Jamie Balfour and claret was drunk 'from the butt'. Indeed, the Jacobite party was the dominant party in most taverns: as Pitcairne put it, 'King James domineers' the taverns. There was also a strong territorial element to political socialising in the 1690s, for 'a

man that had walked betwixt the Strait Bowe and the Cross could Imagine by ther converses that he had marched out of KWs territories to KJs'. The aristocracy rubbed shoulders with tavern culture in other ways too: John Lamb's tavern was on the same stair as Lady Wemyss' house, while as the King's representative in the General Assembly of the Kirk of Scotland, 'the Royal Commissioner . . . held his *levées*' at Fortune's Tavern in Old Stamp Office Close, whence to 'his state processions issued forth to church, the ladies and gentlemen walking up the street in all the finery of Court dress'.[38]

Inn names in Edinburgh did not follow London models, nor did social practice: no less a body than the Royal Company of Archers leased out the hall where they met as a tavern when it was not in use.[39] Clubs frequently met in them and took their names from them: the Rankenian Club met in Ranken's Tavern.[40] Coffee houses and taverns or inns could be locations for clubs and societies to carry out charitable collections, and also to plot.[41] The Select Society famously met at the Carriers Inn over twelve cases of claret to discuss a 'strategy for the defense of "infidel' philosophers' after the 1755 campaign had begun to 'censure the writings of David Hume and Lord Kames for their alleged infidelity'.[42]

Freemasonry

Freemasonry provided a social network which was both homophile and heterophile, local, national and international, and one where the leaders of opinion might gather. Far from it being, in Margaret Jacob's curious judgement, a matter of 'local Scottish customs and clan governance', Scottish masonry was very much a part of the European masonic networks of which it had acted as a key catalyst.[43] In Edinburgh, as elsewhere, it provided a major focal point for change.

Lodges increased in number and significance in the capital in the early eighteenth century, becoming more speculative as craft masonry declined. The Edinburgh Lodge was the oldest, dating itself back to St Mary's Chapel in 1598 (though Canongate Kilwinning had a tradition of its own great antiquity). As the first Lodge 'to admit non-stonemasons', the Edinburgh Lodge had by the early eighteenth century become 'a focal point for the aristocracy'. John Clerk of Penicuik, who turns up

everywhere, was admitted in 1710. The Lodge of Journeymen Masons was founded by 1713, and, unlike many of the others, stayed true to its mission as a craft Lodge: 79 per cent of admissions from 1736 to 1746 were stonemasons. However, as Lisa Kahler points out, 'the fact that the lodge remained operative and yet still participated in the Grand Lodge suggests that the Edinburgh masonic community was not élitist'. Other lodges included Vernon Kilwinning and Holyroodhouse, which had a hiatus in its Minutes from 2 September 1745 to 7 April 1746, in part because Robert Maxwell, whose responsibility it was to write the Minutes, 'ran away to join the Jacobites'. As with Canongate Kilwinning, this was not unusual behaviour for this Lodge: Robert Gordon, a merchant in the Canongate, served in Glenbuchat's; Charles Allen and Robert Seton joined Elcho's Life Guards, while William Brodie the gunsmith acted as a Jacobite recruiting officer in Edinburgh. Nor were these all: but with greater loyalty to the British Crown than his professed craft, James Purdie, also a Lodge member, supplied the authorities with evidence against his craft brethren.[44]

Kilwinning Scots Arms was founded on 14 February 1729, initially meeting at, and taking its name from, 'William Gray's Scots Arms, near the Cross of Edinburgh': Gray was a vintner. It had just under a hundred members in 1736, the vast majority of whom were gentry/nobility, professionals and merchants. In 1734–5, Canongate Kilwinning, allegedly founded in 1677 (there were certainly lodges active from the late 1680s in Canongate and Leith), 'was re-established ... after a period of dormancy' 'at the extreme end' of St John's Close, with Thomas Trotter (whom we have come across in the context of the Academy of St Luke) as Right Worshipful Master. Its offshoot Leith Kilwinning (somewhat less elite, but still strongly gentry/nobility and professional, including the Earl of Carnwath and a Rotterdam merchant) was founded on 24 June 1736: there were some twenty-six members. These 'three lodges, with some assistance from the Lodge of Edinburgh, instigated the Grand Lodge of Scotland' on 30 November 1736 (St Andrew's Day). The initiative appears to have come from Canongate Kilwinning, and there are signs that the smaller Holyroodhouse lodge was also engaged in this development. Almost eight hundred men were involved in Edinburgh Freemasonry during this period: perhaps 4–5 per cent of the adult male population. There is plenty of evidence of homophile clustering, where 'members of the same

occupation join together' in lodge membership: 49 per cent of the professionals in the lodges were lawyers, while 25 per cent of merchants were Freemasons. Only three of Edinburgh's nine lodges had no nobility in their membership.[45]

The Grand Lodge was itself fairly socially mixed as a whole, being around 40 per cent craftsmen and one-third gentry/ nobility. As Lisa Kahler notes, the extensive social mixing in Edinburgh's lodges 'may be seen as a result of the physical characteristics of the city'. The lodges were close together, with four meeting 'in rooms or taverns on or right off the High Street' and four in the Canongate: only Leith Kilwinning, for obvious reasons deriving from its name, met elsewhere. As with other clubs, associations and institutions, Freemasonry was also 'a reflection of Edinburgh as a place where men lived and worked in close proximity, regardless of class or wealth'.[46]

By 1736, there were almost fifty Masonic Lodges in Scotland, six of them in Edinburgh, where Canongate Kilwinning, 'almost opposite' St John Street ('through St John's Close'), was rapidly becoming the most influential. St John Street itself was home in the era to Sir Charles Preston of Valleyfield, Bart, Lord Blantyre, the earls of Dalhousie and Hyndford, Tobias Smollett, the Earl of Wemyss and Lord Monboddo, who held his 'learned suppers' at No.13, his house 'almost opposite' Canongate Kilwinning. The Lodge was thus positioned at the heart of an address for some of the most significant nobles/gentry in the city: at the heart of social capitalism, if you like. Canongate Kilwinning had long been associated with the 'foremost noblemen and gentlemen of Scotland who were devoted to the Stuart cause', and Lodge tradition was that the original Lodge collapsed in the aftermath of the 1715 Rising. In this context, the Lodge's support for the 'Relief of the Indigent Episcopall Clergy and their widows in Scotland', an organisation that was to some extent a Jacobite front, is no surprise. Canongate Kilwinning's membership numbered seventy-eight in 1736, of whom some fifty were gentry/ nobility, professionals and merchants. As 'the lodge for visiting freemasons to attend while in Edinburgh', Canongate Kilwinning was also arguably the most prestigious of the Edinburgh lodges: it certainly enjoyed the highest profile. Its members included Hugh Blair, James Boswell, John Boswell (his Jacobite uncle), William 'Deacon' Brodie, Viscount Kenmure, John Murray of Broughton and, later, Allan Masterton (through whom Burns was probably introduced into the Lodge), Stephen Clarke and

James 'Balloon' Tytler, and it was to be just as influential on the world of Burns as it had been on that of Ramsay. It also has cosmopolitan members, including James Maule, 'Commander of a Gothenburg India Ship', and Bartholomew Sandilands, merchant in Bordeaux.[47]

Richard Cooper (who became Grand Steward in 1750) joined the Lodge (which had six members who were also members of the Academy of St Luke) in around 1735, and it was meeting in his house before the end of that year. In masonry, as in art and drama, Cooper was a mover and shaker in Scotland, being instrumental in 'the appointment of William St Clair of Roslin as the first Grand Master for Scotland'. In 1736, Cooper 'was deeply involved in the construction' of the new Lodge, which stood 'immediately to the north' of the building he had recently purchased. Ramsay was also a Mason, and there was a strong artistic element in Canongate Kilwinning, with six musicians, including Francesco Barsanti and Adam Craig, and William Westcomb, a member of a 'company of strolling players', all being among the Lodge's membership. There was a Masonic procession to attend a special production of *Henry IV* done in their honour at Tailors' Hall under Ramsay. On St Andrew's Day 1737, George, 3rd Earl of Cromartie, became Grand Master of Scottish Freemasons, being succeeded in this role in 1742 by William Boyd, 4th Earl of Kilmarnock (1705–46). Both of these leading Jacobites were members of Canongate Kilwinning Lodge, as was (as we have seen) Murray of Broughton (Junior Grand Warden in 1743), along with Sir Alexander Dick (originally Cunynghame) (1703–85) and many other prominent figures in Edinburgh society. The cosmopolitan nature of Canongate Kilwinning may have been key to its innovation in driving forward the Grand Lodge development, which was founded by 'four [including Holyroodhouse] Edinburgh area lodges' just as 'The Grand Lodge of England was founded by four London area lodges'. Both the patriot statement of founding the Grand Lodge on St Andrew's Day and the Lodge's overseas reach are also suggestive. Freemasonry on the Continent, not least Jacobite Freemasonry, was coming under unanticipated pressure from the papacy's outlawing of all Freemasons.[48]

In keeping with the cosmopolitan and international nature of Edinburgh's professional and associational society, the Scottish Grand Lodge was particularly influential in its advice to Amsterdam lodges from the 1730s onwards. The 'first known

lodge of women and men anywhere in Europe' was to open in the Hague in 1751, and, just as in Scottish associational life, Masonry on the Continent was seen as a meeting place where 'politeness cements ... all together'. In Scotland, the intellectual agenda was very much part of Freemasonry, and Chevalier Ramsay, a Scot in exile and one of the Craft's most prominent Continental advocates, provided speculative and intellectual leadership: Ramsay was secretary to Archbishop Fénelon, acquainted with Hume, Hutcheson and the Foulis brothers, and was tutor to Charles Edward Stuart, as well as being a profoundly ecumenical advocate of humane tolerance in his person and life. He was an unflinching Jacobite, and saw Freemasonry as a natural ally to the cause, claiming that the Restoration of Charles II had itself been 'determined at a Masonic gathering'.[49]

As we saw in Chapter 4, Cunynghame acted as cicerone to Allan Ramsay junior in Italy in 1736–7. Their trip there involved hospitality from noted Jacobites, such as 'Dr Hay, who had been in the rebellion of 1715' and 'Captain Urquhart [possibly Adam Urquhart, Lieutenant in Panmure's Foot in 1715], a Scots gentleman in the Spanish service, who was to go ... to meet the Earl Marshal'. In Italy, the two travellers 'fell in with' the Jacobite peers Lord Winton and James Murray (c. 1690–1770), Earl of Dunbar, Assembly director Nicky Murray's brother, and King James's doctors, Robert Wright and James Irvine (1687–1759), who was both an Archer (as were Ramsay and Cunynghame) and a member of the Jacobite Lodge, founded in 1733, which admitted both Catholics and Protestants. Irvine later played a significant role in the Jacobite 'Society of Young Gentleman Travellers at Rome', which was a front for the Lodge after the condemnation of all – not just Hanoverian, as the Jacobites had planned – masonry in Clement XII's *In Eminenti Apostolatus Specula* on 28 July 1738. Cunynghame and Ramsay also met William Hay (1706–60), the Jacobite courtier, on 20 November 1736, and he showed them round the city walls of Rome on 14 January 1737. Both Cunynghame and Ramsay were admitted to the Jacobite Lodge in Rome on 2 January 1737; Captain John Forbes, another Archer, had recently been a 'visiting Brother' at the Lodge. John Halliburton, an Edinburgh merchant later active in the 'Forty-five, joined them as a member on 9 May in the same year, and on 20 August John Murray of Broughton (another Archer and, of course, to be a member of Canongate Kilwinning) was received as a member. By this time, Cunynghame's visit was over, but

Allan Ramsay junior attended three Lodge meetings, the last on 9 May when Halliburton was present. Six months later, Ramsay senior was writing to Cunynghame anxious as to the doings of his son: 'I had at last a letter from my callan about ten days ago', he wrote with relief on 19 November. On 6 December 1738, the Roman Lodge paid a visit to Canongate Kilwinning, and there was clearly a close connexion between the lodges: Alexander Cunynghame was only one link they had in common, though he did not formally join Kilwinning 'from the Lodge at Rome' until 29 November 1756, long after the peak political risk involved in his association with the latter had passed.[50]

Clubs, taverns and associations have long been understood to be central to the development and circulation of Enlightenment ideas throughout Europe. In Edinburgh's case, it is important to note the small size of many of the clubs and associations operating within a confined space, and their consequent role as substitute kinship networks, creating loose homophile ties in the context of a membership who often enjoyed a varied and cosmopolitan education or experience, certainly sufficient to create heterophile effects and influence within the associational kinship node. In addition, the relatively flat and democratic structures of these organisations, in many cases open from the beginning to a meritocratic elite, made a significant difference to both the variety of experience and the outlook of their members. Last but by no means least, the profound presence of oppositional politics, primarily Jacobite politics, was very important in intensifying bonds between individuals and groups within these institutions and often a sense of both shared and cosmopolitan purpose between them, as this alternative government for Scotland enjoyed residence and support in Italy and France. The public sphere may have been most effective when least public and engaged in political and cultural struggle. Even men like Hume and Smith understood the contribution of the thought and writing of Jacobites such as Law, Steuart and Hamilton to the Enlightenment, and while they were no Jacobites themselves, the Moderates of the Select Society were in their milder way adversarial to much of the provincial religious and burgh culture of Scotland. The struggle for acceptance and ascendancy is heterophile by necessity: the agents of change are minorities, or those with minority experiences of education, trade or other interchange. Habermas's iconic concept of the public sphere has arguably always underestimated the importance of that

struggle, whereby every lastingly successful public originated as a counter-public: such is the process of innovation and change, and such was the nature of the Scottish Enlightenment in much of Edinburgh's club and associational life.

Notes

1. Davis D. McElroy, 'The Literary Clubs and Societies of 18th Century Scotland' (unpublished PhD, University of Edinburgh, 1952).
2. Lisa Kahler, 'Freemasonry in Edinburgh, 1721–1746: Institutions and Context' (unpublished PhD, St Andrews, 1998), 27; Rab Houston, 'Popular Politics in the Reign of George II: The Edinburgh Cordiners', *Scottish Historical Review* LXXI:2 (1993), 167–89 (188); Jerry White, *London in the Eighteenth Century: A Great and Monstrous Thing* (London: The Bodley Head, 2012), 297.
3. Roger L. Emerson, 'The Philosophical Society of Edinburgh, 1737–1747', *The British Journal for the History of Science* 12:2 (1979), 154–91 (155–8, 164); HMC 72 *Report on the Laing Manuscripts Preserved in the University of Edinburgh*, 2 vols (London: HMSO, 1914, 1925), II:156–7.
4. John Finlay, *The Community of the College of Justice: Edinburgh and the Court of Session, 1687–1808* (Edinburgh: Edinburgh University Press, 2014 [2012]), 49; Alexander Fraser Tytler, *Memoirs of the Life and Writings of the Honourable Henry Home of Kames*, ed. John Valdimir Price, 2 vols (London: Routledge/Thoemmes, 1993), I:184; Emerson (1979), 158, 172, 175.
5. Kahler (1998), 26; William Skinner, *The Society of Trained Bands of Edinburgh* (Edinburgh: Pillans & Wilson, 1889), 16; Edinburgh City Archives SL 167/2/1 (Society of Captains); ECA SL 167/1 ('Convivial Records of the Society of Trained Bands, 1750–1798').
6. Richard B. Sher, *The Enlightenment and the Book* (Chicago: University of Chicago Press, 2006), 110, 132; Jennifer Macleod, 'The Edinburgh Musical Society: Its Membership and Repertoire 1728–1797' (unpublished PhD, University of Edinburgh, 2001), 12–13.
7. National Library of Scotland, Rosebery III.a.10 No. 19; Linda Zionkowski, 'Preface' to Corey Andrews, *Literary Nationalism in Eighteenth-Century Scottish Club Poetry* (Lampeter: Edwin Mellen Press, 2004), iv; National Library of Scotland Ry. III.a.10 f. 19; James H. Jamieson, 'Social Assemblies of the Eighteenth Century', *BOEC* XIX (1933), 31–91 (34–5).

8. J. Balfour Paul, *History of the Royal Company of Archers* (Edinburgh, 1875), 19; Nick Haynes, *Scotland's Sporting Buildings* (Edinburgh: Historic Scotland, 2014), 26–7.
9. Paul (1875), 36–7, 71, 82, 358–65; Murray Pittock, *Material Culture and Sedition, 1688–1760* (Basingstoke: Palgrave Macmillan, 2013), 85 and passim; NLS Adv. MS. Ch.B. 2155.
10. Marie W. Stuart, *Old Edinburgh Taverns* (London: Robert Hale, 1952), 168; F. Peter Lole, *A Digest of the Jacobite Clubs*, Royal Stuart Society Paper LV (London: Royal Stuart Society, 1999), 39–40; Andrew Gibson, *New Light on Allan Ramsay* (Edinburgh: William Brown, 1927), 23.
11. Archibald Pitcairne, *The Latin Poems*, ed. John and Winifred MacQueen (Arizona Centre for Medieval and Renaissance Studies: Royal Van Gorcum, 2009), 318.
12. Edinburgh University Library Laing MS. II:212 ff. 1, 3, 7; Gibson (1927), 53.
13. EUL Laing MS II:212 ff. 1, 10.
14. EUL Laing MS II:212 ff. 1, 6; Daniel Szechi, *1715* (New Haven: Yale University Press, 2006), 106.
15. Allan Ramsay, *Works* I:27–30; Alexander Law, 'Allan Ramsay and the Easy Club', *Scottish Literary Journal* 16:2 (1989), 18–40; Murray Pittock, *Poetry and Jacobite Politics in Eighteenth-Century Britain and Ireland* (Cambridge: Cambridge University Press, 2006 [1994]), 154–5.
16. EUL Laing MS II:212 f.9
17. Andrew Gibson, *New Light on Allan Ramsay* (Edinburgh: William Brown, 1927), 23, 39, 42, 44; Pittock (2013), 85 and passim; Pittock (2006 [1994]), 155; Szechi (2006), 67, 210; Ramsay, *Works* IV:15: National Records of Scotland GD 47/356.
18. McElroy (1969), I:54; NLS MS 1954.
19. Macleod (2001), 12; Alexander Broadie, *The Scottish Enlightenment* (Edinburgh: Birlinn, 2001), 26.
20. Lole (1999), 13, 19, 45, 58; David D. McElroy, *A Century of Scottish Clubs 1700–1800*, 2 vols (Edinburgh, 1969), I:48–50. For Revolution Club admission tickets, see NRS GD 103/2/389, 401, 402, 433.
21. James Holloway, *William Aikman 1682–1731*, Scottish Masters 9 (Edinburgh: National Gallery of Scotland, 1988), 11; Worthies commemorative plaque.
22. Holloway (1988), 4, 7–8, 10–11, 17; Margaret M. Smith et al. (eds), *Index of English Literary Manuscripts* (London: Mansell, 1992), II:201; David Allan, *Scotland in the Eighteenth Century* (Harlow and London: Pearson, 2012), 158: Robert Cochrane, *Pentland Walks with their Literary and Historical Associations*, ill. George Shaw Aitken (Edinburgh: Andrew Elliot, 1930), 98.

23. David Stevenson, *The Beggar's Benison* (East Linton: Tuckwell Press, 2001), 1; Stuart (1952), 22. See, for example, items for pleasure and use in the 'Polite and Impolite Pleasures of the Georgian City', Fairfax House, York, 2016–17.
24. *An Account of the Fair Intellectual Club in Edinburgh* (Edinburgh: J. McEuen, 1719), 3–6, 7–9, 17; McElroy (1969), I:42; NLS MS 35.4.14 ff. 524–5; *The Edinburgh Evening Courant*, 8–10 December 1719. See also Bob Harris, *A Tale of Three Cities: The Life and Times of Lord Daer, 1763–1794* (Edinburgh: John Donald, 2015), 48.
25. Haynes (2014), 12, 26, 30, 37–8, 59, 73–4.
26. NLS Adv MS 23.1.1 ff. 1–7, 22, 96, 102, 202–3; Richard B. Sher, *Church and University in the Scottish Enlightenment* (Princeton, NJ: Princeton University Press, 1985), 81; Macleod (2001), 15; Broadie (2001), 26.
27. NLS Adv MS 23.1.1 ff. 7, 14, 19, 33; McElroy (1969) I:88–9, 117; Sher (1985), 68.
28. Sher (2006), 102n9.
29. NLS Adv MS 23.1.1, ff. 187–201.
30. NLS Adv MS 23.1.1 ff. 16, 187–201.
31. Sher (1985), 79, 105, 122, 123, 151, 152–4, 221, 328.
32. NLS Adv MSS 23.1.1 f.50.
33. Brian Cowan, *The Social Life of Coffee* (New Haven and London: Yale University Press, 2005), 79, 135; Tytler (1993), I:60; Stuart (1952), 11, 15, 167, 169, 171.
34. W. J. Coupland, *The Edinburgh Periodical Press*, 2 vols (Stirling: Eneas Mackery, 1908), I:27; James H. Jamieson, 'Some Inns of the Eighteenth Century', *BOEC* XIV (1925), 121–46 (126, 131); Stuart (1952), 12.
35. Stuart (1952), 17, 21, 22.
36. *Poems by Allan Ramsay and Robert Fergusson*, eds. Alexander Kinghorn and Alexander Law (Edinburgh and London: Scottish Academic Press, 1974), 198 n2; Stuart (1952), 22, 36, 40–1, 43, 58, 100, 102, 133.
37. Anthony Cook, *A History of Drinking: The Scottish Pub since 1700* (Edinburgh: Edinburgh University Press, 2015), 29, 34, 38, 55.
38. Lole (1999); Archibald Pitcairne, *The Phanaticks*, ed. John MacQueen (Leiden: Brill, 2010), 8; Stuart (1952), 36, 93–4.
39. John Yonge Akerman, *Tradesman's Tokens Current in London and Its Vicinity between the Years 1648 and 1672* (London: John Russell Smith, 1849), v–vii; McElroy (1969), I:254.
40. Thomas Ahnert, *The Moral Culture of the Scottish Enlightenment 1690–1805* (New Haven and London: Yale University Press, 2014), 35: McElroy (1969), I:45.

41. NLS Adv. MS 16.2.1 (Exchange Coffee House Meeting Minutes 1754–88).
42. Sher (1985), 65, 72.
43. Margaret Jacob, *The Origins of Freemasonry: Facts & Fictions* (Philadelphia: University of Pennsylvania Press, 2000), 13.
44. Kahler (1998), 152, 168–70, 187, 193, 207, 209, 210, 214; *An Introduction to Lodge Canongate Kilwinning* (Edinburgh: Lodge Canongate Kilwinning No. 2, 1982 [1951]), 3–4.
45. Kahler (1998), v, 53, 57–8, 64, 91, 99, 107, 151, 171, 173, 174, 182, 184, 188, 189, 217, 248, 252, 291, 298; Allan Mackenzie, *History of the Lodge Canongate Kilwinning No. 2* (Edinburgh: Printed for the Lodge by Brother James Hogg, 1888), 11, 13.
46. Kahler (1998), 103, 292, 294.
47. Mark Colman Wallace, 'Social Freemasonry 1725–1810: Progress, Power, Politics' (unpublished PhD, St Andrews, 2007), 70; Kahler (1998), 117, 126, 127, 129, 132, 133; Brannigan and McShane (2015), 85–7; Mackenzie (1888), 27; *An Introduction to Lodge Canongate Kilwinning* (1982), 8.
48. Allan Mackenzie, *History of the Lodge Canongate Kilwinning No. 2* (Edinburgh: James Hogg, 1888), 9, 11, 26, 39, 237 ff; Preston, *BOEC* ns 9, 119; Wallace (2007), 319, 322, 328, 332; Kahler (1998), 128, 133, 237–8, 244–5; Joe Rock, 'Robert Gordon, goldsmith and Richard Cooper, engraver: A glimpse into a Scottish atelier of the eighteenth century', *Silver Studies* (2005), 49–63 (58).
49. Margaret Jacob, *Living the Enlightenment* (New York and Oxford: Oxford University Press, 1991), 105, 127; G. D. Henderson, *Chevalier Ramsay* (London: Thomas Nelson, 1952), 172, 199–200, 205; NLS ACC 8422.
50. Sir Alexander Dick, Bart, 'A Journey from London to Paris in the year 1736', *The Gentleman's Magazine* 39 (1853), 22–5 (24); William James Hughan, *The Jacobite Lodge at Rome 1735–7* (Torquay, 1910), 15, 19, 21, 22, 49–50; Edward Corp, *The King over the Water* (Edinburgh: Scottish National Portrait Gallery, 2001), 104; Corp, *The Stuarts in Italy 1719–1766* (Cambridge: Cambridge University Press, 2011), 224, 323, 327–8, 332; Joe Rock, 'Richard Cooper Senior (c. 1696–1764) and his Properties in Edinburgh', *BOEC* ns 6 (2005), 11–23 (13–15); John Ingamells, *A Dictionary of British and Irish Travellers in Italy 1701–1800* (New Haven and London: Yale University Press, 1997), 475, 477; Mackenzie (1888), 237 ff; NLS MS 5308 f. 31. [See NRS GD26/13/271, a 1690s auction catalogue which advises on the procedure to be undertaken when pictures are 'Packed up in Cases, to send them into the Countrey'.]

6 Booksellers, Newspapers and Libraries

Newspapers

As we saw in Chapter 2, the development of a strong newspaper and publishing industry was one of the key elements in the development of Edinburgh at the turn of the eighteenth century, which set it apart from other British cities outwith London.

In 1661, the Episcopalian playwright and theatre manager Thomas Sydserf (1624–99) was responsible for the appearance of the newspaper the *Mercurius Caledonius* (*The Caledonian Mercury*), which reported the reinterment of the Royalist hero James Graham, Marquis of Montrose. There had been an earlier *Mercurius Criticus* in 1651–2 and a *Mercurius Politicus* in 1654, albeit these were Cromwellian imports. Edinburgh newspapers were an early innovation, and from the late seventeenth century were to pose a challenge to the imported 'London-based newspapers', as well as drawing on them extensively.[1] The short-lived *Mercury* promised – again an innovative development indicative of the Scottish capital's national sense of itself – to cover 'affairs in England and abroad'. Sydserf was the son of an Episcopalian bishop, and Pitcairne's mother, a Sydserf of Ruchlaw, was a relative. Sydserf, who took over management of the Tennis Court Theatre from 1667, was typical of the Restoration regime's crossover between creative thinking and the arts and the gentry and clergy of the Scottish capital, which was intensifying its grip on the country's intelligentsia. Sydserf's paper, which was 'designed to appeal not only to a non-religious government, but to an elitist and conservative

nobility', was closed down as 'irreverent' by the Privy Council in 1661: it was to give its name to a more famous successor of similar political outlook.[2]

The burgh authorities of Glasgow and Stirling appointed Edinburgh correspondents in the 1650s and 1660s; by the end of the seventeenth century, the burgh council of Montrose was ordering both London and Edinburgh papers. Newspapers began to be distributed seriously from 1680 onwards, with the appearance on St Andrew's Day of the anti-Covenanter *Edinburgh Gazette*, which was based on the *London Gazette*. Newspapers were left in coffee houses (the *Gazette* was also sold by ballad-criers), just as Act III of Sydserf's play *Tarago's Wiles* (1668) had been set in one, offering the heterophile and exotic flavour of London (where it was first performed) to the Scottish capital before its own first coffee house was open.[3]

The *Edinburgh Gazette* of 1680 was printed by Andrew Anderson, *The Edinburgh Courant*, edited by Adam Boig, was printed by James Watson the elder, and that of 1702 by John Reid in Libertoun's Wynd; it was sold at the Exchange Coffee House between Craig's Close and Post Office Close, as (slightly later) was the *Scots Courant*. The Union controversy helped feed Edinburgh's newspaper and pamphlet industry (such as Banks's *A List of the Nobility and Gentry . . . for and against the Union* (1706)): both Watson and Reid's families were associated with anti-Union Jacobitism. Watson's father, also James, had been printer to James VII, while his grandfather, an Aberdeen merchant, married a Dutchwoman who lent money to Charles II. James Watson set up shop in Warriston's Close in 1695, and was imprisoned for printing *Scotland's Grievances respecting Darien* (1700), while Margaret, John Reid's widow, printed an account of the Jacobite court at Perth in 1716.[4]

The Edinburgh press, although dependent on news first gazetted in London to a significant extent, both utilised other sources and expressed strong national concerns, contradicting the received wisdom that 'the "provincial press" in its first flush was actually spreading metropolitan opinion, rather than reflecting local views'.[5] Newspapers such as the *Mercurius Reformatus: or The New Observator*, founded in 1690, reprinted London news, it is true; but equally there were papers such as *The Present State of Europe: or, the Historical and Political Monthly Mercury*, taken 'from the Original published at the *HAGUE*'. *The Present State* has a slightly different perspective from that

which might be expected in the London press: for example, in March 1692, it noted that 'England is in pursuit of Glory now upon a foreign Theatre, and therefore there is little to be expected from thence.'[6] Newspapers could be bought from the printing houses where they were produced; they were also distributed by post and sold in coffee houses. Unlicensed street selling was replaced in 1710 by the vending of newspapers on licensed authority.[7]

In 1706, the *Haarlem Courant* and *Paris Gazette* were both being translated and published in Edinburgh to provide perspective from Scotland's more traditional allies on the Union. Their distribution was to an extent in the hands of those who opposed the Union: Freebairn sold the *Paris Gazette* from Parliament Close. But the Union did not lead to a collapse of the Scottish press, rather to the beginnings of its distinctive national voice, which we still know today. While 'the open border after the Union' threatened 'the fragile state of the Scottish publishing market', there was a defensive turn to patriotism, especially after the abolition of the Scottish Privy Council in 1708 ended what had been the discouragement 'of news relating to Scotland'. From 1709, John Moncur produced *The Scots Post-Man* from his shop at the foot of Bull Close; *The Edinburgh Evening Courant* (supported by Defoe) appeared the next year (and again from 1718 to 1720), and the *Evening Post* (again from Moncur) in 1712; George Stewart printed and sold the *Freeholder* from 1716. At the same time, this domestic industry was complemented by the increasing appearance of English journalism such as *The Spectator* preaching the values of gentility which were to form such an important part of the language of Enlightenment. Edinburgh publications, such as the 1711 Scottish *Tatler* (printed by Watson, following a reprint of the London version), imitated these. However, the adoption of English gentility – 'to Instruct, Rectify and Reform the NORTH COUNTRY', as Duncan Tatler put it in *The Mercury* – was not necessarily an admission of intrinsic Scots inferiority: Tatler noted that the state of Scotland was due to the fact that 'PARLIAMENTS, LAWS, MONEY &c have taken Flight, and settled in another Kingdom'. As a consequence, Scotland now is 'quite another Thing to me than what I thought it was' as a young man.[8]

Much has been made of how Edinburgh associations such as the Easy Club took on the language and characters of *The*

Spectator shortly after the Union; equally, these were suddenly reversed in a decision to promote Scottish nationality in November 1713. It is likely that such role-playing was quite sensitive to contemporary politics: the Scottish grievances over the Malt Tax and the close vote in favour of Union in spring and summer 1713 changed the political weather in a manner only intensified by the discontent leading up to the major Jacobite Rising two years later. The language of self was in flux, and this was reflected in the press. In any case, some of the language of *The Spectator* played directly into Scottish culture: Joseph Addison might support 'polite writing', but he also advocated (in 'The Ballad' of 21 May 1711) the 'songs and fables ... most in vogue among the common people'. This in turn suited the agenda of Watson and Ramsay: indeed, it has been argued that 'Watson's connecting of print, improvement and the Scottish identity set the tone for the century'.[9]

Moreover, while fugitive publications such as the Edinburgh *Tatler* (first printed eleven days after its London equivalent ceased, although an earlier *Tatler* reprinted the London periodical) and later the more Jacobite-leaning *Thistle* provided evidence of the influence of London journalism on Edinburgh, it would only be appropriate to note that there was a good deal of competition, and even direct resistance, to the cultural practices and claims of the metropolitan media. *The New Statistical Account* might claim that 'the Edinburgh newspapers were merely compilations from the London prints, and seldom ventured on any original speculations, especially of a party political nature', but the newspapers of the Scottish capital in the first age of Enlightenment do not altogether bear that assertion out.[10]

Before the Union, 'all newspapers required the sanction of the Scottish Privy Council', such as the 'full warrant and authority' that James Donaldson (c. 1663–1719) received from the Council on 10 March 1699 to publish the *Edinburgh Gazette*.[11] Donaldson's *Gazette* aimed to combine 'ane abridgement of fforaigne newes together with the occurrances at home'. Both before and increasingly after the Union, there was a repeated emphasis on the need for Scottish news, and to produce reporting which was *'no more ... the promiscuous Coppie: of the Common English News Papers'*. As *The Scots Post-Man* went on to say, 'SCOTLAND shall no more be imposed upon by English News Letters, nor the False and Foolish Stories there

Printed'. These were replaced by, among other things, digests of reports from Berlin, Brussels, Cologne, Frankfurt, Geneva, Genoa, Naples, Palermo, Paris, Riga, Venice, Vienna, Zurich and elsewhere. London was numbered among these, but it was – like Edinburgh itself – only one among several. The capital's Scottish newspapers were, like so many of its elite, cosmopolitans.[12]

The Union controversy unquestionably fed the national ambitions of the press, as well as kindling its denominating taste for controversy, not least in the unfortunate case of Captain Green and the *Worcester* affair, where an English captain was condemned to death and executed for piracy against Scottish shipping on what looked suspiciously like political grounds. Scotland's emerging press did not distinguish itself: the newspapers 'declared the crew guilty and linked the circumstances of the trial to ongoing constitutional conflict between Scotland and England'.[13] Partisanship began to intensify in the newspapers in the context of the Union debates. The thrice- weekly *Edinburgh Courant* of 1705 was a Tory title, produced by Adam Boig and sold through the caddies at a discount to his rivals (and then later, following an industrial dispute, through coffee houses and shops), which lost its licence from the Privy Council after only a few months; *The Observator* was published by John O. Pierce, an English Whig 'who had fled to Scotland in 1704 to escape prosecution for libel in England'. The public was also clearly hungry for information, with even the press in London advertising the articles of Union for sale. The list of available titles in Edinburgh also continued to expand: *The Edinburgh Gazette* accompanied the party titles above, while *The Scots Post-Man: Or, The New Edinburgh Gazette* appeared in 1708, as did *The Edinburgh Flying-Post*. Freebairn's sale of the *Paris Gazette* from Parliament Close in 1706 and its reprinting as the *Scots Courant* encapsulated Edinburgh's proximity to a much wider range of European media than the so-called 'provincial' press. Post-Union publication continued pre-Union practice in this sphere, for the original *Edinburgh Gazette*, following its London exemplar, had contained overseas news from its second number in 1680.[14]

In 1699, the *Edinburgh Gazette* was fully engaged in Scotland's nascent overseas empire, advertising for apprentice boys for Darien and printing reports from the African Company's (the Company of Scotland Trading to Africa and

the Indies) Jamaica operations. Businesses such as the 'White Paper Company of *Scotland*' traded under similar titles, evocative of the importance of the Company to national commerce and a sense of self-worth. Even the University of Edinburgh was reported as making mention of 'our New Caledonia', a term which appears to originate with William Paterson (1658–1719), who had sought to promote a version of the Darien scheme in England and the Netherlands before bringing it to Scotland.[15]

From 1699, John Reid senior and junior produced a number of newspapers, finally and most successfully the later 1714 *Edinburgh Gazette*. The *Gazette* was sold at the Exchange Coffee House; other papers (such as the *Monthly Mercury*) through booksellers in central Edinburgh. These papers not only took a different approach from the London press, but were also prepared to challenge it directly: on 7 August 1711, Reid junior's *Scots Post-Man* took the London *Flying Post* to task 'for its misrepresentation of the minutes of a crucial meeting of the . . . Faculty of Advocates', this being the meeting of 30 June where the Faculty voted to accept a medal from the Duchess of Gordon which portrayed 'King' James VIII. Other titles of the era included *The Examiner*, sold by James Watson at his shop next to The Red Lyon; *The Freeholder and the Weekly Packet*, sold at Steven's Coffee House, on the south side of the High Street by the Cross; *The Mercury, The Flying Post or the Postmaster* (1699, 1712) and many others, such as the weekly journal *The Eccho*, supplied from Allan Ramsay's shop. The *Dublin Intelligence* first appeared in 1708, while in England, the founding of papers such as *The Stamford Mercury* (1714) and the *Leeds Mercury* (1718) was slower, and 'the regional character of much of the provincial press' in England was not echoed at Edinburgh. The Edinburgh newspapers' interest in foreign in preference to London news was a mute implication of their standing and the standing of the capital within Europe. In 1718, the Edinburgh bookseller James McEuen, together with William Brown and John Mosman, founded the thrice-weekly *Edinburgh Evening Courant*, which, while it exaggerated its originality compared with that of its predecessors, still marked a notable innovation in Scottish journalism. The *Courant*, with its excerpts from the Dutch and French press, seems to have been 'made available in London coffee-houses', no doubt facilitated in this by McEuen's own shop in London, which provided a satellite office to boost circulation. McEuen also

employed 'his own correspondents at Amsterdam and Paris' and deposited his sources at the Royal or other coffee houses. The *Courant* was mildly Unionist, but strongly Scottish for all that, triumphantly pointing 'to information in their sheets that had not yet appeared in the London press' as proof of its ascendant originality, which extended to innovation in advertising development, including what has been claimed to be 'the first real estate ad' on 15 January 1719.[16]

This did in fact overstate the case, for housing auctions had been advertised in *The Edinburgh Gazette* at least as early as 1699, including one 'in the House of Mrs *Anderson*, Vintner; at the back of the Cross' on 13 November that year. Freebairn's book auctions were in full swing by then (book and art auctions had been advertised in the *London Gazette* from at least 1691, and had begun to take place in 1676), and there were many other elements of the emergent press which were prophetic of modernity, not least the developing lost-and-found column, again anticipated in the *London Gazette* of the 1680s. The *Edinburgh Gazette* for 20–23 March 1699 published the following plea:

> LOST in the Canongate on the 18th instant, a Black Spaniel Dog, notice to James Lindsay at the Flanders Coffee house 2 dollars reward.[17]

Apart from its modernity, one of the interesting things in this notice is the currency of the reward, presumably referring (because of the strong Edinburgh trading links) to the Dutch Lion dollar (worth S£2 4s) rather than the Spanish one (worth S£3 12s). Scottish burghs had long been used to multiple exchange rates as Scotland never had enough bullion to circulate in its own currency; and the Dutch were renowned for never debasing the quality of their silver.

The Edinburgh press also took their duty as national newspapers within Scotland seriously, carrying adverts from far outside the capital: an auction in Montrose was advertised in *The Scots Post-Man* of 26–28 April 1709, while 'all sorts of Goods fit for the West Indies and Coast of Guinea' were advertised for export from the same port on 11–14 June. A Glasgow book auction was advertised in *The Edinburgh Gazette* four weeks before it took place in Glasgow College on 21 November 1699. Adverts were taken at coffee houses such as Robert Trotter's

Eden and Robert Cunningham's Caledonia (where textbooks such as *Husbandrie Anatomized* were also sold), and also by booksellers.[18]

The Caledonian Mercury, perhaps the most famous Edinburgh paper of the eighteenth century, first appeared on 28 April 1720, printed by William Adams junior in Parliament Close and sold there and in Carrubber's Close. It swiftly adopted a Jacobite tone, and by 1722 this was represented in its distribution network. On 13 January 1724, Thomas Ruddiman took over its printing from his works at the fourth storey of the turnpike near the foot of Morocco Close opposite the head of Libertoun Wynd near the Lawnmarket.[19] The European news on which the *Mercury* reported included the doings of 'King' James VIII, and the newspaper sellers who stocked it (such as Alexander Symons) also stocked pro-Episcopalian and Jacobite titles. At various times (for example, in March 1725) there was direct contact between the *Mercury* and Nathaniel Mist, who began *Mist's Weekly Journal*, the most prominent Jacobite periodical in England, in May the same year. The possibility of the influence of *The Caledonian Mercury* on Mist cannot be dismissed, not least since Ruddiman, a man with widespread British Jacobite connexions, was now (since 13 January 1724) the printer of the Edinburgh newspaper. On 27 April 1725, just before *Mist's Weekly Journal* first appeared, the *Mercury* advertised the sale of Belhaven's anti-Union speeches at St James, Muirhead and the Laigh coffee houses, and from John Moncur's printing house, opposite the head of Fraser's Wynd.[20] On 14 October 1745, *The Caledonian Mercury* carried Charles Edward's declaration that 'with respect to the pretended Union . . . the King [that is, James VIII and III] cannot possibly ratify it', while on 4 September 1746, the same newspaper noted that Lord Balmerino had died on the scaffold 'in the very *same Regimentals* he wore at the Battle of Culloden' and wearing a *Plaid cap*.[21]

Not every paper was so explicit, but many – such as *The Thistle*, first printed by William Cheyne from the foot of Craig's Close in February 1734 – had an unmistakably patriotic tone, again leaning towards Jacobitism. The initial editorial noted that 'this Country is not near so fully apprised of the State of Affairs, both at Home and Abroad, as our *Neighbours* in England are', and *The Thistle* set out to address this lack and to appeal to a patriot market, where 'it is to be hoped, that all

sincere Lovers of their Country will contribute to and support and encourage this Undertaking'.²² Extracts from *Fog's* (the successor to *Mist's* after Mist's presses were destroyed) were printed in *The Thistle*, together with articles allegedly authored by 'William Wallace'. On 13 March, 'Broad Scotch' opined that Scotland was being cheated financially in the Union; on 7 August, verses in praise of Mary, Queen of Scots, 'By factious hands expell'd thy lawful Throne', appeared. The references were obvious. But *The Thistle* also makes uncomfortable reading for those historians and theorists for whom Jacobitism is the enemy of Enlightenment, with discussions on liberty and the state of nature, as well as the confluence between slavery and the absence of the right to resist tyrants.²³

The 'print patriotism' of early eighteenth-century Scotland gave rise to a stream of titles, culminating in two major magazines, the *Scots Magazine* of 1739 and the first *Edinburgh Review* of 1755, which was a key outlet for the dissemination of Moderatism in its 'aspiration . . . to generality and coherence'.²⁴ In addition to foreign and domestic news, philosophical discussions began to appear in these magazines at an early date, for example on 'the language of Beasts' in the first year of the *Scots Magazine*, a piece quite possibly read by Lord Monboddo, who was to develop an enduring interest in this topic. The *Scots Magazine* also carried a discussion of electricity in its June 1745 number. Such material in the new magazine culture had its forerunners in the development of serious reflective pieces in earlier newspapers. For example, *The Edinburgh Evening Courant* for 30–1 March 1719 carried a discursive account of suttee (Sati), while in *The Caledonian Mercury* for 20 April 1725, Professor Alexander Munro disclaimed any dependence on graverobbing for the study of anatomy, a century before the infamous case of Burke and Hare.²⁵

The *Scots Magazine*'s opening editorial was revealing in its summary of the issues that motivated the sustaining of a national press in Edinburgh. One of the key rationales for the *Magazine*'s existence was the fact that news coming from England/London is seen as 'stale' in the editorial, given 'our distance from the place of their publication'. But even more than that, it says that 'surely the *interest of Scotland*, abstractedly considered, is worth our most watchful attention', as 'in many things calculated for the good of *Great Britain, Scotland* is little more than nominally consider'd'. The editorial goes on to give

further reasons for the launch of this new venture. The first of these is *'That* our readers might have a more impartial view of political disputes', an interesting hint of Scotland's claim to detachment from the intrigues of London. The second reason endorses that claim to independence of judgement from another direction, *'That* the occurrences of *Europe* might not be wholly lost'. In other words, it remains important for Scotland to have a direct reporting line on international affairs. The third reason is a classic – if expressed in rather a fey manner – statement of Enlightenment values: *'That* the *Caledonian* Muse might not be restrain'd by want of a *publick Echo* to her song'. In other words, the new *Scots Magazine* will give the nation voice and provide it with some of the aspects of a public sphere. Lest the overall patriotism of the message be misunderstood, the conclusion of the editorial is unequivocal: 'as our labours, so are our wishes employed on the PROSPERITY OF SCOTLAND'. The *Scots Magazine* was not Jacobite, but the use of a phrase so closely associated with Jacobitism ('Prosperity to Scotland and no Union' was a Jacobite slogan) was a definitive use of the rhetoric of the Stuart cause's nationalism in support of a broader definition of patriotism, one which preserved a cultural while backgrounding a political challenge to the British state. In 1748, the *Scots Magazine* explicitly recommended moving from 'MARS' to 'MINERVA', a switch which could almost become a metaphor for the Scottish Enlightenment's influence on the British polity following the defeat of Scotland's military challenge to that polity at Culloden: 'Graecia capta ferum victorem cepit' [captive Greece took captive her brute conqueror], as Horace put it. The Scottish capital followed suit, and Edinburgh became, in Thomas Sheridan's 1761 phrase, the 'Second Athens'.[26]

When it came to dealing with the Jacobite Rising of 1745–6 itself, the *Scots Magazine* developed no change in tone. After warning in June 1745 that one David Gilles of Fife was going round Edinburgh impersonating the Prince, 'among weak people, and, by conferring honours and places, 'tis said got a good deal of money',[27] the *Scots Magazine* met the political challenge of the ensuing armed conflict by espousing its role in providing 'a more compleat history of SCOTS AFFAIRS . . . than was to be found in any of the collections made in *England*; where our laws and customs are not generally well understood, nor . . . properly attended to'. This was quite a bold statement

to make at the time of an armed Rising designed to break the Union. In describing that Rising itself, the *Scots Magazine* 'gave the accounts published by the rebels, as well as those by the king's troops':

> Such impartiality we supposed to be all that the most judicious of the vanquished party would expect, nor could we reasonably doubt of its being agreeable to the most generous of the victors.[28]

The second statement was, as the writers of the *Scots Magazine* may well have known, aspirational rather than realistic. Yet although the *Magazine* carried views biased in favour of the British Army and government in 1746, its patriotic aspirations remain worthy of note, as does a determination to be unbiased remarkable in the journalism of that and perhaps any era, and evident in the account of the battle of Fontenoy from the (victorious) French point of view in their June 1745 number. There is evidence that its position was recognised by both sides, for during the Jacobite occupation of Edinburgh Charles Edward Stuart made no move to shut the *Scots Magazine* down even though it was critical of him, while a dragoon of Lord Mark Ker's chose the *Scots Magazine* to report news of British atrocities when he 'came to the office . . . to lodge information regarding the cruelties practiced after Culloden'.[29]

Booksellers

Of a sample of thirty-nine booksellers, printers and stationers whose business address is known in the early eighteenth century, twenty-five were in business in or very near Parliament Close, some being in the Luckenbooths, and they mixed with the lawyers of the city on a daily basis. Between 1679 and 1749, it is estimated that there were 13,000 Edinburgh imprints, while even at the beginning of this period there were 'over sixty book traders in Edinburgh'. Many of them were centrally situated: George Mosman, printer and bookseller, on the south side of Parliament Close; Thomas Ruddiman, for a time printer there; Alexander Ogston, John Paton, James Wardlaw, all booksellers; and Gideon Shaw, stationer in Parliament Close. John Vallance was a bookseller just above the Cross in the High Street. These figures were central to the processions and socialising of the

powerful. The printed word lay at the heart of the capital and its institutions, absolutely core to the development of new ideas and new ways of thought: contiguity and intensity of population and movement again working their magic. Many, if not most, of these individuals were connected to one another, but there were also cosmopolitan connexions: Evan Tyler, printer and bookseller in Edinburgh from 1660, became Master of the Company of Stationers in London in 1671, just as James McEuen had both distribution in London and was a printer and bookseller on the north side of the Cross from 1718 to 1732. Later, Thomas Ruddiman (1674–1757), the famous classical scholar who worked for Robert Freebairn for a time, became well known as the printer of *The Caledonian Mercury*, and also rose to be Keeper of the Advocates Library from 1730 to 1752. Ruddiman, a schoolmaster at Laurencekirk, fortuitously met Archibald Pitcairne when he was stranded at the town in 1699. Perhaps as a direct consequence of this encounter, Ruddiman came to Edinburgh the next year to seek his fortune, and worked with both Freebairn and Watson, also becoming an auctioneer in 1707. Ruddiman (possibly with Ramsay) wrote one of the earliest glossaries of Scots, for the 1710 edition of the *Aeneid* of Gavin Douglas, and was involved extensively in patriotic printing. Allan Ramsay probably took the pseudonym 'Gavin Douglas' in the Easy Club in honour of this edition and in memory of Pitcairne, Ruddiman's mentor. In his turn, it was Ruddiman who printed Ramsay's *Poems* of 1721 and his *Ever Green* collection, designed to rehabilitate the voice of medieval Scots poetry, 'the most elegant Thoughts in a Scots Dress'. As Ramsay noted in the Preface, 'When these good old *Bards* wrote, we had not yet made Use of imported Trimmings'.[30]

William Adams, who printed *The Caledonian Mercury* from 1720 to 1723, initially for the lawyer William Rolland, was in business in Carrubber's Close from 1717 to 1725; John Baskett, who had gone into business in London in 1709, set up an Edinburgh printing house in 1725. Robert Brown was 'based in the middle of Forrester's Wynd'; Robert Drummond in Swan Close below the Cross printed popular books; Thomas Brown was printer and bookseller on Plainstanes until 1722; William Brown and John Mosman 'assumed the title of King's Printers' at their Parliament Close business in 1724, while James Davidson, Robert Fleming and Ruddiman were 'conjoint printers to the University' in 1728. Thomas Lumisden was a printer

from 1723, while James McEuen was also in partnership with Brown and Mosman; John Mackie, the Parliament Close bookseller, died c. 1722, but his fellow bookseller James Martin was still in business at that date. James Young's printing house was opposite the Tron Kirk. By 1748, 510 book imprints were produced; speciality books in areas like cookery were available from the 1730s, while the production of professional and official documentation (most of the publishing business) underlined Edinburgh's capital status. Many of the printers made use of the tall close lands to organise their business, with a shop on the ground floor, the heavy wooden or heavier metal presses on the first, and warehousing on the second. There were (from the end of the seventeenth century at least) also a number of book auctioneers: Freebairn's auction house was 'on the North side of the High-Street, next Stair to the Sign of the Ship'.[31]

As well as the printer of *The Caledonian Mercury*, Thomas Ruddiman acted as the printer for a wide range of patriotic and Jacobite material, including the selected poems of Pitcairne, Douglas's *Aeneid* and Abercromby's *Martial Atchievements of the Scottish Nation*. Both patriotic and other forms of publishing flourished in the aftermath of the 1710 Copyright Act (8 Anne c.21), as pirating as a form of political resistance and of profitable cheap reprints alike enjoyed significant success. The Act was opposed or evaded in Scotland for patriotic and commercial reasons: perhaps rather like the Malt Tax, it was seen as a foreign imposition (on the other hand, it helped transform the Advocates Library through conferring copyright rights). Before 1710, Scottish copyright had been 'underpinned by royal prerogative' including the royal licence, which – when granted, for example, to Andrew Anderson in 1671 – 'included the unprecedented right to approve all publications by other printers in Scotland', though at other times, especially those of social anxiety or emergency, the Scottish Privy Council demanded a say in what stationers or booksellers could stock.[32] Since Crown rights were centrally those preserved to Scotland in the aftermath of the Union, while Parliamentary rights went to London (the constitutional doctrine of Crown in Parliament not having yet been developed), it was natural that attempts to extend legal title to copyright to Scotland on the basis of parliamentary legislation might meet with patriot resistance, the more so that in September 1710 the society of paper cryers was dissolved in Scotland, which allowed 'any one to sell printed papers,

pamphlets, ballads and story books in the street'.³³ Piracies also came into Scotland from Ireland and the Netherlands, and were distributed there.³⁴

In the eighteenth century, the booksellers took full advantage of the legally somewhat ambiguous situation following on from the 1708 abolition of the Scottish Privy Council (hitherto 'the main granting agent for copyright in Scotland'), to practise extensive piracy, also serving as a distribution point for Irish or Dutch pirated publications. One effect of Scottish print piracy was to make texts more freely available and thus to speed the circulation of information and new ideas in an early version of what today would be termed open-access publishing. There was a ready audience, with some 65 per cent of the population of Lowland Scotland being literate. The buccaneering booksellers of the Scottish capital fed the diffusion of innovation while increasing their own profits: a case of the benefits of Adam Smith's invisible hand, and the promotion of social goods through selfish ends. Interestingly, in the Scottish legal tradition the physical manuscript or book 'was legal property, but not the text or its idea': Scots Law was not constructed to engage with the notion of intellectual property, which was making one of its earliest appearances in copyright legislation. The Roman law inheritance, like the College of Justice itself, thus supported the dissemination of new ideas: ideas were free. Attempts, such as those of Andrew Millar in 1739 which summonsed twenty booksellers for piracy, including Ramsay, were not successful, and Ramsay was not included in a second attempted prosecution of 1743. Ironically, the poet himself disapproved strongly of piracy, requesting the Town Council in 1719 to take action on his behalf against his being 'abused by some Printers Ballad Cryers and others by Printing & Causeing to be Printed Poem's of his Composure without his Notice or allowance upon False and Uncorrect Coppies'. Ramsay was clearly preparing to release his work in book form, and wanted no cheap competition at large on the streets.³⁵

As has been seen already in this study, social mobility in the Scottish capital was greater than might have been the case in London, and the cultural and class barriers more fissiparous, thus enhancing the possibility of the diffusion of innovations. This group was very much strengthened not only by their closeness to a core professional quarter of the city, but also by the capital's position as a place where official documents were

printed for its professions and other bodies: for example, the *Minutes of the Proceedings in Parliament* were first issued on 9 May 1695 (somewhat ahead of Hansard in 1909, though a little later than the 1689 *Account of the Proceedings of the Meeting of the Estates*), while the Acts of the General Assembly were also available in the same decade.

The discourse of the Edinburgh printers, like that of the capital's newspapers, was both eclectic and international, with James Wardlaw publishing both a medical work by Archibald Pitcairne and a poem on the Royal Company of Scotland trading to Africa in 1697, the year he moved his business from the middle of the Luckenbooths to Parliament Close. More local issues also won support. In the *Edinburgh Miscellany*, McEuen championed local poetry (some written by the women 'members of the Fair Intellectual Club' who were opposed to the 'vernacular verse' of Ramsay). But McEuen was also advertising his stock of patriot texts well into the 1720s, and selling new ventures such as *The Eccho*, which carried both a London and Edinburgh gazette, giving equal billing to the two British capitals.[36] Indeed, 'cheaper texts' produced at Edinburgh 'infuriated the Company of Stationers in London'; Andrew Millar took the opportunity, and transferred Edinburgh's cheaper techniques to London, thus 'revolutionizing the British book trade'.[37] Meanwhile, in Edinburgh trade expanded, fuelled by the capital's professional classes and their markets. The paper, its printers, booksellers and newspapers consumed helped paper manufacturing as a business. Some of the printers themselves had other paper-related sidelines: Peter Bruce, who succeeded James Watson at the Holyrood Press in 1687, had set up a 'factory for making playing cards' at Canonmills in 1681.[38] Within Scotland the Edinburgh book trade was dominant, with only 2.5 per cent of Scotland's 243 imprints in 1707 being published outwith the capital. Edinburgh's book trade was also an international trade, with paper and books coming into Leith 'from the Netherlands, Norway, Russia, Germany, France, Portugal and Spain'. By 1740, bookselling and printing had captured 3 per cent of the capital's labour market.[39] Among the most prominent figures in the business were Agnes Campbell (Mrs Anderson), in business from 1676 to 1716, who succeeded William Mosman as printer to the General Assembly in 1712, and had a stock of 50,000 books valued at over £11,000, and Jan Colmar and Joshua van Solingen, Dutchmen in business 'at the foot of Heriot's Bridge'

in the Grassmarket from 1680, who had been introduced to the city by the bookseller John Cairns. James Watson, printer to James VII and his household, and Peter Bruce his successor printed Catholic apologia including Dryden's *The Hind and the Panther* and some Scottish subject matter such as James Paterson's *A Geographical Description of Scotland*.[40]

Libraries

The library was, as Jonathan Israel has observed, the lifeblood of the Enlightenment, and here again Edinburgh's innovation placed it at the leading edge of development. In 1695, Thomas Bray (1656–1730) had conceived of the idea of providing a library in towns throughout England, but it was Scotland that was to the forefront in creating 'permanent institutions'. Archbishop Leighton's Library in Dunblane (1688) was converted into a 'general subscription library' in 1734, as was Dumfries Presbytery Library two years later. In the Highlands, Society for the Propagation of Christian Knowledge (SPCK) monies underpinned the founding of dozens of small libraries, some in inns. Innerpeffray Library near Crieff, founded in 1680, became effectively Scotland's first public library, remaining a lending library until 1968. Although it was founded for students, 'local farmers and tradesmen' became its borrowers. At Jedburgh in 1714 and Lochmaben in 1726, libraries developed from schools; at Haddington, borrowing was 'freely available to residents from 1729', following the Revd John Gray's bequest to the town. Leadhill Miners' Library was founded in 1741 with encouragement from the Glasgow graduate and Snell Exhibitioner James Stirling FRS, expelled from Balliol College, Oxford for Jacobitism in 1715, who became manager of the Leadhills mines, as Allan Ramsay's father had been before him.[41]

It is thus fair to say that Scotland was highly innovative in this field as a whole, but it was nonetheless Edinburgh which had the requisite critical mass. Even private libraries (such as Archibald Pitcairne's, purchased after his death by Peter the Great, or Fletcher of Saltoun's, which numbered six thousand volumes) could be impressive in international terms, while the Advocates Library, founded by King's Advocate Sir George Mackenzie in 1682, grew to five thousand volumes by 1710 and thirty thousand or more by 1770. From an early date it regarded itself as a

library of national quality; as early as 1699, it was advertising in the *Edinburgh Gazette* for donations of MSS, 'Historys' and charters for its holdings.[42]

The University's own library had reached eleven thousand volumes by 1710; in the 1720s, the Writers to the Signet also opened a library, while the Royal College of Physicians had been developing theirs since 1681. Once again there was a high degree of crossover between libraries and other institutions and associations: Thomas Ruddiman, so prominent in the capital's activities in other spheres, became Keeper of the Advocates Library in 1730, remaining both a printer in Parliament Close and Librarian of the neighbouring great library for the next twenty-two years.

Allan Ramsay is often held to be responsible for creating the first effective subscription library in the British Isles, which was opened in 1725 with a subscription of 10s annually (at a time when £50 a year was the baseline for middle-class status), 'although a nightly fee was available'. Ramsay's library was followed by libraries at Bristol, Birmingham (1728) and Bath (1735) (James Leake), as well as Philadelphia (Benjamin Franklin and friends, 1731).[43] Ramsay's library was an act of cultural innovation, but it was clear that the environment that sustained it contained – given the presence of at least four major libraries in the capital and others outside – a plethora of potential early adopters, to whom the free availability of books on a commercial basis beyond the libraries established in the legacy institutions of the former Scottish state offered an additional benefit. Ramsay had recognised the need, and commercialised it. In doing so, he was building on the practice of his peers: a surviving bookseller's day book from 1715–17 in the National Library of Scotland clearly shows occasional lending as a constituent part of the business, which otherwise took between £8 and £17 sterling a month in sales. Indeed, Ramsay himself was a beneficiary, borrowing Hill's *Arithmetick* from the bookseller in question on 25 August 1715, and borrowing Latin texts the same November. A strongly clustered, densely located, homophile group in close propinquity (the booksellers) had developed a practice as an occasional part of their business. Ramsay, himself a bookseller, identified a broader potential market for this practice, then systematised and commercialised it into a completely new kind of cultural offering.[44] Within a few decades his innovation had passed into use across the

Anglophone world. The subscription library was thus an innovation based on an existing unsystematised practice among commercial booksellers.[45]

Ramsay's library was criticised by Robert Wodrow, who first used the phrase 'The Killing Times' to characterise legal and military action against the Covenanters, on the grounds of its immoral books. Wodrow's criticisms were being widely repeated by the 1740s across the growing library sector, as fears grew as to the effect of fiction on 'impressionable young ladies'. Moral doubts about the circulating or subscription library were one of its standard accompaniments: the circulation of ideas and representations of exotic or transgressive lifestyles were feared by the customary patriarchal culture of social and domestic control of familial and Presbyterian Scotland and Britain. Women were deemed particularly vulnerable, not least because they were less mobile and could circulate less, hence their exposure to heterophile ideas through print was seen as doubly dangerous by virtue of their own lack of experience and hence perceived lack of judgement. The movement of ideas that characterised the Enlightenment library was a form of virtual freedom that undermined the gender politics of domestic confinement and thus elicited strong opposition. In this respect, Jane Austen's *Northanger Abbey* (1817) is more finely balanced than it at first appears in its critique of the effects of the Gothic novel on female sensibility, for General Tilney is exactly the kind of misogynistic patriarch who reveals the Gothic's relevance to real life. It was arguably Ramsay's innovation that helped to make the social issues which Jane Austen described possible.[46]

It is possible to challenge exactly how innovative Ramsay's library was. Parish libraries had a long history in both Scotland and England: there was one in Bristol from 1567. There is evidence of book-borrowing in France in the 1660s, while as early as 1661, Francis Kirkman in Bishopsgate Street, London 'was renting out volumes to willing readers'. Books were being rented out regularly in Edinburgh (as we have seen), Huntingdon, Bath, Bristol and Birmingham in the 1715–30 period. Yet it was Ramsay who developed this fairly widespread practice in a truly innovative way. As David Allan cautiously puts it:

> In purely logistical terms, Ramsay may well have been the first trader in Britain to hit upon the device of separating his lending collection physically from his sale stock.[47]

Small as this innovation appears, it was critical to defining the library and the bookshop as discrete cultural entities, and providing for the development of the levels of circulation necessary to expand the stock of the library far beyond the commercially sensible one of a bookshop. Velocity of money, ideas and influence accompanied this innovation, which was followed almost at once by Leake in Bath, who became 'perhaps the first proprietor in England to organize a collection of rentable books that were kept physically distinct from his bookselling stock'. By the end of the eighteenth century 'there were about 1000 circulating libraries', though developments could be relatively slow, with Bristol gaining a public library in 1740, and Manchester a circulating library in 1757 and Liverpool in 1758.[48]

Ramsay's library survived for over a century, passing to John Yair in 1740 and to his widow in 1758, the year of Ramsay's death. In 1780, the year after it was bought by James Sibbald, it reached twenty thousand volumes. By this time it certainly had a music section, and indeed it may have possessed one under Ramsay (who was a notable song collector), though exact details are lacking. The integration of music into Scottish library holdings was yet another example of the cross-fertilisation of associational practice, and by the last quarter of the eighteenth century it was to have very powerful effects indeed.[49]

Just as Edinburgh to some extent paralleled the rise of the London rather than the provincial press, and through its defensive patriotism and commitment to foreign news reports provided a distinctive approach in the eighteenth-century media of the British Isles, so too the innovative creation of the commercial library service by Allan Ramsay opened the way to the creation of a huge range of these knowledge-intensive business services. Libraries and books were indeed the lifeblood of Enlightenment circulation; they were also the co-producers of innovation, and even to some small extent incipient creators of gender equality. And just as the press circulated the innovations of real-estate markets, national commercial reporting, reflection pieces and lost-and-found adverts, so too did the libraries accelerate that innovation – without serious resistance save from the voices of patriarchal disapproval – from Edinburgh across the British Isles.

One overarching theme throughout this book has been the deep involvement of Edinburgh's professional and noble elites

with each other and with the national and civic institutions of the capital. The cosmopolitan experience of the city's elites and their relative openness to intermingling with talented newcomers from elsewhere in Scotland, England or abroad, combined with their high levels of education, broad horizons, densely packed commercial and residential development and belief in and anxiety about their own status, all served to overcome the resistance of a provincialised civic administration. Edinburgh remained the home of many of the Scottish nobility for much longer than is sometimes acknowledged: Whig or Tory, they were often Scottish patriots. As Roger Emerson argues, the power of noble patronage was central in driving the first age of Enlightenment forward, providing the social and sometimes directly financial support which was often critical in speeding the adoption of innovations and innovative ways of thinking in a city which, taking its lead from Amsterdam and Paris as well as London, nonetheless produced achievements of its own which would change the world.

Notes

1. R. Scott Spurlock, 'Cromwell's Edinburgh Press and the Development of Print Culture in Scotland', *Scottish Historical Review* XC:2 (2011), 179–203 (203).
2. Julia Buckroyd, 'Mercurius Caledonius and its immediate successors, 1661', in *Scottish Historical Review* LIV:1 (1975), 11–21 (11, 20).
3. John MacQueen (ed.), *Tollerators and Con-Tollerators: a comedy attributed to Archibald Pitcairne* (Columbia: University of South Carolina Libraries, 2015), 28–9.
4. W. J. Coupland, *The Edinburgh Periodical Press*, 2 vols (Stirling: Eneas Mackery, 1908), I:58, 72, 74, 166, 178; Clare Jackson, *Restoration Scotland, 1660–1690* (Woodbridge: The Boydell Press, 2003), 33, 41; Karin Bowie, 'Newspapers, the early modern public sphere and the 1704–5 *Worcester* affair', in Alex Benchimol, Rhona Brown and David Shuttleton (eds), *Before Blackwood's* (London: Pickering & Chatto, 2015), 9–20 (12); Henry R. Plomer et al., *A Dictionary of the Printers and Booksellers who were at work in England, Scotland and Ireland from 1668 to 1725* (Oxford: Oxford University Press, The Bibliographical Society, 1922); *The Edinburgh Gazette* (1680, 1699, 1708, 1709); *The Edinburgh Courant* (1707, 1708); *The Edinburgh Flying Post* (1709); *The Scots Courant* (1710); *Mercurius Caledonius*, 31

December 1660–8 January 1661; Stuart (1952), 133; James Watson, *PREFACE to the History of Painting 1713*, ed. James Munro (Greenock: Thomas Rae, 1963), vii–viii; Mathison (2005), 147.
5. Jeremy Black, *Eighteenth-Century Britain 1688–1783*, 2nd edn (Basingstoke: Palgrave Macmillan, 2008 [2001]), 221.
6. *Mercurius Reformatus: or The New Observator; The Present State of Europe: or, the Historical and Political Monthly Mercury* III:110.
7. W. J. Coupland (1908), I:124, 125, 132, 135, 215.
8. *The Mercury* I (1717), 'The General Introduction', ii, iii; Alex Benchimol, 'For "The Prosperity of Scotland": Mediating National Improvement – the *Scots Magazine*, 1739–1749', *Studies in Scottish Literature* 39 (2012), 82–103 (83); Coupland (1908) I:31, 97, 222, 242; Jeremy Black, *The English Press 1621–1861* (Stroud: Sutton, 2001), 1, 6.
9. *Critical Essays from the Spectator by Joseph Addison*, ed. Donald Bond, 1, 36; Benchimol (2012), 82–103 (83); Coupland (1908) I:31, 97, 222, 242. For the opposition to Scottish news of the Privy Council, see Black (2001).
10. *The New Statistical Account of Scotland* (Edinburgh and London: William Blackwood, 1845), I:695.
11. Stephen Brown, 'Advertising and the *Edinburgh Evening Courant*', in Benchimol, Brown and Shuttleton (2015), 21–32 (24); Robert T. Skinner, *A Notable Family of Scots Printers* (Edinburgh: printed privately for T. & A. Constable, 1927), 1.
12. *The Scots Post-Man, or The New Edinburgh Gazette*, 7, 14–16 September, 6–9 November 1708; 5–8 November 1709; Skinner (1927), 1–2.
13. Karin Bowie, 'Newspapers, the early modern public sphere and the 1704–5 *Worcester* Affair', in Benchimol, Brown and Shuttleton (2015), 9–20 (11).
14. *The Flying-Post; or, the Post-Master*, 12–24 April 1712; *The Edinburgh Gazette* 2, 7–14 December 1680. See also Bowie, in Benchimol, Brown and Shuttleton (2015), 12–13.
15. *The Edinburgh Gazette* (1699); C. P. Finlayson, 'Edinburgh University and the Darien Scheme', *Scottish Historical Review* 34 (1955), 97–102 (97).
16. Stephen W. Brown, 'Newspapers and Magazines', in Brown and Warren McDougall (eds), *History of the Book in Scotland* Vol. 2 (Edinburgh: Edinburgh University Press, 2012), 353–68 (353–4, 364); Coupland (1908), I:31, 34, 97, 132, 135, 220, 225, 242; II:11, 15, 17, 19, 62, 67, 250–4; Black (2001), 9, 113; *The Edinburgh Gazette* (1680, 1705, 1708); National Records of Scotland GD 18/4323, 4325; Brown, in Benchimol, Brown

and Shuttleton (2015), 22–4, 26. See *The Caledonian Mercury*, 12 July 1726, for McEuen's advertisement of Crawfurd's *Lives of the Officers of the Crown and of the State in Scotland*; *The Edinburgh Evening Courant*, 15 December 1718; *The Eccho*, 27 August 1729; *Monthly Mercury* III (1692).

17. *The Edinburgh Gazette* 1699 (10–13, 20–23 March, 1–4 May, 9–13, 13–16 November); *London Gazette*, 27–31 August 1681, 10–14 September 1683, 5–8 October and 22–26 October 1691; Brian Cowan, 'Art and Connoisseurship in the Auction Market of Later Seventeenth-Century London', in Neil de Marchi and Hans J. Van Miegroet (eds), *Mapping Markets for Paintings in Europe 1450–1750* (Turnhout: Brepols, 2006), 263–84 (264).

18. *The Edinburgh Gazette*, 10–13 July, 23–26 October 1699; *The Scots Post-Man*, 26–28 April, 5–7 May, 11–14 June 1709.

19. *The Edinburgh Evening Courant* (1718–20); *The Caledonian Mercury*, 28 April 1720, 17 June 1723, 13 January 1724; *BR 1701 to 1718*, xl; Adam Fox, 'The Emergence of the Scottish Broadside Ballad in the late Seventeenth and early Eighteenth Centuries', *Journal of Scottish Historical Studies* (2012), 169–94 (174); *Ramsay* IV (1970), 13–14; James Dibdin, *The Annals of the Edinburgh Stage* (Edinburgh: Richard Cameron, 1888), 26; Bill Findlay (ed.), *A History of Scottish Theatre* (Edinburgh: Polygon, 1998), 68–9, 71; David Allan, *Scotland in the Eighteenth Century* (Harlow and London: Pearson, 2002), 131; Sara Stevenson and Duncan Thomson, with John Dick, *John Michael Wright: The King's Painter* (Edinburgh: SNPG, 1982), 78–9; Allan Macinnes, *Union and Empire: The Making of the United Kingdom in 1707* (Cambridge: Cambridge University Press, 2007), 238.

20. *The Caledonian Mercury*, 28 April 1720, 14 November 1721, 17 June 1723, 13 January 1724, 25 March 1725, 27 April 1725; Coupland, 41; Rhona Brown, '"Rebellious Highlanders": The Reception of Corsica in the Edinburgh Periodical Press, 1730–1800', *Studies in Scottish Literature* 41 (2015), 108–28 (112).

21. 'Notes on Provost Stewart's actions in 1745', NLS MS 16971 f. 1; *The Caledonian Mercury*, 14 October 1745, 4 September 1746, 24 November 1748; Bob Harris, *The Scottish People and the French Revolution* (London: Pickering & Chatto, 2008), 21.

22. *The Thistle*, 13 February 1734, 1; Stephen W. Brown, 'Newspapers and Magazines', in *History of the Book in Scotland* Vol. 2, 353–68 (353, 354, 364); Alex Benchimol, 'For "The Prosperity of Scotland": Mediating National Improvement – the *Scots Magazine*, 1739–1749', *Studies in Scottish Literature* 39 (2012), 82–103 (83).

23. *The Thistle*, 13, 20, 27 February, 6, 13 March, 7 August 1734; 28 May, 4 June, 13 August 1735.

24. Benchimol (2012), 83; William Christie, 'The Modern Athenians: The *Edinburgh Review* in the Knowledge Economy of the Early Nineteenth Century', *Studies in Scottish Literature* 39 (2012), 115–38 (130); Brown, in Brown and McDougall (2012), 364; Coupland (1908), II:90.
25. *Scots Magazine* 1739, 175; 1745, 277; *The Edinburgh Evening Courant*, 30-31 March 1719; *The Caledonian Mercury*, 20 April 1725.
26. *Scots Magazine* 1739, ii, iv; Benchimol (2012), 98–9.
27. *The Scots Magazine* (June 1745), 296.
28. *Scots Magazine* 1746, Preface, iv.
29. *Scots Magazine* 1745, 285; Coupland, I:250, II:75.
30. *BR 1701 to 1718*, xl, xli; Duncan (1965), 2, 3, 49, 57; A. M. Kinghorn and Alexander Law (eds), *The Works of Allan Ramsay* (Edinburgh: Blackwood, 1970), IV:236; Fox (2012), 174; Christopher A. Whatley, with Derek Patrick, *The Scots and the Union* (Edinburgh: Edinburgh University Press, 2006), 7; Aonghus MacKechnie, 'The Earl of Perth's Chapel of 1688 at Drummond Castle and the Roman Catholic Architecture of James VII', *Architectural* Heritage XXV (2014), 107–31 (109); Brown and McDougall (2012), 9; Helen Dingwall, *Late Seventeenth-Century Edinburgh: a demographic study* (Aldershot: Scolar Press, 1994), 132.
31. Henry R. Plomer et al., *A Dictionary of the Printers and Booksellers who were at work in England, Scotland and Ireland from 1668 to 1725* (Oxford: Oxford University Press, The Bibliographical Society, 1922); Adam Fox, '"Little Story Books" and "Small Pamphlets" in Edinburgh, 1680–1760: The Making of the Scottish Chapbook', *Scottish Historical Review* XCII:2 (2013), 207–30 (214, 219); Coupland (1908), I:34–5, II:16; John Morris, 'Inside the Printing-House', in Brown and McDougall (2012), 40–51 (41); *The Edinburgh Gazette*, 20–23 March, 12–15 June 1699.
32. Alasdair J. Mann, *The Scottish Book Trade 1500–1720* (East Linton: Tuckwell Press, 2000), 16, 99; Michael Graham, *The Blasphemies of Thomas Aikenhead* (Edinburgh: Edinburgh University Press, 2013 [2008]), 65.
33. Mann (2000), 17, 95; Murray Pittock, 'Scottish Sovereignty and the Union – Then and Now', *National Identities* 14:1 (2012), 11–21.
34. Duncan (1965), 4, 43, 49; Warren McDougall, 'The Emergence of the Modern Trade: Copyright and Scottishness', in Brown and McDougall (2012), 23–39 (23, 25, 26).
35. Plomer et al. (1922); Alastair J. Mann, *The Scottish Book Trade 1500–1720* (East Linton: Tuckwell Press, 2000), 17,

97, 123; Warren McDougall, 'The Emergence of the Modern Trade: Copyright and Scottishness', in Brown and McDougall (2012), 23–39 (23, 25–7); Douglas Duncan, *Thomas Ruddiman* (Edinburgh and London: Oliver & Boyd, 1965), 27. For literacy rates, see Alexander Murdoch, 'The Popular Press and the Public Reader', in Brown and McDougall (2012), 287–96 (287). See also Bowie, in Benchimol, Brown and Shuttleton (2015), 9–20 (12); Edinburgh City Archives Town Council Records SL1/1/47 pp. 43–4, 26 August 1719.
36. Brown, in Brown and McDougall (2012), 353–4, 364; *The Eccho*, 27 August 1729.
37. Alexander Law, *Education in Edinburgh in the Eighteenth Century* (London: University of London Press, 1965), 27; Peter Jones, 'The Scottish professoriate and the polite academy', in Istvan Hont and Michael Ignatieff (eds), *Wealth and Virtue: The Shaping of Political Economy in the Scottish Enlightenment* (Cambridge: Cambridge University Press, 1983), 89–117 (92).
38. William Cowan, *The Holyrood Press, 1686–1688* (Edinburgh: privately printed, 1904), 7–8.
39. Brown and McDougall (2012), 1–22 (4–6, 14–15).
40. Cowan (1904), 3, 9, 12–14; *BR 1701 to 1718*, xl, xli.
41. K. A. Manley, *Books, Borrowers, and Shareholders: Scottish Circulating and Subscription Libraries Before 1825* (Edinburgh: Edinburgh Bibliographical Society, 2012), 2, 7–8, 11–12, 14–15, 17–19, 28.
42. Marie W. Stuart, *Old Edinburgh Taverns* (London: Robert Hale, 1952), 41; Hugo Arnot, *The History of Edinburgh* (Edinburgh: West Port Books, 1998 [1779]), 171; *Edinburgh Gazette*, 12–14 April 1699.
43. Manley (2012), 9, 10, 26.
44. Manley (2012), 10; National Library of Scotland ACC 9800.
45. For example, *The Edinburgh Miscellany* (1718–20): the account of suttee is on 30–31 March 1719; Brown and McDougall (2012), 4–5, 15; Alexander Murdoch, 'The Popular Press and the Public Reader', in Brown and McDougall (2012), 287–96 (287); Murray C. T. Simpson, 'Institutional Libraries', idem, 323–30 (323, 327); K. A. Manley, 'Subscription and Circulating Libraries', idem, 337–52 (337–9); Brown, in Brown and McDougall (2012), 353–68 (354, 364); Catherine Brown, 'Cookery Books', idem, 407–11 (407); W. J. Couper, 'James Watson, King's Printer', *Scottish Historical Review* VII (1910), 244–62 (248–9); Roger L. Emerson and Jenny MacLeod, assisted by Allen Simpson, 'The Musick Club and the Edinburgh Musical Society', *BOEC* ns 10 (2014), 45–105 (46); Dibdin (1888), 26. For middle-class status in the eighteenth century and differential income needed in

London and elsewhere, see Vic Gatrell, *City of Laughter* (London: Atlantic Books, 2006), 85. For the bookseller records, see NLS ACC 9800.
46. Manley (2012), 9; Robert Wodrow, *Analecta,* Maitland Club 60 (1843), 515–16; Mark Towsey, 'Women's Reading', in Brown and MacDougall (2012), 438–46 (442); David Allan, *A Nation of Readers: The Lending Library in Georgian England* (London: British Library, 2008), 119–20.
47. Allan (2008), 124, 157n, 165.
48. Allan (2008), 65, 126; Manley (2012), 9; Black (2008), 173–4.
49. Manley (2012), 46, 117 and passim.

Bibliography

Primary Sources: MSS

Aberdeen University Library
MS 2909 (Moir Papers)

Edinburgh City Archives
Index to the Inventory of Miscellaneous Papers Called Moses' Bundles
Inventory of Miscellaneous Papers Called Moses Bundles Vols I–VIII and Supplementary
J25 Bundle 41a
Moses Bundles VI, VII
SL 1/1/29-48 (Town Council records)
SL 3/2/2 ('List of the Polable Persones in the Lady Yester's Parish Given up Conforme to the Act of Parliament in Anno 1698 as Follows')
SL 34/1 (Records of the Acts and Statutes of St Mary's Chapel)
SL 35/33-37 (Stent Rolls)
SL127/14/1-9 (Militia Records)
SL 144/13/1 (Book of the Dean of Guild Court: 'List of Unfree Traders' [1701])
SL 149/2/4-5 (Acts of the Bailies of the Canongate)
SL 159/1/7/1 ('John Huttons Protocol Book 1682')
SL 167/1 ('Convivial Records of the Society of Trained Bands, 1750–1798')
SL 167/2 (Society of Captains)
SL 225 (Name Index for Poll Tax Returns)
SL 225/3/1 ('List of the Names and Qualities of the Pollable Persons Within the College Church Pariche in the City of Edinburgh')
SL 225/3/2/1/1-50 (Poll Tax returns)

Edinburgh University Library
Laing MS II: 212 (see HMC 72 also)
Laing MS La IV. 20
Laing MS La IV. 24

National Archives
NA State Papers 99/61

National Library of Scotland (NLS)
NLS ACC 3948
NLS ACC 6842
NLS ACC 7634 (Trial of 6 Canongate bakers 1745)
NLS ACC 8380
NLS ACC 8422 (Masonic MS on a Scottish academy)
NLS ACC 8479
NLS ACC 8575
NLS ACC 9202
NLS ACC 9546 (Verse Epistle to the Musical Club [1719])
NLS ACC 9800 (1715–17 Edinburgh bookseller's daybook)
NLS ACC 11490
NLS ACC 11594 (Leith Races details of trophy entries)
NLS ACC 12369
NLS Adv MS Ch.A. 109–24
NLS Adv MS Ch.B. 2155
NLS Adv MS 16.2.1 (Exchange Coffee House Meeting Minutes 1754–88)
NLS Adv MS 19.1.13
NLS Adv MS 19.3.15
NLS Adv MS 19.3.44
NLS Adv MS 22.2.10
NLS Adv MS 23.1.1 ('Rules and Orders of the Select Society')
NLS Adv MS 23.3.6
NLS Adv MS 23.3.26 (Eaglescarnie Papers)
NLS Adv MS 23.6.4
NLS Adv MS 23.6.14
NLS Adv MS 25.9.9
NLS Adv MS 28.3.12 ('Loca urbis Edinburgensis notabi digna')
NLS Adv MS 33.5.14
NLS Adv MS 33.5.20
NLS Adv MS 35.4.14
NLS Adv MS 82.3.5
NLS AP 3.215.01
NLS AP 4.83.32
NLS APS 4.83.4 (*The Last Speech and Dying Words of the Cross of Edinburgh*)

Bibliography

NLS Dep 184 (Byres Papers)
NLS MS 1.42.29 (Glasgow Picture Auction 1702)
NLS MS 35.4.14 (William Thoir of Muiresk Commonplace Books)
NLS MS 98
NLS MS 210
NLS MS 293 ('An Impartial and Genuine List of the Ladys in the Whig ... or ... Jacobite Partie' [1746])
NLS MS 295 ('Account of Arms deliver'd out of Edinburgh Castle')
NLS MS 488
NLS MS 494
NLS MS 582
NLS MS 660
NLS MS 1036
NLS MSS 1539–45 (Sir William Forbes' Journal of a Continental Tour)
NLS MS 1695
NLS MS 1833 (Journal of General Ramsay)
NLS MS 1834 (Journal of General Ramsay)
NLS MS 1954 (Society for Endeavouring Reformation of Manners)
NLS MS 2092
NLS MS 2233 (In Defence of an Edinburgh Theatre)
NLS MS 2617
NLS MS 2904
NLS MS 2914 (Collection of Ballads)
NLS MS 2968 (Culloden Papers)
NLS MS 3134
NLS MS 3142
NLS MS 3417 ('Letter Relating to the Dispute with John Davidson WS concerning the property at Ramsay Garden 1757–1760')
NLS MS 3648
NLS MS 3813
NLS MS 3830
NLS MS 3836
NLS MS 3912 (Rules of the St Luke Club)
NLS MS 5308
NLS MS 5657
NLS MS 6290
NLS MS 6414
NLS MS 6415
NLS MS 7073
NLS MS 8027
NLS MS 11033 ff. 48–51 ('Proposals anent the Charity Workhouse 1748')
NLS MS 14261 (Letter of Andrew Lumisden to his sister, 9 June 1748)
NLS MS 14491
NLS MS 15973 (Ramsay MSS)

NLS MS 16611
NLS MS 16680 (Saltoun Papers)
NLS MS 16971
NLS MS 17498
NLS MS 17503
NLS MS 17517 ff. 102–6 (List of [87] teachers who took the oaths)
NLS MS 17525
NLS MS 17527 ff. 139–43 (Memorial to Cumberland)
NLS MS 17602 (Papers on Edinburgh 1714–64)
NLS MS 17604 (Saltoun Papers)
NLS MS 17871
NLS MS 19979 ('Proposals for carrying on Certain Public Works In the City of Edinburgh')
NLS Rosebery Ry.1.1.35, 1–85 (Pamphlets 1689 to 1814)
NLS Rosebery Ry. 1.2.85
NLS Rosebery Ry. III.a. 10: 1–124 (Old Scottish Ballads, Broadsides &c 1679–1730)

National Records of Scotland
Edinburgh Burgh Sasines Register B 22/2/23
NRS CC 8/12/3, 5 (Commissary Court Warrants of Inventories)
NRS CC 8/89/34 (George Warrender's will)
NRS CC 8/8/121/555 (Testament and Inventory of Thomas Trotter senior)
NRS CC 8/8/129/2 (Testament and inventory of Hon Andrew Erskine)
NRS CH 12/12/1871
NRS CH 12/12/1877
NRS GD 1/483 (Papers on Scottish violin music)
NRS GD 1/1401 (Account Book of Robert Brown, Vintner)
NRS GD 18/4313-63 (Clerk of Penicuik)
NRS GD 18/4533-4566 (Music Papers of Clerk of Penicuik)
NRS GD 18/4567-94 (Aikman)
NRS GD 26/7/102-11 (Bruce of Kinross warrants)
NRS GD 26/13/271, 391 (Leven and Melville Muniments)
NRS GD 27/6/13
NRS GD 28/9/7
NRS GD 29/ 432/1-5
NRS GD 29/1951-53
NRS GD 30/2081 ('Articles agreed on for surrendering the Castle of Edinburgh', 13 June 1689)
NRS GD 44/51/465/2667 (Gordon Castle Muniments)
NRS GD 45/14/437 (Dalhousie Papers)
NRS GD 47/356 (Information on Jacobites)
NRS GD 103/2/ 389, 396–97, 401, 402, 433 (Revolution Club)
NRS GD 110/946/2 (Letter from William Hamilton)

NRS GD 122/2/17
NRS GD 124/13/68/1-5 ('Private Arming & Mustering latter end of Q. Anne's Reign')
NRS GD 170/943
NRS GD 205/34/4
NRS GD 235/9/4 (Dundas of Arniston Papers)
NRS GD 241/380/14 (Copy Proclamation of the Earl of Mar)
NRS GD 241/380/18
NRS GD 331/5/25-32 (Letters from Ramsay to Cunningham)
NRS GD 331/31/37 (Dick Cunyngham Muniments)
NRS RH 15/10/41
NRS RH 15/10/42
NRS RH 15/32/1-10 (Clephane Papers)
NRS RH 15/36/84
NRS RH 15/85/1-2 (Fearn papers)
NRS RH 15/101/1 (Piper papers)
NRS RH 15/138 (Papers of David Denune)
NRS RH 15/176/1-6 (Papers of Colin Mitchell)

Scottish National Portrait Gallery
PG A1/2/2 (Sir Hew Hamilton Dalrymple Papers)

University of South Carolina
PR 1175. TT3
PR 3499.GS 3,553
PR 4791
Ross Roy card index (Allan Ramsay)

Printed Primary Sources

An Account of the Fair Intellectual-Club of Edinburgh in a letter To An Honourable Member of an Athenian Society there. Edinburgh: J. McEuen, c. 1719.
The Acts of the Parliaments of Scotland IX (1689–95); X (1696–1701); XI (1702–7).
Ancient Law and Customs of the Burghs of Scotland. Volume II AD 1424–1707. Edinburgh: Scottish Burghs Record Society, 1910.
Aikin, John. *Essays on Song-Writing.* 2nd edn. Warrington: William Eyres, 1774.
Arnot, Hugo. *The History of Edinburgh.* Edinburgh: West Port Books, 1998 [1779].
Black, George F. *A Calendar of Cases of Witchcraft in Scotland 1510–1727.* New York: New York Public Library, 1938.

Burke, John. *A Genealogical and Heraldic History of the Extinct and Dormant Baronetcies of England, Ireland and Scotland*. London: Scott, Webster & Geary, 1841.

Caledonian Mercury. 1720–30/48.

Cockburn, Henry. *Memorials of His Time*. Edinburgh: Mercat Press, 1971 [1856].

Cordiner, Charles. *Remarkable Ruins, and Romantic Prospects of North Britain*. London, n.d. [1788].

Cuningham, Thomas of Campvere. *The Journal of Thomas Cuningham of Campvere 1640–1654*. Ed. Courthope, Elinor Joan. Edinburgh: Edinburgh University Press, 1928.

Defoe, Daniel. *A Tour Through the Whole Island of Great Britain*. Ed. Pat Rogers. Harmondsworth: Penguin, 1971 [1724–6].

___.*The History of the Union between England and Scotland*. London: John Stockdale, 1786.

Dick, Sir Alexander. 'A Journey from London to Paris in the Year 1736'. *The Gentleman's Magazine* 39 (1853), 22–5.

D'Urfey, Thomas. *Wit and Mirth; or Tom D'Urfey's Pills to Purge Melancholy: A Selection of his Best Songs into one Volume with an Account of the Author's Life*. London: William Holland, 1791.

The Eccho. Edinburgh, 1729.

Edinburgh Courant, 1705–9.

Edinburgh Evening Courant, 1718–20.

Edinburgh Flying Post, 1709.

Edinburgh Gazette, 1680–1708.

The Euing Collection of English Broadside Ballads in the Library of the University of Glasgow. Ed. John Holloway. University of Glasgow, 1971.

Extracts from the Records of the Burgh of Edinburgh 1681–1689. Ed. Marguerite Wood and Helen Armet. Edinburgh: Oliver & Boyd, 1934.

Extracts from the Records of the Burgh of Edinburgh 1689–1701. Ed. Helen Armet. Edinburgh: Oliver & Boyd, 1962.

Extracts from the Records of the Burgh of Edinburgh 1701–1718. Ed. Helen Armet. Edinburgh: Oliver & Boyd, 1967.

Forbes, Hon. Mrs Atholl (ed.). *Curiosities of a Scots Charta Chest 1600–1800 With the Travels and Memoranda of Sir Alexander Dick, Baronet*. Edinburgh: William Brown, 1897.

Foxon, D. F. *English Verse 1701–1750*. 2 vols. Cambridge: Cambridge University Press, 1975.

Geddes, John. *Some account of the state of the Catholic Religion in Scotland during the years 1745, 1746 and 1747*. Ed. Fr. Michael Briody. n.p., n.d.

Gilhooley, J. *A Directory of Edinburgh in 1752*. Edinburgh: Edinburgh University Press, 1988 [1952].

Hearne, Thomas. *Remarks and Collections of Thomas Hearne*. Eds C. E. Doble and D. W. Rannie. Oxford: Clarendon Press, 1885–98.

Herd, David. *Ancient and Modern Scottish Songs*. 2 vols. Edinburgh, 1870 [1769].
Lord Hervey's Memoirs. Ed. Romney Sedgwick. Harmondsworth: Penguin, 1984 [1963].
The Index of English Literary Manuscripts III: 1700–1800. Eds Margaret Smith and Penny Bourelha. London and New York: Mansell, 1992.
An Inventory of the Ancient and Historical Monuments of the City of Edinburgh with the Thirteenth Report of the Commission. Edinburgh: Royal Commission on the Ancient Monuments of Scotland/HMSO, 1951.
Laing MSS: *Report on the Laing Manuscripts Preserved in the University of Edinburgh*, 2 vols. London: HMSO, 1914, 1925.
Letters of the Critical Club. Edinburgh: Cheyne, 1738.
London Chronicle. 10 July 1792.
London Gazette, 1681–91.
Marwick, Sir James D. *Edinburgh Guilds and Crafts*. Edinburgh: Scottish Burgh Records Society, 1909.
The Medal. London: E. Curll, 1712.
Mercurius Caledonius. Edinburgh, 1661.
Mercurius Reformatus: or The New Observator. Edinburgh, 1690–1.
The Mercury: Or, the Northern Reformer. Edinburgh, 1717.
The New Statistical Account of Scotland. Edinburgh and London: William Blackwood, 1845.
The Observator. Edinburgh, 1705.
Oxford Dictionary of National Biography. Oxford: Oxford University Press, 2004.
Pennecuik, Alexander. *An Historical Account of the Blue Blanket: or Crafts-Men's Banner*. Edinburgh: John Mossman, 1722.
Pitcairne, Archibald. *The best of our owne: Letters of Archibald Pitcairne, 1652–1713*. Ed. W. T. Johnston. Edinburgh: Saorsa Books, 1979.
___. *The Latin Poems*. Ed. John and Winifred MacQueen. Arizona Centre for Medieval and Renaissance Studies: Royal Van Gorcum, 2009.
___. *The Phanaticks*. Ed. John MacQueen. Edinburgh: Scottish Text Society, 2012.
___. *Tollerators and Con-Tollerators: a comedy attributed to Archibald Pitcairne*. Ed. John MacQueen. Columbia: University of South Carolina Libraries, 2015.
Pope, Alexander. *The Dunciad in Four Books*. Ed. Valerie Rumbold. London: Longman, 1999.
Proposals for Retrieving the Sinking State of the Good Town of Edinburgh. Edinburgh: Davidson & Trail, 1737.
Public Advertiser. 12 July 1792.

The Works of Allan Ramsay. Ed. Burns Martin and John W. Oliver, Alexander Kinghorn and Alexander Law. 5 vols. Edinburgh and London: Blackwood/Scottish Text Society, 1945–72.

Poems by Allan Ramsay and Robert Fergusson. Ed. Alexander Kinghorn and Alexander Law. Edinburgh and London: Scottish Academic Press, 1974.

Ramsay, John of Ochtertyre, *Scotland and Scotsmen in the Eighteenth Century*. Int. David J. Brown, 2 vols. Bristol: Thoemmes Press, 1996 [1838].

Ray, James. *A Journey Through Part of England and Scotland Along with the Army Under the Command of his Royal Highness the Duke of Cumberland*. London: Osborne, 1747.

Register of Edinburgh Apprentices. 2 vols. Edinburgh: Scottish Record Society/Skinner & Co., 1929.

Registers of the Episcopal Congregation in Leith. Ed. Angus Macintyre. Edinburgh: J. Skinner & Co., 1949.

The Register of Marriages for the Parish of Edinburgh 1595–1700. Ed. Henry Paton. Edinburgh: Scottish Records Society, 1905.

The Register of Marriages for the Parish of Edinburgh 1701–1750. Ed. Henry Paton. Edinburgh: Scottish Records Society, 1908.

Register of the Privy Council of Scotland. 3rd series Volume XIV (1689) ed. Henry Paton, intr. Robert Kerr Hannay. Edinburgh: General Register House, 1933.

Register of the Privy Council of Scotland. 3rd series, Vol. XV (1690). Ed. Evan Balfour-Melville. Edinburgh: HMSO, 1967.

Register of the Privy Council of Scotland. 3rd series, Vol. XVI (1691). Edinburgh: HMSO, 1970.

Sandby, Paul. *The Virtuosi's Museum*. London: Kearsly, 1778.

Sanderson, William. *Graphic: The use of the Pen and Pensil*. London: Robert Crofts, 1658.

The Scots Courant. Edinburgh, 1710–11, 1718–19.

The Scots Magazine. Edinburgh, 1739–46.

The Scots Post-Man or the New Edinburgh Gazette, 1708–12.

The Autobiography of Sir Robert Sibbald. Edinburgh and London, 1833.

Slezer, Captain John. *Theatrum Scotiae*. Edinburgh: William Paterson, 1874 [1693].

Smollett, Tobias. *Travels through France and Italy*. Ed. Frank Felsenstein. Oxford: Oxford University Press, 1981.

The First and Second Statistical Accounts of the City of Edinburgh 1799 and 1845. Edinburgh: West Port Books, 1998.

Strenae Natalitiae Academiae Oxoniensis in Celsissimum Principia. Oxonii: E Theatro Sheldoniana, 1688.

Theocritus. *Idylls*. Tr. Anthony Varty, with Introduction and Notes by Richard Hunter. Oxford: World's Classics, 2003 [2002].

The Thistle, 1734–6.
Tytler, Alexander Fraser. *Memoirs of the Life and Writings of the Honourable Henry Home of Kames*. Ed. John Valdimir Price. 2 vols. London: Routledge/Thoemmes, 1993.
Watson, James. *James Watson's PREFACE to the History of Printing 1713*. Ed. James Munro. Greenock: Thomas Rae, 1963.
___. *James Watson's Choice Collection of Comic and Serious Scots Poems*. Ed. Harriet Harvey Wood. 3 vols. Edinburgh: Scottish Text Society, 1977 [1709–11].

Secondary Texts

Ahnert, Thomas. *The Moral Culture of the Scottish Enlightenment 1690–1805*. New Haven and London: Yale University Press, 2014.
Akerman, John Yonge. *Tradesman's Tokens Current in London and Its Vicinity between the Years 1648 and 1672*. London: John Russell Smith, 1849.
Allan, David. *Virtue and Learning in the Scottish Enlightenment*. Edinburgh: Edinburgh University Press, 1993.
___. *Scotland in the Eighteenth Century*. Harlow and London: Pearson, 2002.
___. *A Nation of Readers: The Lending Library in Georgian England*. London: British Library, 2008.
Anderson, H. M. 'The Grammar School of the Canongate'. *BOEC* XX (1935), 1–25.
Anderson, R. D. *Scottish Education Since the Reformation*. Dundee: Economic and Social History Society of Scotland, 1997.
Anderson, R. D., Lynch, Michael and Phillipson, Nicholas. *The University of Edinburgh: An Illustrated History*. Edinburgh: Edinburgh University Press, 2003.
Anderson, R. D. (Robert), Freeman, Mark and Paterson, Lindsay (eds). *The Edinburgh History of Education in Scotland*. Edinburgh: Edinburgh University Press, 2015.
Andrew, Patricia R. 'Four Statues and a Landslip: Allan Ramsay, John Wilson, Thomas Guthrie and Charity'. *BOEC* ns 12 (2016), 65–82.
Andrews, Corey. *Literary Nationalism in Eighteenth-Century Scottish Club Poetry*. Lampeter: Edwin Mellen Press, 2004.
Anson, Peter F. *Underground Catholicism in Scotland 1622–1878*. Montrose: Standard Press, 1970.
Archaeologica Scotica. Edinburgh, 1831.
Archbold, Johanna. *Creativity, the City & the University*. Dublin: Trinity Long Room Hub, 2010.
Armet, Helen. 'Notes on Rebuilding Edinburgh in the Last Quarter of the Seventeenth Century'. *BOEC* XXIX (1956), 111–42.

___. 'Allan Ramsay of Kinkell's Property on the Castlehill'. *BOEC* XXX (1959), 19–30.
Armstrong, Norma. *Edinburgh as it was: The People of Edinburgh*. Nelson, Lancs: Hendon Publishing, 1977.
Arnold, Thomas. *History of the Cross of Edinburgh commonly called the Mercat Cross*. Edinburgh: William Paterson, 1885.
Atkinson, David. *The English Traditional Ballad: Theory, method, and practice*. Aldershot: Ashgate, 2002.
Bamford, Francis. 'Some Edinburgh Furniture-Makers'. *BOEC* XXXII (1966), 32–53.
Barclay, Katie and Simonton, Deborah (eds). *Women in Eighteenth-Century Scotland*. Farnham: Ashgate, 2013.
Bastian, F. *Defoe's Early Life*. London and Basingstoke: Macmillan, 1981.
Bayer, Thomas M. 'The Seventeenth Century Dutch Art Market: The Influence of Economics on Artistic Production'. *Athena* X (1991), 21–7.
Bayer, Thomas M. and Page, John R. *The Development of the Art Market in England: Money as Muse, 1730–1960*. London and New York: Routledge, 2016 [2011].
Bell, D. *Edinburgh Old Town*. Edinburgh: Tholis Publishing, 2008.
Benchimol, Alex. 'For "The Prosperity of Scotland": Mediating National Improvement – the *Scots* Magazine, 1739–1749'. *Studies in Scottish Literature* 39 (2012), 82–103.
Benchimol, Alex, Brown, Rhona and Shuttleton, David (eds). *Before Blackwood's*. London: Pickering & Chatto, 2015.
Bender, Thomas (ed.). *The University and the City: From Medieval Origins to the Present*. Oxford: Oxford University Press, 1991.
Bermingham, Ann and Brewer, John (eds). *The Consumption of Culture 1600–1800: Image, Object, Text*. London: Routledge, 1995.
Berry, Christopher J. *The Idea of Commercial Society in the Scottish Enlightenment*. Edinburgh: Edinburgh University Press, 2015.
Bignamini, I. 'The "Academy of Art" in Britain before the Foundation of the Royal Academy in 1768', in Boschloo, Anton W. A. et al. *Academies of Art Between Renaissance and Romanticism, Leids Kunsthistorisch Jaarboek* V–VI (1986–7), 434–50.
Black, George F. *A Calendar of Cases of Witchcraft in Scotland 1510–1727*. New York: The New York Public Library, 1938.
Black, Jeremy. *Eighteenth-Century Europe*. 2nd edn. Basingstoke: Macmillan, 1999 [1990].
___. *The English Press 1621–1861*. Stroud: Sutton, 2001.
___. *The Grand Tour in the Eighteenth Century*. Stroud: Sutton, 2003 [1992].
___. *Eighteenth-Century Britain 1688–1783*. 2nd edn. Basingstoke: Palgrave Macmillan, 2008 [2001].

Blaikie, Walter Biggar. 'Edinburgh at the Time of the Occupation of Prince Charles'. *BOEC* II (1909), 1–60.
Blom, Peter. *Scots Girn about Grits, Gruel and Greens: Four Centuries of Scots Life in Veere*. Tr. James Allan. Veere: Stichting-Veere-Schotland, 2008 [2003].
Bonehill, John and David, Stephen (eds). *Paul Sandby: Picturing Britain*. London: Royal Academy of Arts, 2009.
Bonnino, Stefan. *Muslims in Scotland: The Making of Community in a Post-9/11 World*. Edinburgh: Edinburgh University Press, 2017.
The Book of the Old Edinburgh Club XI. Edinburgh: T. & A. Constable, 1922.
Boran, Elizabethanne and Gribben, Crawford (eds). *Enforcing Reformation in Ireland and Scotland, 1550–1700*. Aldershot: Ashgate, 2006.
Borsay, Peter. *The Image of Georgian Bath, 1700–2000: Towns, Heritage, and History*. Oxford: Oxford University Press, 2000.
___. *A History of Leisure: The British Experience since 1500*. Basingstoke: Palgrave Macmillan, 2006.
Bower, Alexander. *The History of the University of Edinburgh*. 3 vols. Edinburgh, 1817.
Bowie, Karen. *Scottish Public Opinion and the Anglo-Scottish Union 1699–1707*. Woodbridge: Boydell & Brewer/Royal Historical Society, 2007.
Boydell, Brian. *A Dublin Musical Calendar 1700–1760*. Dublin: Irish Academic Press, 1988.
Branningan, Jerry and McShane, John. *Robert Burns in Edinburgh: An Illustrated Guide to Burns' Time in Edinburgh*. Ill. David Alexander. Glasgow: Waverley Books, 2015.
Brett, Vanessa. *Bertrand's Toyshop in Bath Luxury Retailing 1685–1765*. Wetherby: Oblong, 2014.
Broadie, Alexander. *The Scottish Enlightenment*. Edinburgh: Birlinn, 2001.
___ (ed.). *The Cambridge Companion to the Scottish Enlightenment*. Cambridge: Cambridge University Press, 2003.
___ (ed.). *History of Universities* XXIX/2 (2016). Oxford: Oxford University Press, 2017.
Bronson, Bernard. *Joseph Ritson: Scholar-at-Arms*. 2 vols. Berkeley: University of California Press, 1938.
Brookes, Patricia. 'The Trustees' Academy, Edinburgh – 1760–1801: The public patronage of art and design in the Scottish Enlightenment'. Unpublished PhD, Syracuse, 1989.
Brown, Iain Gordon. 'Allan Ramsay's Rise and Reputation'. *The Walpole Society* 50 (1984), 209–47.

___. '"I Understand Pictures Better than Became my Purse . . .': The Clerks of Penicuik and Eldin as Collectors and Connoisseurs'. *Journal of the Scottish Society for Art History* 8 (2003), 27–36.

___. 'David Martin and Allan Ramsay: A candid view by Alexander Fraser Tytler'. *Journal of the Scottish Society for Art History* 16 (2011–12).

___. 'Inspecting Rebus: "Nonsense Methodized" in a Hieroglyphic Letter of Richard Cooper and Allan Ramsay'. *Journal of the Edinburgh Bibliographical Society* 11 (2016), 23–42.

Brown, Rhona. 'Literary Communication and Commemorations in the Edinburgh Cape Club'. *Journal for Eighteenth-Century Studies* (special issue on Networks of Improvement) 38:4 (2015), 525–39.

___. '"Rebellious Highlanders": The Reception of Corsica in the Edinburgh Periodical Press, 1730–1800'. *Studies in Scottish Literature* 41 (2015), 108–28.

Brown, Stephen W. and McDougall, Warren (eds). *The History of the Book in Scotland* Vol. 2. Edinburgh: Edinburgh University Press, 2012.

Brydall, Robert. *Art in Scotland: Its Origin and Progress*. Edinburgh and London: William Blackwood, 1889.

Buckroyd, Julia. 'Mercurius Caledonius and its immediate successors, 1661'. *Scottish Historical Review* LIV:1 (1975), 11–21.

Bulman, William J. and Ingram, Robert G. *God in the Enlightenment*. Oxford: Oxford University Press, 2016.

Burke, Peter. *What is Cultural History?* London: Polity, 2006 [2004].

___. *A Social History of Knowledge*. Cambridge: Polity, 2008 [2000].

Bushnell, Nelson. *William Hamilton of Bangour: Poet and Jacobite*. Aberdeen: Aberdeen University Press, 1957.

Butler, Revd D. *The Tron Kirk of Edinburgh*. Edinburgh and London: Oliphant, Anderson & Ferrier, 1906.

Bynum, W. F. and Porter, Roy. *William Hunter and the eighteenth-century medical world*. Cambridge: Cambridge University Press, 1985.

Cairns, John. *Enlightenment, Legal Education, and Critique*. Edinburgh: Edinburgh University Press, 2015.

Calaresu, Melissa and Hills, Helen (eds). *New Approaches to Naples c. 1500–c. 1800: The Power of Place*. Farnham: Ashgate, 2013.

Cameron, Alan. *Bank of Scotland 1695–1995: A Very Singular Institution*. Edinburgh and London: Mainstream, 1995.

Camic, Charles. *Experience and Enlightenment: Socialization for Cultural Change in Eighteenth-Century Scotland*. Edinburgh: Edinburgh University Press, 1983.

Campbell, R. H. and Skinner, Andrew (eds). *Origins & Nature of the Scottish Enlightenment*. Edinburgh: John Donald, 1982.

Carter, Jennifer J. and Pittock, Joan (eds). *Aberdeen and the Enlightenment*. Aberdeen: Aberdeen University Press, 1987.
Catterall, Douglas. *Community Without Borders: Scots Migrants and the Changing Face of Power in the Dutch Republic, c. 1600–1700*. London, 2002.
Chappell, W. *Popular Music of the Olden Time*. 2 vols. London: Cramer, Beale & Chappell, n.d. [1857–8].
Checkland, S. G. *Scottish Banking A History, 1695–1973*. Glasgow and London: Collins, 1975.
Chitnis, Anand. *The Scottish Enlightenment: A Social History*. London: Croom Helm, 1976.
Christie, William. 'The Modern Athenians: The *Edinburgh Review* in the Knowledge Economy of the Early Nineteenth Century'. *Studies in Scottish Literature* 39 (2012), 115–38.
Cities as a Lab: Designing the Innovation Economy. American Institute of Architects, 2013.
Clark, Jonathan. 'The Enlightenment: Catégories, Traductions, et objects sociaux'. *Lumieres* 17–18 (2011), 19–39.
___. *From Restoration to Reform: The British Isles 1660–1832*. London: Vintage, 2014.
___. '"God" and "the Enlightenment": The Divine Attributes and the Question of Categories in British Discourse', in Bulman, William J. and Ingram, Robert G. *God in the Enlightenment*. Oxford: Oxford University Press (2016), 215–35.
Clayton, Timothy. *The English Print 1688–1802*. New Haven and London: Yale University Press, 1997.
Clifford, Timothy. 'Imperiali and his Scottish Patrons', in Ciardi, Roberto Paolo, Pinelli, Antonio and Sicca, Cinza Maria (eds). *Pittura Toscana E Pittura Europea Nel Secolo dei Lumi*. Pisa, 1990.
Clough, Monica. *Two Houses: New Tarbat, Easter Ross; Royston House, Edinburgh*. Aberdeen: Aberdeen University Press, 1990.
Cobban, Alfred. *In Search of Humanity: The Role of the Enlightenment in Modern History*. London: Jonathan Cape, 1960.
Cochrane, Robert. *Pentland Walks with their Literary and Historical Associations*. Ill. George Shaw Aitken. Edinburgh: Andrew Elliot, 1930.
Cockburn, Harry A. 'An Account of the Friday Club, Written by Lord Cockburn, Together with Notes on Certain other Social Clubs in Edinburgh'. *BOEC* III (1910), 105–78.
Coen, Paolo. 'Andrea Casali and James Byres: The Mutual Perception of the Roman and British Art Markets in the Eighteenth Century'. *Journal for Eighteenth-Century Studies* 34:1 (2011), 291–313.
Coghill, Hamish. *Lost Edinburgh*. Edinburgh: Birlinn, 2014 [2008].
Coleman, James J. *Remembering the Past in Nineteenth-Century Scotland*. Edinburgh: Edinburgh University Press, 2014.

Colston, James. *The Guildry of Edinburgh: Is it an Incorporation?*. Edinburgh: Colston & Co., 1887.

___. *The Incorporated Trades of Edinburgh*. Edinburgh: Colston & Co., 1891.

Coltman, Viccy and Lloyd, Stephen (eds). *Henry Raeburn: Context, Reception and Reputation*. Edinburgh: Edinburgh University Press, 2012.

Conner, R. D. and Simpson, A. D. C. *Weights and Measures in Scotland: A European Perspective*, ed. Morrison-Low, A. D. Edinburgh and East Linton: National Museums of Scotland and Tuckwell Press, 2004.

Connolly, S. J., Houston, R. A. and Morris, R. J. (eds). *Conflict, Identity and Economic Development: Ireland and Scotland, 1600–1939*. Preston: Carnegie Publishing, 1995.

Connon, Heather, 'The disruptors'. *Trust* (winter 2015), 10–12.

Cooke, Anthony. *A History of Drinking: The Scottish Pub since 1700*. Edinburgh: Edinburgh University Press, 2015.

Cooper, David, Donaldson, Christopher and Murrietta-Flores, Patricia (eds). *Literary Mapping in the Digital Age*. London and New York: Routledge, 2016.

Cornforth, John. 'Glorious Propaganda'. *Country Life*, 13 October 1988, 220–3.

Corp, Edward. *The King over the Water: Portraits of the Stuarts in Exile after 1689*. Edinburgh: Scottish National Portrait Gallery, 2001.

___. *Jacobites at Urbino*. Basingstoke: Palgrave Macmillan, 2009.

___. *The Stuarts in Italy, 1719–1766: A Royal Court in Permanent Exile*. Cambridge: Cambridge University Press, 2011.

Corp, Edward et al. *A Court in Exile: The Stuarts in France, 1689–1718*. Cambridge: Cambridge University Press, 2004.

Corp, Edward (ed.). *The Stuart Court in Rome: The Legacy of Exile*. Aldershot: Ashgate, 2003.

Cosh, Mary. *Edinburgh: The Golden Age*. Edinburgh: John Donald, 2003.

Couper, W. J. *The Edinburgh Periodical Press*. 2 vols. Stirling: Eneas Mackay, 1908.

___. 'James Watson, King's Printer'. *Scottish Historical Review* VII (1910), 244–62.

___. 'The Pretender's Printer'. *Scottish Historical Review* 15 (1918), 106–23.

___. *The 'King's Press' at Perth, 1715–6*. Perth: privately printed, 1919.

Cowan, Brian. *The Social Life of Coffee*. New Haven and London: Yale University Press, 2005.

___. 'Art and Connoisseurship in the Auction Market of Later

Seventeenth-Century London', in de Marchi, Neil and Van Miegroet, Hans J. (eds). *Mapping Markets for Paintings in Europe 1450–1750*. Turnhout: Brepols (2006), 263–84.
Cowan, William. *The Holyrood Press, 1686–1688*. Edinburgh: Privately printed, 1904.
Cowgill, Rachel and Holman, Peter (eds). *Music in the British Provinces, 1690–1914*. Aldershot: Ashgate, 2007.
Cox, Nancy. *Retailing and the Language of Goods, 1550–1820*. Farnham: Ashgate, 2015.
Craig, Cairns. *Intending Scotland: Explorations in Scottish Culture Since the Enlightenment*. Edinburgh: Edinburgh University Press, 2009.
Crowley, Lizzie. *Streets Ahead: what makes a city innovative*. Lancaster: The Work Foundation, 2011.
Davidson, John and Gray, Alexander. *The Scottish Staple at Veere: A Study in the Economic History of Scotland*. London: Longmans, Green & Co., 1909.
De Jean, Joan. *How Paris Became Paris: The Innovation of the Modern City*. New York: Bloomsbury, 2014.
De Landa, Manuel. *A Thousand Years of Nonlinear History*. New York: Swerve, 1997.
Dennison, Patricia. *Holyrood and Canongate: A Thousand Years of History*. Edinburgh: Birlinn, 2005.
Dennistoun, James. *Memoirs of Sir Robert Strange &c.* 2 vols. London: Longman, 1855.
Devine, T. M. *Scotland's Empire 1600–1815*. London: Allen Lane, 2003.
___. *To the Ends of the Earth: Scotland's Global Diaspora*. London: Allen Lane, 2011.
Devine, T. M. (ed.). *Scottish Elites*. Edinburgh: John Donald, 1994.
Dibdin, James. *The Annals of the Edinburgh Stage*. Edinburgh: Richard Cameron, 1888.
Dijn, Annelien de. 'The Politics of Enlightenment: From Peter Gay to Jonathan Israel'. *Historical Journal* 55:3 (2012), 785–805.
Dingwall, Helen. *Late Seventeenth-Century Edinburgh: a demographic study*. Aldershot: Scolar Press, 1994.
___. *Physicians, Surgeons and Apothecaries: Medical Practice in Seventeenth-Century Edinburgh*. East Linton: Tuckwell Press, 1995.
Dingwall, Helen, et al. *Scottish Medicine: An Illustrated History*. Edinburgh: Birlinn, 2011.
Dobson, David. *Huguenot and Scots Links 1575–1775*. Baltimore: Clearfield, 2005.
Drummond, Andrew and Bulloch, James. *The Scottish Church 1688–1843: The Age of the Moderates*. Edinburgh: Saint Andrew Press, 1973.
Dubois, Pierre. *Music in the Georgian Novel*. Cambridge: Cambridge University Press, 2015.

Duishea, Philip. 'Another 18th Century reference to Arthur's Oven'. *PSAS* 140 (2010), 207–9.
Duncan, Douglas. *Thomas Ruddiman*. Edinburgh and London: Oliver & Boyd, 1965.
Dwyer, John, Mason, Roger A. and Murdoch, Alexander (eds). *New Perspectives on the Politics and Culture of Early Modern Scotland*. Edinburgh: John Donald, n.d. [1983].
Easson, D. E. 'French Protestants in Edinburgh (1)'. *PHSL* 18 (1947–52), 325–44.
The Economist, 1 July 2017.
Edgar, James, Maitland, William et al. *History of Edinburgh*. Edinburgh: Hamilton, Balfour & Neil, 1753.
Edgar, John. *History of Early Scottish Education*. Edinburgh: James Thin, 1893.
Einberg, Elizabeth. *William Hogarth: A Complete Catalogue of the Paintings*. New Haven: Yale, 2016.
Emerson, Roger. 'The Philosophical Society of Edinburgh, 1737–1747'. *The British Journal for the History of Science* 12:2 (1979), 154–91.
___. *Academic Patronage in the Scottish Enlightenment: Glasgow, Edinburgh and St Andrews Universities*. Edinburgh: Edinburgh University Press, 2008.
___. *An Enlightened Duke: The Life of Archibald Campbell (1682–1761) Earl of Ilay 3rd Duke of Argyll*. Kilkerran: humming earth, 2013.
Emerson, Roger L., Macleod, Jenny, with Simpson, Allen. 'The Musick Club and the Edinburgh Musical Society'. *BOEC* ns 10 (2014), 45–105.
Errington, Lindsay. *Alexander Carse c. 1770–1843*. Scottish Masters 11. Edinburgh: Scottish National Portrait Gallery, n.d.
Fedosov, Dimitry. *The Caledonian Connection: Scotland–Russia Ties: Middle Ages to early Twentieth Century*. Aberdeen: Centre for Scottish Studies, 1996.
Ferguson, Thomas. *The Dawn of Scottish Social Welfare: A survey from mediaeval times to 1863*. London and Edinburgh: Thomas Nelson, 1948.
Fife, Malcolm. *The Nor' Loch: Scotland's Lost Loch*. Lancaster: Scotforth Books, 2004 [2001].
Findlay, Bill (ed.). *A History of Scottish Theatre*. Edinburgh: Polygon, 1998.
Finlay, John. *The Community of the College of Justice: Edinburgh and the Court of Session, 1687–1808*. Edinburgh: Edinburgh University Press, 2014 [2012].
Finlayson, C. P. 'Edinburgh University and the Darien Scheme'. *Scottish Historical Review* 34 (1955), 97–102.
Fiske, Roger. *English Theatre Music in the Eighteenth Century*. London: Oxford University Press, 1973.

Foote, Henry Wilder. *John Smibert Painter: With a Descriptive Catalogue of the Portraits And Notes on the Work of Nathaniel Smibert.* Cambridge, MA: Harvard University Press, 1950.
Fortescue, William Irvine. 'Black Slaves, Apprentices or Servants in Eighteenth-Century Scotland: Evidence from Edinburgh Newspapers'. *BOEC* ns 12 (2016), 17–26.
Fotheringham, Henry Steuart. *We that Istradds: The Incorporated Trades of Edinburgh.* Edinburgh: The Convenery of the Trades of Edinburgh, 2013.
Fox, Adam. *Oral and Literate Culture in England 1500–1700.* Oxford: Clarendon Press, 2000.
___. 'The Emergence of the Scottish Broadside Ballad in the late Seventeenth and early Eighteenth Centuries'. *Journal of Scottish Historical Studies* (2012), 169–94.
___. '"Little Story Books" and "Small Pamphlets" in Edinburgh, 1680–1760: The Making of the Scottish Chapbook'. *Scottish Historical Review* XCII:2 (2013), 207–30.
Foyster, Elizabeth and Whatley, Christopher A. (eds). *A History of Everyday Life in Scotland, 1600–1800.* Edinburgh: Edinburgh University Press, 2010.
Fraser, James E. *From Caledonia to Pictland: Scotland to 795.* Edinburgh: Edinburgh University Press, 2014 [2009].
Friedenwald-Fishman, Eric. 'No art? No social change. No innovation economy'. *Stanford Social Innovation Review*, 26 May 2011.
Gardner, Ginny. *The Scottish Exile Community in the Netherlands, 1660–1690.* East Linton: Tuckwell Press, n.d.
Gatrell, Vic. *City of Laughter.* London: Atlantic Books, 2006.
___. *The First Bohemians.* London: Penguin, 2014 [2013].
Gay, Peter. *The Enlightenment: An Interpretation: The Rise of Modern Paganism.* London: Weidenfeld & Nicolson, 1967 [1966].
Gelbart, Matthew. *The Invention of 'Folk Music' and 'Art Music'.* Cambridge: Cambridge University Press, 2007.
Gemmill, Elizabeth and Mayhew, Nicholas. *Changing values in mediaeval Scotland: A study of prices, money, and weights and measures.* Cambridge: Cambridge University Press, 1995.
Gibson, Andrew. *New Light on Allan Ramsay.* Edinburgh: William Brown, 1927.
Gibson, A. J. S. and Smout, T. C. *Prices, food and wages in Scotland 1550–1780.* Cambridge: Cambridge University Press, 1995.
Gibson-Wood, Carol. 'George Turnbull and Art History in Scottish Universities in the Eighteenth Century'. *Revue d'art canadien* XXVIII (2001–3), 7–18.
Glaeser, Edward. *Triumph of the City: How Urban Spaces Make Us Human.* London: Pan, 2012 [2011].

Glover, Katharine. *Elite Women and Polite Society in Eighteenth-Century Scotland*. Woodbridge: The Boydell Press, 2011.
Gordon, George and Dicks, Brian (eds). *Scottish Urban History*. Aberdeen: Aberdeen University Press, 1983.
Graham, Michael. *The Blasphemies of Thomas Aikenhead*. Edinburgh: Edinburgh University Press, 2013 [2008].
Gray, W. Forbes. 'The Musical Society of Edinburgh and St Cecilia's Hall', *BOEC* XIX (1933), 189–245.
___. 'An Eighteenth-Century Riding School'. *BOEC* XX (1935), 111–59.
___. 'Edinburgh in Lord Provost Drummond's Time'. *BOEC* XXVII (1949), 1–24.
Gray, John G. *The Capital of Scotland: its precedence and status*. Edinburgh: The Edina Press, 1980.
Greengrass, Mark. *Christendom Destroyed: Europe 1517–1648*. London: Penguin, 2015 [2014].
Griffiths, Anthony, with Gerard, Robert A. *The Print in Stuart Britain 1603–1689*. London: British Museum, 1998.
Grosjean, Alexia and Murdoch, Steve (eds). *Scottish Communities Abroad in the Early Modern Period*. Leiden: Brill, 2005.
Guy, John C. 'Edinburgh Engravers'. *BOEC* IX (1916), 79–113.
Habib, Vanessa. 'William Cheape of the Canongate, and Eighteenth Century Linen Manufactures'. *BOEC* ns 5 (2002), 1–12.
Hall, Stuart and du Gay, Paul (eds). *Questions of Cultural Identity*. London: Sage, 1996.
Hannay, R. K. 'The Visitation of the College of Edinburgh in 1690'. *BOEC* VIII (1916), 79–100.
Harris, Bob. *The Scottish People and the French Revolution*. London: Pickering & Chatto, 2008.
___. 'Landowners and Urban Society in Eighteenth-Century Scotland'. *Scottish Historical Review* XCII:2 (2013), 231–54.
___. *A Tale of Three Cities: The Life and Times of Lord Daer 1763–1794*. Edinburgh: John Donald, 2015.
Harris, Bob and McKean, Charles. *The Scottish Town in the Age of Enlightenment 1740–1820*. Edinburgh: Edinburgh University Press, 2014.
Harris, Stuart. 'New Light on the First New Town'. *BOEC* ns 2 (1992), 1–13.
___. *The Place Names of Edinburgh*. London: Steve Savage Publishers, 1996.
Haynes, Nick. *Scotland's Sporting Buildings*. Edinburgh: Historic Scotland, 2014.
Henderson, G. D. *Chevalier Ramsay*. London: Thomas Nelson, 1952.
Herron, Andrew. *Kirk by Divine Right: Church and State*. Edinburgh: Saint Andrew Press, 1985.

Holloway, James. *William Aikman 1682–1731*. Scottish Masters 9. Edinburgh: National Gallery of Scotland, 1988.
___. 'John Urquhart of Cromarty: An Unknown Collector of Italian Painting'. *Scotland & Italy: Papers Presented at the Fourth Annual Conference of the Scottish Society for Art History 1989*. Edinburgh (1989), 1–13.
Holmes, Heather (ed.). *Institutions of Scotland: Education*. Scottish Life and Society: A Compendium of Scottish Ethnology 11, general editor Alexander Fenton. East Linton: Tuckwell Press, 2000.
Hont, Istvan and Ignatieff, Michael (eds). *Wealth and Virtue: The Shaping of Political Economy in the Scottish Enlightenment*. Cambridge: Cambridge University Press, 1983.
Home, Bruce J. 'Provisional List of Old Houses remaining in High Street and Canongate of Edinburgh'. *BOEC* I (1908), 1–30.
Home, George. 'Notes on Rebuilding in Edinburgh in the Last Quarter of the Seventeenth Century'. *BOEC* XXIX (1956), 111–42.
Houston, R. A. *Scottish Literacy and the Scottish Identity: Illiteracy and Society in Scotland and Northern England, 1600–1800*. Cambridge: Cambridge University Press, 1985.
___. 'Popular Politics in the Reign of George II: The Edinburgh Cordiners'. *Scottish Historical Review* LXXI:2 (1993), 167–89.
___. *Social Change in the Age of Enlightenment: Edinburgh, 1660–1760*. Oxford: Clarendon Press, 1994.
___. 'Fire and Faith: Edinburgh's Environment, 1660–1760'. *BOEC* ns 3 (1994), 25–36.
Howie, Les. *George Watson's College: An Illustrated History*. Edinburgh, 2006.
Hughan, William James. *The Jacobite Lodge at Rome 1735–7*. Torquay: n.p., 1910.
Huizinga, Johan. *Homo Ludens: A Study of the Play Element in Culture*. London: Paladin, 1970 [1949].
Hutton, Ailsa. 'Re-Viewing history: antiquaries, the graphic arts and Scotland's lost geographies, c. 1660–1820'. Unpublished PhD, University of Glasgow, 2016.
Hutton, Ronald. *Charles the Second King of England, Scotland, and Ireland*. Oxford: Clarendon Press, 1989.
Imbruglia, Girolamo (ed.). *Naples in the Eighteenth Century: The Birth and Death of a Nation State*. Cambridge: Cambridge University Press, 2000.
Ingamells, John. *A Dictionary of British and Irish Travellers in Italy 1701–1800*. New Haven and London: Yale University Press, 1997.
Inglis, Lucy. *Georgian London: into the Streets*. London: Penguin, 2014 [2013].
Innes, Sir Malcolm of Edingight. 'Ceremonial in Edinburgh: The Heralds and the Jacobite Risings'. *BOEC* ns 1 (1991), 1–6.

Insh, Fern. 'An Aspirational Era? Examining and Defining Scottish Visual Culture 1620–1707'. Unpublished PhD, University of Aberdeen, 2014.
An Introduction to Lodge Canongate Kilwinning. Edinburgh: Lodge Canongate Kilwinning No. 2, 1982 [1951].
Irons, James Campbell. *Leith and its Antiquities*. 2 vols. Edinburgh: Morrison & Gibb for the subscribers, 1897.
Israel, Jonathan. *A Revolution of the Mind: Radical Enlightenment and the Intellectual Origins of Modern Democracy*. Princeton and Oxford: Princeton University Press, 2010.
___. *Democratic Enlightenment: Philosophy, Revolution, and Human Rights 1750–1790*. New York: Oxford University Press, 2011.
Jack, R. D. S. *The Italian Influence in Scottish Literature*. Edinburgh: Edinburgh University Press, 1972.
Jackson, Clare. *Restoration Scotland, 1660–1690*. Woodbridge: The Boydell Press, 2003.
Jackson, John. *The History of the Scottish Stage*. Edinburgh: Peter Hill, 1793.
Jacob, Margaret. *Living the Enlightenment*. New York and Oxford: Oxford University Press, 1991.
___. *The Origins of Freemasonry: Facts & Fictions*. Philadelphia: University of Pennsylvania Press, 2000.
___. *The Enlightenment: A Brief History with Documents*. Boston and New York: Bedford/St Martin's Press, 2001.
Jacob, Margaret J. and Secretas, Catherine (eds). *In Praise of Ordinary People: Early Modern Britain and the Dutch Republic*. Basingstoke: Palgrave Macmillan, 2013.
Jacobs, Jane. *The Economy of Cities*. London: Jonathan Cape, 1970 [1969].
Jajdelska, Elspeth. '"Singing of Psalms of which I could never get enough": Labouring Class Religion and Poetry in the Cambuslang Revival of 1741'. *Studies in Scottish Literature* 41 (2015), 88–103.
Jamieson, Bill. 'In the Family Way'. *Scottish Field* (June 2017), 168–9.
Jamieson, James H. 'Some Inns of the Eighteenth Century'. *BOEC* XIV (1925), 121–46.
___. 'Social Assemblies of the Eighteenth Century'. *BOEC* XIX (1933), 31–91.
Jamieson, John H. 'The Edinburgh Street Traders and their Cries'. *BOEC* II (1909), 177–222.
___. 'The Sedan Chair in Edinburgh'. *BOEC* IX (1916), 177–234.
Jay, Ricky. *Extraordinary Exhibitions*. New York: Quantuck Lane Press, 2005.
Jeaffreson, John Cordy. *Annals of Oxford*. 2 vols. London: Hunt & Blackett, 1871.

Jenkinson, Jacqueline. *Scottish Medical Societies 1731–1939: Their History and Records*. Edinburgh: Edinburgh University Press, 1993.
Johnson, David. *Music and Society in Lowland Scotland in the Eighteenth Century*. London: Oxford University Press, 1972.
___. *Scottish Fiddle Music in the Eighteenth Century: A Music Collection and Historical Study*. 3rd edn. Edinburgh: Mercat Press, 2005 [1984].
Jonckheere, Koenraad. *The Auction of King William's Paintings 1713: Elite International Art Trade at the end of the Dutch Golden Age*. John Benjamins, 2008.
Jones, Peter (ed.). *Philosophy and Science in the Scottish Enlightenment*. Edinburgh: John Donald, 1988.
Kahler, Lisa. 'Freemasonry in Edinburgh, 1721–1746: Institutions and Context'. Unpublished PhD, St Andrews, 1998.
Keefe, Simon P. (ed.). *The Cambridge History of Eighteenth-Century Music*. Cambridge: Cambridge University Press, 2014 [2009].
Kelsall, Helen and Keith. *Scottish Lifestyle 300 Years Ago: New Light on Edinburgh and Border Families*. Edinburgh: John Donald, 1986.
Kerr, Henry F. 'Map of Edinburgh in the Mid-Eighteenth Century'. *BOEC* XI (1922), 1–20.
Kissinger, Henry. *World Order: Reflections on the Character of Nations and the Course of History*. London: Penguin, 2014.
Koester, Olaf. *Painted Illusions: The Art of Cornelius Gijsbrechts*. London: National Gallery, 2000.
Kroll, Richard W. F. *The Material World*. Baltimore and London: Johns Hopkins University Press, 1991.
Latour, Bruno. *Reassembling the Social: An Introduction to Actor-Network-Theory*. Oxford: Oxford University Press, 2005.
Law, Alexander. *Education in Edinburgh in the Eighteenth Century*. London: University of London Press, 1965.
___. 'Teachers in Edinburgh in the Eighteenth Century'. *BOEC* XXXII (1966), 108–57.
___. 'Allan Ramsay and the Easy Club'. *Scottish Literary Journal* 16:2 (1989), 18–40.
Lawson, John Parker. *History of the Scottish Episcopal Church from the Revolution to the Present Time*. Edinburgh: Gallie & Bayley, 1843.
Lax, Lucinda. 'The Bonnie Prince in Print: Robert Strange's *Everso Missus* Portrait and the Politics of the '45'. *Journal of the Scottish Society for Art History* 22 (2017–18), 15–22.
Lees, J. Cameron. *St Giles, Edinburgh*. Edinburgh and London: W. R. Chambers, 1889.
Leneman, Leah. *Alienated Affections: The Scottish Experience of Divorce and Separation, 1684–1830*. Edinburgh: Edinburgh University Press, 1998.

Leneman, Leah and Mitchison, Rosalind. *Sexuality and Social Control: Scotland 1660–1780*. Oxford: Basil Blackwell, 1989.

___. *Sin in the City: Sexuality and Social Control in Urban Scotland 1660–1780*. Edinburgh: Scottish Cultural Press, 1998.

Lenman, Bruce. *Enlightenment and Change: Scotland 1746–1832*. The New History of Scotland, 2nd edn. Edinburgh: Edinburgh University Press, 2009 [1981].

Leppert, Richard. *Music and image: Domesticity, ideology and socio-cultural formation in eighteenth-century England*. Cambridge: Cambridge University Press, 1988.

Lesger, Clé. *The Rise of the Amsterdam Market and Information Exchange*. Tr. J. C. Grayson. Aldershot: Ashgate, 2006.

Lévi-Strauss, Claude. *The Savage Mind (La Pensée Sauvage)*. London: Weidenfeld & Nicolson, 1981 [1962].

Lippincott, Louise. *Selling Art in Georgian London*. Paul Mellon Centre for Studies in British Art. New Haven and London: Yale University Press, 1983.

Lochhead, Marion. *The Scots Household in the Eighteenth Century*. Edinburgh: The Moray Press, 1948.

Lockhart, Brian R. W. *Jinglin' Geordie's Legacy: A History of George Heriot's Hospital and School*. East Linton: Tuckwell Press, 2003.

Lole, F. Peter. *A Digest of the Jacobite Clubs*. Royal Stuart Society Paper LV. London: Royal Stuart Society, 1999.

Louw, Hentie. 'Dutch Influence on British Architecture in the Late-Stuart Period, c. 1660–c. 1714'. *Dutch Crossing* 33:2 (2009), 83–120.

Lowrey, John. 'The Influence of the Netherlands on Early Classicism and the Formal Garden in Scotland'. *Scottish Society for Art History Journal* 1 (1996), 21–34.

McCarthy, Angela and MacKenzie, John M. (eds). *Global Migrations: The Scottish Diaspora Since 1600*. Edinburgh: Edinburgh University Press, 2016.

Mackay, John. *History of the Burgh of Canongate*. Edinburgh and London: Oliphant, Anderson & Ferrier, 1900.

McCrae, Morrice. *Physicians and Society: A History of the Royal College of Physicians in Edinburgh*. Edinburgh: John Donald, 2007.

McDougall, Sheena and Armstrong, Norma. *Treasures of the Edinburgh Room*. Edinburgh: Edinburgh City Libraries, 1984.

McDougall, Warren. 'Gavin Hamilton, John Balfour and Patrick Neill: a Study of publishing in Edinburgh in the 18th century'. Unpublished PhD, Edinburgh, 1975.

McElroy, Davis D. 'The Literary Clubs and Societies of 18th Century Scotland'. Unpublished PhD, Edinburgh, 1952.

McElroy, Lucille and David, 'Index: The Literary Clubs and Societies of Eighteenth-Century Scotland'. Unpublished PhD, Vol. 2, Edinburgh, 1955.

McGilvary, George. *East India Patronage and the British State: The Scottish Elite and Politics in the Eighteenth Century*. London and New York: Tauris, 2008.
McInally, Tom. *The Sixth Scottish University: The Scots Colleges Abroad: 1575 to 1799*. Leiden and Boston: Brill, 2012.
Macinnes, Allan. *Union and Empire: The Making of the United Kingdom in 1707*. Cambridge: Cambridge University Press, 2007.
Macinnes, Allan, Riis, T. and Pedersen, F. G. (eds). *Ships, Guns and Bibles in the North Sea and the Baltic States, c. 1350–c. 1700*. East Linton: Tuckwell, 2000.
McIntosh, John R. *Church and Theology in Enlightenment Scotland: The Popular Party, 1740–1800*. Scottish Historical Review Monographs. East Linton: Tuckwell Press, 1998.
MacKechnie, Aonghus. 'The Earl of Perth's Chapel of 1688 at Drummond Castle and the Roman Catholic Architecture of James VII'. *Architectural Heritage* XXV (2014), 107–31.
McKean, Charles. *Edinburgh: Portrait of a City*. London: Century, 1991.
McKendrick, Neal, Brewer, John and Plumb, J. H. *The Birth of a Consumer Society*. London: Hutchinson, 2007 [1982].
Mackenzie, Allan. *History of the Lodge Canongate Kilwinning No. 2*. Edinburgh: Printed for the Lodge by Brother James Hogg, 1888.
McKenzie, J. 'School and University Drama in Scotland, 1650–1760'. *Scottish Historical Review* XXXIV (1955), 103–21.
MacLean, Colin and Veitch, Kenneth (eds). *Religion*. Scottish Life and Society: A Compendium of Scottish Ethnology 12, general editor Alexander Fenton. East Linton: Tuckwell Press, 2006.
Macleod, Jennifer. 'The Edinburgh Musical Society: Its Membership and Repertoire 1728–1797'. Unpublished PhD, University of Edinburgh, 2001.
___. 'The Edinburgh Musical Society'. *BOEC* ns 9 (2012), 31–91.
McLuhan, Marshall. *Understanding Media: The Extensions of Man*. London: Sphere, 1968 [1964].
McPhail, Bridget. 'Through a Glass Darkly: Scots and Indians Converge at Darien'. *Eighteenth-Century Life* 18 (1994), 129–47.
Maitland, William. *History of Edinburgh*. Edinburgh, 1753.
Manley, K. A. *Books, Borrowers, and Shareholders: Scottish Circulating and Subscription Libraries Before 1825*. Edinburgh: Edinburgh Bibliographical Society, 2012.
Mann, Alastair J. *The Scottish Book Trade 1500–1720*. East Linton: Tuckwell Press, 2000.
___. *James VII: Duke and King of Scots, 1633–1701*. Edinburgh: John Donald, 2014.
Markus, Thomas A. (ed.). *Order in Space and Society: Architectural*

Form and its Context in the Scottish Enlightenment. Edinburgh: Mainstream, 1982.
Marshall, Rosalind K. Women in Scotland, 1660–1780. Edinburgh: National Galleries of Scotland, 1979.
___. John de Medina 1659–1710. Edinburgh: National Gallery of Scotland Scottish Masters, 1988.
___. St Giles': The Dramatic Story of a Great Church and its People. Edinburgh: Saint Andrew Press, 2009.
Marwick, W. H. 'Shops in Eighteenth and Nineteenth-Century Edinburgh'. BOEC XXX (1959), 119–41.
Mathison, Hamish. 'Robert Hepburn and the Edinburgh Tatler: a study in an early British periodical'. Media History 11:1/2 (2005), 147–61.
Mauries, Patrick. Cabinets of Curiosities. London: Thames & Hudson, 2011 [2002].
Maxwell, Richard. The Historical Novel in Europe, 1650–1950. Cambridge: Cambridge University Press, 2009.
Meadows, Anne. 'Collecting Seventeenth-Century Dutch Painting in England 1689–1760'. Unpublished PhD, University College London, 1988.
Mee, Jon, 'Introduction'. Journal for Eighteenth-Century Studies (special issue on Networks of Improvement) 38:4 (2015), 475–82.
Meikle, Henry W. 'Glasgow and the French Revolution'. Transactions of the Franco-Scottish Society VI:1 (1912), 98–109.
Melville, Lewis. Life and Letters of John Gay. London: Daniel O'Connor, 1921.
Mijers, Esther. 'The Netherlands, William Carstares, and the Reform of Edinburgh University, 1690–1715'. History of Universities XXV/2 (2011), 111–42.
___. "News from the Republick of Letters": Scottish Students, Charles Mackie and the United Provinces, 1650–1750. Leiden and Boston: Brill, 2012.
Mijers, Esther and Onnekirk, David (eds). Redefining William III: The Impact of the King-Stadtholder in International Context. Aldershot: Ashgate, 2007.
Miller, Robert. The Municipal Buildings of Edinburgh. Edinburgh: Printed by Order of the Town Council, 1895.
Minay, Priscilla. 'Eighteenth and Early Nineteenth Century Edinburgh Seedsmen and Nurserymen'. BOEC ns 1 (1991), 7–27.
Mitchell, Ken. Tradition and Innovation in English Retailing, 1700 to 1850: Narratives of Consumption. Farnham: Ashgate, 2014.
Monod, Paul. 'Pierre's White Hat: Theatre, Jacobitism and Popular Protest in London, 1689–1760', in Cruickshanks, Eveline (ed.), By Force or By Default? The Revolution of 1688–1689. Edinburgh: John Donald (1989), 159–89.
Monod, Paul, Pittock, Murray and Szechi, Daniel (eds). Loyalty and

Identity: Jacobites at Home and Abroad. Basingstoke: Palgrave Macmillan, 2010.
Morgan, Margery. 'Jacobitism and Art after 1745: Katherine Read in Rome'. *British Journal for Eighteenth-Century Studies* 27:2 (2004), 233–44.
Morton, Graeme. *William Wallace: A National Tale*. Edinburgh: Edinburgh University Press, 2014.
Munck, Bert de and Lynn, Pries (eds). *Concepts of Value in European Material Culture, 1500–1900*. Farnham: Ashgate, 2015.
Munro, Neil. *The History of the Royal Bank of Scotland 1727–1927*. Edinburgh: R. & R. Clark Ltd, 1928.
Murdoch, Steve. *Network North: Scottish Kin, Commercial and Covert Associations in Northern Europe 1603–1746*. Leiden and Boston: Brill, 2006.
Nenadic, Stena. 'Middle-Rank Consumers and Domestic Culture in Edinburgh and Glasgow 1720–1840'. *Past & Present* 145 (1994), 122–56.
James Norie: Painter 1684–1757. Edinburgh: Privately printed, 1890.
North, Michael and Ormrod, David (eds). *Art Markets in Europe, 1400–1800*. Aldershot: Ashgate, 1998.
O'Brien, John. *Harlequin Britain*. Baltimore: Johns Hopkins University Press, 2004.
Ogborn, Miles and Withers, Charles W. J. (eds). *Georgian Geographies*. Manchester: Manchester University Press, 2004.
Oliphant, Margaret. *Royal Edinburgh*. Twickenham: Senate, 1999 [1890].
Ottenheym, Konrad. 'Dutch Influences in William Bruce's Architecture'. *Scotia-Europa interactions in the late Renaissance, Architectural Heritage* XVIII (2007), 135–49.
Ozouf, Mona. *Festivals and the French Revolution*. Tr. Alan Sheridan. Cambridge, MA: Harvard University Press, 1988.
Packham, Catherine. 'Disability and Sympathetic Sociability in Enlightenment Scotland: The Case of Thomas Blacklock'. *Journal of Eighteenth-Century Studies* 30:3 (2007), 423–38.
The Painters' Progress: The Life and Times of Thomas and Paul Sandby. Nottingham Castle Museum Festival Exhibition, 1986.
Paul, J. Balfour. *History of the Royal Company of Archers*. Edinburgh, 1875.
Pears, Iain. *The Discovery of Painting: The Growth of Interest in the Arts in England, 1680–1768*. New Haven and London: Yale University Press, 1988.
Phelps, Edmund. *Mass Flourishing*. Princeton and Oxford: Princeton University Press, 2013.
Phillipson, Nicholas. 'Lawyers, Landowners, and the Civic Leadership of post-Union Scotland'. *The Juridical Review* (1976), 97–120.
Phillipson, Nicholas and Mitchison, Rosalind (eds). *Scotland in the*

Age of Improvement. Edinburgh: Edinburgh University Press, 1970.
Pierazzo, Elena. *Digital Scholarly Editing*. Farnham: Ashgate, 2015.
Pittock, Murray. *Poetry and Jacobite Politics in Eighteenth-Century Britain and Ireland*. Cambridge: Cambridge University Press, 2006 [1994].
___. 'Scottish Sovereignty and the Union – Then and Now'. *National Identities* 14:1 (2012), 11–21.
___. *Material Culture and Sedition, 1688–1760: Treacherous Objects, Secret Places*. Basingstoke: Palgrave Macmillan, 2013.
Pittock, Murray (ed.). James Hogg: *The Jacobite Relics of Scotland First Series*. Edinburgh: Edinburgh University Press, 2002.
Plomer, Henry R. et al. *A Dictionary of the Printers and Booksellers who were at work in England, Scotland and Ireland from 1668 to 1725*. Oxford: Oxford University Press: The Bibliographical Society, 1922.
Pointon, Marcia. *Hanging the Head: Portraiture and Social Formation in Eighteenth-Century England*. New Haven and London: Yale University Press, 1993.
___. *Strategies for Showing: Women, Possession and Representation in English Visual Culture*. Oxford: Oxford University Press, 1997.
Porter, Roy. *Enlightenment: Britain and the Creation of the Modern World*. London: Penguin, 2001 [2000].
Porter, Roy and Teich, Mikulas (eds). *The Enlightenment in National Context*. Cambridge: Cambridge University Press, 1981.
The Present State of Europe: or, the Historical and Political Monthly Mercury. 1690–5.
Preston, Judy. 'Thomas Wright's Edinburgh Almanack, 1733'. *BOEC* ns 9 (2000), 115–21.
Price, Cecil. *Theatre in the Age of Garrick*. Oxford: Blackwell, 1973.
Proceedings of the Huguenot Society of London. Vols 18 (1947–52) and 19 (1952–8).
Prunier, Clotilde. *Anti-Catholic Strategies in Eighteenth-Century Scotland*. Frankfurt: Peter Lang, 2004.
Pryke, Sebastian. 'At the Sign of the Pelican'. *Regional Furniture* VI (1992), 10–21.
Pryor, Mary. 'John and Cosmo Alexander: of Recusancy, Jacobites and Aberdeen Junctures'. *Recusant History* 31:2 (2012), 219–38.
Purser, John and McGuinness, David. *The Georgian Concert Society Programme Notes*, 28 March 1998.
Raffe, Alasdair. *The Culture of Controversy: Religious Arguments in Scotland, 1660–1714*. Woodbridge: The Boydell Press, 2012.
Raymond, Joad (ed.). *The Oxford History of Popular Print Culture*. Oxford: Oxford University Press, 2011.

Rendall, Jane. *The Origins of the Scottish Enlightenment 1707–1776.* London and Basingstoke: Macmillan, 1978.
Rigney, Ann. 'Things and the Archive: Scott's Materialist Legacy'. *Scottish Literary Review* 7:2 (2015), 13–34.
Robertson, John. *The Case for the Enlightenment: Scotland and Naples 1680–1760.* Cambridge: Cambridge University Press, 2005.
Robertson, Una A. 'An Edinburgh Lawyer and his Bees'. *BOEC* ns 1 (1991), 79–81.
Rock, Joe. 'Richard Cooper'. *Scottish Archives* 8 (2002), 71–81.
___. 'Richard Cooper Senior (c. 1696–1764) and his Properties in Edinburgh'. *BOEC* ns 6 (2005), 11–23.
___. 'Robert Gordon, goldsmith and Richard Cooper, engraver: A glimpse into a Scottish atelier of the eighteenth century'. *Silver Studies* (2005), 49–63.
___. 'Richard Cooper Sr and Scottish Book Illustration', in Brown, Stephen W. and McDougall, Warren (eds). *The History of the Book in Scotland.* Edinburgh: Edinburgh University Press (2012), II:81–90.
___. 'The Decorated Room at Moray House, c. 1706–c. 1710'. *BOEC* ns 12 (2016), 1–16.
Rodger, Richard. *The Transformation of Edinburgh: Land, Property and Trust in the Nineteenth Century.* Cambridge: Cambridge University Press, 2001.
Rodger, Richard (ed.). *European Urban History.* Leicester and London: Leicester University Press, 1993.
Rodger, Richard and Herbert, Joanna (eds). *Testimonies of the City: Identity, Community and Change in a Contemporary Urban World.* Aldershot: Ashgate, 2007.
Rogers, Everett M. *Diffusions of Innovation.* 3rd edn. New York: Free Press, 1983 [1962].
___. *Diffusion of Innovations*, 5th edn. New York: Free Press/Simon & Schuster, 2003 [1962].
Rosenmeyer, Thomas G. *The Green Cabinet: Theocritus and the European Pastoral Lyric.* Berkeley and Los Angeles: University of California Press, 1969.
Ross, William C. A. *The Royal High School.* 2nd edn. Edinburgh and London: Oliver & Boyd, 1949 [1934].
Roy, Stéphane. 'The art of trade and the economics of taste: the English print market in Paris, 1770–1800'. *Studies in Voltaire and the Eighteenth Century* 2008:06, 167–92.
Royal College of Physicians of Edinburgh: The Sir Robert Sibbald Physic Garden. Edinburgh: Stationery Office, 1997.
Thirty-Fourth Annual Report of the Council of the Royal Scottish Academy. Edinburgh: Thomas Constable, 1861.

Saunders, Richard H. *John Smibert: Colonial America's First Portrait Painter*. New Haven and London: Yale University Press, 1995.
Savile, Richard. *Bank of Scotland: A History 1695–1995*. Edinburgh: Edinburgh University Press, 1996.
Scotland, James. *The History of Scottish Education*. 2 vols. London: University of London Press, 1969.
Scotland & Italy: Papers Presented at the Fourth Annual Conference of the Scottish Society for Art History 1989. Edinburgh, n.d.
Shepard, Leslie. *The History of Street Literature*. Newton Abbot: David & Charles, 1973.
Sher, Richard B. *Church and University in the Scottish Enlightenment*. Princeton: Princeton University Press, 1985.
___. *The Enlightenment and the Book*. Chicago: University of Chicago Press, 2006.
Sher, Richard B. and Smitten, Jeffrey R (eds). *Scotland & America in the age of the enlightenment*. Edinburgh: Edinburgh University Press, 1990.
Shukman, Ann. *Bishops and Covenanters: Religion and the Church in Scotland 1688–1691*. Edinburgh: Birlinn, 2012.
Simpson, A. D. C. 'Sir Robert Sibbald – The Founder of the College'. The Stanley Davidson Lecture. *Proceedings of the Royal College of Physicians of Edinburgh Tercentenary Congress 1981*. Edinburgh: Royal College of Physicians (1982), 59–91.
Siskin, Clifford and Warner, William (eds). *This is Enlightenment*. Chicago and London: University of Chicago Press, 2009.
Sitwell, Sacheverell and Bamford, Francis. *Edinburgh*. London: Faber, 1938.
Skinner, Basil. *Scots in Italy in the 18th Century*. Edinburgh: National Galleries of Scotland, 1966.
___. 'Philip Tideman and the Decoration of Hopetoun House'. *Scottish Society for Art History Journal*, Vol. 1 (1996), 11–19.
Skinner, Robert T. *A Notable Family of Scots Printers*. Edinburgh: Privately printed for T. & A. Constable, 1927.
Skinner, William. *The Society of Trained Bands of Edinburgh*. Edinburgh: Pillans & Wilson, 1889.
Smailes, Helen. 'David Le Marchand's Scottish Patrons'. Unpublished paper given at the Henry Moore Centre for the Study of Sculpture, Leeds, 18–20 October 1996.
___. 'The Price of Friendship? Romney and Sir Robert Strange'. *Transactions of the Romney Society* 3 (1998), 12–17.
Smailes, Helen and Thomson, Duncan. *A Celebration of Mary Queen of Scots: The Queen's Image*. Edinburgh: Scottish National Portrait Gallery, 1987.
Smart, Alastair. *Allan Ramsay 1713–1784*. Edinburgh: Scottish National Portrait Gallery, 1982.

Smout, T. C. *Scottish Trade on the Eve of Union 1600–1707*. Edinburgh and London: Oliver & Boyd, 1963.

___. 'Scottish–Dutch Contact 1600–1800', in Williams, Julia Lloyd (ed.). *Dutch Art and Scotland: A Reflection of Taste*. Edinburgh: National Gallery of Scotland (1992), 21–32.

Smout, T. C. (ed.). *Scotland and Europe, 1200–1850*. Edinburgh: John Donald, 1986.

'The Social Dividend'. *Royal Society of Arts Journal* 3 (2015), 7.

Spufford, Margaret. *The Great Reclothing of Rural England: Petty Chapmen and their Wares in the Seventeenth Century*. London: Hambledon Press, 1984.

___. *Figures in the Landscape*. Aldershot: Ashgate, 2000.

Spurlock, R. Scott. 'Cromwell's Edinburgh Press and the Development of Print Culture in Scotland'. *Scottish Historical Review* XC:2 (2011), 179–203.

Stafford, Barbara Maria. *Artful Science: Enlightenment Entertainment and the Eclipse of Visual Education*. Cambridge, MA: MIT Press, 1994.

Stephen, Jeffrey. 'Defending the Revolution: The Church of Scotland and the Scottish Parliament, 1689–93'. *Scottish Historical Review* LXXXIX:1 (2010), 19–53.

___. *Defending the Revolution: The Church of Scotland 1689–1716*. Farnham: Ashgate, 2013.

Stevenson, David. *The Beggar's Benison*. East Linton: Tuckwell Press, 2001.

Stevenson, Sara and Thomson, Duncan, with Dick, John. *John Michael Wright: The King's Painter*. Edinburgh: Scottish National Portrait Gallery, 1982.

Stewart, Laura A. M. *Urban Politics and the British Civil Wars: Edinburgh, 1617–1653*. Leiden and Boston: Brill, 2006.

Strong, John. *A History of Secondary Education in Scotland*. Oxford: Clarendon Press, 1909.

Stuart, Marie W. *Old Edinburgh Taverns*. London: Robert Hale, 1952.

Szechi, Daniel. *1715*. New Haven: Yale University Press, 2006.

___. *Britain's Lost Revolution*. Manchester: Manchester University Press, 2015.

Taylor, Charles. *Philosophy and the Human Sciences*. Cambridge: Cambridge University Press, 1985.

These Fifty Years: The Story of Carrubber's Close Mission Edinburgh. Edinburgh: The Tract and Colportage Society, 1909.

Thin, Robert. 'Medical Quacks in Edinburgh in the Seventeenth and Eighteenth Centuries'. *BOEC* XXII (1938), 132–59.

Thomas, Keith. *Man and the Natural World*. Harmondsworth: Penguin, 1987 [1983].

Thomson, Duncan et al. *Raeburn: The Art of Sir Henry Raeburn 1756–1823*. Edinburgh: Scottish National Portrait Gallery, 1997.
Tobin, Terence. *Plays by Scots 1660–1800*. Iowa City: University of Iowa Press, 1974.
Tomalin, Claire. *Samuel Pepys: The Unequalled Self*. London: Peregrine, 2003 [2002].
Towell, Rev. Edwin S. 'The Minutes of the Trades Maiden Hospital'. BOEC XXVIII (1953), 1–43.
___. 'The Minutes of the Merchant Maiden Hospital'. BOEC XXIX (1956), 1–92.
Townsend, Richard P. 'Alexander Keirincx's royal commission of 1639–1640'. *Leids Kunsthistorisch Jaarboek* XXII. University of Leiden, 2003, 137–50.
Turner, A. Logan. *Story of a Great Hospital: The Royal Infirmary of Edinburgh 1729–1929*. Edinburgh: Oliver & Boyd, 1937.
Uglow, Jenny. *The Lunar Men*. London: Faber, 2002.
Varst, Sander. 'Off to a new Cockaigne: Dutch migrant artists in London, 1660–1715'. *Simiolus* 37:1 (2013–14), 25–60.
Vasey, Peter G. 'The Canonmills Gunpowder Manufactory and a Newly Discovered Plan by John Adair'. BOEC ns 4 (1997), 103–6.
Walker, N. H. *Kinross House and its Associations*. Published privately, 1990.
Walkley, Giles. *Artists' Houses in London, 1764–1914*. Aldershot: Scolar Press, 1994.
Wallace, Mark C. 'Social Freemasonry 1725–1810: Progress, Power, Politics'. Unpublished PhD, St Andrews, 2007.
___. '"The Scotch Diable Boiteaux" Or, The Lame Scottish Devil: Masonic Rebellion and the Rise of the Whigs'. BOEC ns 12 (2016), 47–64.
Warren, Jeremy and Turpin, Adriana (eds). *Auctions, Agents and Dealers: The Mechanism of the Art Market 1660–1830*. Oxford: Beazley Archive/Wallace Collection, 2007.
Waterston, Robert. 'Further Notes on Early Paper Making near Edinburgh'. BOEC XXVII (1949), 40–59.
Watson, Charles B. Boog. *Notes on the Names of the Closes and Wynds of Edinburgh*. Edinburgh: T. & A. Constable, 1923.
Watson, W. N. Boag. 'Early Baths and Bagnios in Edinburgh'. BOEC XXXIV:2 (1979), 57–67.
Watt, Douglas. *The Price of Scotland: Darien, Union and the Wealth of Nations*. Edinburgh: Luath Press, 2007.
Wedd, Kit, with Peltz, Lucy and Ross, Cathy. *Creative Quarters: The Art World in London from 1700 to 2000*. London: Merrell; Museum of London, 2001.
Wemyss, Charles. 'Merchant and Citizen of Rotterdam: The Early Career of Sir William Bruce'. *Architectural Heritage* XVI (2005), 14–30.

Wenley, Robert M. G. 'William, Third Earl of Lothian'. *Journal of the History of Collections* 5:1 (1993), 23–41.
Westover, Paul. *Necromanticism: Travelling to Meet the Dead, 1750–1860*. Basingstoke: Palgrave Macmillan, 2012.
Whatley, Christopher A. 'Reformed Religion, Regime Change, Scottish Whigs and the struggle for the "Soul" of Scotland, c. 1688–c. 1788'. *Scottish Historical Review* XCII (2013), 66–99.
Whatley, Christopher A., with Patrick, Derek. *The Scots and the Union*. Edinburgh: Edinburgh University Press, 2006.
Whetstone, Ann E. *Scottish County Government in the Eighteenth and Nineteenth Centuries*. Edinburgh: John Donald, 1981.
White, Jerry. *London in the Eighteenth Century: A Great and Monstrous Thing*. London: The Bodley Head, 2012.
Williams, J. Lloyd. 'The import of art: the trade for northern European goods in Scotland in the seventeenth century', in Roding, Juliette and Van Voss, Lex Heerma (eds). *The North Sea and Culture (1550–1800)*. Hilversum: Verloren (1996), 298–323.
Willigan, Adriaan van der and Meijer, Fred G. *A Dictionary of Dutch and Flemish Still-life Painters Working in Oils, 1525–1725*. Leiden: Primavera Press, 2003.
Wilson, Sir David. *Memorials of Edinburgh In the Olden Time*. 2nd edn. Edinburgh and London: Adam & Charles Black, 1891.
Wintoun, Calhoun. *John Gay and the London Theatre*. Lexington: University Press of Kentucky, 1993.
Withers, Charles W. J. *Geography, Science and National Identity: Scotland since 1520*. Cambridge: Cambridge University Press, 2001.
___. *Placing the Enlightenment: Thinking Geographically about the Age of Reason*. London and Chicago: University of Chicago Press, 2007.
Withrington, Donald. 'What was Distinctive about the Scottish Enlightenment?' in Carter, Jennifer J. and Pittock, Joan H. (eds). *Aberdeen and the Enlightenment*. Aberdeen: Aberdeen University Press (1987), 9–19.
Wood, Marguerite. '"All the Statelie Buildings of ... Thomas Robertson" – A Building Speculator of the Seventeenth Century'. *BOEC* XXIV (1942), 126–51.
___. 'Survey of the Development of Edinburgh'. *BOEC* XXXIV (1974), 23–56.
Wood, Paul (ed.). *The Scottish Enlightenment: Essays in Reinterpretation*. Rochester: University of Rochester Press, 2007 [2000].
Woolf, Daniel. *The Social Circulation of the Past*. Oxford: Oxford University Press, 2003.
Youngson, A. J. *The Making of Classical Edinburgh*. Edinburgh: Edinburgh University Press, 1988 [1966].

Index

Abercrombie, Patrick, 163, 201
accountancy, 44, 96–7
Adam, John, 58
Adam, Robert, 198
Adam, William, 147
Adams, William, 231, 235
Addison, Joseph, 32, 162, 168, 227
Advocates, Faculty of, 45, 52, 64–7, 73, 197
 in Edinburgh, 65
 library, 236, 240
 and the Netherlands, 65
Aikenhead, Thomas, 71–2
Aikin, John, 167
Aikman, William, 132, 138, 141, 143, 145–6, 206–7
Alexander, Cosmo, 143, 147, 149, 150, 151
Alexander, John, 142–3, 148, 149
Allan, David (historian), 15
Allan, David (painter), 150, 241
Anne, Queen, 156
Archers, Royal Company of, 45, 178, 199–201, 204
Argyll, Archibald Campbell, 3rd Duke, 110, 114; *see also* Ilay
Argyle, John Campbell, 2nd Duke, 158
Associated Critics, 197
Aston, Anthony, 158, 178
auctions, 90–1, 135–7, 139–40
Austen, Jane, 241

Balfour, Andrew, 53
Bank of England, 51
Bank of Scotland, 48
Beattie, James, 210
Beggar's Benison, 207
Berkeley, George (Bishop), 4
Berry, Christopher, 1, 13
Black, Jeremy, 4, 5, 7, 172
Blair, Hugh, 110, 183, 208, 209, 211, 216
Bocchi, Lorenzo, 160, 162–3, 169
Bolla, Peter de, 4
booksellers, 234–9
Boswell, James, 20–1, 143, 210, 216
Botanic Garden, 52–3
Broadie, Alexander, 11
Bruce, Sir William, 98, 132, 133, 145, 205
Buckle, Henry, 10, 34
burgesses, 86–7
Burke, Peter, 22

Caledonian Mercury, 148, 152, 175, 231, 232, 235, 236
Campbell, Roy (R. H.), 13
Canongate, 69
Canongate Kilwinning, 215–19
Captains, Society of, 197–8
Carlyle, Alexander, 110, 183, 208, 209
Carse, Alexander, 206

Carstares, William, 107–8, 109, 111, 112, 114
Catholics, 106
Chalmers, Roderick, 88, 136–7, 147
Chalmers, Sir George, 143, 147
Chambers, Robert, 12, 46
Charles II, 30, 46, 49, 86, 93, 95, 151, 174, 218
Clark, Jonathan, 4, 6, 8, 9
Clerk of Penicuik, Sir John, 20–1, 109, 132, 138, 161, 167, 172, 197, 214
 Clerk family, 93–4, 96
clubs and societies, 196–212
Coaches, 48, 59–60
Cobban, Alfred, 9
coffee and coffee houses, 59, 90, 212–14
College of Justice, 67
Commission for Visiting Universities Colleges & Schools, 110–11
Company of Scotland, 48, 50–1, 228–9, 238
Cooper, Richard, 30, 147–9, 169, 178–9, 183, 199, 217
copyright, 237–8
Courtonne, Jean-Baptiste, 15
Crafts, 86–7
Craig, Adam, 160
cricket, 208
Cullen, William, 198

D'Alembert, Jean le Rond, 15
Darien, 51, 228–9
David, Anthony, 145
Davis, Leith, 167
Defoe, Daniel, 27, 72, 226
Dick, Sir Alexander (Cunynghame), 132, 135, 149, 182, 208, 217, 218–19
Dick, Sir James, 99
Dingwall, Helen, 45
divorce, 66
Donaldson, James, 227
Drummond, George, 52, 180
Drummond, Lord John, 100, 145, 166
Dublin, 21

Dundas, Henry, 68
Dupra, Domenico, 145

East India Company, 51
Easy Club, 201–5, 226
The Eccho, 238
Edinburgh
 art, 132–40
 business, 44–5
 charities, 65, 68–9, 165
 cityscape, 17–19, 25–8, 41–2, 46–7
 climate, 70–1
 clubs and societies, 101, 196–212
 compared to: Amsterdam, 27–9; Canongate, 69; Chicago, 70; Exeter, 20; France, 43; London, 27, 31, 55, 70; Manchester, 20; Netherlands, 43, 61, 64, 72, 132–7; Paris, 48; Vienna, 70
 dancing, 164–6
 fire, 57–8
 Freemasonry, 214–18
 fruit and vegetables, 87–8
 gardening, 90–1
 gender equality, 66, 72, 207–8
 Gladstone's Land, 92
 goldsmiths, 44–5
 hospitals, health and hygiene, 54, 56–7, 64, 118; compared to London, 55
 house prices, 91–3, 230
 infrastructure, 47–8
 law, 114–15; *see also* Advocates, Writers to the Signet
 life expectancy, 70
 medicine, 112, 114–17; *see also* College of Physicians
 mercat cross, removal of, 49
 migration, 69–70
 multiculturalism, 93
 music, 68, 154, 159–60, 162, 164–6
 New Town, 22, 28, 52, 54–5, 180
 newspapers, 87, 224–34
 nobility, 20, 62
 orphanage diet, 120

Edinburgh (cont.)
 pensions, 64
 pew rental, 106–7
 poor relief, 69, 120
 population, 24, 45
 postal services, 48
 printing and publishing, 234–9
 professional classes, 25–6
 public baths, 55
 pubs, 89, 212–14
 schools, 118–21, 171; Dalkeith Grammar School, 171; George Heriot's, 118–19, 121; George Watson's, 120, 121; Haddington Grammar School, 171; Mary Erskine's, 119–20, 121; Royal High School, 120
 surgeons, 115
 theatre, 154–8, 179–84; Tennis Court Theatre, 155–8, 214
 trade, 42–3, 90, 95–7
 Trades, 86
 university, 13, 62, 97, 110–18; library, 240
 urban area, 17–19, 25–8
 water supply, 55
 wealth, 45, 60–1
Edinburgh Courant, 228
Edinburgh Evening Courant, 163, 207, 226, 229–30, 232
Edinburgh Flying-Post, 261
Edinburgh Gazette, 225, 227, 228, 230, 240
Edinburgh Review (1755), 232
Eglinton, Susannah Countess of, 176
Elcho, David Lord, 145, 199
Elliott of Minto, Sir Gilbert, 21, 49, 54, 75, 147, 180, 206
Emerson, Roger, 14, 243
Enlightenment, 2–31, 131
 collecting, 15–16, 131
 and England, 2–3
 models of, 5–10
 nature, 15–16
 Scottish, 10–14
 in United States, 7
Episcopalians, 71, 101–3, 104–5
Evangelical Revival, 108

Evening Post, 226
excise duty, 73

Fair Intellectual Club, 207–8
Ferguson, Adam, 183, 208, 210, 211
Ferguson, William Gouw, 95
Fergusson, Robert, 88
Fernandi, Franceso (Imperiali), 140, 149
Fletcher of Saltoun, Andrew, 11, 91, 239
Forbes, Robert, 105
Foulis, Sir John of Ravelston, 46
Freebairn, David, 90
Freebairn, James, 175
Freebairn, Robert, 73, 74, 142
Freemasonry, 16, 161, 179, 214–18
Friedenwald-Fischmann, Eric, 183

Gatrell, Vic, 27
Gay, John, 68, 168–9, 171–4
Gay, Peter, 2, 4, 5, 7, 9
Gelbart, Matthew, 160
Gibbs, James, 140, 142, 143, 152
Gibson, John, 31
Glaeser, Edward, 19, 22
Glasgow, 21, 55, 69, 112
goldsmiths, 44, 48
Golf, 208
Gordon, Alexander, 160, 162–3
Grant, Sir Francis, 67
Greenshields, James, 104

Habermas, Jürgen, 31, 219
Hamilton, Francis de, 95
Hamilton, Gavin, 139
Hamilton, James de, 95
Hamilton, William of Bangour, 91, 108, 149, 165, 176
Handel, George Frideric, 161–2
Harris, Bob, 1, 23, 57
Hay, Andrew, 142, 148
Hay, William, 218
Herder, Johann, 167
Hermann, Arthur, 10
Highlands, 144–5
Himmelfarb, Gertrude, 3
Hogg, James, 108

Home, John, 110
 Douglas, 182–3, 211
Honourable Society of Improvers, 161
Hont, Istvan, 10
Hopetoun, John Hope, Earl of, 99
Hopetoun House, 99–100
Houston, Rab (R. A.), 1, 86
Huguenots, 100–1, 108
Huizinga, Johann, 21
Hume, David, 4, 11, 12, 16, 20, 183, 208, 209, 210, 213, 219

Ignatieff, Michael, 10
Ilay, Archibald Campbell Earl of, 61, 180; see also under Argyll
Insh, Fern, 11
insurance, 57
Israel, Jonathan, 2–4, 5, 6, 7, 239

Jackson, Clare, 12
Jacob, Margaret, 8
Jacobitism, 34, 71–75, 105, 116, 173, 204, 205, 217–18
 and Freemasonry, 218
Jacobs, Jane, 17, 45
James VII, 46, 48, 50, 51, 52, 61, 156, 225, 239
James 'VIII', 73–4, 142, 174–5, 199, 229
Jews, 106
Johnson, David, 160
Jones, Peter, 13

Kahler, Lisa, 216
Kames, Henry Home, Lord, 21, 67, 161, 208, 210, 213
Kant, Immanuel, 7, 8
Knights of the Horn, 198–9

Landa, Manuel de, 25
Lauderdale, John Maitland 1st Duke, 97
Law, John, 44, 142, 219
Leiden, 61, 64, 65, 111, 112, 116–17
Leith, 42, 44
Lenman, Bruce, 2, 5, 10
Lesger, Clé, 1, 28
L'Estrange, Roger, 202

libraries, 65–6, 239–42
Licensing Act (1737), 162, 181–2
Lumisden, Andrew, 149, 150

McCrae, Morrice, 54
McElroy, David, 196
McGibbon, William, 160, 161
McKean, Charles, 1, 23, 57
Maclehose, Agnes, 198
Maclaurin, Colin, 197, 198, 205
McLuhan, Marshall, 33
Macpherson, James, 150, 169
Malt Tax, 73, 227, 236
Mar, John Erskine Earl of, 54, 61, 73, 142
Marians, 143
Marischal, George Keith Earl, 142, 144, 151
Marrowmen, 108–9, 114
Mary II, 134
Medical Society, 118
Medina, Sir John Baptiste de, 138–9, 143, 146
Melville, Andrew, 103
Mengs, Anton Raphael, 150
Mercury, The, 22
Methodists, 106
Mijers, Esther, 107
Miller, John, 198
Milton, Andrew, 68
Milton, John, 169
Mist, Nathaniel, 175
Moderate party, 13, 24, 108–10, 156, 211
Monboddo, James Burnett Lord, 62, 216
Mosman, William, 139, 140, 142, 149
Munro, Alexander, 111
Murray, John of Broughton, 142, 200, 205, 216, 217, 218
Murray, Patrick Livingston, 53
Musical Club and Society, 68, 159–60, 162, 174
Mylne, Robert, 43, 58

Netherlands, 93–8
 Scots students, 97
 Universities, 111–12, 113
newspapers, 87, 224–34

Newton, Sir Isaac, 2, 5, 6, 12, 16
Norie, James, 88, 136–7, 148, 154

Ogilby, John, 155
Oliphant, Laurence of Gask, 68

Paterson, William, 229
Phelps, Edmund, 16, 17, 25
Phillipson, Nicholas, 5, 11, 27, 61, 109
Philosophical Society, 197
Pitcairne, Archibald, 63, 72, 73, 74, 90, 102, 116, 175, 199, 201, 202, 203, 213, 224, 235, 238
 library, 239
Porter, Roy, 3–4, 9, 11, 154
Price, Richard, 7

Ramsay, Allan senior, 21, 30, 62, 68, 75, 87, 91, 97, 99, 109, 139, 140, 144, 147, 150, 151–2, 156, 159–70, 161–2, 166–74, 201, 202, 203, 204, 206–7, 213, 217, 227, 235, 237, 238
 The Gentle Shepherd, 174–8
 library, 240–2
 theatre, 179–84
Ramsay, Allan junior, 20, 147, 148, 149, 152, 199, 208, 218
Ramsay of Ochtertyre, John, 73
Rankenian Club, 108, 161, 197, 205, 214
Rankinan Club, 205
Reid, John, 225, 229
Rheims, 116–17
Robertson, John, 10
Robertson, William, 109, 110, 147, 172, 183, 198, 208, 209, 211
Rodger, Richard, 41
Rogers, Everett, 29–31
Royal College of Physicians, 45, 52, 63–4, 74, 112, 114, 115–16
 library, 240
 and medical education, 112, 117
 and politics, 74
Royal Society of Edinburgh, 118

Ruddiman, Thomas, 175–6, 201, 231, 234, 235, 236
Rule, Gilbert, 110
Runciman, Alexander, 143, 154

St Cecilia's Day Concerts, 159
St Luke's Academy, 143, 146–9, 171
St Mary's Chapel, 137, 160, 214
Sandby, Paul, 152–3
Schumpeter, J. A., 28
Scotland
 Church of Scotland, 101, 103–6, 107, 209–10
 colonies, 50
 economic growth, 46
 and Italy, 140–1
 money, 20
 nobility, 20
 Scots language, 87, 167–8
 Toleration Act, 104
Scots Courant, 160
Scots Magazine, 31, 232–4
Scots Post-Man, 157, 226, 228
Scott, William Robert, 10
Scougal, John, 87, 145–6
sedan chairs, 60
seedsmen, 90
Select Society, 208–10, 219
Senckenberg, Johann Christian, 53
Sharp, James, 102
Sher, Richard, 6, 9, 13, 28, 109, 210–11
Sheridan, Thomas, 11, 233
Sibbald, Sir Robert, 52–3, 87–8, 91, 101, 105, 115–18
Siskin, Clifford, 16, 31–2
Skinner, Andrew, 13
Skirving, Archibald, 144
slavery, 43–4
Sloane, Sir Hans, 15, 90–1
Smith, Adam, 8, 16, 131, 197, 208, 209, 219, 237
Smollett, Tobias, 216
Smout, Christopher (T. C.), 31
Society for Endeavouring Reformation of Manners, 197, 205
Society for the Improvement of Medical Knowledge, 197

Spectator, The, 32, 201, 226, 227
Spinoza, Baruch, 2–3, 12, 72
Spottiswoode, John, 67
Steele, Richard, 202
Steill, John, 163
Steill, Patrick, 163, 171
Stephen, Jeffrey, 102, 104
Steuart, Archibald, 75, 147
Steuart, James of Goodtrees, 219
Stewart, Dugald, 154
Stewart, Margaret, 74
Stiùbhart, Iain Ruadh, 151, 164
Strange, Robert, 149, 150–1
Stuart, Alexander, 160, 178
Stuart, Charles Edward, 152, 164
Stuart, Gilbert, 7
Sutherland, James, 53, 73
Swift, Jonathan, 202
Sydserf, Thomas, 155, 224, 225
Szechi, Daniel, 72

tartan, 75, 200
Tatler, Scottish, 226, 227
Tatler, The, 202
taverns, 212–14; *see also* Edinburgh, Pubs
theatre
 Canongate, 67
 Tennis Court, 155–8, 224
Theocritus, 174
Thistle, Order of, 45
Thistle, The, 231–2
Thomson, William, 161, 163
Thriepland, Sir Stuart, 105
Traquair family, 142, 147–9, 205
Trevisiani, Francesco, 145

Trevor-Roper, Hugh (Lord Dacre), 10, 34
Trotter, Thomas, 171
Trustees Academy, 154
Tweeddale, John Hay, 1st Marquis, 98

Union (1707), 11, 12, 34, 49–50, 61, 72–3, 228
useful learning, 53

Veere, 96
Vincent-Lancrin, Stéphan, 183
Violante, Signora, 68, 157
Voltaire, Arouet Marie de, 6, 8

Warner, Bill, 16, 31
Warrender, Thomas, 51, 132–3
Watson, James, 87, 169, 225, 226, 227, 238, 239
Westphalia, Treaty of (1648), 9, 15, 16
Wet, Jacob de, 98
Whatley, Chris (C. A.), 73, 75
Whitfield, George, 108, 109
Wig Club, 207
William II and III, 134, 146
Winner, Ellen, 183
witches, 71
Witherspoon, John, 107, 156
Wodrow, Robert, 108, 241
Worcester affair, 228
Writers to the Signet (WS), 66
 library, 240

Yester, 132–3
Young, William, 7
Youngson, A. J., 22, 24